FASHIONING CHARACTER

Cultural Frames, Framing Culture

ROBERT NEWMAN, EDITOR

JUSTIN NEUMAN, ASSOCIATE EDITOR

Fashioning Character

STYLE, PERFORMANCE, AND IDENTITY IN
CONTEMPORARY AMERICAN LITERATURE

Lauren S. Cardon

UNIVERSITY OF VIRGINIA PRESS
Charlottesville and London

University of Virginia Press
© 2021 by the Rector and Visitors of the University of Virginia
All rights reserved
Printed in the United States of America on acid-free paper

First published 2021

9 8 7 6 5 4 3 2 1

Library of Congress Cataloging-in-Publication Data
Names: Cardon, Lauren S., author.
Title: Fashioning character : style, performance, and identity in
 contemporary American literature / Lauren S. Cardon.
Description: Charlottesville : University of Virginia Press, 2021. |
 Series: Cultural frames, framing culture | Includes bibliographical
 references and index.
Identifiers: LCCN 2020042629 (print) | LCCN 2020042630 (ebook) |
 ISBN 9780813945880 (hardcover ; acid-free paper) | ISBN 9780813945897
 (paperback ; acid-free paper) | ISBN 9780813945903 (ebook)
Subjects: LCSH: American fiction—20th century—History and criticism.
 | Clothing and dress in literature. | Fashion in literature. | Identity
 (Psychology) in literature.
Classification: LCC PS374.C565 C373 2021 (print) | LCC PS374.C565 (ebook) |
 DDC 813/.509353—dc23
LC record available at https://lccn.loc.gov/2020042629
LC ebook record available at https://lccn.loc.gov/2020042630

Cover art: Eagle in Flight Protective Mood, Patricia Michaels. Hand-painted silk
organza cape. (Photo by Zoë Urness)

For my mother and my grandmother, who introduced me to the world of fashion, and to my daughter, Joanna, who will someday learn about it

Contents

Acknowledgments

I HAVE MANY PEOPLE to thank for their assistance with this project, including those who helped by reading and editing chapters, aiding in the research process, or just talking with me and providing moral support. I began work on this book shortly after commencing employment at the University of Alabama, where I have been blessed with supportive colleagues, research assistants, and friends. In 2014 I was fortunate to secure Research Grants Committee funding through the University of Alabama. This generous grant allowed me to conduct research in New York City and Washington, DC, and to visit exhibitions that aided me in my research and writing. The grant also gave me the opportunity to work with a graduate research assistant, Kit Emslie, a talented poet and insightful literary scholar. Since working with Kit, I have also had the opportunity to work with two other talented writers as research assistants, Elizabeth Theriot and Sarah Landry. These three researchers have been essential in the successful development and completion of this manuscript.

I cannot adequately express my gratitude to my colleagues in my interdisciplinary writing group, who have kept me on schedule, read nearly every chapter of this book, and provided invaluable suggestions for further research and editorial changes. In particular, I would like to thank Utz McKnight,

Hilary Green, Marie-Eve Monette, Marin Odle, Sara-Maria Sorentino, Lamar Wilson, Stefanie Fishel, Jessy Ohl, Gwenetta Curry, Holly Pinheiro, Alexis McGee, Rachel Stephens, and especially Cajetan Iheka, who has continued to read sections for me outside of our scheduled writing group sessions. In addition to the assistance provided on specific chapters, this group was a much-needed source of encouragement and inspiration as I worked on this project. I would also like to thank my dear friend Anne-Marie Womack, who read and edited early chapter drafts of this book and provided endless encouragement, and Xabier Granja, who assisted me with securing the visual material for this project.

I am grateful to the librarians and administrators at the Howard Tilton Memorial Library at Tulane University, the Stephen A. Schwarzman Building and Schomburg Center for Research in Black Culture of the New York Public Library, the Metropolitan Museum of Art, the Smithsonian Institute, the Library of Congress, the Condé Nast archives, and the Amelia Gayle Gorgas Library at the University of Alabama. Jacqueline WayneGuite, Fashion Study Collection manager at Columbia College of Chicago, assisted me in finding historically significant gowns and images for the book, and Courtney Chartier at the Rose Library of Emory University helped me locate content in special collections. In addition, I want to extend my gratitude to Robbi Siegel at Art Resource, Daniel Trujillo at Artists Rights Society, Ron Hussey at Houghton Mifflin, and Miranda Muscente, Tiffany Boodram, and Allison Ingram at Condé Nast for their assistance in securing permissions for the illustrations featured in this book. I am grateful to talented artists Teri Greeves and Patricia Michaels, who have generously allowed me to feature their exquisite work in this book.

I would like to thank Sarah Sides, administrative specialist in the Department of English at the University of Alabama, and the other members of the English department's administrative staff at Alabama for helping make my research trips and other scholarly pursuits connected with this project possible. I also want to thank my department chair, Joel Brower, for being a constant advocate for my work throughout the process of researching and writing this book.

During the process of completing this project, I have been privileged to be a part of various scholarly communities. My colleagues in the College Language Association and the Pacific Ancient and Modern Language Association offered their valuable questions and feedback when I presented portions of the manuscript at their annual conferences.

I would like to extend my deepest gratitude to the University of Virginia Press's Eric Arthur Brandt, who first took an interest in my manuscript and was instrumental in getting it published, as well as his assistant Helen Marie Chandler, and editor Angie Hogan who has aided me in the final stages of this manuscript. I also want to thank Robert Newman, series editor, for his confidence in my project and for giving me the opportunity to publish a second book in the outstanding Cultural Frames/Framing Culture series.

I want to thank my dear friends and family for their continued love and encouragement, as well as moral support that kept me focused during the writing of this book. My mother, JoAnn, and my stepfather, Ron, always motivate me to succeed in my personal and professional goals through their love and their confidence in my work ethic. My sister, Caroline, and her husband, Casey, parents of my precious nephews Carden, Aiden, and Hudson, have offered their encouragement, as well as room and board, during multiple research trips to Washington, DC, and my brother, Aaron, inspires me through his hard work and intellectual curiosity.

Finally, I want to thank Thomas Altman, my partner in life, for his patience, love, and support throughout this project.

FASHIONING CHARACTER

Fashion as Freedom

IN HER NOVEL THE *Handmaid's Tale* (1985), set in Boston, Canadian author Margaret Atwood describes a dystopia in which a right-wing Christian government rules the United States, and women are confined to three roles: wives (child rearers and social companions for men of status); Marthas (housekeepers); and handmaids (breeders). All women must wear strict uniforms of red, green, and blue to represent their roles. In this terrifying dystopia, women have been stripped of many freedoms—reproductive rights, the freedom to choose their own partners, and even control over their own bodies. The loss of fashion, therefore, feels relatively insignificant in comparison; however, the narrator, Offred, makes a point of noting its loss and the reality of wearing the same full-coverage, veiled garment for the rest of her life.

Late in the novel, Offred is given an old fashion magazine by her Commander. She reflects on its contents: "What was in them was promise. They dealt in transformations; they suggested an endless series of possibilities. . . . They suggested one adventure after another, one wardrobe after another, one improvement after another, one man after another. They suggested rejuvenation, pain overcome and transcended, endless love. The real promise in them was immortality" (157). For Offred, the pages of the magazine and the

roles they depict represent freedoms she once took for granted: freedom to have adventures, to remake oneself, to fall in love, or—as a young girl says in the novel's television adaptation—to "wear whatever I want" ("Mayday"). Offred reads these freedoms in the exposure of a woman's legs, in the confident poses, in the range of clothing options, and, implicitly, in the promise of *becoming*.

These same magazines, in the past, have been the subjects of feminist censure.[1] In fact, American literature often reinforces this perception of fashion, exposing the patriarchal dimensions of the fashion and beauty industries. More recently, however, scholars have recognized fashion's complex relationship with feminism and identity—as cultural studies scholar Susan B. Kaiser notes, fashion is associated with "an ever-changing interplay between freedoms and constraints," as well as a paradoxical relationship between individualism and participation in a global economy, and between both standing out and fitting in (1). Kaiser, Ilya Parkins, Llewellyn Negrin, and other scholars of fashion and feminist theory offer theoretical context for the authors' perspectives discussed in this book: fashion represents a site for understanding one's relationship to class, gender, race, ethnicity, religion, and any other number of affiliations by playing with the multitude of signifiers offered by a consumer-oriented fashion industry.

Postwar American fashion, these texts show, has marketed itself as a venue for role-play and identity construction, even beginning with the late 1940s and 1950s period famously critiqued by feminist Betty Freidan. This industry goal is self-serving: the more potential female roles offered by the fashion industry at any particular moment, the more women will see themselves in fashion, and thus the more consumers will worship at fashion's altar. The industry must also strike a balance between providing such a range of looks and ensuring that it still prioritizes some styles as trendy while deeming others outdated.

Yet the significance of fashion as a vehicle for role-play should not be overlooked. In the landscape of contemporary fashion, with its countless array of "possibilities"—to use Offred's phrasing—in which subjects can transform, improve, have adventures, transcend pain, and rejuvenate, fashion is more than a costume to be discarded. The identities that a subject tries on can leave their mark, becoming part of the subject. In other words, as Atwood and the other authors discussed in this book reveal, fashion is not only a vehicle for self-discovery; it *is* its subject, its wearer. These texts suggest that when we curate our style and see ourselves reflected back in a

way that feels genuine, we align our public presentations with the people we feel we have become—or wish to become.

In my 2016 book *Fashion and Fiction: Self-Transformation in American Literature,* I argue that American fashion emerged as a consumer-focused version of the European fashion industry during the early twentieth century. While in Paris the fashion industry elevated talented designers to the status of artists, artists who created to serve royalty and a social elite, in the United States the industry grew to serve as many consumers as possible. The accessibility of fashion for American consumers made it possible for individuals to use fashion as a tool for upward mobility, for blurring lines between classes. American literature of the early twentieth century features characters obsessed with social mobility: they try to enter exclusive groups or spaces, they try to erase ethnic origins or "pass" as white, or they try to reinvent themselves as better, freer individuals. These characters employ the symbolic text of fashion to aid them as they navigate among various groups and construct new identities.

While the early twentieth-century works I discuss in my previous book focus on the limitations of American fashion in transcending boundaries of race and gender as they intersect with class, the post–World War II texts I discuss in the chapters that follow expose how understanding fashion opens possibilities for characters to explore a host of different identities—in some cases, identities that represent not upward mobility or overcoming limitations of class and race, but rather a rejection of privilege. In some cases, this means deepening one's relationship with ethnic or cultural identity, refusing to adhere to the social codes associated with economic privilege, or prioritizing relationships with family and community over relationships with an imagined national identity. As American fashion grows more affordable and pluralistic (diverse in its styles and target markets), it becomes easier for the characters to transform themselves, and therefore their performances can be temporary rather than permanent roles. The value of the temporary performance is not in escapism, but in testing alternate identities in a quest for self-discovery, showing that identity is a process constantly negotiated and questioned, never completely fixed. In some texts, fashion reinforces problematic constructions of race, gender, and sexuality that lead characters to lose themselves in self-destructive archetypes. Yet for the characters who understand fashion as a set of signifiers, clothes liberate: these

characters treat clothing as a temporary shell, a means of entering a new space or becoming someone different, with the ultimate aim of finding a skin that feels like one's own.

This book, therefore, is concerned with fashion as a tool for performing and ultimately constructing identity. By performance, I refer to the conscious adoption of recognizable signifiers associated with a particular racial, gender, class, or other identity. These signifying garments and accessories are generated from multiple sources: from popular culture images; from the fashion industry's appropriation of nonwhite or non-Western cultural artifacts; from political symbols; from individual icons; or from deeply entrenched cultural traditions. In performing an identity, what matters is that the wearer understands the signifying power of the garments and accessories and wields them both to inhabit a particular identity and to present that identity to the public.[2]

Authors offer a range of interpretations for how fashion allows for identity performance. In some texts, performance might mean using clothing to express affiliation or ideology, or in some cases, appropriating from other cultures. As an example, in Danzy Senna's 1998 novel *Caucasia,* discussed in chapter 3, the narrator describes her mother's childhood friend, Jane: "She had graying brown hair, Indian jewelry, and a bright-colored smock, and she was involved in Boston politics. My mother said she was a real radical" (53). The narrator of the passage, Birdie, describes the dress of her mother's friend Jane and then juxtaposes her description with her mother's statement that "she was a real radical" (53). The details of Jane's dress—"Indian jewelry" and "a bright-colored smock"—reflect the late 1960s and early 1970s countercultural style, a style associated with antiwar ideology and radicalism. As the novel begins in the 1970s, Jane's style is not fashionable but instead belies her affiliation and her politics. She uses her clothing to perform a countercultural identity and to present her radical political ideals. In observing Jane's graying hair, Birdie hints that the energy of this countercultural movement is waning, and yet Jane continues her efforts and adheres to her fashion signifiers. Her clothes are dated as fashion items, but they retain the same social meaning despite the passage of time.

Affiliation represents just one possibility for using fashion to construct a public identity. American authors writing after World War II echo earlier twentieth-century writing in how they use fashion within their texts (that is, to chart characters' attempts to alter their social positions), but the changing landscape of American fashion allows them to use it in other ways:

(1) to project different aspects of characters' social identities (including but not limited to affiliations and political leanings) in a public sphere; (2) to indicate the relationship between clothing and the body—and by extension, between clothing, sex, and gender; (3) to subvert prevailing ideologies by embracing antifashion or counterculture fashion; and (4) to portray a character's relationship to an ethnoracial community, often by writing against mainstream misappropriations of that community's culture.

In earlier twentieth-century narratives, characters like Edith Wharton's Lily Bart or Theodore Dreiser's Carrie Meeber might have used clothing as a tool for upward mobility. In works of immigrant, ethnic, or African American literature like Anzia Yezierska's *Salome of the Tenements* (1923), Nella Larsen's *Passing* (1929), and Jessie Redmon Fauset's *Comedy, American Style* (1933), the authors deal more explicitly with intersectionality in their incorporation of fashion, as characters navigate ethnic and immigrant identity or racial identity in relation to their social class, yet privilege remains a key focus of how fashion is used in these narratives. In later works of American literature, however, characters project other defining characteristics beyond class, race, and ethnicity through their clothing: cultural heritage, sexual orientation, taste in music or art, political views, professional identities, social or religious affiliation, subcultures, or any other number of defining traits. In this sense, fashion moves from the modern (expressing a fixed identity) to the postmodern (expressing multiple identities that remain in flux).[3]

Cultural studies scholars have documented this shift as paradigmatic in developing the fashion industry not only in the United States but in non-Western cultures as well. In *Fashion and Its Social Agendas* (2000), Diana Crane observes how developing design firms, manufacturers, and retailers in cities scattered across the globe meant that consumers had more options, options advertised through storefronts, fashion magazines, and other media: "The development of powerful electronic media with enormous audience penetration and postmodern imagery changed the diffusion of fashion and redefined issues of democratization" (132). Fashion journalism embraced this postmodern concept of fashion, using fashion spreads (and later, commercials, social media outlets, websites, and other media) to advertise not only the clothes themselves but also the attitudes and identities they represented.

Unfortunately, in the fashion world, too often "freedom" is conflated with consumerism. In their book *Channels of Desire: Mass Images and the*

Shaping of American Consciousness (1992), Stuart and Elizabeth Ewen explain this conflation in the fashion industry, noting, "Issues of choice were being recast as issues of *consumer choice*. Social ideas, ecological concerns, the search for meaningful identity; these became new raw materials of merchandising" (198–99). In other words, according to Ewen and Ewen, what presents the illusion of self-expression and identity construction is really strategic consumer marketing.[4] Minh-ha T. Pham makes a similar point in the context of post–9/11 marketing, particularly the Fashion for America campaigns, in which "fashion emblematizes and enacts multiple neoliberal freedoms, including the freedom to consume and, connected to that, the freedoms of self-expression and self-determination" ("Right to Fashion" 386). Pham and American studies scholar Lizabeth Cohen trace this conflation of good citizenry and consumerism to the onset of World War II, when purchasing products to fulfill the desire for comfort and luxury represented postwar and post-Depression economic rehabilitation (Pham 396, Cohen 8–9). In muddling the freedom of expression associated with fashion with a consumerist imperative, such historical conflations demand a distinction between fashion as something to buy and fashion as something to wear, or even just to try on. The texts in this book are selected to illustrate a spectrum between mindlessly consuming fashion for a temporary thrill and embracing clothing (whether mainstream fashions or dress associated with antifashion or a subject's cultural traditions) to negotiate individual identity. As Pham, Cohen, and Ewen and Ewen suggest, the influence of popular media images and fashion journalism can undercut notions of fashion as freedom—rather, they imply fashion as the illusion of freedom for interpellated subjects. Betty Friedan echoes these ideas in *The Feminine Mystique* (discussed in chapter 1): middle-class women, denied the freedom of choosing their careers and their social paths in life (or facing social ostracism), had only the illusion of freedom in the opportunity to choose from a multitude of pretty clothes and accessories within a booming and expanding fashion market. Yet even this "freedom" was limited, for women in the 1950s did *not* have much choice in how they dressed, as long as they wished to be judged as respectable and stylish.

Other authors illustrate how individuals can still make choices outside of those dictated by the mainstream, as demonstrated by the Beat women writers discussed in chapter 2, who often made their own clothing and cultivated bohemian styles. Similarly, the American Indian authors discussed in chapter 4 illustrate how indigenous designers incorporate aspects of

mainstream fashions (some of their textiles and silhouettes, for example) and blend them with distinctive tribal traditions like beadwork and hand-dyeing fabrics, which allow them to put their own flourishes on their garments. Such efforts—of cultivating new styles and celebrating aspects of traditional dress—speak to the ways that individual subjects as well as communities outside of the mainstream fashion industry have worked to change fashion, to see themselves in it and carve out a space for different lifestyles, different attitudes, different traditions, and different body types.

A second departure from earlier fashion-themed novels is the way the authors of these texts pay more attention to the way clothing interacts with the body, especially women's bodies. Without the same binding undergarments squeezing women into the modish shape of the time (with the exception of many 1950s ensembles), women become more attuned to the way certain clothes feel or the way garments make them appear thinner, heavier, curvier, taller, or shorter. American culture teaches women to be ever conscious of how their bodies fit or fail to fit contemporary standards of beauty and health, and at many historical moments, fashion has excluded women who fail to fit a particular body type: the slim silhouette of the 1920s, the petite hourglass silhouette of the 1950s, the "Twiggy" look of the 1960s, the Kate Moss "heroin chic" look of the 1990s. Yet after the 1950s, as high-end designers lost some of their hegemony over the industry thanks to the rise of street fashion and an expanding global market, female consumers have had more options for stylish and on-trend looks—styles that fit their body types as well as their personalities. Popular features in fashion magazines included articles instructing women on how to dress for their body types, explaining what silhouettes, lengths, and materials were most flattering to different shapes and sizes, much as men's magazines provide instruction on cuts, materials, and styles of menswear appropriate for their sizes and lifestyles. More specifically, these features began to place a greater emphasis on personal expression. The term "personal style" (which I define in the next section) first appeared in *Vogue* in 1900, but in the context of men's dress ("Well-Dressed Man" 334). It appeared again in 1933 in a piece about "self-expression" in fashion, but this feature very clearly was still promoting a specific mode (the long, slim silhouettes of the 1930s, the shorter haircuts). In contrast, in 1972 *Vogue* featured an entire issue devoted to personal style, with features on a range of different celebrities who celebrate their unique looks and fashion choices, as well as another piece featuring models with different clothing styles (mod, bohemian, traditional, etc.) as

well as different hair lengths and textures. During the late twentieth century, these features that emphasize finding one's style among a range of
possibilities became increasingly popular.

The range of silhouettes in women's fashion has also given women different options for expressing themselves as women, with magazines offering feminine looks and more androgynous styles. Crane cites the theory of
Judith Butler in *Gender Trouble* (1990) that regards "gender as constructed
through playacting and performance" and indicates how contemporary
fashion, while still operating within gender constraints, nevertheless creates a space for embodying gender roles outside of the normative constructions described by Butler: "This perspective implies an important role for
fashion in providing the wherewithal for commenting upon, parodying, and
destabilizing gender identities, without necessarily alleviating the social
constraints imposed by gender" (204). Such possibilities for destabilizing
gender norms have only increased with time. True, women's fashion choices
are constantly policed, and the availability of "a plethora of products and
technologies for modifying the body, such as diet pills, exercise programs,
and cosmetic surgery" (Negrin 9) pressures women to conform to a perceived
standard of beauty. This policing is paradoxical: women in the spotlight are
often celebrated for asserting a distinct personal style but at the same time
face media scrutiny for their choices. On the one hand, for example, recent
first ladies and other political figures have enjoyed increased freedoms in
shaping their public personas: from the feminine and conservative gowns of
Laura Bush to the menswear-inspired pants suits of Hillary Clinton to the
stylish populist ensembles of Michelle Obama, who famously wore affordable brands like J. Crew and H&M during her husband's 2008 campaign, to
the trendy but controversial styles of Melania Trump—most notably, her
choice to wear Gucci's "Pussy Bow" blouse to the presidential debate and
a Zara jacket printed with the words "I REALLY DON'T CARE DO U" to a
migrant children's shelter. But on the other hand, many of these women
cultivated such personas with an awareness of how every fashion choice
would be read as a coded statement—one they would not always be able to
control. In her autobiography *Becoming* (2018), Michelle Obama describes
her consciousness of how everyone was reading her clothing, and how, in a
way, her personal style became an attempt to confound those trying to read
her: "When it came to my choices, I tried to be somewhat unpredictable,
to prevent anyone from ascribing any sort of meaning to what I wore. . . . I
mixed it up. I'd match a high-end Michael Kors skirt with a T-shirt from the

Gap. . . . For me, my choices were simply a way to use my curious relation-ship with the public gaze to boost a diverse set of up-and-comers" (332–33). Obama, who was considered stylish by fashion media and her followers, reveals the dialogic nature of contemporary American women's fashion, a balance between self-assertion and fitting in, between novelty and classic pieces, between asserting one's persona and maintaining some mystery. The authors discussed in the following chapters show their knowledge of these connections between postwar fashion and identity politics, as well as fash-ion's power to destabilize gender norms.

As a third factor, these authors depict fashion as potentially subversive, at odds with the prevailing ethos of a white dominant culture in the United States, perhaps because, since the 1960s, magazine culture and fashion have both targeted a younger consumer base. Such deviant, rebellious styles have been labeled "antifashion," "oppositional dress," and "counterculture fashion," yet these terms all imply a style aesthetic outside and indeed in opposition to a fixed mainstream construction of fashion. At numerous moments in the late twentieth century and today, mainstream fashion mag-azines have featured content seemingly engineered to shock. Referring to a 1992 *Vogue* fashion spread titled "Grunge and Glory" (Poneman), editor-in-chief Anna Wintour stated, "That was such an important shoot. . . . You have to do something that's going to really make people sit up and think and be shocked and confused and angry" (*In Vogue*). Wintour has gained recognition for what she terms "trickle-up" fashion, fashion that begins in the streets and generates new ideas, silhouettes, and styles for high-end designers, later appearing on the runways of fashion capitals and in maga-zine spreads. If a consumer then purchases a pair of grunge-inspired torn jeans, she may not have been part of the Seattle music subculture that inspired the fashion spread, but the attitude, the antiestablishment feel of the trend, does not completely disappear just because it has become a part of the fashion system.

As a literary example of this phenomenon, in Douglas Coupland's *Pola-roids from the Dead* (1996), characters wear tie-dyed clothing, resuscitating a 1960s counterculture-era style as they attend Grateful Dead concerts in the 1990s. Their efforts to re-create that style appear superficial, as they lack the connection to the music and the antiwar movement embraced by the Dead's earlier fans; however, to these younger attendees, the tie-dye sym-bolizes a more general sense of deviance and nonconformity. Antifashion illustrates the problem of selecting fashion to mediate one's public image,

for public perceptions are never monolithic: other members of this new Deadhead generation may reaffirm the choice of tie-dye; community outsiders may react negatively to the clothing and yet still endorse the connection between tie-dye and music counterculture; however, older Deadheads may see the superficiality in purchasing mass-produced tie-dyed shirts and view this younger generation as inauthentic or conformist.

Such issues of authenticity also characterize a fourth theme in these texts: fashion as a means of negotiating or appropriating ethnoracial identity. The authors show the impact of race and ethnicity on American fashion, and the tension between so-called cultural appreciation and cultural appropriation in dress. In his novel *Reservation Blues* (1995), Sherman Alexie satirizes a white dominant culture tendency to appropriate jewelry or garments associated with American Indian dress as a means of demonstrating their own cultural sensitivity or spirituality. Two white women, Betty and Veronica, wear their hair in braids and adorn themselves with turquoise jewelry as a means of displaying their superficial interest in tribal culture. Other authors depict cultural appropriation even when the characters believe themselves part of a given culture: Alice Walker critiques this tendency through several dashiki-clad African American characters, including Dee in "Everyday Use" (1973) and the middle-class Truman Held in *Meridian* (1976). Other writers, like Senna and Winona LaDuke, show how the semiotics of non-Western dress are critical for forging a positive cultural consciousness that exists outside of mainstream American fashion. Authors represent the development of these non-Western styles in the United States through both alternate fashion media (e.g., African American periodicals in *Caucasia*) and tribal dress that reflects a dual legacy of traditional clothing and trade with other groups (e.g., the ribbon shirts of the Otoe tribe in *Last Standing Woman*). The authors therefore show how trends can exist in American culture even outside of a mainstream fashion system. In many cases, as these characters embrace and adapt traditional, nonmainstream clothing, they enrich their sense of cultural solidarity and understanding.

Of course, these same clothes take on a different symbolic meaning when appropriated by cultural outsiders and especially the fashion industry itself. The term "cultural appropriation" is often attributed to George Lipsitz, who describes it in the context of American literature and popular music in his 1994 book *Dangerous Crossroads: Popular Music, Postmodernism and the Poetics of Place*. He illustrates the concept with the example of white

male protagonist Jim Burden dancing with "ethnic working-class women" in Willa Cather's novel *My Ántonia* (1918). Jim feels alienated and disillusioned with the "stultifying constraints of middle-class life" (Lipsitz 51), so he begins attending the local dances and flirting with the "hired girls" of the neighborhood. Lipsitz explains: "He derives erotic stimulation and moral edification from the culture of exploited and aggrieved people. No longer 'bridled by caution,' he compensates for the diminished sense of self created by his obedience to middle-class mores with an augmented sense of masculinity gained through his boldness with ethnic working-class women" (51). In other words, through his contact with the ethnic women, Jim benefits emotionally—he feels less alienated, more masculine—and yet he feels superior to them. He has done nothing to change the circumstances that reinforce his hegemony as a white, dominant culture man and the social subordination of the women because of their gender, ethnic identity, and socioeconomic class. His engagement thereby reflects a larger pattern in Western culture: people in positions of power and privilege derive pleasure from controlled contact with the culture of marginalized groups; they benefit from these cultures and perhaps help the careers of a few individuals from these cultures, yet ultimately they do nothing to subvert the hierarchy of dominant and marginalized groups. In fact, they implicitly reinforce their inferiority by suggesting their culture is a collection of curiosities they can draw from at random to enrich their own lives.

The fashion industry—both American and worldwide—is so rife with instances of cultural appropriation that it is impossible to police, and often only the most egregious cases (usually those involving misappropriations of sacred objects or reinforcement of a racial or ethnic stereotype) draw enough media attention to have a negative impact on the designer. In chapter 4, I discuss some of these instances—particularly those relating to cultural misappropriation, or appropriation from a marginalized culture that creates misinformation about that culture or—worse yet—exploits something sacred to that culture (for example, the warbonnet or totem pole). In other instances, garments that began as instances of cultural appropriation (working-class clothing like jeans and T-shirts appropriated by a middle-class counterculture in the 1950s, for example) have become staples of American fashion, losing their initial association with a class or cultural group but retaining some aspect of their connotation (rebellious, cool, nonconformist). It is worth noting here that, as I discuss further in chapter 3, the global fashion industry's hegemonic appropriation of motifs

and garments from non-Western and/or marginalized groups, while problematic, has also fueled interest in new fashion markets and designers from nonwhite and non-Western groups, leading to an increasingly globalized and pluralistic network of fashion capitals and designers.

If American fashion has evolved to become increasingly pluralistic, then it simultaneously has to work harder to stay relevant. If a magazine includes a feature on "punk style" one season, the editors will have to reinterpret that style and introduce new features into it if they want to promote punk fashion in a future issue. Certainly the options have to change from month to month and from season to season; fashion has to change, and the industry must encourage consumers to keep experimenting and role-playing. Similarly, editors cannot just market punk style to punks: they have to help a range of consumers see themselves in the style. If designers are showing military jackets on the runway, it is the job of fashion magazines to incorporate military jackets into multiple consumer identities. Magazine readers will see a military jacket with jeans and a T-shirt as part of "street style," a military-inspired blazer as part of a polished career look, and a high-fashion embellished military jacket incorporated into a stylish jet-setter ensemble. Fashion magazines therefore instruct consumers on trend items and on personal style, demonstrating how to incorporate the new garment into looks that already define them, or introducing new fashion personas that consumers might not yet have explored.

As fashion fluctuates, so does consumer identity: the clothing provides a costume, a means of experimenting and role-playing, of fashioning and refashioning individual identity. Diana Crane explains: "People make choices that require the continual assessment and evaluation of consumer goods and activities in light of their potential contributions to identities or images they are attempting to project. From time to time, a person is likely to alter her lifestyle, and, as large numbers of people engage in this process, the characteristics of lifestyles themselves evolve and change" (10). When fashion editors consider a wider range of consumers and encourage those consumers to find themselves within the pages of their magazines, they successfully instill the need to shop, to expand wardrobes, to experiment with new looks and new public personas. Over the course of the twentieth century, the options once offered exclusively in print media, catalogs, and shop windows have multiplied to include television programs, films, music

videos, billboards, internet advertisements, online retailers, fashion blogs, and a range of other media. The result is, to borrow Atwood's phrasing, "an endless series of possibilities."

As the authors in this book show, an individual's consumer identity can obscure rather than reveal herself—particularly if she focuses too much on fitting in and proving herself to a group. Yet even when the subject takes on a persona marketed to consumers, the texts imply that the anchoring aspects of the subject's life—family, heritage, politics, even personal prefer-ence—ultimately allow the subject to move from interpellated consumer to self-aware individual. The experimentation with alternate identities thus becomes an important step in self-actualization.

A Definition of Fashion Terms

While in American vernacular we often use the terms "fashion," "style," and "dress" or "clothing" interchangeably, for the sake of clarification I make careful distinctions among these terms.[5] Like Roland Barthes in *The Fash-ion System* (1967), I use the term "fashion" to refer to a fluctuating system that deems certain looks, textiles, pieces of clothing, accessories, or other aspects of attire in style and others out of style.[6] However, I find the system less abstract than Barthes suggests: it's largely governed by the aforemen-tioned collaboration between fashion journalism, high-end designers, and advertisers; it establishes trends yet also revives older trends, deems some pieces classic (and therefore *always* stylish), and tends to value clothing aes-thetics over utility. Being part of the system requires knowledge, research, and maintenance—knowledge of fashion rules (What fabrics are appropri-ate for evening wear? Can I wear white after Labor Day?); research of cur-rent trends and any changes or updates to the fashion rules (we no longer have to match our purses to our shoes); and maintenance of that knowledge as well as the pieces themselves (regular wardrobe purges/updates, repairs to clothing, visits to the tailor, dry cleaner, or cobbler). For the sake of this study, I assert that fashion is the system; the fashion industry is the govern-ing body that controls the system.

Scholars of the social and economic dimensions of fashion have tended to follow different theoretical approaches—approaches that offer not only a clear perspective on fashion's function in a post-industrial society, but also an analysis of how fashion changes and evolves. Georg Simmel, for example,

offers a class-based theory in his seminal 1904 article "Fashion": "The elite initiate a fashion and, when the mass imitates it in an effort to obliterate the external distinctions of class, abandons it for a newer mode" (541). His theory echoes Thorstein Veblen's theory of conspicuous consumption and emulation;[7] however, while Veblen focuses on emulation within the upper or "leisure" class, Simmel focuses more on emulation of the wealthy by the poorer classes. In contrast to Simmel's "trickle-down" theory, Barthes suggests fashion emerges not from specific social classes but from the makers and producers of fashion in conjunction with fashion journalists (xi–xiii).

In 1984, Pierre Bourdieu presented a theory that posed rebuttals to Simmel's, explaining that the working class cannot simply imitate the upper class—not merely because working-class citizens cannot afford the clothes, but because their clothes are partially dictated by lifestyle: "the tastes of working-class men would be based on a 'culture of necessity' characteristic of that class, in other words, clothing that was practical, functional, and durable rather than aesthetically pleasing and stylish" (Crane 8). Those who moved into the middle classes would be expected to adopt the clothing and behavior of that class "but would not exhibit the same levels of taste and refinement owing to insufficient socialization and education" (8). Bourdieu acknowledges the role of fashion in upward mobility yet characterizes changes in dress not as the gate keys to different social echelons but as necessary signifiers of embracing a new status.

The problem with all of these theories is that they cannot be universally applied: fashion functions in various ways in post-industrial nations across the globe, as well as at different historical moments. In addition, as cultural studies scholar Jennifer Craik has observed, fashion is not even "unique to the culture of capitalism" (3), and is not explicitly concerned with consumption.[8] Craik rejects theories like Simmel's and Veblen's and instead argues that fashion "is a technique of acculturation—a means by which individuals and groups learn to be visually at home with themselves in their culture" (10). Some of the authors in the following chapters offer glimpses of how such acculturation functions within alternative fashion systems— for example, Winona LaDuke's depiction of contemporary indigenous dress in chapter 4. Even within the mainstream industry in the United States, fashion has emerged from different wellsprings and has held different symbolic meanings even from decade to decade. Applying Veblen's theory of fashion among the leisure class, for example, does not adequately explain

the character of conspicuous consumption among the leisure class during the Gilded Age in New York. In *The Age of Innocence,* Edith Wharton—a critical observer of women's fashion—depicts the contrast between members of the New York "old society" who wait several seasons to wear their Parisian couture dresses and the *nouveau riche* Regina Beaufort, who wears the newest Parisian designs as they debut (Wharton 258). The women of the New York aristocracy imply that they find Regina's choice vulgar, even though it represents the latest fashion and connotes high economic value. The example shows the difficulty in detaching the value of fashionable clothing to longstanding rules of style and taste.

In the same vein, the theories fail to account for when fashion inspiration has derived from a different country, culture, or counterculture. When asked where fashion comes from, many people within the industry will simply state "Paris"; however, during the 1950s, the premium on beautiful leather goods and new textiles helped to launch Italy to the apex of the fashion world, and in the 1960s, the youth culture of London dictated new modes of fashion and style. During the 1980s, Tokyo emerged as a major fashion capital due to the emergence of provocative new designers like Issey Miyake and Comme des Garçons, and since then other global fashion capitals have emerged in South Africa, Nigeria, Brazil, and Australia. In recent years, the popularity of sites like Etsy and television programs like *Project Runway* have created competition with the hegemony of big-name designers, as fashion subjects seek out unique pieces and new points of view, and some even attempt to make their own creations. The rise of ecofashion, the popularity of sites like eBay and Poshmark, and the proliferation of thrift stores and consignment shops have also encouraged fashion subjects to be more conscious of contributing to fashion waste—to wear recycled fashion or at least to blend some vintage pieces in with newer purchases.

Today, therefore, the fashion industry in its most traditional sense—the world of Parisian ateliers and haute couture—does not hold the same cache that it did á century ago: fewer women remain slaves to seasonal trends but instead adopt a few trend items into a wardrobe of classics. In fact, many Americans during the recent economic recession have come to denigrate the conspicuous consumption of wealthy citizens: during the 2008 presidential election, for example, citizens admired Michelle Obama's accessible yet stylish wardrobe (often featuring pieces from J. Crew and H&M) while condemning Sarah Palin's $150,000 wardrobe budget for campaigning. In the United States, style has gained greater civic value and regard than fashion.

"Style" is often used interchangeably with "taste," but I want to draw a distinction. Taste, in this context, refers to the ability to recognize what is appropriate and elegant. Style is the embodiment of taste in one's attire and carriage. In other words, the stylish woman not only recognizes what pieces are tasteful but also knows whether they will suit her—her lifestyle, her figure, her coloring, and so on. Taste might direct a woman to a particular scarf and pair of jeans, but the woman with style skillfully pairs that scarf and pair of jeans with the perfect jacket, leather satchel, and pair of ankle boots. The resulting look is deliberate, put-together, and appropriate.

If the look also feels consistent with the woman's personality, then the woman has *personal style:* she expertly uses clothing to express something about her personality and/or lifestyle.[9] This concept of personal style dominates contemporary popular culture and fashion journalism. As an example, the popularity of the television show *Sex and the City* (1998–2004) delineated four distinct constructs of personal style that became crucial in defining the four main characters: the fiscally irresponsible free spirit who blends vintage finds with high-end pieces (Carrie); the old-fashioned romantic who wears Dior-inspired classics (Charlotte); the career-driven alpha female in tailored designer suits (Miranda); and the hypersexual public relations executive in skin-revealing, cutting-edge fashions (Samantha). While later series episodes and the two *Sex and the City* films obscured the show's initial fashion and style aims with their promotion of specific high-end brands (Manolo Blahnik, Louis Vuitton, and Hermés, for example), the show's initial fashion focus fell on personal style, not high-end fashion.

Personal style has become a hallmark of American fashion, representing the freedom and savviness to customize one's look by selecting from an endless range of options. Even though the garments and accessories may be mass produced, their availability does not limit personal style: the stylish consumer finds innovative ways to wear any given piece, as well as new combinations that work with her chosen public identity.[10]

In addition to these key terms, I use "clothing" and "attire" interchangeably to refer to the garments themselves (whether a thrift-store T-shirt or an haute couture gown). "Attire" refers to anything worn as part of an ensemble, whether clothing or accessories. Lastly, "dress" denotes a particular mode of clothing associated with an occasion, an occupation, a ceremony, or some other subcategory in which observers can spot identifiable similarities in clothing (as in "women's dress during the Gilded Age"). In his sociological work *Fashion and Focus* (2011), Tim Edwards notes that while

fashion fluctuates, "dress remains relatively static" (3); he gives the example of how, while "what is in or out of fashion" may change seasonally, "the distinction of formal from informal or casual dress" (3) remains the same, with only minor changes over the years. In order for the fashion industry to continue its relevance and its hegemony over a nation of consumers, then, it has to function symbiotically with the rules that dictate style. Over time the industry may break some of these rules (for example, the recent popularity of winter whites has shattered the traditional label of white as a summer color). Nevertheless, having some consistency in dress across fluctuating fashion seasons helps uphold longstanding social conventions and class barriers—even if those barriers become permeable.

Chapter Summaries and Context

The texts discussed in the following chapters vary in terms of their genre (poetry, short stories, novels, memoirs), their time period (from the 1950s to 2018), and the authors' cultural, gender, racial, and class identities. And yet they share a few common elements. First, the texts all engage the negotiation of personal identity as a common theme—more specifically, negotiating a sense of self with regard to different aspects of their identities as well as the demands of community (in terms of gender, race, culture, politics, etc.). Second, all of the texts indicate the relationship between that negotiation and the characters' fashion choices—both the options available and the choices made. And third, the subjects in these texts work toward that negotiation of identity through performing identities using fashion signifiers. These performances may feel natural or uncomfortable, exhilarating or numbing, liberating or restraining, driven by mainstream fashion or out of rebellion from social norms, distinctive or conformist—or something in between. In each case, the performances are essential for the character— sometimes the author—to negotiate different facets of identity.

The texts selected are not comprehensive but are framed by time and thematic emphasis. To explore some topics in depth, I have limited the scope in other areas. For example, I discuss cultural appropriation in fashion in several chapters—chapters 2, 3, and 4. Chapter 2 engages this topic in relation to Beat writing, chapter 3 in terms of African American literature, and chapter 4 in relation to American Indian literature. This is not to suggest that such themes do not relate to other cultures or works of literature

(Chinese American literature, for example), but only that these areas represent a body of literature where such themes are especially visible and prevalent. Similarly, in focusing on transgender literature in chapter 5, rather than a larger body of queer literature, I am choosing to spotlight an underexamined body of literature and one in which clothing and performance are especially critical for negotiating identity.

I have chosen the time frame for these discussions of fashion and performance because of the shift in consumer marketing that occurred after World War II. During the Depression years and World War II, when few Americans had access to French fashions, the American fashion industry promoted designers from within the United States and preached the necessity of economizing, particularly after the War Protection Board issued its strict L85 regulation that forced designers to use less fabric, slimmer silhouettes, and more masculine tailoring (Hill 71). By the early 1940s, fashion media were promoting slim silhouettes for women, as well as masculine tailoring, an economical use of fabric, and comfort-chic sportswear for about two decades. However, this trend toward economy, modernity, and the blurring of gender boundaries was about to change. When the United States emerged from World War II, it did so with a growing economy that would rely on the purchasing power of an expanding middle class. Lizabeth Cohen refers to the emerging "purchaser as citizen" of this time period, the consumer subject who felt that the consumption of goods was not only pleasurable but a patriotic duty (119). This sense of duty to consume encompassed clothing products as well as automobiles, appliances, cleaning products, cigarettes, and food products—now marketed through print and television media. This convergence of marketing, good citizenship, and consumption frames the discussion of fashion in chapter 1.

With wartime rations lifted, the late 1940s and 1950s also brought a resurgence of Parisian influence as well as a return to an earlier construct of femininity in fashion. In chapter 1, "Plath, Sexton, and the 'New Look,'" I discuss the poetry of Sylvia Plath and Anne Sexton, as well as Plath's semi-autobiographical novel *The Bell Jar* (1963), which portrays Esther Greenwood's struggle to negotiate her identity during her internship for the women's magazine *Ladies' Day*. Esther's frustration with attempting to fit the *Ladies' Day* mold reflects the 1950s gender expectations articulated in Betty Friedan's seminal work *The Feminine Mystique* (1963). While Sexton and Plath seemingly express disdain for the trappings of the beauty and fashion industries, I suggest that both authors recognize the liberating potential of

these garments and accessories: they allow women to have a sense of agency in curating their public personas, as well as to explore different identities and futures. However, Sexton and Plath present two obstacles in achieving a sense of self-actualization through these means. First, the women cannot clearly determine *when* they are asserting their own agency in selecting a persona and when they are simply enacting a choice made for them—that is, they cannot always see when they are interpellated by consumer marketing and social pressure. And second, these women face an insurmountable pressure to choose one identity—to essentially kill off the alternate selves, which forces the repression of desires and even potential futures.

I situate Sexton's and Plath's writing within the post–World War II period, a time when women were pressured to embrace roles as housewives and homemakers. This period also marked a new dawn for Parisian couture in the United States, thanks to designer Christian Dior's "New Look" (fig. 1). Dior represented not only a return to a more confining feminine silhouette, but also a return to Paris as primary inspiration for the fashion industry. The "bar suit" pictured in Figure 1 is heavily structured and padded to mold its wearer into an idealized feminine shape. Dior's silhouettes may have reinstated an older model of style within the industry; however, his more longstanding influence was to maintain that feminine silhouette as a presence in an otherwise evolving, modernizing, and expanding industry.

It's tempting to view the postwar period as a backlash against the progressive styles that preceded this period. However, as writers like Sexton and Plath struggled to find themselves in the New Look, other writers turned to styles outside of an American cultural mainstream. While Sexton's and Plath's writing conveys the postwar pressure to conform to a national identity with strictly defined gender roles, other works of this period convey a countercultural response to an era of Cold War conformity and McCarthyism.

Chapter 2, "The Beat Writers and the Dawn of Street Fashion," looks at a series of texts that reject mainstream identity and seek alternate codes of dress and behavior. These texts include Jack Kerouac's *On the Road* (1957), Joyce Johnson's memoir *Minor Characters* (1983), Hettie Jones's memoir *How I Became Hettie Jones* (1990) and poetry collection *Drive* (1997), and the poetry of Elise Cowen. These writers articulate a tendency for the American fashion industry to draw inspiration from its detractors—that is, from the very people who reject fashion. I argue that despite the protagonists' rejection of the middle class and its materialism, their attire ultimately became the iconic look of American style. This progression shows how even rebelling

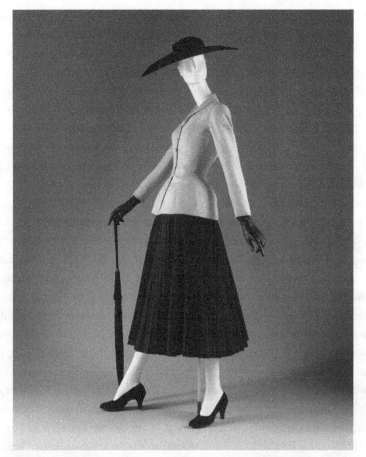

FIGURE 1. A 1947 bar suit designed by Christian Dior for the spring/summer 1947 collection. Silk. (Metropolitan Museum of Art, Costume Institute; gift of Mrs. John Chambers Hughes, 1958, C.I.58.34.30, NY)

against fashion still requires fashion as a text,[11] and therefore the counter-fashion becomes mainstream when the nonconformists are a recognizable entity. In each text, the author depicts the appropriation of counterculture fashion by people of relative privilege. Their fashion draws inspiration or specific pieces from the clothing of cultural outsiders—whether working-class attire, clothing associated with members of a different race or nationality, or dress associated with a particular time period or movement. By turning to these marginalized groups, the Beat writers on the one hand discovered a means of publicly expressing their disillusionment with mainstream

middle-class American values, but on the other hand essentialized the cultures from which they appropriated.

By the 1960s the fashion industry was becoming more diverse in terms of its inspirations and target consumers, driven by countercultural influences in the United States and Europe, the youth culture influence in London, and an increasingly globalized fashion market. In the United States, the Black Arts Movement began to impact both African American consumption of mainstream fashions and African American presence in fashion journalism. Black models were doing features in mainstream fashion magazines, and *Essence,* a fashion and lifestyle magazine for black women, began circulation in 1968. In chapter 3, "Afrocentric Fashion in the Writing of Walker, Morrison, and Senna," the characters of Alice Walker's short story "Everyday Use" (1973), Toni Morrison's *Tar Baby* (1981), and Danzy Senna's *Caucasia* (1998) engage with the Black Arts Movement. In each of these works, characters associate the black aesthetic with a sense of "authentic" blackness, a problematic construct that drives divisions among each novel's characters. These works capture black aesthetic style as it began to surface in the 1960s—revealing how it embraced alternative standards of beauty but also created new tensions within African American communities. In each novel, the performance of a perceived "authentic" racial identity by a black character ultimately exposes the fluidity of racial identity (i.e., there is no pure or authentic way to be black) and allows the character to negotiate her relationship between herself and her cultural community.

Afrocentric fashion brought African-inspired prints, beauty products, and hairstyles into the mainstream (e.g., Bo Derek's cornrows in the 1979 film *10,* or dreadlocks in the 1970s after reggae became part of the American music scene). However, examples of cultural appropriation of African and African American culture existed well before the 1960s—for example, in the printed textiles of the Art Deco fashions, or the Congolese hats of the Edwardian period. The authors acknowledge, therefore, the complex relationship between mainstream fashion, Afrocentric fashion during the 1960s and 1970s, and traditional dress and crafts within the African American community.

This relationship between a mainstream fashion industry that thrives off of mass-marketing trends to a broad consumer base, alternative fashion markets, and distinctive communities with both traditional and contemporary dress extends beyond the African American community. In chapter 4, "American Indian Literature and a Legacy of Misappropriation," I discuss

how contemporary writers of indigenous and aboriginal literature simultaneously expose mainstream fashion's misappropriations of indigenous culture and assert an evolving and thriving tribal culture through their depictions of indigenous dress. Sherman Alexie's *Reservation Blues* (1995) and Joseph Boyden's *Through Black Spruce* (2008) specifically critique an acquisitive American popular culture, spotlighting a legacy of whites appropriating—often performing—Indian identity, initially as a means of asserting an American national identity distinct from England, and later as a symbolic affiliation with the land. Over the years, such tendencies to appropriate indigenous cultures have consolidated in institutions (especially within Hollywood, the music industry, and the fashion industry), contributing on a larger scale to misrepresentations of tribal culture that can impact these groups socially, politically, and economically. In *Last Standing Woman* (1999), Winona LaDuke points to this legacy of misappropriation while also representing the fashions of a thriving Ojibwe culture. These fashions, the author suggests, blend European influences, other nonwhite American communities, and traditional indigenous motifs and practices. In their complex depiction of tribal identity, the authors illustrate how tribal identity is performed and reinterpreted via contact with other cultures: tribal identity, they suggest, is not frozen in the past but is fluid and ever-changing.

American indigenous authors and designers, as well as the artists and designers of the Black Arts Movement, have destabilized a Western hegemony over standards of beauty and design through their work, which fuses elements of Western culture with traditional non-Western motifs, ideals, and values. One consequence of this fusion is a tendency among white mainstream designers and consumers to seize upon non-Western motifs and appropriate them for personal or institutional benefits, often decontextualizing these motifs in the process. However, another consequence has been a more public, sustained cross-cultural dialogue in literature, fashion, and popular culture: one that challenges Western values, goals, standards, and master narratives. By adding their voices and perspectives to the mainstream venues of American literature and the American fashion industry, these artists have raised questions about key contemporary issues, including globalization, environmental cost, racial subjugation, cultural appropriation, and gender norms.

The deconstruction of gender norms is the focus of the final chapter of this book. In chapter 5, "Gendered Fashion and Transgender Literature," I

look at how contemporary American transgender narratives showcase the transformative power of clothing as a symbolic source of empowerment: a means of understanding, and ultimately curating, gender identity and presentation. While clothing intended for these individuals' biological genders may feel like a prison (the authors often describe such clothing as "humiliating" or "unnatural"), the transgender narrators attach an almost supernatural power to the clothing intended for their chosen gender presentation (e.g., a lacy bra, a men's motorcycle jacket, a vintage shawl). Donning these pieces allows the writers/characters to test the waters of transitioning, to feel a temporary sense of masculinity/femininity, or in the case of Aleshia Brevard and the transgender sex workers in Jonathan Ames'a *The Extra Man* (1998), to perform in public as the opposite gender before taking the more permanent step of surgery. In this chapter, I look at a group of contemporary authors (including Ames, Brevard, Janet Mock, and Leslie Feinberg) as they depict this relationship between clothing and gender performance. Through discussing Brevard's and Mock's memoirs, I show how these authors establish the centrality of both gender performativity and gender performance in their negotiations of gender identity, revealing their awareness of the social cost of being feminine as well as the way femininity can be empowering. In the last section of the chapter, I discuss Ames's novel and Feinberg's *Stone Butch Blues* to illustrate how temporary performance of gender can deconstruct gender binaries. In these works, the narrators' gender identity remains ambiguous and liminal.

The self-fashioning narratives in these chapters may critique fashion, but they also champion its performative and transformative powers. For all its flaws, its excesses, its promotion of impossible standards of beauty, the American fashion industry has evolved: it has progressed from adulation and emulation of a Parisian standard of luxury and beauty to a multicultural, consumer-driven enterprise extending to all ethnoracial groups, nationalities, and socioeconomic classes in the United States. The American fashion industry thrives on its inclusivity and signifying potential, but both of these elements depend upon the accessibility of the clothes themselves. In the United States, haute couture continues to set a standard for artistic design and luxury in these varying industries (think of the buzz generated by couture looks at the Oscars or Met Gala), yet even within the realm of

ready-to-wear the industry can preserve its socioeconomic hierarchy while maximizing its consumer base.

The availability of so many ready-to-wear options has only enhanced the performative potential of fashion in recent years, beginning with the 1990s. Daniel Delis Hill calls the early 1990s "pluralistic," noting that "women began to explore individualism within the confines of their workplace wardrobes: greater variety of skirt lengths and widths, pleated and plain-front trousers, maybe one longline jacket, possibly a pair of city shorts, and enough accessories to change each outfit into several new looks season after season" (132). In Hill's example, he points to the American emphasis on personal style that works in conjunction with the industry: women learn how to make pieces work for multiple seasons by mixing new combinations of garments, new styling, and new accessories that give them more autonomy over their presentation—whether they wish to project a look that reads as feminine, androgynous, or bohemian, for example. In recent years, fashion has come to signify not only class, race, ethnicity, or gender but also political or subculture affiliations, music taste, or even one's general outlook on life. For the characters discussed in the chapters that follow, the direction of fashion has allowed for a greater indulgence in exploring alternate identities—ensuring that the groups to which they aspire can really bring them the freedom, happiness, or sense of fulfillment that they seek.

Because of the fashion industry's expansion to encompass alternative fashion markets and ethnoracial fashion journalism (for example, African American fashion magazines like *Essence* and American Indian fashion blogs like *Beyond Buckskin*), the heteronormative and colonial thrusts behind the industry are consistently challenged, corrected, and questioned. If a designer presents a collection "inspired" by a non-Western culture (Ralph Lauren's 2011 Chinese-inspired ready-to-wear collection, for example), some media venues praise the beauty and innovation of the line; some question the ethics of appropriating garments or motifs from another culture; and still others excoriate the designer's exploitative treatment of the appropriated culture. What was once a triangular relationship between French designers, Western consumers, and mainstream fashion journalists has grown infinitely more complex—a mainstream fashion market, multiple countercultural fashion markets, fashion media offering an endless range of perspectives on and challenges to the fashion industry, a globalized consumer base spanning different classes and ethnoracial backgrounds, and a Chambre Syndicale that now includes invited members from Lebanon,

Jordan, Turkey, China, and other nations around the globe. As the industry has grown more transnational and mediated by its consumer base, fashion itself has expanded its space for performance and exploration, for constructing and reconstructing identities, and for shattering problematic representations of gender, class, sexuality, and culture.

1

Plath, Sexton, and the "New Look"

Why can't I try on different lives, like dresses, to see which
fits best and is most becoming?
—Sylvia Plath, *Journals*

SYLVIA PLATH'S NOVEL *THE Bell Jar* opens with a striking juxtaposition of
images: on the one hand, images of death—the execution of the Rosenbergs
and the first time the narrator saw a cadaver; on the other hand, images of
beauty and glamour—hotels, parties, "size seven patent leather shoes," a
dress of "imitation silver-lamé" and "white tulle" (2). The narrator, Esther
Greenwood, acknowledges that she should "be having the time of [her] life,"
having secured a prestigious editorial internship at *Ladies Day,* living for a
summer in a New York City hotel, spending her days shopping and attend-
ing parties and getting to know the other women. In this opening passage,
Plath hints at the disconnect between what Esther feels and what she thinks
she should feel. She surfaces as a character trapped within her own psyche,
disconnected from the rest of the world. This disconnect makes her obsess
over why she's so different, why she can't be happy the way everyone else
seems to be.

Halfway through this opening passage, Plath pulls the reader into Esther's mind, and we see the world through her eyes. Plath likens her first to "a numb trolleybus," then to "the eye of a tornado . . . moving dully along in the middle of the surrounding hullabaloo." Both of these symbols are mobile, transitory, moving from one place to another; yet the words "numb" and "dully" connote robotic movement: we see Esther trapped in her own mind and therefore doomed to live life as an impartial, passive observer. Both symbols also suggest she is being worked on by outside forces, foreshadowing the many characters who will come into her life and try to mold her into their images—her mother, her patroness Philomena Guinea, her boss Jay Cee, her friend Doreen. As the outside forces swirl around her, Esther remains impervious.

In this novel and in much of her poetry, Plath provides an apt depiction of a bright, career-minded, white middle-class woman living in the 1950s. Amid a landscape of luxury and consumerism, a booming economy, and an eagerness to bury the Depression and the war in the past, Esther Greenwood struggles with a malaise and existential yearning that cannot be nourished. Confronted with the limited futures for respectable young women, Esther—like Plath herself—struggles to stay afloat in this conformist postwar landscape.

A "New Look" for the Postwar Era

American historical memory of the decade following World War II tends to be fairly polarized. Many Americans talk about the 1950s as a time when life was easier, children safer, homes more affordable, moral values stronger. For others, the 1950s era represents a time of Cold War fears and mass conformity, of racial oppression and subjugation of women.[1] In her seminal 1963 book *The Feminine Mystique,* Betty Freidan asserts that the fear engendered by the Depression and the war drove women and men to seek "the comforting reality of home and children" (269): women were relegated to the domestic sphere "as men shrugged off the bombs, forgot the concentration camps, condoned corruption, and fell into helpless conformity" (274). The conformity of the 1950s, which Americans alternately associate with recovery from the Depression and World War II, "white flight," McCarthyism, and Cold War paranoia, infected the world of middle- and upper-class

American women who had, only a decade before, enjoyed new freedoms and opportunities.

This virus of conformity thus stemmed in part from cultural trauma, which "occurs when members of a collectivity feel they have been subjected to a horrendous event that leaves indelible marks upon their group consciousness, marking their memories forever and changing their future identity in fundamental and irrevocable ways" (Alexander 1). In the 1950s, still reeling from the Depression and the war, Americans found themselves in the three-pronged position of victim, complacent bystander, and perpetrator. Americans suffered the deprivations of a global economic depression that impacted all socioeconomic classes, as well as the loss of lives during World War II. As coverage of the Holocaust permeated American media during the 1950s, Americans also confronted their own complacency, having turned away thousands of Jewish refugees in 1942 and having interned Japanese citizens during the war. And as the first nation to drop an atomic bomb, ushering in the nuclear age and the Cold War, Americans became perpetrators of collective trauma.

These are only a few examples, but they illustrate the complicated position of a collective American consciousness during this period. The largely white middle class of Americans during the 1950s exhibited the symptoms of trauma victim and perpetrator. As a population who survived the Depression and the war, many Americans exhibited the behavior of a psychoanalytic response to cultural trauma; Jeffrey C. Alexander characterizes this response as simultaneously recognizing and suppressing trauma: "The truth about the experience is perceived, but only unconsciously. In effect, truth goes underground, and accurate memory and responsible action are its victims. Traumatic feelings and perceptions, then, come not only from the originating event but from the anxiety of keeping it repressed" (5). As Americans threw themselves into the economic boom of the 1950s, accepting en masse a template for home, family, and economic restructuring that promised the Depression was but a distant memory, the United States as a social collective reflected the trauma-induced anxiety that Alexander describes. At the same time, white, middle-class Americans exhibited the response of the perpetrator group, who either was complicit or directly brought about a collective trauma. According to social psychologist Gilad Hirschberger, perpetrators might cope "by thoroughly denying the events, disowning them and refusing to take any responsibility for them. But, more often than not,

reactions to an uncomfortable history will take on a more nuanced form with group members reconstructing the trauma in a manner that is more palatable, and representing the trauma in a manner that reduces collective responsibility." This response to the cultural traumas of the 1940s surfaces most prominently in the continued presence of Holocaust deniers, as well as in U.S. historical accounts of the bombings of Hiroshima and Nagasaki both in academic settings and in public displays.[2] Such characterizations of the bombings epitomize the type of historical elision in the interest of self-reaffirmation that Hirschberger describes.

The middle-class response to the traumas of the 1930s and 1940s, then, prompted efforts to avoid a repetition of such events and to maintain a positive collective identity as Americans. In her book *Homeward Bound: American Families in the Cold War Era* (1988), Elaine Tyler May suggests that the conformist model of suburban home, strict gender roles, and consumer-driven economy was fueled mainly by the Depression and the war. Scarred by the deprivations and insecurities of these cataclysmic events, Americans were vulnerable to the powerful ideology of domesticity and consumer capitalism, both of which distracted from the cultural traumas of the past and provided a blueprint for recovery. May argues that these events "laid the foundation for a commitment to a stable home life, but they also opened the way for a radical restructuring of the family. . . . Ironically, traditional gender roles became a central feature of the 'modern' middle class home" (20). Numerous spheres of American life—from the government to popular print media to television programs to the real estate industry to economic and merchandising institutions—seemed to conspire in an effort to reinforce the highly structured nuclear family, with its clearly inscribed domestic imperative for women.

The fashions of the 1950s reflect both this postwar expectation of gender conformity and the slow struggle to escape it. For nearly two decades, American retailers had championed American designers, for the Depression made Parisian imports too costly, and Nazi occupation cut off French imports entirely. After the war, however, American consumers and retailers returned to their worship of Parisian design. Wartime fabric rations were lifted, and designers used luxurious textiles in abundance. The Nazi Occupation of Paris ended in 1944, and Parisians, too, sought to distance themselves from the trauma of war. As was the case for U.S. citizens, constructed notions of "tradition" came to symbolize comfort and safety for many Parisians in a time of instability.

This distancing and embrace of tradition helped inspire the fantastical style of 1940s and 1950s designer Christian Dior. In her book *Poiret, Dior and Schiaparelli*, Ilya Parkins states of Dior's style: "It performed a kind of aesthetic cleansing that participated in a national repression of the atrocities enabled by the attitudes and practices that had been rampant in France during the war" (114). Dior responded not only to the trauma of the war, but also to the restraint that the Depression and war years necessitated in fashion. What some now view as progressive in early 1940s women's wear, postwar designers denigrated. In *Dior and I*, Dior suggests his traditional style filled a collective need for indulgence borne out of "the prolonged stagnation of the war years": "In order to meet this demand," he says, "French designers would have to return to the traditions of great luxury" (21). In February 1947 in Paris, Dior debuted his Corolle collection, more commonly—and ironically—known as the New Look,[3] a line with Victorian silhouettes, corseted bodices, elegant accessories, and feminine details like bows, pleats, and flounces (Hill 76). After the frugal use of fabrics and frills during the war years, the sumptuous gathers of luxurious materials in the line's dramatic skirts brought a note of whimsy back to the fashion world. Hailed as the designer who initiated a "return to femininity" (Hill 75), Dior famously proclaimed, "I brought back the art of pleasing" (77).

Headlines from late 1940s fashion journalism echo Dior's proclamation and focus on men as the subjects of pleasure. A trend report headline from 1948 reads, "New Fashions Chosen with a Man in Mind" (Hill 78). In November of that same year, *Vogue* featured a fashion spread entitled, "Fashions for a Man's Eye . . . We Hope." The gorgeous flounced skirts and gathers and luminous textiles harkened back to the excesses of nineteenth-century aristocratic fashions. The gown featured in figure 2, called "Eugenie," debuted in 1948 and exemplifies the workmanship, the fantasy, as well as the Victorian elements—the layers, the full skirt, the corseted bodice—associated with Dior's early collections. As striking as these pieces were to a captivated consumer audience, the label "New Look" feels exaggerated if not outright misleading. As Dior himself suggests, his collection revived older, more constricting silhouettes and materials, representing a "return" to a previous style rather than a "new" style for women.

Not all women appreciated this return to femininity. American women in particular rebelled against the longer, fuller skirts after decades of shorter hemlines and more comfortable sportswear (Hill 76). During Dior's first visit to the United States, he was met by demonstrators protesting his

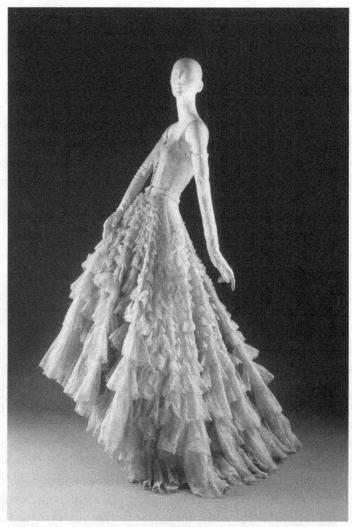

FIGURE 2. "Eugenie" dress designed by Christian Dior for the fall/winter 1948–49 collection. Nylon and leather. (Metropolitan Museum of Art, Costume Institute; gift of Mrs. Byron C. Foy, 1953, C.I.53.40.2a–c, NY)

longer hemlines (Parkins 111). Coco Chanel, whose designs had helped to bring "comfort chic" to women's wear, attacked the fantastical elements of these clothes and reasserted her preference for the practical, natural looks that preceded Dior's New Look: "I made clothes for the new woman. She could move and live naturally in my clothes. Now look what those creatures have done. They don't know women" (qtd. in Steele 28). Chanel's slights to the designers show that she attributes the style shift of the 1940s and 1950s not to popular tastes and postwar anxieties, but to the designers' personal tastes. Her comments allude to a common view among women's designers that they know better than male designers what women want to wear.

Despite this opposition, Dior would dominate the high fashion scene until his death in 1957, and many of his designs—in particular, his A Line—have never gone out of style. Dior's legacy in the fashion world has been twofold. First, his designs influenced the images of women in popular media and therefore correlated with the limiting gender roles for women during the postwar period. The silhouette of these gowns, so reminiscent of the Victorian era, seemed to demand women take on submissive roles. Explaining the relationship between clothing, the body, and social mores, Jennifer Craik notes that "clothes construct a personal *habitus*" (4), determining, in their style, the social freedoms and limitations of that body: "The body, as a physical form, is trained to manifest particular postures, movements and gestures. The body is a natural form that is culturally primed to fit its occupancy of a chosen social group . . . [Body trainings] form part of a 'habitus'—simultaneously a set of habits and a space inhabited, as a way of being in the world" (4). Craik indicates how gender norms intersect with class norms, a combination "central to the production of advice for women on how to be feminine" (47). The clothing of the postwar era, in its elaborate embellishment and constricting design, instructed women to enhance their femininity and limit their activities to those befitting proper ladies. Even in the ready-to-wear styles, designers embedded these mores in their garments: in the late 1950s, American designer Anne Fogarty wrote in her book *Wife Dressing* that "a woman should always think of herself first as a wife—either as her goal or as her vocation" (Hill 78). Through his high-end designs, Dior essentially created a costume for an elegant, stylish housewife, one who did not need to move around too much and served a domestic and decorative role for her husband.

On the other hand, Dior brought an element of whimsy back to the fashion world after decades of economizing, apparent in the designs featured

in figures 2 and 3. His gowns were exquisite, recalling the workmanship of Charles Frederick Worth in their opulence and beauty. One of his most famous looks, the "Junon" dress from his fall/winter 1948–49 collection (the same collection as the Eugenie gown), displays his creativity as well as his talent in design construction (fig. 3). It also gives a sense of his vision for women. The dress's sequin-embroidered petals on the skirt mirror the shape and color of peacock feathers—the wearer means to stand out and make a statement, even though the silhouette is traditional and feminine, with the

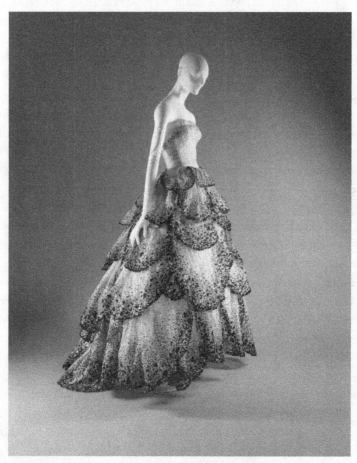

FIGURE 3. "Junon" dress designed by Christian Dior for the fall/winter 1948–49 collection. Silk and plastic. (Metropolitan Museum of Art, Costume Institute; gift of Mrs. Byron C. Foy, 1953, C.I.53.40.5a–e, NY)

same fitted bodice and full skirt seen throughout his collection. The manne-
quin wears opera-length gloves, alluding to Dior's meticulous styling: Dior
did not just design a dress or a gown; he selected the perfect accessories to
create a whole look.

These show-stopping gowns became food for fantasy, his designs the
most coveted of the era in fashion, permeating an international fashion
scene and various channels of popular culture. In Paul Gallico's popular 1958
novel *Mrs. 'Arris Goes to Paris,* he narrates the title character's response to
seeing a Dior gown for the first time: "She found herself face to face with
a new kind of beauty—an artificial one created by the hand of man the
artist, but aimed directly and cunningly at the heart of woman. . . . Her
reaction was purely feminine. She saw it and wanted it dreadfully" (24). Gal-
lico's middle-aged charwoman parallels much of the fashion world in her
response to Dior: the beautiful gown elicits a desire for a fantasy version of
femininity.

Plath also references Dior in her poem "Dialogue En Route," written just
a year or two before her summer internship in New York City..In the poem,
she imagines a conversation between a man (Adam) and a woman (Eve) as
they rapidly ascend in an elevator. The two share their fantasies, with Eve
vocalizing her longing for luxury:

> "I wish millionaire uncles and aunts
> would umbrella like liberal toadstools
> in a shower of Chanel, Dior gowns,
> filet mignon and walloping wines,
> a pack of philanthropical fools
> to indulge my extravagant wants."

As with Gallico's Mrs. Arris, for the young Plath, the Dior gown (like filet
mignon and wine) serves as a paragon of wealth and fantastical luxury. Eve,
a persona for Plath, knows that such luxury is beyond her reach, unless
some "philanthropical fool" in a fit of generosity buys her one. The poem
illustrates Plath's conflicting attitude toward such extravagance, her simul-
taneous longing for and denigration of the indulgent fashions of the time.

The two authors discussed in this chapter, Sylvia Plath and Anne Sexton,
reflect the conflicted legacy of fashion woven into the designs of Christian
Dior. Their writing betrays a fascination with clothing and accessories and
at times a consumer's desire to appear stylish or fashionable. However, they
also critique the limiting roles, the habitus, written into the garments. Both

women treat clothing as a kind of costume, a selection of garments and accessories with power in their own right, independent of the woman who dons them. An ensemble allows a woman to step into a role. Unfortunately, for all the potential roles women confront, Plath laments that they must choose only one. This fear and disappointment surfaces repeatedly in her journals: "People are happy—if that means being content with your lot: feeling comfortable as the complacent round peg struggling in a round hole, with no awkward or painful edges—no space to wonder or question in. I am not content, because my lot is limiting, as are all others" (*Journals* 44). Plath's comment implicitly speaks to how in making such choices, women also feel constrained in their ability to develop a personal style—a mixture of personas, yearnings, and role models—that is, an assemblage of fragments that translates the fashion subject for the public gaze. Too often, the female fashion subjects cannot know whether their selected ensembles really stem from their own choices and desires or are the inevitable result of their mediation as consumer subjects. These conflicts surface in the confessional style of Plath's and Sexton's writing. In the poetry of Plath and Sexton, as well as in Plath's novel *The Bell Jar,* the authors use fashionable women's clothing to articulate the options for women's roles, thereby endowing the garments with the positive connotation of promise and fantasy, the potential of possessing the agency to curate one's own identity and future, as well as the more negative connotation of a limited role to play, a prison for personal identity.

The Postwar Beauty Industry and the Feminine Mystique

During the postwar era, mainstream fashion journalism worked to guide women into their identities. This practice became the subject of Friedan's 1963 book *The Feminine Mystique.* In her book, Friedan critiques the media culture of the late 1940s and the 1950s for coercing American women (predominantly white middle-class women) into channeling all of their efforts into becoming the perfect wife and mother, in behavior and appearance. She argues that most women came to realize that these roles were unfulfilling and provided no spiritual or intellectual challenges, yet they felt powerless to speak out about their dissatisfaction, shamed by the same media culture into thinking their dissatisfaction was a personal character flaw. Friedan calls this unnamed feeling of malaise "the problem with no name."

Describing the ideal woman of the fashion magazine as "young and frivolous, almost childlike; fluffy and feminine; passive; gaily content in a world of bedroom and kitchen, sex, babies, and home," Friedan muses, "In the magazine image, women do no work except housework and work to keep their bodies beautiful and to get and keep a man" (82–83). In other words, magazines presented women with an image of pretty, feminine perfection and then marketed products in a way that promised women the ability to achieve this image. The image was a powerful one, for the woman not only appeared perfect in her feminine, domestic prettiness, but she also appeared perfectly happy with her role as a housewife. Friedan illustrates, through numerous examples, how print media of this period convinced women they wanted this role while also convincing them that if they did not find such a life desirable, they were somehow unhappy, lacking in refinement, unattractive, unlovable, or even mentally unfit. Simultaneously, she argues, American popular media marketed products to women as tools for achieving happiness and fulfillment within this feminine framework.[4]

These images and social guides, Friedan suggests, are not incidental, but a result of careful manipulation and strategizing on the part of the editors. In one instance, she describes her meeting with a consultant, hired immediately after World War II, to analyze the thinking patterns of young American women and determine how to encourage the women to purchase products within struggling industries (for example, silver and fur) through media marketing (300–301): "Properly manipulated . . . , American housewives can be given the sense of identity, purpose, creativity, the self-realization, even the sexual joy they lack—by the buying of things" (301). Friedan describes how the report details the proper way to present fur to make women feel they must have it for aesthetic, emotional, and even moral reasons (357). Retailers and editors conspired to implement this strategy of putting the product first. Friedan thus clarifies the methods by which popular and print media perpetuate the "happy housewife heroine" and promote consumer accessories for this role, even as they shame women who desire "more" (education, a career, etc.) as being too masculine or otherwise deficient.

Depression and mental illness, in many cases resulting from the "problem that has no name," are dismissed or demeaned by these popular media. A *Cosmopolitan* article titled "Psychiatry and Beauty," mentioned in Plath's June 13, 1959, journal entry, suggests that beauty treatments can cure women's mental illnesses: "Often, psychiatrists and psychologists will prescribe beauty treatments to a female patient before therapy or analysis

begins, in the hope that the beautician can help the woman re-establish some of the self-respect her neurosis has bled away" (Fleming 32). The author and many of the physicians cited argue that attractive women have self-respect and aim to please, whereas "the deliberately unbeautiful, the women who neglect their looks, are rarely enjoying the best of mental health" (35). After reading this issue of *Cosmopolitan,* Plath resolved to "write [a novel] about a college girl suicide" (*Journals* 495), a description reminiscent of her novel *The Bell Jar.*

Plath, Sexton, and Friedan indicate fashion's negative power over women's freedom and identity construction through several means. First, they look at the physical limitations of the clothing, the binding or otherwise uncomfortable garments and accessories. Second, they show how fashion controls the body, rather than the other way around; women's interactions with clothing make them feel better or worse about their figures (usually worse), and they often express such inferiority in terms of the undergarments they must wear to assume the outward appearance of standardized beauty. And finally, they identify the roles women are expected to play as suggested by these garments and the media that promote them, as well as how these roles feel limiting and unfulfilling. Certainly, these critiques paint an ominous picture of fashion and style. Yet despite these criticisms of 1950s fashion, both Plath and Sexton acknowledge the liberating potential of contemporary fashion beyond the superficial beauty of the garments and accessories. They see how the right garment can tease out some strength from within, pull inner potential up to the surface.

The Poetry of Plath and Sexton

The feminine mystique permeates the poetry of Sexton and Plath, as they grapple with pressure to conform to patriarchal gender norms, to play the happy housewife heroine and doting mother, to gain approval of men and women alike, and yet their poems also seethe with rebellion, resenting and resisting the conventions to which their narrators aspire. In her article "Her Kind: Anne Sexton, the Cold War and the Idea of the Housewife," Claire Pollard observes that though Sexton is often labeled a feminist writer, she did not necessarily identify as such—in fact, as a housewife and fashion model, she more closely resembles the women who have absorbed the mystique than those who attempted to subvert it (2). Nevertheless, both Plath's

and Sexton's poetry yield fruitful feminist readings, and their critiques of social norms indicate their desires to subvert the patriarchal status quo.

Plath is far more outspoken about fashion in her journals and her novel (which, after all, focuses on an internship at a fashion magazine) than in her poems, yet she and Sexton engage both the limitations and imaginative potential of fashion in their poetry. They also allude to the horrors of the international sphere (war, Nazism, nuclear weapon technology, etc.) from which the highly structured, conformist culture of the 1950s was supposed to shield them. These horrors became symbols in their poetry, sometimes conflated with domineering men or traumatic experiences in their lives (e.g., the Nazi imagery in Plath's "Daddy" and Sexton's "Walking in Paris"). While the poets address these themes from the periphery, they address more personal themes directly—women's limitations, spousal relationships, children, dreams lost.

The poets' style of writing bears some interesting parallels to the concept of personal style. As with personal style, the confessional style of poetry both authors used is a way to "perform the self" (Grobe). In his book on the different forms of confessional art originating in the 1950s (and continuing with reality television today), Christopher Grobe discusses confessional poetry as "a performance genre," a form that grew out of "a craze for poetry readings." This craze encompassed not only poets like Sexton, Plath, and Robert Lowell, but also Beat poets like Allen Ginsberg, Diane di Prima, and Gregory Corso. Confessional art emerged in other genres too, including the standup comedy routines of Lenny Bruce and Mort Sahl. In both poetry and comedy of the 1950s, Grobe argues, audiences responded to the spontaneity of the performance, the possibility for constant "new material" generated by the dynamic between performer and audience, and, above all, the association of this form with a freedom from restraint: "Telling this story of confession's sudden ascent, poets and critics reach for the same word again and again. This was a *breakthrough*—past formalism, past repression, past social restraint—into emotion, into experience, into the world." The flexibility of this poetic genre, as well as its intimacy, felt like a form of liberation during a time when so many people felt repressed by social mores. In addition to this freedom from restraint, Grobe emphasizes the confessional genre's potential for self-revelation. It didn't matter that poetry was a performance of the self—that is, the knowledge that it was performance did not negate its value as a revelatory medium: "We demand not authenticity, but the spectacle of crumbling artifice; not direct access to the personal,

but a sidelong view of the persona falling away; not straight ahead fact and sincerity, but the roundabout truths of an ironic approach." Grobe's analysis of the confessional approach helps clarify the poets' relationship to fashion and, specifically, personal style. In cultivating personal style, a fashion subject seeks to align her dress with her persona. The act of dressing in accordance with one's persona is itself a kind of confession, a revelation to a public gaze despite the possibility of judgment or disapproval. When the authors speak of dress in conjunction with restraint, therefore, they speak of personal restraint, a misalignment of public and private selves.

Both poets, for example, specifically allude to Victorian dress, a style that connotes physical restraint and strict social norms, in their poems. Victorian style dominated the earliest high fashion, dating to the founding of the first association of couture houses in 1868 by Charles Frederick Worth. This style of dress covered and bound women in layers of fabric and tight corsetry, and more detailed workmanship and embellishment often signified a woman of class. Stuart and Elizabeth Ewen have compared Victorian fashion to foot binding in China, explaining, "The enfeeblement of women was a crucial aspect of nineteenth-century middle-class fashion. The restrictive practices placed women on a pedestal, above concerns of trade and carnality, yet it produced generations of women whose concerns were mobilized around issues of the body" (101). Ewen and Ewen indicate the connection between the restrictive clothing of the late nineteenth century and the "restrictive practices" of women, whose sexual and social behavior was monitored and even scripted at times. Women of this period who could afford high fashion were extremely wealthy, and their public display of the restrictive clothing signified their leisure as well as her husband's wealth (Montgomery 10). Similarly, Craik notes how we can "distinguish techniques associated with the occupancy of a female body (being female) from techniques that deploy gender as a social strategy (being feminine)" (44), the former of which, she suggests, often center on discourses of fertility, and the latter, with femininity and domesticity. By alluding to Victorian clothing, therefore, Plath and Sexton allude to the policing of women's fertility, women's sexuality, and women's social freedom.

In her poem "Morning Song," Plath hints at these practices of policing women's fertility and social freedoms by conveying her narrator's sense of alienation from her newborn baby, as well as her own body. The speaker expresses no affection toward her child but instead compares it first to inanimate objects—"a fat gold watch" and a "statue"—then to the ocean,

and later to a "cat." The speaker's disconnection from her crying child over-
whelms the other elements of the poem, but Plath embeds her commen-
tary on the mother's body within this sense of dull obligation to her child.
In the fifth stanza, she describes her body as "cow-heavy and floral," and in
the next line mentions her "Victorian nightgown." Her description is femi-
nine yet in an unappealing way—a contrast to the vision of happy feminin-
ity promoted by contemporary media. Plath's words conjure the figure of a
woman whose body is bloated and exhausted from childbirth and nursing,
dressed in a flowered muumuu, not an ethereal, glowing young mother.

The phrase "Victorian nightgown" is paradoxical: Victorian fashion cen-
tered on the public showcasing of wealth and leisure, yet here the speaker
wears an intimate garment in the Victorian style—her implicit discomfort
is pointless, since only she and the baby will see it. By juxtaposing the phrase
with her changed body, Plath alludes to both Victorian and contemporary
fashion's emphasis on "correcting" the female form—that is, forcing the
body into a corseted, appropriately feminine shape. In addition, by making
this connection between contemporary and Victorian fashion, Plath alludes
to their common ideals, confining women to specific roles that they had to
embrace and appear to enjoy.

Although Sexton also alludes to Victorian fashions in her poem "Walking
in Paris," she does not comment directly on motherhood but rather ponders
the life of her maiden aunt Nana:

> I come, in middle age,
> to find you at twenty in high hair and long Victorian skirts
> trudging shanks' mare fifteen miles a day in Paris
> because you could not afford a carriage

In these lines, Sexton conveys her identification with her maiden aunt as
she immerses herself in the past. The speaker is visiting Paris and reading
her aunt's "Paris letters of 1890," which she reads nightly in her "thin bed"
and learns "as an actress learns her lines." Alone in her room in Paris, she
leaves behind her family—"I have deserted my husband and children"—to
inhabit the young body the letters conjure, thereby conflating herself with
her aunt. She closes the poem, "Come, my sister, / we are two virgins, / our
lives once more perfected / and unused." In symbolically donning her maiden
aunt's "long Victorian skirts," she does not necessarily escape a restrictive
role for a more liberating one or vice versa. What matters, instead, is the
possibility of trying on an alternate identity and embracing the possibilities

that accompany it. Sandra M. Gilbert suggests that such an empirical search for self-definition is a hallmark of women's confessional poetry: "The female poet . . . writes in the hope of discovering or defining a self, a certainty, a tradition. Striving for self-knowledge, she experiments with different propositions about her own nature, . . . a passionate empiricist who sees herself founding a new science rather than extending the techniques and discoveries of an old one" (102). In this case, donning the more restrictive costume of her maiden aunt's Victorian style means temporarily shedding her own identity, confronting a new self who is "perfected" and "unused"— a blank slate. Yet despite the restrictive implications of the Victorian dress, Sexton sees through this momentary embodiment of her aunt an opportunity for self-discovery and freedom. Imagining inhabiting her aunt's persona means leaving the trappings of her own consciousness and her past to see the world through different eyes and present in a different way. Leaving these aspects of herself behind, even momentarily, she implies, may lead to better self-understanding.

In contrast to "Walking in Paris," in other poems Sexton directly engages how clothing confines and reshapes the body. In "Cinderella," Sexton reworks a classic fairy tale to comment on the fantasy promised by marriage. In the poem's longest stanza, she describes the two stepsisters trying to fit into Cinderella's slipper: "The eldest went into a room to try the slipper on / but her big toe got in the way so she simply / sliced it off and put on the slipper"; and "The other sister cut off her heel / but the blood told as blood will." The disturbing, bloody image—true to the original fairy tale—here serves to exaggerate the violence that clothing can wreak upon the body. Instead of the shoe causing the pain, here the women inflict pain upon themselves to fit the shoe. By reviving this image from the traditional version of the fairy tale, Sexton alludes to the way women of her era adapt their bodies by reducing or purchasing expensive, uncomfortable undergarments to fit beautiful clothing, rather than selecting clothing that fits their natural forms—and, analogously, adapt to embody the persona of a model 1950s wife.

In "Woman with Girdle," Sexton paints a clearer picture of how clothing can make women feel uncomfortable in their own skin, even ashamed of their bodies. Sexton's poem exposes the consciousness of the woman trapped in the girdle, one afraid to look at her natural body underneath the mold. The poem begins, "Your midriff sags toward your knees; / your breasts lie down in air, / their nipples as uninvolved / as warm starfish." The

language of these opening lines—"sags," "lie down," "uninvolved"—characterizes the woman as indifferent and disengaged, her body exhausted. The speaker's reference to "the surgeon's careful mark" implies the addressee has had a child, or several children, and her body bears the changes and scars of childbearing. For most of the poem, the woman seems ashamed of her body, implied both by the woman's choice to wear a girdle and Sexton's word choice—"belly, soft as pudding, / slops into the empty space." Sexton's comparison of the belly to "pudding" and use of the word "slops" highlight the stretched-out, slackened feeling of her midsection and amplify it with her use of onomatopoeia. Her belly creates a sound, the wording implies, when she removes the girdle. The girdle, which for many women of the period represented an opportunity to control her appearance and fit modish clothing, instead becomes "an elastic case," a "hoarder"—something secret, uncomfortable and repressive.

The girdled body, to Sexton, is encased and imprisoned. The process of removing the girdle, freeing rolls of flesh and moving the garment down "over crisp hairs" and "thighs, thick as young pigs"—the parts of herself she hides—carries two connotations: first, a sense of judgment and shame as the woman views and touches her imperfect yet natural body, and second, an acknowledgment, a reconnection with her body forged by naming and seeing its components. In the earlier section of the poem, the speaker feels very close to the subject (possibly even the subject herself, looking in the mirror). However, in the last section of the poem, the speaker feels further from the subject; her gaze is less specific and less critical:

> Now you rise,
> a city from the sea,
> born long before Alexandria was,
> straightway from God you have come
> into your redeeming skin.

At the end of the poem, the woman has removed the girdle, and Sexton surprises the reader by changing the speaker's attitude toward the woman's body. The removal of the girdle is liberating, as implied by Sexton's shift in language to empowering religious words like "rise," "redeeming," and "straightway from God."

The girdle, first popularized in the 1930s (Hill 50), became the mid-twentieth-century version of the Victorian corset. In the 1950s women wore these garments even in the home: during this period, fashion magazines

implied everywhere that women needed to adapt and mold their bodies to fit fashionable clothing, rather than the other way around (Hill 78, 80).[5] The world of fashion restricted women's bodies to a strict ideal of feminine and curvy yet petite and ethereal—Hill posits Audrey Hepburn as the beauty ideal of the period (78)—while the clothing and women's undergarments restricted women's bodies in a literal sense. Many higher-end garments of this period had built-in corsets or girdles, like the custom-made Dior dress shown in figure 4. The petite, tailored navy suit reveals layers of tulle beneath to maintain its shape as well as a built-in bra and boning to make the dress lie properly on the woman's body. The dress itself is simple and demure, with a touch of lace detailing on the edges. It hides a much more complicated mechanism on the inside—an apt metaphor for women's social norms of the period.

"Woman with Girdle," much like other Sexton and Plath poems, reveals a relationship between women's bodies, their clothing, and the male gaze. The term "male gaze" was initially used by Laura Mulvey to describe how women in film "are simultaneously looked at and displayed, with their appearance coded for strong visual and exotic impact so that they can be said to connote *to-be-looked-at-ness*" (837). Mulvey's use of the term is implicitly sexual, casting the woman as an object of male sexual fantasy; her role in literature and film is to serve as a projection of that fantasy. In Plath's and Sexton's poems, however, the fantasy is alternately sexual and domestic. The male gaze can represent a physical or imagined male presence that makes the woman conscious of how she appears to him—either for his sexual approval or his acknowledgment that she fits with a paradigm of femininity. "Woman with Girdle" feels like a private poem even though the speaker observes the woman; Sexton suggests the woman is speaking to herself. The evidence of a male gaze—for example, the "surgeon's careful mark"—surfaces amid judgmental language and implicit shame about the body. Yet as the speaker continues, the woman begins to feel more triumphant in her body. The language grows less judgmental and more abstract, more focused on the subject within the "redeeming skin."

Sexton creates a similar feeling in her poem "The Nude Swim." Alone, the speaker feels beautiful in her nakedness as she lies on the water:

I lay on it as on a divan.
I lay on it just like
Matisse's *Red Odalisque*.

FIGURE 4. Fitted day dress with cropped bolero jacket by Mark Bohan for Dior for the fall/winter 1961 haute couture collection. Silk and lace. (Columbia College Chicago, Fashion Study Collection; 2001.033AB.)

Water was my strange flower.
One must picture a woman
without a toga or a scarf
on a couch as deep as a tomb.

The tone in this third stanza sounds intimate and confident. The woman likens herself to one of a series of Matisse paintings in which a woman lounges languidly in a seductive pose. These paintings from his 1920s Nice period are

bright, bold, and colorful, the women's positioning passive yet confident. In several of these paintings, the woman reclines with her breasts exposed; Sexton's use of the phrase "my strange flower" sexualizes the painting's image even further. The stanza ends, however, with the bleak phrase "a couch as deep as a tomb," foreshadowing the shift that comes next in the poem. In the fourth stanza, the woman's lover makes her self-conscious about her naked body even though he compliments her: "you said, 'Look! Your eyes / are seacolor. Look! Your eyes / are skycolor.' And my eyes / shut down as if they were / suddenly ashamed." Suddenly the speaker feels embarrassed of her naked body, even though she had been enjoying it just a moment ago. Her lover makes her aware that her appearance is not solely subject to her own judgment, but to a host of others who will admire or condemn her.

The women in these poems seem most vulnerable when they are aware of the male gaze, yet they often submit to this controlling force, playing the roles allotted for them within a patriarchal society. Sexton shows how these roles demand that women conform both physically and behaviorally. As in "Woman with Girdle," Sexton depicts the mutilation of the female body in "Cinderella" in a far more violent rendering of how women damage their bodies to conform to an ideal femininity. Her more dominant message, however, focuses not on the clothing but a mythology of femininity and marriage, especially in the poem's last stanza:

> Cinderella and the prince
> lived, they say, happily ever after,
> like two dolls in a museum case
> never bothered by diapers or dust,
> never arguing over the timing of an egg,
> never telling the same story twice,
> never getting a middle-aged spread,
> their darling smiles pasted on for eternity.

After retelling the fairy tale for most of the poem in a witty and skeptical tone, Sexton finally delivers her punch line: fairy tales end with marriage because marriage is not a fairy tale. Falling in love, proposing, and getting married are romantic, but marriage itself is not. By ending the story of Cinderella with the wedding, the storyteller preserves the couple in their happy state "like two dolls in a museum case." She follows with a litany of images, of arguments and bodies aging, that shatter the dream of the museum case.

Sexton attacks neither Cinderella nor her marriage, but rather the mythology, both ancient and contemporary, that makes women believe marriage is the end goal and fails to prepare them for the life that follows it.

Plath uses a similar metaphor in "Munich Mannequins," in which she describes fashion models, or live mannequins, posing in a window. Instead of perfect "dolls in a museum case," her vision of "perfection" appears in a store window in Munich: "Perfection is terrible, it cannot have children." Though the opening may sound like a commentary about the models' figures and their ability to, literally, bear children, the word "children" here functions more metaphorically—it can mean ideas, creativity, or meaning. In his discussion of Plath's professional experience with *Mademoiselle* magazine, Garry M. Leonard discusses the perfection of the models as pure femininity, a machine-like perfection that carries with it a false sense of security and "an increasing fear that one is trapped within a perfection in which any sign of individual life is unacceptable" (Leonard). The poem bears an eerie resemblance to Dior's description of one of his fashion mannequins, Renée, "the one who comes nearest to [his] ideal," in his autobiography *Dior by Dior*: "She brings fabric to life so exquisitely that her face is lost. As she shows her clothes, distant, aloof, it seems as if her very life centres around the folds of the material" (132, qtd. in Parkins). In response to Dior's comment, Parkins observes, "Note that Dior ultimately subordinates her to the clothing. She gives life to the material, but in doing so, she vanishes." Parkins argues that the model transfers "her vitality" to Dior's garment. This willing sacrifice is what makes her Dior's ideal. Similarly, the models in Plath's poem, however magnificent their clothing, however "glittering" their beauty, are ultimately "Intolerable, without minds." The poem closes with the line "Voicelessness. The snow has no voice." Plath conveys a woman drained of vitality, a paragon of style, beauty, and femininity, trapped behind a layer of glass and insulated from the outside world, acting as others want her to act. Leonard indicates the obvious parallel here to the bell jar metaphor that drives Plath's semi-autobiographical novel, the sense of feeling trapped, observed, and pressured to act as others demand.

Dior's description of Renée reveals the contrast between the women in Sexton's poems and the fashion models in Plath's. In both "Cinderella" and "Woman with Girdle," the women are conscious of themselves and their bodies, particularly the way they don't fit the clothes as they want. Their failure to fit makes them vulnerable and unfeminine, and part of the struggle becomes finding ways to fit—but this struggle demands self-consciousness.

In Plath's poem, however, the self has disappeared entirely. Both the fashion models and the Dior model, Renée, are deemed beautiful because of their ability to disappear, to sacrifice themselves for the stunning display.

Through this depiction of self-erasure, Plath portrays the danger of succumbing to a socially prescribed standard of beauty. Considering the submissive nature of the feminine ideal, in their efforts to conform, women risk losing themselves, submerging their identities beneath the dazzling surface. And yet despite such a critique of the fashion and beauty industries, Plath and Sexton also reveal the potential of clothing to transform women in a more empowering way. In Sexton's poem "Song for a Red Nightgown," she begins by correcting herself: "No. Not really red." The poem begins with trying to capture the color of the nightgown yet shifts to characterizing the wearer. By labeling the poem an "ode," Sexton implies that she begins with a kind of object worship but shifts to admiring the woman wearing the nightgown. Unlike Dior's model, who sacrifices her energy to the garment, here Sexton transfers life from the garment to the woman.

Sexton's diction describing the nightgown is passionate: "Schiaparelli Pink," "fire," "like capes in the unflawed / villages in Spain," "ravaged by such / sweet sights." Her allusion to Schiaparelli connotes boldness: Schiaparelli was best known for her avant-garde designs of the 1930s, and her shade of pink is often called "shocking pink." Like Chanel, Schiaparelli—as a daring, innovative female designer—is often posited in contrast to Dior stylistically: her modernity versus his traditional femininity. Sexton's characterization of the nightgown and association with Schiaparelli set a confident, almost defiant tone for the second part of the poem.

In the third stanza, Sexton interrupts the flow of the poem with the short declaration: "The girl is." She validates the girl as a being independent of the garment and the male gaze. In the images that follow, Sexton appropriates a familiar metaphor of a butterfly emerging from a cocoon, a metaphor that conveys power and strength when juxtaposed with her diction—"not terrified," "awesome flyer."

Plath conveys more discomfort with fashion and clothing in her poetry than Sexton, though her journals and her novel *The Bell Jar* betray a more complicated relationship with the world of fashion. While fashion may still surface as restrictive, Plath also portrays the way it can serve as a tool for identity construction, or a clue to someone's intentions. For example, when Plath or her narrator gets advice from another woman, she almost always describes what the woman is wearing, as though her style establishes

her credibility. In one journal entry from the early 1950s, Plath relates the advice she received from a friend: "I remember Liz, her face white, delicate as an ash on the wind; her red lips staining the cigarette; her full breasts under the taut black jersey. She said to me, 'But think how happy you can make a man someday'" (*Journals* 20). Her portrayal feels ironic, even contradictory: the red lipstick and black jersey fabric (a staple of Coco Chanel's designs) appear modern, but her advice sounds submissive and complicit in a patriarchal paradigm. As I discuss in the next section, Plath uses a similar tactic when her heroine, Esther, meets Dr. Nolan. Although Esther's experience with doctors up to this point has been harrowing, her first impression of Dr. Nolan seems favorable: she sees Dr. Nolan as attractive and fashionable, yet not in a superficial way. Unlike the other women, Dr. Nolan has a clear personal style—a way of appearing stylish without looking like a fashion mannequin, a way of asserting herself through the pieces she selects. Dr. Nolan's physical appearance, Plath suggests, helps endear her to Esther, despite Esther's past experiences with psychiatrists.

Plath and Esther see how fashion both limits and liberates—clothing allows her to read people; it lets her play a role or put on a temporary performance when it suits her; it can serve as a kind of social armor. In *The Bell Jar,* Plath provides extensive visual details about fashionable clothing, some of which indicate her discomfort or even disgust with a trend. Yet she also hints at clothing's ability to mask, transform, expose, and emphasize, and she illustrates how understanding its semiotic potential can empower women to control what they reveal to the public eye, as well as to assert agency in shaping their identities.

The Bell Jar

In 2003, Diane Johnson published a "nostalgia" piece in *Vogue* about her summer as a guest editor for *Mademoiselle* magazine—the same opportunity made famous by Sylvia Plath in her novel *The Bell Jar.* Johnson writes of the experience, "In those days, *Vogue* was the magazine for sophisticated women. *Mademoiselle* was for girls. Yet how strict was the version of womanhood the *Mademoiselle* editors imposed on us: We were to be ladylike, made up, dressed up, and chaperoned as we went into the office each day, hatted of course, to shadow a senior editor" (208). With her brief image of what "womanhood" meant at the magazine, Johnson conveys the paradoxical

nature of the internship. On the one hand, the women were being groomed as careerists and professionals, given real editorial experience and mentorship from working women. Yet on the other hand, they absorbed constant instruction—both on the job and off—about what being a lady meant: being protected, being chaperoned, being covered (or "hatted"), and always having perfect makeup, matching shoes, and an overall demure manner. The women did not arrive ladylike, according to Johnson: "While we worked on the magazine, its editors went to work on us. They devised trips to underwear showrooms, fashion shoots, ad-agency lunches—I still have, as a sort of historical curiosity, my Merry Widow corset, a killing, boned, strapless bodice designed to nip the waist in. We also had waist-cinchers not too different from those Scarlett O'Hara must have used—these items essential if we were going to fit into the New Look" (208). Johnson describes the proportionate amount of attention devoted to dressing and behaving like a lady in comparison with learning to run a magazine. Plath portrays this atmosphere in her novel, in which women are chaperoned to social events, ladies' luncheons, and movies; undergo makeovers by beauty experts and consultants; and are photographed in stylish clothes to emphasize their physical attractiveness and their popularity with the boys. Such attentions, in turn, deemphasize the women's intellectual pursuits while reinforcing values of femininity, appearance, and social propriety.

The college issue of *Mademoiselle* from 1953, the one featuring Plath as a guest editor, reflects Johnson's characterization. On the surface, the issue appears to focus on college women, with image after image of women with books in various university settings. However, the magazine presents these images in a way that undermines the experience of learning and shifts focus from education to dating and beauty. In one image, a young woman in a long plaid skirt, pink blouse with matching hat and gloves, and perfectly coiffed hair looks coyly at a man on the phone; the caption reads, "This little Sacony shirt goes to college with 3 Sacony skirts"; this caption erases the woman and anthropomorphizes the clothes. In an ad for a bra and girdle, a woman lounges in her undergarments beside a stack of books. She is surrounded by drawings of a girl in various stages of courtship (walking with a boy, talking on the phone, sharing ice cream). The text reads, "Intuition, unlike tuition, is *free*. It's also feminine and quick to pick this Gossardeb pantie and girdle because they're such whizzes at school girl figures." In another advertisement, a cartoon woman sits with legs spread before her books, wearing only a slip and a bra, before a backdrop of illustrated items

associated with science and math. The text reads, "Plane curves are for the math books. For captivating curves, try Hidden Treasure. . . . Instantly transforms a blue belle into 'a dish fit for the gods'!"

In each of these advertisements, the brand features educational content—pictures of books or laboratory equipment, a reference to Shakespeare—yet this content is trumped by text and content promoting an ideal of femininity epitomized by clothing or undergarments. Words like "perfect," "captivating," and "feminine" appear again and again. The third advertisement, like the *Cosmopolitan* article that helped inspire *The Bell Jar*, suggests that a woman feeling sad ("a blue bell") will be happy if she feels attractive. The name of the product, "Hidden Treasure," has more of a sexual connotation, and the woman sits in a provocative pose with her legs spread to the viewer but chastely covered up by her long white slip. Thus the ad alludes to the woman's sexuality while simultaneously marking it as inaccessible, something that should remain hidden beneath her visage of femininity. The resulting message of the advertisement seems contradictory: on the surface it seems to promote education, but the symbols of education dissolve as the woman's real value resides in her femininity and her chastely protected sexuality.

Editors and marketers employed such subliminal messages to indicate that women's self-worth should derive not from educational or career roles, but from their ability to attract eligible men, and then to become good wives and homemakers by making smart consumer choices. A woman who took education and career too seriously was deemed "unfeminine." Friedan relates the social pressure steering college women away from professional goals and toward marriage and motherhood: "A number of educators suggested seriously that women no longer be admitted to the four-year colleges and universities: in the growing college crisis, the education which girls could not use as housewives was more urgently needed than ever by boys to do the work of the atomic age" (Friedan 67). One interviewee explains that she and all of her friends were expected to attend college, but not to pursue careers: "a girl who got serious about anything she studied—like wanting to go on and do research—would be peculiar, unfeminine. I guess everybody wants to graduate with a diamond ring on her finger. That's the important thing" (231). Friedan distills a central contradiction of the period: women were still going to college, but they were not expected to get a real education or to have career goals. Such contradictions permeate the 1953 college issue of *Mademoiselle*.

In *The Bell Jar,* Sylvia Plath portrays her experience interning as a guest editor for *Mademoiselle* during the summer of 1953, as well as her psychotic break and hospitalization after the internship, through her heroine Esther Greenwood. Throughout the novel, Plath provides detailed descriptions of women's clothing: Esther's various fashionable purchases with matching accessories, the fur stoles and other items promoted by her internship, the ensembles of her colleagues that range from dowdy to daring, and the clothing worn by characters Esther introduces into the narrative. Readers are challenged to find any consistency in her references to fashion details and clothing description, for they surface in a range of contexts and carry positive and negative connotations.

Plath departs from earlier American writers of fashion in fiction in that she portrays fashionable clothing as accessible—not merely a single dress or work suit, but an entire wardrobe of options. Earlier writers who attempt to capture the dynamics of social maneuvering vis-à-vis fashion—for example, Edith Wharton, Anzia Yezierska, and Theodore Dreiser, among others—did so on the cusp of an emerging American ready-to-wear market. Plath's protagonist, Esther, in one sense is at an advantage to characters like Wharton's Lily Bart, Yezierska's Sonia Vrunsky, or Dreiser's Carrie Meeber, in that she can afford to shop for fashionable yet affordable garments and accessories, well suited for a range of occasions. Such a distinction reflects a larger shift in the American fashion industry: from a system based on Parisian haute couture, accessible only to the wealthiest class, to a more affordable albeit market-driven system based on mass consumerism. And yet, the relative accessibility of the garments does not necessarily make the system more progressive; in fact, Jennifer Craik suggests how it may be the opposite. Femininity, she explains, is "characterised by techniques of display and projection of the female body. . . . Since the eighteenth century, techniques of femininity have been organized around body techniques, interactive modalities and mental dispositions through which 'feminine' attributes are displayed" (47). During the 1950s, when the novel is set, these displays of femininity become more urgent and pervasive after the relatively progressive, even androgynous fashions of the 1920s and 1930s. The Dior wardrobe was designed to package women in such "displays of femininity," to cast them in roles—a young socialite in a ball gown, a good housewife entertaining friends, a well-bred college girl—that echo a dogma of femininity. Inevitably, the symbolic power of fashionable clothing yields confusion, as Plath demonstrates: for example, Esther's boss serves as her professional

mentor, yet Esther instinctually evaluates her only in terms of her appearance; Esther goes shopping as part of her professional internship, yet the clothes she buys are more for social events than for professional scenarios. Esther senses this confusion centered on the clothing that she consumes, as well as the clothing she observes and interprets on her friends and would-be mentors.

The fashion paradoxes in the novel are echoed in the internship opportunity itself. Given the setting of the novel in the 1950s, when young women were encouraged by popular media to forgo career opportunities in the interest of becoming housewives, mothers, and homemakers, an internship at a magazine seems progressive, even feminist. In his article examining the contradictory connotations of the internship, both in *The Bell Jar* and in American culture writ large, Nicholas Donofrio acknowledges this apparent progressivism in the *Mademoiselle* opportunity: "even if the guest editorships were partly a stunt designed to sell more magazines, even if the work was sometimes too demanding and at other times too fluffy, even if they were temporary positions that many editors considered a lark, . . . it would be hard to deny that there was something progressive about the arrangement" (230). Certainly, as Donofrio acknowledges, Plath herself benefited from her magazine internship, which helped launch her career as a writer. When it was founded during the Depression, *Mademoiselle* initially championed college women, working women, and literary women (Donofrio 223). Beginning in the 1950s, however, the magazine faced pressures to balance its championing of the career woman with the prevailing ideology of femininity and domesticity. Donofrio suggests the magazine's shift in tone began with the 1952 publication of the "Suburbs" issue. Rather than affirming that women could balance career and home life, these life goals were now viewed "through the prism of Cold-War warm-hearth ideology, as successive stages in a young woman's development: first she was a student, then a 'working girl,' and then a wife and mother" (224). These stages, Donofrio argues, are paralleled by feature issues of the magazine: "the College issue," "the Career issue," "the Brides issue," and "the Suburbs issue."

Donofrio's analysis of the magazine's shift in the 1950s complements his reading of the internship opportunity, an opportunity that he suggests emerged at the turn of the twentieth century (216) and continues to generate controversy today: Americans question whether such positions are exploitative or deliver the career-launching results they promise. In the case of Plath's internship, and by extension Esther's, the opportunity is further

complicated: not only do we question whether the internship can help the women launch their careers, but we also question whether they leave the internship still wanting careers. Plath and Johnson reveal how the coordinators of the *Mademoiselle* internship program clearly balanced its career opportunities with both overt and subtle reminders that the women must remain pretty and feminine. In *The Bell Jar,* Plath devotes far less attention to the professional aspects of the internship (her work with Jay Cee, the editor) than to the social aspects—the gifts, social events for mingling with men, photo shoots, or other facets of the internship that reinforce patriarchal ideas of femininity.

The internship is framed therefore as a kind of training ground, though neither the reader nor Esther really knows if it's meant to launch her career or steer her toward life as a housewife. Donofrio considers the novel as a kind of bildungsroman, suggesting the term "internship narrative" (247). Calling the novel a bildungsroman makes sense when considering the popularity of the trope in nineteenth-century British realism—it is a trope that initially served to reinforce a "prevailing social order" and to initiate a young person coming into adulthood in the mores of that order (Keith 31, 42–43). The problem, though, is that the kind of initiation presented by the internship feels limiting to Esther. She views each woman she meets as a potential life path, one that means turning away from other potential paths.

Plath represents this problem of choice in her use of the fig tree metaphor. During her internship, Esther reads a short story about a fig tree, which she imagines as a metaphor for her life: "From the tip of every branch, like a fat purple fig, a wonderful future beckoned and winked" (77). Esther sees each branch as a possibility—"a husband and a happy home and children," "a famous poet," "a brilliant professor," "Ee Gee, the amazing editor," "Europe and Africa and South America," "an Olympic lady crew champion." As she imagines herself looking up at the branches, however, Esther envisions herself "starving to death" because she cannot choose one fate out of so many promising possibilities, for such a choice means "losing all the rest." As she waits in her ambivalence, Esther explains, "the figs began to wrinkle and go black, and, one by one, they plopped to the ground at my feet" (77). The figs in this frequently cited passage represent different roles, or different life paths, branching out before her. While many scholars have noted how these figs represent Esther's choices, the metaphor also emphasizes the separation or isolation of each fig: Esther's anxiety stems from believing that none of those choices seem to overlap or intersect. She does not believe she

can have a husband and family *and* be a famous poet, for example, and her interactions with her boyfriend Buddy have confirmed those expectations. Like Esther, Plath feared having to choose a role, and she believed choosing one role in life meant canceling out another, or many others. During her college years at Smith, she questioned, "Would marriage sap my creative energy and annihilate my desire for written and pictorial expression which increases with this depth of unsatisfied emotion . . . or would I achieve a fuller expression in art as well as in the creation of children? . . . Am I strong enough to do both well?" (*Journals* 55–56). Donofrio suggests that the internship opportunity at *Ladies' Day* (the fictional version of *Mademoiselle*) undergirds Esther's perception that her ultimate goal should be domestic and not professional; that the magazine shows "complicity in the transformation of working women into wives." Plath's journal entry mirrors the anxiety Esther feels about having to choose, an anxiety heightened by the mixed messages presented throughout the internship. Plath and Esther both show a reluctance to make choices about the future, believing they cannot combine multiple visions into one life.

The choices presented to Esther throughout the novel are represented not only through women, or potential role models, but also through their clothing. The clothes Esther describes represent different roles in life, the different figs on the fig tree. We might therefore read the clothes as the costumes that accompany a particular life choice, much as the Dior wardrobe was meant to outfit women for roles as society women, college girls, housewives, and other appropriately feminine ideals. The clothes therefore present an opportunity that choosing a career path or partner cannot, for donning these clothes means being able to try on a role without committing to it. At the same time, the roles are prescribed by fashion media, leaving no room for fluidity, for developing a personal style by blending different elements. The Dior model of fashion packaged whole outfits—gowns or suits with hats, gloves, and other pieces that resulted in a cohesive look that, in turn, connoted a clear persona.

This concept of fashion as role-play emerges when Esther interacts with a potential mentor or role model. As a guest editor, Esther entertains ambitions to write for a magazine like her supervisor, Jay Cee, yet even as she seems eager to impress the editor, she appears repulsed by her clothing. Jay Cee violates the sanctions of femininity with her professional success, and the lilac shade of her clothing and its fussy details fail to mask the impact of her "wise" appearance: "Then she slipped a suit jacket over her lilac blouse,

pinned a hat of imitation lilacs on the top of her head, powdered her nose briefly and adjusted her thick spectacles. She looked terrible, but very wise" (39). The word "imitation," a word Plath frequently uses when describing women's clothing in the novel, further suggests that any attempts to be feminine (flowers, the pastel color) fail to eclipse the masculine professionalism of Jay Cee. For Esther, Jay Cee represents what choosing a career might entail: the erasure of physical desirability and socially sanctioned feminine beauty. She also reveals the failure of the mode in encouraging personal style—Esther sees the dissonance between the feminine "working woman" suit and Jay Cee's physical features and personality.

Esther's friend Doreen represents a possibility for resisting conformity in the way she plays with the boundaries of contemporary fashions. When Doreen first appears in the novel, Esther describes the strict parameters for looking fashionable at Doreen's school: "Her college was so fashion conscious, she said, that all the girls had pocketbook covers made out of the same material as their dresses, so each time they changed their clothes they had a matching pocketbook" (5). Doreen dresses in the current fashion, yet her unbridled sexuality bursts forth in her choice of clothing and styling. She bleaches her hair blonde like Marilyn Monroe, considered an icon of the era—yet in a more sexualized way than "good girl" Audrey Hepburn (Hill 78). Esther's description of Doreen's clothing highlights her voluptuous figure and sexualized appearance: "She was wearing a strapless white lace dress zipped up over a snug corset affair that curved her in at the middle and bulged her out again spectacularly above and below, and her skin had a bronzy polish under the pale dusting powder" (7). Esther endows the clothing, not the wearer, with the power to transform and highlight, to mold Doreen into the seductress; however, Doreen's brash attitude suggests that she has mastered the art of playing with the boundaries of respectability. Her dress has demure and feminine details (the white color, the lace, the corsetry), but these details serve to draw more attention to her curves and her tanned skin.

Esther prefers this subversive play with fashion that she sees in Doreen to the robotic acceptance of trends she witnesses among some of the interns. Even Jay Cee shows some awareness of fashion as a tool, a potential means of finding a balance between her professional persona (hence her choice of a tailored suit) and the feminine standards of her social world (her choice of the color lilac and the hat with imitation flowers). In contrast, Esther's colleague, Hilda, shows no inkling of self-awareness and instead accepts

whatever fashion trends are being promoted. When Hilda is first introduced, Esther's friend Betsy is describing a demonstration of "how to make an all-purpose neckerchief out of mink tails and a gold chain," and she observes how "Hilda nipped down to the wholesale fur warehouses right afterward and bought a bunch of mink tails at a big discount and dropped in at Woolworth's and then stitched the whole thing together coming up on the bus" (28). Esther sees that Hilda is already wearing her new accessory, indicating the immediacy with which she jumps on a trend. In a later passage, Esther indicates that Hilda embraces even the most unflattering trends, trusting wholeheartedly in the industry. Hilda wears a hat that Esther calls "a wisp of bilious green straw perched on her brow like a tropical bird" in "bile green" (99). Esther's description of the color reflects her disdain for the trend and for Hilda's mindless trend chasing; she even suggests Hilda anticipates fads: "They were promoting it for fall, only Hilda, as usual, was half a year ahead of its time." In this same passage, Esther likens Hilda to a dybbuk (100), a disembodied and hollow voice that possesses a shell of a human form. The comparison instantly erases Hilda's humanity. When considered in conjunction with Hilda's comment on the Rosenbergs ("I'm so glad they're going to die"), Esther's analogy portrays her as desensitized and cruel; however, when read in conjunction with her comments on Hilda's trend chasing, the analogy takes on another meaning. Hilda does not select clothing that represents some icon or persona she yearns to embody. Instead, she wears whatever the fashion industry dictates: she is a slave to fashion, a model consumer without a mind of her own. Her ambition to conform erodes any semblance of an independent voice. Esther's attitude toward Hilda's trend chasing reveals the importance of choice in fashion, of finding the right way to construct both persona and intention.

Plath's characterization of Hilda in this passage recalls the image of the "Munich Mannequins": women who have willingly given up their souls, so to speak, for fashion. The dybbuk Esther hears in Hilda's hollow voice parallels the "voicelessness" of the fashion models in the window. The horror Esther feels when speaking with Hilda lends a greater urgency to her vision of the fig tree, the problem of choice. The act of choosing a fig, for Esther, is an act of self-assertion, of becoming. Failing to choose, or making the wrong choice, means losing herself, becoming voiceless.

It is not surprising, then, that Esther fears making the wrong choice. Friedan discovered this same fear of choosing among the women she interviewed, and she implies the fear was inherent in the feminine mystique. It

was also the very notion upon which fashion magazines and other print media preyed. She asks, "What if the terror a girl faces at twenty-one is the terror of freedom to decide her own life, with no one to order which path she will take, the freedom and the necessity to take paths women before were not able to take? What if those who choose the path of 'feminine adjustment'—evading this terror by marrying at eighteen, losing themselves in having babies and the details of housekeeping—are simply refusing to grow up, to face the question of their own identity?" (131–32). Friedan suggests that the fear Esther confronts as she watches the figs ripen and wither mirrors the fear faced by millions of young women. Most women, Friedan argues, responded by believing the myth promised by the magazines, that being feminine and pretty, settling into the life of a housewife, would fulfill all of their needs and save them from making wrong choices. Mrs. Willard, Esther's boyfriend's mother, makes a similar argument to Esther (paraphrased by Buddy): "'What a man wants is a mate and what a woman wants is infinite security,' and, 'What a man is is an arrow into the future and what a woman is is the place the arrow shoots off from'" (72). Her phrasing implies women find fulfillment and purpose in stability and in helping launch another person's dreams, but not their own. Esther initially tries to follow this same path, hinging her hopes for a happy future on finding a desirable male partner and settling on the handsome aspiring doctor Buddy Willard. Her most poignant moments of clarity, however, surface in her resistance to Buddy, her recognition that the very things that make her herself—her ability to write poetry, her creative spirit, even her indecisiveness—are ridiculed or dismissed by Buddy.

Esther's journey to find and nurture this independent spirit thus becomes a journey through the world of fashion, a path marked by outfits and accessories that represent different futures—different figs on the fig tree. Throughout the novel, Plath uses clothing to present a role and then narrates Esther's response to the clothing as her response to the possibilities they represent for her in that role. In the novel's first chapter, Esther describes herself during the first weeks of the internship, lingering on descriptions of her clothing:

> I was supposed to be the envy of thousands of other college girls just like me all over America who wanted nothing more than to be tripping about in those same size-seven patent leather shoes I'd bought in Bloomingdale's one lunch hour with a black patent leather belt and black patent leather pocketbook

to match. And when my picture came out in the magazine the twelve of us
were working on—drinking martinis in a skimpy, imitation silver lamé bodice
stuck on to a big, fat cloud of white tulle . . . everybody would think I must be
having a real whirl. (2)

The glamorous clothes Esther wears suffocate her because of the vision of
womanhood they represent. Over the weeks she sees the symbolic power
these garments wield, and the total disconnect between what they signal
and how she feels. The photograph of her in the silver lamé and tulle, which
appears later in the novel during her psychiatric treatment, connotes femi-
nine pleasure—gorgeous clothes, a luxurious setting, and handsome young
men. Esther suggests that despite the image of perfection she feels discon-
nected, like "a numb trolleybus" or "the eye of a tornado . . . moving dully
along in the middle of the surrounding hullabaloo" (3). Her value lies not
in her professional or academic achievements, but in her ability to appear
happy, pretty, and feminine, to capture an implicit male gaze.

As in her poetry, Plath recognizes the role of the male gaze in shap-
ing women's fashion: Esther often appraises her reflection in terms of her
physical attractiveness, as when she dresses for a dance at a country club: "I
stood quietly in the doorway in my black sheath and my black stole with the
fringe, yellower than ever, but expecting less" (105). Her phrasing under-
lines the performance her clothing entails, as she pairs the ensemble with
an "imitation jet bead evening bag." She has agreed to the date only reluc-
tantly, mentally reassuring herself, "I am an observer" (105). Esther finds
comfort in separating herself from her outer shell (in this case, the clothes
she wears), which she distinguishes from the hollowness and mindless con-
formity she sees in Hilda—she is still herself, Esther reasons. Out of a sense
of obligation to be sociable she agrees to dress and act like an appropriate
date, as long as she can mentally distance herself and adopt the persona of
the observer.

Esther's clothing is her armor; she wears a "sheath"—a popular fitted
dress style of the time, but also a word more generally referring to a cover.
Unfortunately, in this same passage, Esther's clothing fails to protect her.
Early in the evening she identifies her date, Marco, as a "woman-hater" and
realizes he will force her to sexually engage—first by physically pulling her
onto the dance floor, and later by attempting to rape her. Esther spotlights
the moment when he tears off her clothing: "Marco set his teeth to the
strap at my shoulder and tore my sheath to the waist. I saw the glimmer of

bare skin, like a pale veil separating two bloody-minded adversaries" (109). Immediately after Marco violently rips off her clothes with his teeth, he repeatedly exclaims, "Slut!" The word choice in this passage conflates the tearing of clothing with the act of sexual violation. By tearing off Esther's dress and exposing her vulnerable body underneath, Marco destroys her illusion that fashion can function as a protective mask. The chapter concludes with Esther throwing all of her clothes off the roof of her hotel "like a loved one's ashes" (111). Esther's act of shedding her clothes is less about losing her faith in fashion, and more about her repulsion from being *looked at*. Marco's gaze at her bare body makes Esther long for invisibility. If before she feared becoming voiceless and losing her sense of self, now she craves that self-erasure. She therefore heads home wearing another woman's clothing and, upon returning home, suffers a psychotic break.

Esther's breakdown and subsequent hospitalization is characterized by self-denial and inaction both literally and figuratively. Unlike the detailed clothing descriptions Plath provides during Esther's internship, in the chapters that follow Plath leaves out the flamboyant details of women's dress. Esther wears the same clothes for nearly a month—Betsy's "green dirndl [skirt] with tiny black, white and electric-blue shapes swarming across it" and a "white eyelet blouse [with] frills at the shoulder, floppy as the wings of a new angel" (112)—an ensemble that epitomizes her sense of inertia and self-denial. The chaste, demure style of the blouse and dull simplicity of the skirt create a dissonance with Esther's sharp wit and intellectual curiosity. Wearing Betsy's clothing helps her feel less visible, but more importantly, it makes her feel less vulnerable to the gaze of outsiders. When Esther uses clothing to experiment with identity construction, to try on different roles, she retains a sense of connection with this outer "skin," but in Betsy's clothing she loses this connection, retreating into herself.

As Esther retreats further from others, she even rejects and denies images of herself. After her suicide attempt, she sees herself in the mirror at the hospital and refers to her reflection as "the person" (174). During her time at Belsize, Esther encounters a girl from college, Joan, who repeatedly presents Esther with images of her former self; each time, Esther resists or outright denies these images. Looking at newspaper clippings announcing her as "missing," Esther describes herself as "a girl with black-shadowed eyes and black lips spread in a grin," dismissing the image as "tarty" (198). In a later passage, Joan finds the magazine picture of Esther on the roof: "The magazine photograph showed a girl in a strapless evening dress of fuzzy

white stuff, grinning fit to split, with a whole lot of boys bending in around her" (207). When the girls excitedly insist the woman in the photo is Esther, she responds, "No, it's not me. Joan's quite mistaken. It's somebody else" (207). Esther's self-denial is paralleled by her use of the bell jar metaphor. After her psychotic break, Esther repeatedly uses the glass bell jar to convey her sense of separation and suffocation, her inability to connect with other people as well as her sense that people are looking at and judging her without really seeing her.

Esther maintains this distance from any images of herself and her clothing until the end of the novel. While Plath does not conclude the novel with clear resolution or redemption, the ending is hopeful, with Esther having found a mentor in her therapist, Dr. Nolan, and having made progress in her psychotherapy. The first sign of positive change for Esther appears when she meets Dr. Nolan, whom Esther characterizes as someone who embodies multiple possibilities: "I didn't think they had woman psychiatrists. This woman was a cross between Myrna Loy and my mother. She wore a white blouse and a full skirt gathered at the waist by a wide leather belt, and stylish, crescent-shaped spectacles" (186). In this short description, Esther characterizes Dr. Nolan as a professional (though unlike Jay Cee, her glasses are "stylish," and she does not try to force feminine details into her professional wardrobe), a mother figure, and a sex symbol—she fuses elements of Betsy, Doreen, and Jay Cee. The self-image Dr. Nolan presents through her style, Plath reveals, is entirely consistent with the person Esther comes to know. She is completely professional in her treatment; she is open about sexuality (e.g., she helps Esther secure birth control and she shows empathy rather than judgment toward her lesbian patients); and she is nurturing. Unlike Esther's other mentors, Dr. Nolan has developed a personal style—a presentation of herself—that feels genuine and therefore relatable.

In her physical presentation and persona, therefore, Dr. Nolan represents a role model to which Esther can relate: she does not choose a single role or socially sanctioned feminine template but rather blends seemingly disparate traits into one persona and one style. Unlike the other women in the novel, Dr. Nolan does not try to mold Esther into a version of herself. Instead, the doctor listens to her without judging her, gains her trust, and acts as a confidante and a nurturer. It is through her relationship with Dr. Nolan that Esther begins to look at herself once again, to reinitiate her process of experimentation and identity construction. She becomes open and honest about her feelings toward her mother; she begins to form friendships

with the other patients; and she has an honest conversation with Buddy that does not reek of resentment. These honest interactions show that for Esther, the bell jar is lifting: she no longer feels insulated from others and withdrawn into herself. She can begin to see herself again, and perhaps as a result, the novel closes with her once again describing her appearance.

In the novel's final passage, Esther describes her clothing as she prepares for an interview—the interview that will determine whether she can return home from the psychiatric facility. Her description implies that she has returned to the process of self-affirmation, if not acceptance: "My stocking seams were straight, my black shoes cracked, but polished, and my red wool suit flamboyant as my plans. Something old, something new. . . . But I wasn't getting married. There ought, I thought, to be a ritual for being born twice—patched, retreaded and approved for the road" (243–44). Esther is critical of her ensemble, yet more in an honest, slightly self-deprecating way: she is affirming herself and seems amused by her patched-up appearance. While her clothes are not fashionable (the shoes are "cracked," the suit "flamboyant"), she maintains a neat appearance. More importantly, Esther suggests that her outfit accurately represents her persona at this phase in her life: she shows her flaws, her wear and tear, but she feels confident and cautiously optimistic about her future. Unlike the clothing Esther wears during her internship—stylish, shiny, and perfectly accessorized—these clothes feel slightly worn but bold nonetheless. The clothes in this passage do not represent a rejection of fashion or being fashionable, but rather an embrace of personal style, revealing rather than hiding oneself through clothes.

Esther's emphasis on clothes seems surprising in a scene that feels so filled with hope, with promise for her future. When combined with Friedan's analysis and the social critiques of Sexton and Plath in their poetry, it is easy to dismiss fashion in this novel—perhaps in general—as patriarchal and frivolous. Yet doing so undercuts fashion's potential for aesthetic pleasure and self-expression—even self-discovery. Visual studies theorist Llewellyn Negrin explains that simply dismissing any fashion that seems impractical and that prioritizes aesthetics over function implicitly embraces "a puritanical asceticism" and negates "the legitimacy of nonutilitarian needs such as those for beauty and sensuous pleasure" (34). Her word choice reinforces her claim that such reductive views of fashion work in conjunction with "Christian denunciations of fashion as too overtly erotic" and "patriarchal devaluation of activities traditionally associated with women." Plath, too,

implicitly rejects such a dismissive treatment of fashion. While she dispar-
ages blind trend chasing through the character of Hilda, she also revels in
the beauty of stylish clothing worn with confidence in her novel, her poetry,
and her journals. Plath and Sexton celebrate fashion as a vehicle for self-
discovery and self-revelation, but they acknowledge the potential pitfalls
of putting too much stock in the fashion system, in letting it dictate one's
persona.

Fashion, these authors show, can be a means of asserting, exploring,
or obscuring the self, and the years that followed would prove important
for the relationship between identity politics and the fashion industry.
Plath and Sexton wrote during a time when the United States was reeling
from a world war, and returning to the lavish feminine fashions of Paris
gave the illusion of "a return to normalcy" (Hill 80). While some Americans,
like the Beat writers discussed in the next chapter, openly rebelled against
the conformist styles of the era, Sexton and Plath at least attempted to em-
brace the New Look and its offshoots.

During the late 1950s, however, fashion became more international,
establishing recognized fashion capitals outside of Paris, including New
York, London, and Milan (Hill 89) and nodding toward a sea change in the
trickle-down patterns of the fashion industry. Although Paris had reas-
serted itself as the epicenter of high fashion during the late 1940s, other cit-
ies began producing innovative new styles and pioneering young designers.
Meanwhile, in the United States, American designers continued to design
accessible clothing that met with current design trends yet was easy to mass-
produce. Around this time, American designer Claire McCardell, famous
for her mass-produced "popover dress" during the 1950s, first introduced
denim into fashionable women's wardrobes (Gunn 43). Her radical incor-
poration of a working-class textile into a high-class industry contributed
to the emerging American style that first became popular before the war:
a sporty blend of "high fashion and low textile" that combined style with
comfort. Denim would become central to counterculture styles of the 1960s,
an era that produced rebellious film icons like Marlon Brando and James
Dean and emphasized youth culture.

As the fashion scene became more international and accessible, there-
fore, it also became more youth oriented. The first baby boomers became
teenagers (Hill 91), and Yves Saint Laurent—a designer with an innova-
tive vision—took over House of Dior after Christian Dior's death in 1957.
In 1960, he designed a line of "youthful, street-inspired clothing, which

included a jacket of crocodile skin trimmed with mink that was modeled on the motorcycle leather jacket worn by Marlon Brando in *The Wild One*" (95). Saint Laurent, therefore, is often credited with introducing the first street fashion into haute couture, with his winter collection of "leather jackets and turtleneck pullovers" (Vinken 63). The iconic pieces worn by these young stars, including jeans and leather jackets, became some of the first wardrobe staples of a distinctly American street fashion that would be embraced by multiple counterculture groups of the late twentieth century and has never gone out of style. As I discuss in chapter 2, after the fairly traditional, costly, and restrictive high fashions of the late 1940s and early 1950s, the fashion industry would undergo an enormous transformation. From the late 1950s onward, designers worldwide would look to the streets for inspiration. As the baby boomers grew into teens, youth culture and the street fashions it embraced would dominate fashion for the next decade, and it would never disappear from the forefront of the international fashion scene.

2

The Beat Writers and the Dawn of Street Fashion

I long to turn myself into a Bohemian, but lack the proper clothes.

—Joyce Johnson, *Minor Characters*

IN HIS CONTROVERSIAL 1957 essay "The White Negro," Norman Mailer proclaims, "One is Hip or one is Square . . . one is a rebel or one conforms, one is a frontiersman in the Wild West of American night life, or else a Square cell, trapped in the totalitarian tissues of American society, doomed willy-nilly to conform if one is to succeed" (278). Mailer suggests that the collective traumas of World War II, the Holocaust, and the atomic bombings wreaked an unimaginable "psychic havoc" on the "unconscious mind" of humanity, and that the postwar generation was forced to reconcile an individual sense of importance with the realization that one's death "would be unknown, unhonored, and unremarked" (277). This notion of meaningless, faceless death, Mailer argues, sparked adverse reactions among American citizens, reactions echoed by the impulse toward convention depicted in *The Bell Jar* and the rebelliousness that surfaces in the literature of the Beats. The former reflects the desperate conformity of the postwar generation,

those who believed that constructs like the nuclear family, a home in the suburbs, and traditional gender norms could provide a sense of normalcy and security. The latter reflects the existentialist credo of the postwar counterculture, those who resisted mainstream ideals and lived experience-driven, hedonistic lives. Mailer thereby establishes a binary in his essay: hip versus square, conformist versus hipster. His binary construction collapses a host of different emerging countercultures during the postwar period into the category of "hip" or the label "hipster."

The term "counterculture" is often used interchangeably with the term "subculture," and definitions of each term have fluctuated. In *Subculture: The Meaning of Style* (1979), Dick Hebdige defines "counter culture" as "that amalgam of 'alternative' middle-class youth cultures—the hippies, the flower children, the yippies—which grew out of the 60s, and came to prominence during the period 1967–70" (148). He uses the term "subculture" to represent more generally the subversive or resistant groups within a larger culture (the Beats, teddy boys, hipsters, etc.). In contemporary use, however, "counterculture" typically refers to any group within a larger culture whose collective identity embraces an ethos of rebellion against mainstream cultural values. I use "subculture" to refer to a group within a larger culture that expresses its collective identity through style, clothing, music, or other signifiers that are not necessarily linked to an ethos of rebellion (e.g., twenty-first century hipsters, Steampunk, etc.), though they may still represent a common ethos.

Mailer elides the various countercultures and subcultures of the postwar era into the category of "hip"; however, by distinguishing rather than eliding these countercultures, we can illuminate different modes of resistance to the dominant culture that have emerged since the late 1940s. Similarly, understanding variations among these groups exposes the variety of street styles that would eventually become mainstream American fashion within two decades after World War II. Building on the work of Albert Goldman, Hebdige argues that the style embraced by hipsters "was assembled in relatively close proximity to the ghetto black" while "the beat . . . lived an imaginary relation to the Negro-as-noble-savage" (48). Hebdige and Goldman indicate the relationship between counterculture/subculture and black culture, noting that both groups "grew out of the same basic mythology" (48). Their analysis, when paired with Mailer's, sheds some light on the development of American street fashion in the late twentieth century—what many

now consider iconic American style. The identity of the counterculture group depends on a mainstream construct against which to position itself, just as subcultural style depends on a construct of mainstream fashion to have any meaning or relevance. Their argument also indicates how counter-cultural groups often turn to the style and culture of groups not represented (or underrepresented) by mainstream culture for inspiration.

In chapter 1, I discussed how the literature of Sylvia Plath and Anne Sexton characterizes mainstream postwar fashion as conformist and restrictive. Plath in particular reads the gender norms of her time in the clothing she is expected to wear—clothing that expresses the ideals of femininity and that simultaneously denigrates the practical clothing of the career woman as masculine. In this chapter, I illustrate how the Beat writers of the 1950s helped to steer mainstream American fashion in a completely different—and irreversible—direction. By rejecting both mainstream values and mainstream fashion, the Beats unwittingly introduced a new style into American youth culture. This style, known today as "street style," would eventually work its way into mainstream fashion. It has not disappeared but instead has maintained its relevance while evolving well into the twenty-first century.

In terms of its identity politics, street style has appropriated textiles, patterns, and symbols from other cultures as much as mainstream fashion has—if not more so. As the texts in this chapter illustrate, part of rejecting a mainstream identity means seeking out alternative cultural material to construct a counterculture identity. In "The White Negro," Mailer argues that African American men provided this template for white hipster identity, "for he [the American Negro] has been living on the margin between totalitarianism and democracy for two centuries" (278). He continues by describing how hotbeds of counterculture art and performance such as Greenwich Village brought together white hipsters and African Americans, noting that "in this wedding of the white and black it was the Negro who brought the cultural dowry. Any Negro who wishes to live must live with danger from his first day, and no experience can ever be casual to him, no Negro can saunter down a street with any real certainty that violence will not visit him on his walk" (279). Mailer identifies the "American Negro" as a model for the existentialist, experience-driven ethos of the hipster, who in turn imitated his bop "argot," smoked marijuana, and immersed himself in jazz music (all of which Mailer identifies with black American men). In the Beat writing I

discuss in this chapter, such emulation and appropriation saturates the narratives and behavior of Beat men, as well as the style choices of Beat men and women.

Certainly, such fetishization of the "American Negro" represents a problematic example of cultural appropriation, and it oversimplifies black culture and turns the bleak struggle of racial violence into something superficial. Jack Kerouac's protagonist Sal Paradise even goes so far as to express a longing to experience the suffering of a black man in *On the Road,* as I discuss later in this chapter. James Baldwin took issue with Mailer's reflections on the hipster, attributing much of the hipster ethos to a mysterious white male nostalgia: "I am afraid that most of the white people I have ever known impressed me as being in the grip of a weird nostalgia, dreaming of a vanished state of security and order, against which dream, unfailingly and unconsciously, they tested and very often lost their lives" ("Black Boy" 102). This longing for order and meaning, he implies, drives them to appropriate, to emulate, believing that other groups must have the secret purpose and order that eludes them. He questions: "But *why* should it be necessary to borrow the Depression language of deprived Negroes, which eventually evolved into jive and bop talk, in order to justify such a grim system of delusions? Why malign the sorely menaced sexuality of Negroes in order to justify the white man's own sexual panic?" (105). Indeed, the would-be hipsters of the postwar era who claimed to reject the totalitarian ideologies of mainstream culture in fact emulated many of its modes of oppression, especially in terms of racial othering and appropriation as well as gender oppression.

The hipster, and in turn the Beat, was coded as both white and male. In promoting the disaffected white male as the face of Beat art, the creative and stylistic contributions of women and African Americans have often been ignored. Beat artists produced new creative material even as they took—cultural materials and clothing from African Americans, indigenous people, and working-class whites; philosophy and spiritual ideals from Buddhism and other Eastern religions; financial support and sacrifice from women. It's not surprising, perhaps, that the Beat men's subcultural style grew out of cultural appropriation, a performance of working-class identity and an imagined kinship with African American jazz artists. The Beat women's style, in contrast, began more as a deliberate countercultural and bohemian look, a conscious adoption of nonmainstream signifiers. As the women discussed in this chapter show, however, as they developed their own identities—as artists, wives, mothers, intellectuals,

Jews or former Jews, partners or mothers of African Americans, poets, novelists—their style evolved into something both practical and deeply personal.

Street Style and the Fashion Industry

Street style as we know it today has diverged from its mid-twentieth-century countercultural roots, and yet it has continued to blur boundaries between countercultures and mainstream American identity. When she began working at *Vogue* in the 1980s, Condé Nast artistic director Anna Wintour immediately looked to the streets for creative inspiration. In the documentary *In Vogue—The Editor's Eye* (2012), Wintour remarks that she did not see fashion as "trickling down from a very particular, rarified couture sense of fashion," but instead, she explains, "I saw young women in the street dressing in a way that I thought was influencing the designers. Fashion was being influenced by all sorts of people and culture and also of course, the street." This "trickle-up" idea of American fashion can be traced back to the 1920s, when some of the first bohemian-inspired trends hit the pages of *Vogue* (e.g., Coco Chanel's fisherman sweaters and Sonia Delaunay's jazz-print textiles). However, the post–World War II era solidified the trend of fashion emerging from street style, sparked by various countercultures and youth culture as a whole. This period also helped establish American fashion internationally as a distinct aesthetic, one that drew from the casual sportswear of the 1930s and took it a step further.

Like many fashions of the 1920s, post–World War II street style initially grew from working-class dress. Film stars of the 1950s and 1960s, according to fashion consultant Tim Gunn, made specific pieces associated with workers iconic for young Americans: "[Marlon Brando] kicked off a trend in which young people dressed like workingmen as a way of rebelling against the gray-flannel-suit-wearing establishment. It was the first time dressing down was used as a way of rebelling" (243). T-shirts were typically worn by laborers until the Beats helped popularize them as youth fashion; by the 1960s, members of countercultural movements wore tie-dyed T-shirts or T-shirts with slogans, and the first designer T-shirts appeared a decade later. The items of clothing celebrated by the rebellious young icons of the 1950s—jeans, T-shirts, and leather jackets—have since become staples of American fashion.

As with any moment in the history of modern fashion, fashion histori-
ans have debated whether street style grew from emerging countercultures,
or changing fashions helped catalyze countercultural groups—that is, a
common resistance to the restrictions of mainstream dress (for example,
the cost or the discomfort of modish garments) helped forge the commu-
nities that became countercultures. The relationship between the fashion
industry and the cultures that embrace it has always been dialogic, with
designers and journalists taking the pulse of social phenomena, identifying
their markets, and responding in turn.

And yet, street fashion begins not in the fashion industry, but—as the
name suggests—in the streets. The relationship between culture, fashion,
and counterculture is ever evolving: once a countercultural style becomes
mainstream, the counterculture must adapt its style to maintain its iden-
tity of resistance. But once it adapts, the counterculture itself changes. In
Fashion, Culture, and Identity, sociologist Fred Davis suggests that beginning
in the late twentieth century, the fashion industry transformed from the
"fashion system model" outlined by earlier fashion historians like Roland
Barthes to what he terms a "populist model" (201–2). This model, he sug-
gests, features a buying public who has become less concerned with "what
issues from Paris and Milan . . . than, for example what teenagers, feminists,
retirement community senior citizens, surfers and skateboarders, gays, pro-
moters of ethnic consciousness, Third World peoples, etc., are doing with
and to clothing, cosmetics, jewelry, their bodies and public postures" (202).
The populist model as he describes it is alternatively called antifashion,
oppositional dress, subcultural style, and street fashion, with each term
varying slightly in connotation.

While street style has retained its reliance on cultural appropriation for
inspiration, fashion historians have also connected the clothing of coun-
tercultural groups to the concept of antifashion. The term implies style and
clothing choices that exist outside the realm of the fashion establishment.
Such a concept is hard to fathom: as Susan B. Kaiser and Ryan Looysen
have noted, "Remaining outside of fashion actually requires a keen aware-
ness of fashion." The authors suggest an intentionality among wearers of
antifashion—that is, deliberately dressing differently or in opposition to
a mainstream trend, as with the zoot suit, "the Beat and biker looks of the
1950s," or "hippie and feminist styles of the late 1960s." In this respect,
antifashion engages in a direct dialogue with fashion rather than exhibit-
ing "indifference" to fashion (Davis 161). The grunge trend is an excellent

example of this dialogue. During the late 1980s, alternative musicians in Seattle spawned an antifashion look that echoed the ethos of their music—raw and dissonant with themes of alienation and rebellion. Followers of this music scene wore band T-shirts, torn jeans, oversized flannel shirts, knitted sweaters or hats, and combat boots. Within a few years, Wintour edited the "Grunge and Glory" fashion spread directed by *Vogue* creative director Grace Coddington. In this feature, supermodels Naomi Cambell and Kristen McMenamy wear the staples of the grunge look—Doc Martens, flannel, knitwear, and a Nirvana T-shirt. In keeping with the lower-budget spirit of the movement, some items are very low priced for a *Vogue* spread—one model wears a Weltware shirt priced at "about $37" (256). Yet other items stray further from the celebrated thrift-store finds of the original grunge adherents; rather than an oversized knit sweater à la Kurt Cobain, the spread features a "long stretched-out sweater" by Lainey Keogh, priced at $1,400 (262). As with most contemporary fashion, once the trend trickled up, it trickled down, as grunge (both the music and the style) spread well beyond the Seattle scene and into the mainstream. Within the year Kmart was selling back-to-school grunge looks (Blecha 276).

For a counterculture style to gain the kind of momentum that jeans, leather motorcycle jackets, and the grunge look have had within an American mainstream, however, it must have a certain dynamism and cultural capital, or so recent history would suggest. Achieving this dynamism means both adopting a collective visibility as rebels and tapping into a cultural zeitgeist. The first counterculture styles emerged at a moment of vulnerability and angst, and therefore attracted a host of like-minded individuals. Even if these individuals did not want to join a movement or express their discontent through art, the clothing gave them a means of expressing their malaise, their sense of alienation from mainstream values. It became a way to perform an identity that felt more compatible with their disillusionment.

The Beats were arguably the first group to collectively rebel against fashion—to outright reject it rather than merely push its boundaries—and then have their style marketed in a mainstream forum. Beats and other counterculture groups that used clothing to express their difference paved the way for this transformation in the industry, its celebration of cultural expression and affiliation, its shift to a "trickle-up" model. Yet while the Beats gained a legendary status in American popular memory as artists and rebels, their legacy has relied heavily on the cultural materials of marginalized groups—both globally and within the United States—for its content and style, as

well as the labor and support of women writers whose contributions to the Beat legacy have historically been overlooked.

Jack Kerouac and the Early Beat Writers

The Beat Movement began with a series of chance meetings and conversations in the 1940s, when the United States was recovering from World War II and the Cold War had just begun. During this period, three young writers—Jack Kerouac, Allen Ginsberg, and William Burroughs—met at Columbia University in New York. These three writers discovered a common attitude about the postwar United States and its rapidly developing conformist, middle-class credo: such conformity and materialism, the Beats believed, thwarted creative expression and spiritual growth. The writers' circle grew to include an eclectic assemblage of artists, writers, and eccentrics who shared their nonconformist vision.

Kerouac is most often credited with the term "Beat" as a descriptor for his generation of writers and artists (Welters), but several years later, John Clellon Holmes would clarify the term in an article for *The New York Times*: "More than mere weariness, it implies the feeling of having been used, of being raw. It involves a sort of nakedness of mind, and, ultimately, of soul; a feeling of being reduced to the bedrock of consciousness" ("This Is" 10). Holmes's use of words like "raw" and "nakedness" helps explain the dress of the early Beat writers—it characterizes their resistance to the polished dress of the 1950s. The word "naked" encapsulates, simultaneously, the Beats' resistance to the voluminous, covered-up styles of the postwar era and the raw feeling Holmes describes; the word surfaces again and again in Beat writing, perhaps most famously in Ginsberg's poem "Howl": "I saw the best minds of my generation destroyed by madness, starving hysterical naked." Certainly the word conveys the feeling of being beaten down by the modern world, but those familiar with the Beats might also interpret the world more literally—Dean Moriarty answering the door naked in *On the Road,* or even the threadbare, sparse clothing Kerouac's and Burroughs's characters wear.

While "beatnik" may connote hipsters in all black, wearing berets and turtlenecks, "Beat" typically connotes a group of men in worn, casual clothing. In her essay on the Beats' "subcultural style," Linda Welters notes, "For many Americans, the Beat Generation evokes mental images of shabbily dressed men sporting beards, sandals and sunglasses, and women dressed in

black. The contribution of the Beats to twentieth-century fashion is poorly documented and depicted in just a few sentences in a handful of books, none of which agree on what were the components of Beat style" (146). Part of the reason for this sparse documentation of Beat style, perhaps, is that the Beats didn't really have a style. Their dress tended to hinge upon avoiding anything that connoted an investment in mainstream values, as Jennifer Grayer Moore argues in her book on street style: "The original Beat style was truly an antistyle. It was a look born of low wages and indifference toward mainstream sartorial and social standards. Second hand clothes, military surplus, blue jeans, flannel and denim workshirts, sweatshirts, T-shirts, and indigenous dress such as huaraches and other kinds of sandals, peasant blouses, and dirndl skirts composed a style that was not a studied look" (71–72). Despite Moore's claim that the early Beat look was not "studied," other writers imply intentionality in the look—in fact, even the word "antistyle" suggests the Beats selected clothing that allowed them to present themselves as outside of a mainstream aesthetic. As Holmes writes, "In the wildest hipster, . . . there is no desire to shatter the 'square' society in which he lives, only to elude it" ("This Is" 19). The Beats actively pursued life experience and chased their own curiosity. They agreed that "the valueless abyss of modern life is unbearable" (22) and sought out alternatives in their relationships, their art, their spirituality, and their life experiences. Inevitably, this experience and resistance was reflected in their dress.

Despite the Beats' resistance to all things mainstream, their attempt to escape fashion evolved into a recognizable style over time. Hebdige describes the typical Beat as "studiously ragged in jeans and sandals" and suggests he "expressed a magical relation to a poverty which constituted in his imagination a divine essence, a state of grace, a sanctuary" (49). Kerouac, too, acknowledged the Beats' style. A 1958 issue of the *Village Voice* features Kerouac's views on the "two types of beat hipsters": "the Cool: bearded, sitting without moving in cafes, with their unfriendly girls dressed in black, who say nothing; and the Hot: Crazy, talkative, mad shining eyes, running from bar to bar only to be ignored by the cool subterraneans" (Schleifer). While Kerouac glosses only the style of the "Cool" beat hipsters here, in his novel *On the Road* he gives glimpses of the "hot" beat style that he and his friends sported, as well as some of the jazz artists they idolized. Although the narrator, Sal Paradise, tends to describe the jazz artists' clothing as indifferent, the clothing connotes a deliberate countercultural aesthetic, as with the tenor sax player Kerouac describes when he and Dean go out in San

Francisco: "The tenorman wore a tattered suede jacket, a purple shirt, cracked shoes, and zoot pants without press; *he didn't care*" (187, my italics). Here, when Sal claims the tenorman "didn't care," he alludes to the indifference he reads in his overall style—in his attitude as well as in a more literal sense: he doesn't care that his pants aren't ironed, that his clothing is not conventionally stylish. This lack of concern with appropriate dress—combined with a clear concern for conveying indifference through dress—characterizes Sal, Dean, and the other travelers. The characters dress in clothing described as "tattered" (103) or "frayed" (12). Emphasizing the lamentable state of their clothing allows Kerouac to characterize the feeling of spontaneity and risk he associates with his years on the road.

The Beats existed outside the fashion system while also using clothing to rebel against fashion. Their ensembles conveyed their bohemian, countercultural identity. Photographs of Kerouac from the 1940s to the 1960s often depict him in casual, worker's attire—chinos, jeans, T-shirts, wool plaid shirts. Welters affirms that images and descriptions of these artists—aside from those of William Burroughs—"reveal a preference for casual clothes—chinos, jeans, T-shirts, sweatshirts, sweaters and a variety of shirts—foreshadowing the wide acceptance of such attire for most occasions by the late 1960s and 1970s." The Beat writers, like their fictional counterparts in *On the Road,* tended to appear shabby, in threadbare or old clothing. In her book *Minor Characters* (1983), Joyce Johnson (nee Glassman), who dated Kerouac for several years, describes him in their first meeting as "a black-haired man at the counter in a flannel lumberjack shirt slightly the worse for wear" (127). A few years after this meeting, author Diana Trilling would describe her first impression of Allen Ginsberg: "He was middling, tall, slight, dark, sallow; his dress suggested shabby gentility, poor brown tweed gone threadbare and yellow" (216). Other acquaintances of the original Beat writers echo these descriptions, suggesting that the writers either could not afford fashionable clothing, didn't care about fashionable clothing, or deliberately wore clothing that did not conform to contemporary fashion and rules of propriety.

Not all the early Beat writers are described in this manner. While Welters emphasizes the casual nature of Beat style, author Barry Miles suggests they were "quite formal in their dress": "Photographs from a 1959 art opening show Kerouac, Robert Frank, Allen Ginsberg and others with short hair and wearing neckties. Burroughs did not stop wearing a three-piece suit and

hat until the eighties, when he moved to Kansas and his desire to remain anonymous in a crowd made him switch to jeans and a baseball cap" (250). The contrast in style depicted by Miles is explained in *On the Road*. For much of the narrative the characters dress in casual, often tattered clothing. Yet when the characters meet a sudden windfall or need to impress someone (e.g., Remi Bonceur's stepfather, or Dean's prospective employers in Denver), they dress in flashy suits—more like the style of the black jazz artists they admire than mainstream fashion icons. For example, Sal describes Dean's choice of attire when he works as a parking attendant to save for his Denver trip, "in greasy wino pants with a frayed fur-lined jacket and beat shoes that flap," but when leaving to find a job in Denver, he wears "a new suit to go back in; blue with pencil stripes, vest and all—eleven dollars on Third Avenue, with a watch and watch chain" (12). The characters' drastic change in style is integrated into the narrative, heightening the divide between the experience-driven life of Beats on the road or in the jazz clubs and the superficiality of middle-class American life.

Kerouac depicts the resistance to a mainstream style aesthetic in another way as well: through the characters' appropriation of non-Western cultural materials. In Kerouac's and other Beat writers' search for an alternative to the mainstream conventionality of the postwar era, they explored a range of cultural practices they associated with nonwhites—music, religion, philosophy, lifestyle, and dress. In *On the Road*, Kerouac frequently references clothing not to advocate a fashion trend or even to openly engage the concept of fashion but rather to align himself with the marginalized groups he encounters during his travels—whether out of a sense of kinship or, as Joel Dinerstein suggests, because Kerouac "romanticized the community bonds and good times (or 'kicks') he perceived among Mexican immigrants and African-Americans" (240). Sal and his friends wear the clothing of the working class, but they also adopt the clothing of the nonwhite workers they seek to emulate: for example, the flashy suits of the jazz performers, Sal's cotton field pants and Mexican huaraches—"the mark of the New York Bohemian back then" (J. Johnson, *Minor Characters* 22). Kerouac constantly reports on what the people he encounters are wearing, as when he takes "the best ride" with the Minnesota farmers, "the most smiling, cheerful couple of handsome bumpkins you could ever wish to see, both wearing cotton shirts and overalls, nothing else" and observes North Dakota farmers wearing "red baseball caps" (26). By populating his novel with the dress

of the working class, the musicians, and a range of marginalized groups, Kerouac shows how few people really adhere to the respectable middle-class conventions marketed through popular media.

Certainly Sal adopts much of the same dress as the workers he encounters during his journey—the jeans, wool plaid shirts, chinos, and so forth—but he also alludes to the clothing he dons as a means of collapsing differences between himself and the nonwhites he encounters. In these scenes, he fetishizes the practices of the workers. One example of these more problematic instances of appropriation occurs when Sal joins the cotton pickers in southern California: "We bent down and began picking cotton. It was beautiful. Across the field were the tents, and beyond them the brown cottonfields that stretched out of sight to the brown arroyo foothills and then the snow-capped Sierras in the morning air. . . . But I knew nothing about picking cotton. . . . I needed gloves, or more experience. There was an old Negro couple in the field with us. They picked cotton with the same God-blessed patience their grandfathers had practiced in ante-bellum Alabama; they moved right along their rows, bent and blue, and their bag increased" (92–93). Although he acknowledges the difficulty of picking cotton, Sal spends most of the passage marveling at the idyllic landscape, overwhelming the demands of physical labor with the beauty of its setting. Later that day, Sal's reverie suggests he has co-opted the experience of a black laborer in the field, even though Sal has not the dimmest notion of what a life toiling over rows of cotton (particularly in the aforementioned ante-bellum South) would feel like: "Sighing like an old Negro cotton-picker, I reclined on the bed and smoked a cigarette" (93). Sal fetishizes the experience of a black laborer as well as his enslaved ancestors as fulfilling and beautiful: cotton picking, based on his single day of experience, represents honest labor and direct interaction with nature, for Sal meditates on the beauty of his surroundings and the birds singing even as he struggles with the physical demands of the work. Instances like this moment in the novel endow Kerouac's passing mentions of clothing with more symbolic weight. When he mentions his "torn cottonfield pants," the garment becomes a testament to his brief experience picking cotton in the fields, a Whitmanesque moment in which he collapses his experience into what he believes is a cultural and historical legacy.

In a similar manner, Kerouac hints at a kinship between the Beat characters and the black bop artists of the nightclubs they frequent. Kerouac and his fellow Beat writers chased after bop jazz artists with a passion bordering

on worship. It was their fascination with bop and the culture surrounding it that helped engender the famous look so commonly associated with the Beats, though more aptly reminiscent of the beatniks: the beret, glasses and turtleneck. Jazz performers of the 1940s often wore zoot suits and hats with wide brims; in *On the Road* Sal encounters people clad in zoot suits in Ritzy's Bar and at the jazz club on Folsom Street. Bop trumpeter Dizzy Gillespie was famous for his goatee as well as his eyeglasses and beret (Welters); his look would influence followers of the Beat movement during the late 1950s and 1960s. Thus while the Beats lacked a distinct style aside from looking a little worn and casual, they nevertheless propelled distinctive aesthetics that either shaped subcultural styles, catalyzed mainstream fashion trends, or—in most cases—both.

Kerouac and Ginsberg may have been associated with wearing casual, workingman's clothing like khakis and jeans, but when these casual items became more mainstream, the writers were repositioned as cool fashion icons for wearing them, as in a 1993 Gap ad reassuring the public, "Kerouac wore khakis." Ginsberg's black-rimmed glasses have since become a staple of the contemporary hipster look, and the Beats' heyday coincided with the popularization of jeans and T-shirts by film icons like James Dean and Marlon Brando. Decades after the Beats emerged on the literary scene, young rebels and even the fashion industry took their legacy and repackaged it, according to Barry Miles: "in the eighties, another new generation took up [Kerouac's] work and remade him in the image they wanted: their Kerouac was handsome, wore khakis in GAP advertisements, and once again preached personal freedom in an age of conformism" (xviii). The Gap advertisement was just one of many examples. A 1979 *Vogue* piece advertises trendy sunglasses as "reminiscent of Kerouac and coffee houses" ("Eyes Only" 122). More recently, in anticipation of the 2012 film adaptation of Kerouac's novel, *Vogue* featured a fashion spread titled "Lost Highway," in which handsome Cassady portrayer Garrett Hedlund and model Kati Nescher wear rumpled plaids, knits, and cottons and pose in fields and open roads. In one photo, Hedlund poses in khakis, an undershirt, and an open button-down with the caption, "The purpose of the Beats' road trips was purposelessness—just a driving urge to meet each moment as raw, unfiltered experience" (318). Though most of the clothing of the fashion spread (most of the men's fashions aren't priced) costs $500–$4,000—certainly well outside the Beat budget—the captions attempt to encapsulate the original credo of the Beats, and the stylists refrained from collapsing Beat and beatnik style. But as

with the other advertisements, the spread implies a distinct, deliberate Beat aesthetic when the Beats would have resisted such a cohesive style.

The beatniks—hipsters who embraced the philosophy of the Beats within a decade or two of their emergence—had a far more recogniz-able and distinctive style. Miles observes the parallels between the beatnik look and the style of artists in Europe: "It was the Beatniks who extended their rebellion into the streets by adopting the clothes of the European Bohemians: the Breton fisherman's shirt, the beret, paint-splattered jeans, and sandals. Women wore black clothes, baggy sweaters, tight toreador pants or jeans, and their hair long, like Juliette Greco" (Miles 250). The striped-shirt, beret, all-black, and jeans uniforms of the beatniks served a purpose beyond self-expression, for they signaled a life philosophy and affiliation to like-minded individuals, allowing these individuals to form communities and carve out spaces for themselves. Welters explains that as more Beat works were published, making their credo accessible to people across the country, these "disenfranchised youth . . . began to adopt the outward symbols of Beat behavior, including the lingo, a love of jazz music and poetry, and sexual freedom" (150–51). The physical signifiers of non-conformity (as ironically conformist as they became) brought together art-ists, writers, college students, and a host of others eager to embrace the Beat ethos.

The original Beats became disillusioned with the movement, however, as its visible face transformed into that of the Beatnik. In *The Name of the Game* (1965), John Clellon Holmes notes that while bohemians typically resisted anything that reeked of a mainstream middle-class culture, the beatniks were a part of that mainstream culture. Their ethos, he suggested, was more about "shock[ing] the Squares," who in turn needed "to be shocked"; this dialectic "led to rigorous uniformity of language, dress, tastes, attitudes, and values that was almost a mirror image of the very conformity against which they were in revolt" (121). As Holmes suggests, the beatniks were not only visible as a group, but they also became a part of American popular culture and even, ultimately, the fashion industry. One of the most iconic ensembles in American film is Audrey Hepburn's all-black beatnik woman outfit in *Funny Face* (1957). In this scene, Hepburn dances around a bohe-mian café, flanked by men in Breton striped shirts and black turtlenecks (fig. 5). Beatnik men became popular culture icons as well. Writer Steven Womack argues that the character Maynard G. Krebs on *The Many Loves of Dobie Gillis* embodies the ideals and style of the 1950s bohemian, both

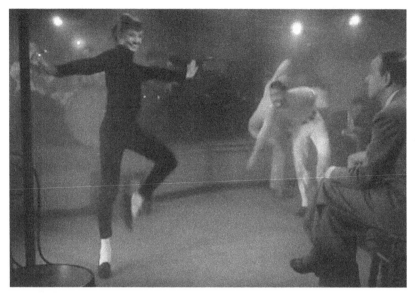

FIGURE 5. Film still from *Funny Face,* starring Audrey Hepburn and directed by Stanley Donen, Paramount Pictures 1957.

in his appearance and the "bop lingo" of his speech (3–4). Kerouac expressed his disdain for these and other adulterated versions of Beat culture, observing in one *New York Herald Tribune* interview, "It's just kind of a fad. It was invented by the press" (qtd. in Theado 25). His friend Joyce Johnson writes, "He saw himself imitated, and hated what he saw. Was that bored indifference his? These new young people with their cultivated inertia, their laconic language (consisting mainly, he observed derisively, of the word like), seemed to have the uniformity of an army" (*Minor Characters* 152). Johnson, like Kerouac, found the uniformity of the beatniks unsettling and oppositional to the Beat values of nonconformity and individual expression. Even more unsettling for Kerouac and Johnson was the reduction of Beat culture to a fetish by the late 1950s: "People wanted the quick thing, language reduced to slogans, ideas flashed like advertisements, never quite sinking in before the next one came along. 'Beat Generation' sold books, sold black turtleneck sweaters and bongos, berets and dark glasses, sold a way of life that seemed like dangerous fun" (187). Just as the suits and tailored fashions of the middle class were marketed as the uniform of a particular lifestyle, now the bohemian dress of the beatniks had become something to be packaged and promoted, a surface identity to be neatly adopted by

mainstream media and thousands of individuals with no knowledge of its countercultural roots.

Although many others, like Kerouac and Holmes, have dismissed the beatniks as derivative in their style and ethos, this group connected several different subcultures in a way that would impact American popular culture for decades to come. Aside from bop jazz and the original Beats, the beatniks also drew from postwar existentialists of the Parisian Left Bank, as Elizabeth Wilson argues in *Adorned in Dreams: Fashion and Modernity*: "The existentialism of the late 1940s was . . . an oppositional movement of ideas clad in a dark and casual uniform of student chic. As a philosophy it was serious, although stamped with the same ambiguity as Romanticism; popularized as a morality—or an immorality—of nihilism and despair" (186). Kerouac's binary of the hot and cool Beat hipster is reflected in this contrast of the eager, manic characters in *On the Road* and the nihilistic roots of the beatnik.

The use of black to represent countercultural ideals has also maintained its cachet, no matter how mainstream the color might be at a given era. While mainstream fashion boasts the classic "little black dress" or employs the familiar phrase "the new black," the color is linked to a number of subcultures: hipsters, bohemians, goths, and punks, for example. Wilson points out that black has been historically linked with mourning; she notes that the nineteenth century emphasis on mourning "may have been because death at any age was no longer taken for granted" (187). The Beats' donning of black implicitly recalls this existentialist mentality. Rather than existing in opposition to a fashion-conscious mainstream culture, she asserts, "Black is the colour of bourgeois sobriety, but subverted, perverted, gone kinky" (189). Wearing black became a way to participate in the middle class without becoming a conformist—that is, while maintaining an awareness of some greater purpose beyond the materialist consumerism that dominated the era.

The color black also connects the women who associated with the original Beats with the generation of beatniks that followed. Women like Elise Cowen, Diane di Prima, Anna Waldman, Joanne Kyger, Joyce Johnson, and Hettie Jones (nee Cohen) were romantically involved with Beat writers and cultivated bohemian identities as they experimented with alternative lifestyles. In her book *Women Writers of the Beat Era*, Mary Paniccia Carden resists the historical marginalization of these artists, noting, "When not ignored completely, women affiliated with Beat circles have been dismissed

as noncontributing hangers-on, as Beat groupies rather than 'real' Beats" (xi). Treating them as such, unfortunately, only reinforces the Beat male writers' marginalization of their work, an impressive array of poetry, literary magazines, novels, memoirs, and other creative contributions of artistic merit. Carden recognizes these women for the way they shaped the counterculture of their time as well: "Beat-associated women found ways to improvise on both traditional gender roles and the male-focused Beat ethos, participating in and pioneering elements of the social experimentation and literary innovation characteristic of Beat cultures" (3). Collectively referred to as women "who wore black,"[1] these Beat women escaped a patriarchal postwar culture only to find another version of that patriarchy in the counterculture they initially found liberating. Nevertheless, these women cultivated a style that publicly proclaimed their bohemian identities during a time when they had very few outlets for creative expression, shaping the counterculture and attempting to mold it into the more nurturing creative community they were seeking.

Women of the Beat Movement:
Johnson, Jones, and Cowen

In the Gap advertisement mentioned above, Kerouac poses alone in front of a building, his body obscuring a sign that a viewer might believe says "GAP." In another image from the same shoot, however, we see that the sign says BAR (from the Kettle and Fish Bar), and another figure has been cropped or faded out of the picture (fig. 6). In this image, Joyce Johnson stands next to and slightly behind Kerouac, fading into the background. This photograph appears on the cover of one edition of her memoir, aptly titled *Minor Characters* (1983).

Like many women of the Beat Movement, Johnson set aside her own writing goals to support her partner, the celebrated Kerouac. Kerouac offers glimpses of the Beats' partners in *On the Road*—Galatea Dunkel, abandoned in the Southwest when her presence becomes too intrusive for the men and their adventures, or Dean's wives Marylou and Camille, at home waiting for him on opposite sides of the country. In *Girls Who Wore Black: Women Writing the Beat Generation*, Ronna C. Johnson and Nancy M. Grace liken the Beat women to the "cool" hipsters Kerouac described in the *Village Voice*: "Women, allowed only a decorative, auxiliary function, are 'cool,' a state of

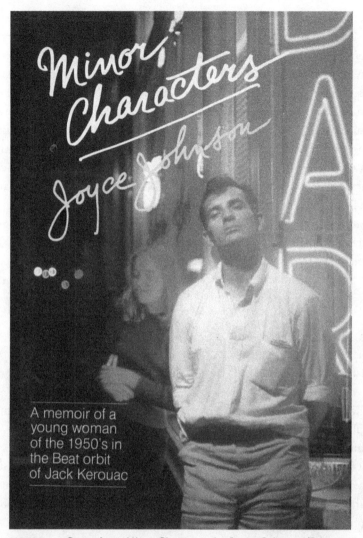

FIGURE 6. Cover from *Minor Characters* by Joyce Johnson (Boston: Houghton Mifflin Harcourt, 1984).

being beaten aside that is overdetermined by gender to preclude literary accomplishment, which requires the 'hard gem-like flame' of the hot hipster (1959, 363) who is explicitly figured as male" (Johnson and Grace 6). Johnson and Grace's reading of women like Hettie Jones and Joyce Johnson is consistent with readings of women in *On the Road*: women in the patriarchal and homogenous postwar culture of the late 1940s and early 1950s were

drawn to the experiential atmosphere of Beat circles, only to find that these circles replicated gender hierarchies of the mainstream.

Nevertheless, the bohemian circles to which these women escaped offered opportunities for growth, creativity, and experimentation that adhering to social conventions would not, and simply dismissing them as oppressed, self-sacrificing women diminishes their personal journeys. Analyzing the writing of Johnson in *Minor Characters,* feminist scholar Gillian Thomson explains that "contrary to the popularised trope of Beat women . . . as silent, ghostly apparitions dressed in black, coffee and cigarette in hand, Johnson suggests that she chooses to remain silent as a means of empowering herself to observe about the occurrences within the movement as opposed to becoming too attached or involved" (3). As Thomson reveals, Johnson spends much of her time observing the men in her memoir, participating occasionally in ways she chooses—as a lover, a breadwinner, a fan—but always feeling a part of the group and always acknowledging her agency. She reiterates what she has given up to become part of the Beat scene and why she willingly gave it up. She relates such choices with a directness absent from many other Beat women accounts for various reasons: for example, Cowen's struggle with mental illness permeates her writing from this period, and her poems feel highly allegorical and image driven; and as the wife of LeRoi Jones, Hettie Jones's experience as a Beat wife is further complicated by issues of racial difference.

Perhaps because they weren't fully accepted as artistic contributors, and perhaps because the romantic partners who initially secured their entry into bohemia were so frequently absent, these women gravitated toward a distinct aesthetic as a means of showcasing their Beat affiliation as well as their choice to reject convention. Their clothing selection feels more cohesive, more deliberate, and more self-conscious than that of the male writers. Early in *Minor Characters* Johnson expresses her desire to become "a Bohemian" and her regret that she does not own "the proper clothes" (31). She stands before The Sorcerer's Apprentice, a store frequented by the new bohemians, and longs to purchase a belt or other accessory that would signify her belonging to that nonconformist group: "Such a belt . . . is a badge, a sign of membership in the ranks of the unconventional. The way is smoothed for the wearer of this belt, or of the dirndl skirt of lumpy handwoven material that usually goes with it, not to mention the sandals crisscrossing up the ankle, or the finishing touch of a piece of freeform jewelry like a Rorschach test figure dangling down to the midriff by a thong." Johnson recognizes the

semiotic potential of bohemian accessories. In fact, she meditates on how important such symbols of unconventionality are when she cannot rely on her own creations to signal her nonconformity. Johnson set aside her writing ambitions during the 1950s to champion the work of the Beat men in her life instead of cultivating her own writing. Constructing a bohemian identity, for Johnson, couldn't hinge on her own art like it could for Kerouac; instead, it initially hinged on associating with the male artists. Clothing became another means of exhibiting her unconventionality, showing that she had veered from the social values with which she had been raised.

It is worth noting that Joyce Johnson, as well as her friends Elise Cowen and Hettie Jones, came from a middle-class Jewish family during a time when Jewish Americans were assimilating into a white middle-class mainstream culture. Responding to the need to bolster the image of a capitalist democracy in the wake of Nazism and the onset of the Cold War, the United States adopted an increasingly universalist ideology—defined by historian David Hollinger as favoring "national and global affiliations" as opposed to "local, regional, religious, and ethno-racial units" (4). Within a universalist society, Hollinger suggests, diversity is not celebrated but presents a problem of national unity (84). While universalism does not exclude based on race or ethnicity, it is not pluralist: instead, it asks those *not* already part of the dominant culture (i.e., nonwhites and white ethnics) to be as much like the dominant culture as possible.[2] Such unity helped promote an inclusive American solidarity that could resist the injunction of foreign influences and created the illusion of social equality, thereby establishing an idealized vision of capitalist society and democracy. As part of Jewish families, Johnson and her friends would have felt even more pressure to conform to a mainstream, middle-class identity than their non-Jewish contemporaries. In this postwar context, they were not permitted to explore or experience their difference as Jewish women.

The older generation of Jewish Americans, represented in this context by Johnson's, Jones's, and Cowen's parents, was eager to erase signifiers of otherness, anything that would prevent their acceptance as Americans during a time when Jews were being persecuted. But the identity they embraced lacked the spiritual and cultural depth that their Jewish heritage once represented. Cowen, Johnson, and Jones may not have longed to hold onto or reclaim their Jewish roots; however, they recognized that consumerism and patriotism did not represent the sense of purpose they needed to carve out meaningful lives. As Jones states in her memoir, "As an outsider Jew I could

have tried for white, aspired to the liberal, intellectual, potentially conserva-
tive Western tradition. But I never was drawn to that history, and with so
little specific to call my own I felt free to choose" (14). The alternative Jones
and her friends encountered, the Beat culture of postwar New York, held far
more promise to them as creative and introspective women than the white-
washed mass culture of mid-century America.

Johnson's tentative and gradual adoption of bohemian clothing and
accessories into her look parallels her gradual immersion in the Beat scene.
She traces her journey allegorically in her 1961 novel *Come and Join the
Dance* through the character of Susan, and more literally in *Minor Charac-
ters:* initially she follows a fairly scripted path, dressing in the current fash-
ion, attending college at Barnard. Yet like many of her friends, she feels
seduced by the growing group of artists and writers communing in one
another's homes to drink, smoke, and share ideas in downtown Manhattan.
She explains in the foreword of *Minor Characters:* "In the late 1950s, young
women . . . left home rather violently. They too came from nice families, and
their parents could never understand why the daughters they had raised
so carefully suddenly chose precarious lives. . . . Experience, adventure—
these were not for young women." The pull toward "experience" and "adven-
ture," Johnson suggests, was a fairly vague one. She acknowledges that the
women understood the danger of leaving their prescribed lives behind, and
that their roles in these bohemian circles would likely be "muses and appre-
ciators" rather than artists.

Even with this knowledge, Johnson expresses admiration not only for
the men in the Beat scene, but also the women, whom she characterizes
as bold and defiant: "I admire the daring of these girls tremendously, their
whole style, in fact—dark clothes and long earrings, the cigarettes they
smoke illicitly, the many cups of coffee they say they require to keep them
going" (*Minor Characters* 26). Johnson collapses the women's defiance—
their willingness to leave a conventional life behind—with their attitude
and their clothing. She sees them as part of a landscape, clad in black cloth-
ing and statement jewelry. As her curiosity grows, Johnson begins wearing
"a pair of long copper earrings" that she carries around and puts in her ears
if she goes downtown (32). These earrings mark her first steps toward join-
ing the bohemian community and, in doing so, taking a more active role in
her identity construction.

Johnson mirrors these flirtations with bohemia in her novel *Come and
Join the Dance,* which she started at the age of twenty-one. The novel has

an immediacy that the memoir, written decades later, does not: the reader can sense Johnson's (at the time, Glassman's) wavering as her protagonist, Susan, prepares to graduate and spend the summer in Paris. Susan questions, "What if you lived your entire life completely without urgency?" (13). She differentiates herself from her boyfriend Jerry and others like him, whom she compares to "tourists . . . half blind perhaps, but doggedly proud of their own identities. They were probably quite comfortable that way— they did not see the world as a magnificent party to which they had not been invited" (31–32). While Johnson knows she does not fit with Jerry or his ilk, neither can she fully commit to the unconventional, unstructured life of her friend Kay (based on Elise Cowen). Kay, she observes, knows her own mind, has tried college and decided she hates it, whereas Susan does not have such self-awareness or deliberation (115). At this moment in Johnson's life, she remains on the precipice, just one class away from college graduation and days away from her trip to Paris, still engaged enough in the respectable life to don shantung sheath dresses and attempt to please her parents.

Johnson's memoir, in contrast, shows a more contemplative Johnson endowed with the wisdom of hindsight. She is no longer straddling the boundary between respectability and Beat rebellion, but rather reinhabits that moment as a turning point in her life. She sees more clearly the reasons behind her reluctance. For much of her memoir, even once she has met Kerouac, Johnson continues to cling to vestiges of her middle-class Jewish upbringing. She situates her curiosity among other women's, deeming it "the psychic hunger of [her] generation" and arguing, "Thousands were waiting for a prophet to liberate them from the cautious middle-class lives they had been reared to inherit" (*Minor Characters* 137). She reins in her desire to join the hordes, for she has been interpellated by the pragmatism of her parents' generation. On a practical level, she must maintain some ties to this world to stay employed as an editor, which allows her to support Kerouac financially.

Johnson uses clothing to convey an inner battle—a battle between the good girl her parents raised and the rebellious lover and artist she longs to become. She mentions the "chignon around a horrible doughnut" she wears as part of her "office identity" (118), a persona she deems necessary to support herself and Kerouac. She even recalls wearing mainstream fashions to some of her Beat friends' parties, as when she attends a New Year's Eve get-together at Lucien Carr's apartment: "I remember what I was wearing that night—a sleeveless black velvet dress with a long satin sash that I'd

recklessly charged to my unpaid account at Lord and Taylor. It was my last attempt at such bourgeois elegance for about the next fifteen years" (125). The black dress she describes, fitted and sleeveless, made of velvet, resonates with the Dior-inspired fashions of the time period.

Even when Johnson immerses herself in bohemian circles and dresses the part, she indicates that her forays make her feel foreign, even uncomfortable. Much like the clothing she begins to wear, the Beat persona does not fit her like a second skin. She tends to use first person when describing herself in conventional clothing and switches to third person—as though seeing herself from a distance—when describing herself in the black clothing of the Beat scene: "I see the girl Joyce Glassman, twenty-two, with her hair hanging down below her shoulders, all in black like Masha in *The Seagull*—black stockings, black skirt, black sweater—but, unlike Masha, she's not in mourning for her life. How could she have been, with her seat at the table in the exact center of the universe, that midnight place where so much is converging, the only place in America that's alive? As a female, she's not quite part of this convergence. . . . Merely being here, she tells herself, is enough" (261–62). Johnson characterizes her Beat persona as a kind of performance; however, she does not mean to suggest it is inauthentic. Instead, she sees it as a necessary exploration to understand herself. She sees herself as a part of something exciting and central to American culture. By donning the costume of the bohemian, Johnson discovers a means of negotiating and eventually constructing her identity rather than slipping into a mold.

Johnson sees parallels between her own struggle and those her close girlfriends within the Beat scene face. Indeed, the women of her circle forge a community we can read as separate from the Beat community: they are tied together by their double marginalization, their sense of not belonging to a mainstream culture and being viewed as subordinate within the Beat scene. Johnson introduces her friend Hettie Jones in a way that highlights her friend's insecurity about her art: "She writes poetry herself, but has never stood up with it at a reading of her own—makes no particular mention of it, in fact—telling herself it isn't good enough ('Some of it was good enough,' she'll admit fiercely, years later)" (*Minor Characters* 212). Instead of publishing or performing her work, Jones supports her husband's career and focuses on raising their biracial daughters and providing a home. At the same time, she cultivates female friendships that would prove essential to her survival after her husband's abandonment.

Jones's relationship with her husband is complicated by both the patriar-chy that infused the Beat scene and their self-consciousness as an interracial couple. In his book *Autobiography of LeRoi Jones,* Amiri Baraka writes about his past relationship as a passing phase, analogous to a fashion trend: "The black man with the white woman, I thought some kind of classic bohemian accoutrement and so this meeting and walking and talking fascinated me" (208). This notion of the white woman as the black bohemian's accessory is reiterated by Hettie Jones in her memoir, *How I Became Hettie Jones* (1990): "He would remain, like any man of any race, exactly as he was, augmented. Whereas I, like few other women at the time, would first lose my past to share his, then, with that eventually lost too, would become the person who speaks to you now" (65). Jones echoes her husband's comparison of her to an accessory: he remains fundamentally unchanged by their relationship, for adding or taking her off his arm changes his status as neither an artist nor a black man. For Hettie Jones, however, the addition of her husband means the loss of her past; the loss of her husband means the loss of her identity as a wife as well as many of the friendships gained by her marriage.

Jones takes on a more studied tone than Johnson in her descriptions of clothing, for she has more at stake in negotiating her identity: she must somehow reconcile her self-perception as artist, white person, Jew, woman, and mother to two mixed-race daughters. Her daughter, Lisa Jones, would acknowledge this reconciliation and reaffirm her mother's bohemian iden-tity in her collection, *Bulletproof Diva* (1994): "Mom's bohemian from way back. The journey she's made as a woman, as an artist, making herself up in America, has been useful to me as a black woman living outside of society's usual paradigms of femininity" (33). Later she refers to her mother as "her own boho Mama-in-the-black-stockings self." This characterization of Het-tie Jones reveals the challenges of acknowledging and honoring the various parts of one's persona. Jones and her daughter underscore the importance of clothing when appearance fails to convey affiliation. The bohemian men's style surfaces as more of an affectation in Hettie Jones's book, as she ref-erences Holmes's feature on the Beats: "To be beat, you needed a B-movie graininess, a saintly disaffection, a wild head of hair and a beard like the poet Tuli Kupferberg, or a look of provocative angst like Jack Micheline. Ted Joans was another beat picture, a black man always dressed in black, from a black beret on down." As she describes the women, however, she indicates the practical purposes for the clothes and accessories: "The women, like me, had all found Goldin Dance Supply on Eighth Street, where dirt-defying,

indestructible tights could be bought—made only for dancers then and only in black—which freed you from fragile nylon stockings and the cold, unreliable, metal clips of a garter belt" (*How I Became* 45–46). The fussy, complicated clothing of the 1950s—with its hidden corsets, its garter belts and costly accessories—is rejected by Jones and her friends, who instead opt for durability and comfort, as well as a color that hides signs of wear.

Acknowledging these pragmatic benefits of her bohemian attire, Jones implies throughout her poetry and prose that clothing, especially the clothing she made herself, offered at least two other benefits: first, it gave her a creative outlet, one that allowed her to express innovation and talent without competing with her husband; and second, it allowed her to explore unconventional dress through construction and styling. Whereas Johnson looks at garments and identifies them as either mainstream fashion or bohemian, Jones recognizes what these nonmainstream categories really encompass—the range of bohemian and non-Western possibilities. In her memoir she notes, "Yet the lovely bravado of anti-clothing! And how simple to cut and fold large pieces, as in kimonos and djellabahs, the easy shapes found outside Western culture. You couldn't buy patterns then for 'unconstructed' women's garments without set-in sleeves to restrict the arm and darts to shape—and reveal—the breast" (84). Jones' reverie about "anti-clothing" encompasses the loose comforts of bohemian style and the emphasis on non-Western cultures. Instead of merely conveying rebellion against the mainstream, then, her clothing underlines her rejection of dominant culture values. After her marriage ends, Jones describes how she feels betrayed by her physical appearance; her skin color proclaims her as part of a mainstream American culture even as her husband's proclaims his otherness: "In a midtown office by himself Roi could only be himself. In a similar situation, without him or the children, I felt misrepresented" (203). Her clothing, then, becomes a contrast to her whiteness, a way of self-othering. In this way, she collapses the identity of the unconventional artist with the identity of one who falls outside of the white, Western dominant culture.

Jones's form of cultural appropriation is complicated. On the one hand, she shows a lack of awareness of her privilege as a white woman, going so far as to express her envy of her husband's otherness and even turning to non-Western dress to express her sense of distance from a white mainstream culture. On the other hand, in researching and designing non-Western dress, Jones does not merely respond to any imagined cultural capital it carries, but she also sees how these styles reflect her physical needs for comfort

and personal expression that mainstream American fashions—with their excessive tailoring and accessories—do not.

Jones reflects this appreciation for non-Western dress in her poetry as well. In her collection *Drive* (1997), which contains some of her older and more recent poetry, she features a poem titled "Dresses: Four of Mine for Naima Belahi." The footnote informs the reader that Belahi is "a dressmaker, persecuted in Algeria for making Western-style clothes" (95). Jones describes, with some intricacy, four dresses she has made, implying through her phrasing that though she sewed these garments for herself, they seem meant for a different woman: "So narrow they seem sewn / for someone fragile, not a woman like me / with a lot on her back." As she looks at one "with butterfly sleeves, bordered wings," she muses, "I must have wanted to fly the night I / broke day over that one, hoped / it would lift me clear of the weight / of my life, the back I bent / over those straight seams." Given how Jones, a Western woman, tended to sew clothing based on non-Western garments and patterns, she creates an interesting symmetry through her choice to dedicate the poem to a non-Western woman who sewed Western clothing. The title implies that Jones identifies with this woman, a dressmaker on the other side of the world—a problematic parallel given the different scales of privilege and persecution. However, it is through this identification that Jones illuminates these imbalances. In his reading of the poem, Barrett Watten explains that Hettie differentiates herself, the speaker, from both Naima Belahi and her younger self: "Hettie . . . is different from the younger woman who made the dresses; just so, there is a difference between the condition of the Western woman poet, who would take dresses for granted, and that of the Algerian woman who would be punished for making them" (116). Both the dresses and the poem serve a similar purpose, Watten suggests; they "are brought together in an instance of form"—that is, both poem and garment are a kind of record. When the speaker looks at these dresses, which do not fit her, she is reluctant to discard them even though they serve no practical use. The connection to her younger self, however, reminds her that during a time when she felt she couldn't write or publish her poems, she turned to this other creative outlet. In contrast, her allusion to Naima Belahi reminds her of the disposability of clothing within her own culture: the mainstream fashion industry churns out mass-produced clothing in keeping with the latest trends.

Each of these connections leads to the speaker's final resolve: "I keep them because I/couldn't see me, myself enlarged/unable to wear them, unable to part with them." She reiterates that she cannot fit into the dresses, and therefore they cannot serve a practical purpose, and yet she suggests the dresses allow her to "see" herself. Her dual comparison—to a younger Hettie and to Naima Belahi—implies that the dresses remind her of her freedom to create, a freedom that in her younger years felt more precious and essential to preserving her identity as an artist.

Jones's prose emphasizes the value she attaches to making her own clothing, for during her marriage to LeRoi Jones, sewing became a creative outlet for her, a means of channeling her creative energy toward something practical. In her memoir, Jones describes how during her pregnancy, she began sewing herself sweaters, establishing a parallel between her sewing and her husband's writing process. At first, the young Hettie contemplates whether she is hiding behind sewing and clothes as a means of avoiding writing, but she concludes that her sewing has its own sense of purpose. Similarly, in the introduction to her collection of correspondence with Helene Dorn, Jones describes their first meeting, which concentrated on a discussion of clothing:

> But here in my house was a tall, beautiful blonde who swooped down, relieved me of my bag of groceries, and with her free hand fingered the fabric of my coat. My outer garment, that is—a poncho I'd pieced together from multi-colored woolen samples.
>
> "Did you *make* that?" she asked.
>
> Her husband, introduced as the poet Edward Dorn, pointed out that Helene—this woman, his wife—had made the finely tailored—lined!—silk jacket he was wearing.
>
> In 1960, few women managed to keep their own skills in sight and so immediately presented the evidence. (*Love, H* 1–2)

Jones and Dorn arrive at the same conclusion in this moment. Once they understand that the other also makes her own clothing, they instantly see the connection between the role of a poet's wife and the art of making clothing. Both women feel stymied in their attempts to create in what was still deemed a man's field, particularly when writing seems like competition with their husbands, and turn to an art recognized as more appropriate for women. And yet Jones suggests that clothing has its own rewards,

creating a sense of kinship between Jones and other women, eradicating the isolation she describes earlier in her marriage. This kinship extends to new women friends like Helene Dorn, to women she has never met (like the Algerian dressmaker), and to strangers she encounters around the city.

These moments reveal how the Beat women, so often excluded from the artistic spotlight usurped by Beat men, shaped the Beat scene and community. What has been characterized by both Beat writers and scholars as a male-dominated movement only becomes so if we ignore the contributions—literary, artistic, social, and philosophical—of the women. As Carden observes, "Beat-associated women found ways to improvise on both traditional gender roles and the male-focused Beat ethos, participating in and pioneering elements of the social experimentation and literary innovation characteristic of Beat cultures" (3). Beat women may have appeared to accept secondary roles to their male friends and partners, but in fact they were shaping the movement, creating their own literary contributions, forging powerful friendships, challenging mainstream social norms and carving out new roles for themselves as women and creators, and building a bohemian community.

Jones illuminates the sense of kinship she feels with other women who feel thwarted in their self-expression as well as by more pragmatic concerns—the need to keep their families together, the need to care for their children, the need to make extra money when their husbands are out of work or have disappeared. In her poem "Having Been Her," from *Drive*, she writes of a woman she sees while returning to New York. The poem begins, "On the bus / from Newark to New York / the baby pukes / into the fox collar / of her only coat." The image conveys a fleeting connection between women in a crowded public space, the identification the speaker feels with a stranger as she projects her own past narrative onto the image. She sees a woman struggling to make ends meet (she assumes the fox-trimmed garment is "her only coat") while saddled with the responsibilities of childrearing—she cleans the baby as she "takes her toddler / by the hand." The poem ends with the speaker's resolve to maintain a sense of kinship with this woman and others like her: "Let me always / support her / Having been her / befriend her" (74).

The poem recalls a moment in *How I Became Hettie Jones,* in which Jones finds herself in a sudden rainfall, clutching a cart of laundry and a baby carriage. An older woman immediately steps in to help her: "She's wearing an old blue coat with military buttons, and above her beautiful Irish

face her white hair is a thick ropy pile. She's dismissing my thanks, too, because there's something bitter on her mind. 'The men, they don't know about this,' she says. 'They don't know and they don't care to know, them with their lives, their damned *lives*'" (146). In both the poem and the recollection of the past (in which the older woman takes the speaker's role in the poem, and Hettie is the woman being observed), Hettie focuses on the coat. Each coat is described as worn and yet having some fashionable element (the fox fur collar on the young woman's, or the "military buttons" on the old woman's). The worn appearance of these coats connotes the Beat life, for it mirrors their ragged and frayed clothing, as well as the different kind of "beat" experienced by the women of this movement: women responsible for holding everything together, raising children, earning extra income, all in the name of supporting the men's lifestyles and creativity. The fashionable details of these clothes speak to a creative spirit that surfaces in the subtlest of ways yet shines through the wear and tear.

The personal meaning Jones attaches to bohemian dress may explain why she, too, laments the eventual trendiness of beatnik style. Later in her memoir, she passes by a shop window and sees a "predecessor to Barbie" wearing black stockings. She muses, "It felt odd to have so prompted the culture, to have many other women want to seem to *be* you, whatever they thought you were. I turned to Helene and shrugged. Both of us were wearing black stockings, of course, but so was an old woman coming from mass" (130–31). Through this brief exchange, Jones records the way that antifashion becomes fashion: in looking for alternatives to mainstream dress, women still had to use patterns and inspirations and often purchase the accessories from stores (even if those stores were thrift shops, dance supply shops, or bohemian boutiques). Once they became trends among one group, they became a part of the fashion system, eventually packaged, marketed, and sold to consumers looking for the latest in youthful street fashion.

In becoming mainstream, the clothing loses its initial meaning, the symbolism it once held for the women who abandoned their parent-sanctioned, scripted lives to embrace lives of experimentation and art. For Hettie Jones, the clothing had a distinct aesthetic appeal, but it also provided a creative outlet when she felt stymied in her writing career and needed another venue for self-expression. For Joyce Johnson, the clothing allowed her to inhabit a different persona, to perform a new identity in order to discover her own.

Elise Cowen, a friend of both Johnson and Jones, never really cultivated the bohemian look, even as she engaged it in her poems. Cowen's look, like

that of the early Beat men, seemed incongruous, a departure not only from mainstream fashion but also from the all-black artsy style of her peers. Joyce Johnson met Cowen during her time at Barnard, and she immediately identified her as someone who strayed from the conformist culture of the postwar era, a kindred spirit: "She was even wearing one of those telltale belts from the Sorcerer's Apprentice—the spiral kind—into which she'd tucked a drab and unbecoming skirt and a demure white blouse with a Peter Pan collar, the kind your mother might make you wear in seventh grade. . . . Behind her black-rimmed glasses, eyes looked out at you sorrowfully and fiercely" (51). Cowen blends more conventional dress with bohemian accessories (her belt and glasses), but unlike Johnson, she does not achieve a harmonious look, nor does she seem to have a full understanding of each item's semiotic potential. Her look seems more haphazard than Johnson's, even more so with the short, boyish haircut she would adopt a few years later. Thomson suggests that Johnson's movements between the mainstream and bohemian worlds are possible because of her "chameleon-like qualities" (5), her ability to adopt the signifiers of either world and therefore to blend in. Cowen, in contrast, commits herself to the performance of an unconventional, antifashion identity.

In many of her poems, Cowen uses clothes to illuminate her sense of alienation, her feeling of being an outsider even within her Beat community. If anyone among Johnson's circle of friends epitomized the nonconformist woman, it was Cowen, who openly dated women (after brief affairs with one of her professors and with Allen Ginsberg), wrote yet did not publish poetry, and embraced antifashion—more so than Johnson, Jones, or other Beat women like di Prima or Waldman. She conformed neither to mainstream constructs of style and beauty nor to an emerging bohemian aesthetic. Rather than embracing any cohesive style, Johnson suggests, Cowen seemed to find her clothing an inconvenience: "Elise cuts off her hair a few months later and becomes the lover of this daring girl, Sheila. She walks rashly into a Puerto Rican barbershop and asks for 'a Joan of Arc haircut, por favor.' She wears stiff, ill-fitting Levi's with those girlish blouses her mother bought her in high school; carries a large deathly black handbag like the ones old ladies have" (91–92). Though the haircut may have held some symbolic meaning for Cowen—implied by her association of short hair with Joan of Arc—the rest of her clothing is a mishmash of pieces one might associate with a child, an old woman, and a man, as though Cowen viewed herself as an assemblage of fragments. Despite the seeming dissonance

of her clothing, therefore, Cowen's odd style reveals a kind of personal style, something that reflects the different parts of her persona—even if she chose her garments and haircut without putting much thought into them.

The fragmented style and theme surfaces in many of Cowen's poems, collected in a volume titled *Elise Cowen: Poems and Fragments,* edited by Tony Trigilio. In the Frankenstein-esque "I took the skins of corpses," the speaker stitches together pieces of corpses—representing the poetic masters of the past—to make herself clothes, an act that represents finding her own poetic style. Each time she assembles something from the corpses, she discovers she has failed in some way:

> I took the skins of corpses
> And dyed them blue for dreams
> Oh, I can wear these everywhere
> I sat home in my jeans.

The speaker in this poem finds confidence in piecing something new together from something dead. She initially feels hopeful and renewed with each creation, but then the creation fails to live up to its promise.

Through different parts of the corpses (the hair, ears, eyes, genitals, heads, thoughts), the narrator attempts to add to her own person, whether by giving herself a new ability (e.g., she takes the eyes so that she can "face the sun") or a new garment (a wreath, a hood, a union suit). In this way, Cowen conflates the natural abilities of the body with the protection and signifying potential of the garments she might wear. None of these things, however, serves its purpose. Over the course of the poem, Cowen as speaker comes to realize she cannot create something new and beautiful from the fragments she gleans from the dead. In this poem, therefore, through the language of clothing, two central facets of Cowen's poetry emerge: her firm belief that she was a mediocre poet,[3] and her appreciation for the literary canon. As the poem progresses, Cowen reveals that she cannot learn from the ghosts of the past—the writers who inspire her—and decides that when she dies, her body (of writing) will not serve those who knew and loved her, but "the student doctor's knife"—that is, it will be dissected by critics.

As noted by the editor of her posthumous collection, Tony Trigilio, this poem makes allusions to Mary Wollstonecraft Shelley's *Frankenstein;* here, Cowen sees herself as a failed Frankenstein. This theme of failure and self-consciousness emerges in other Cowen poems as she references some of her literary influences. Trigilio notes in particular how several of her poems

allude to or mimic the style of Emily Dickinson (133), including "The Body Is a Humble Thing":

> The body is a humble thing
> Made of death & water
> The fashion is to dress it plain
> And use the mind for border (25)

Cowen once again uses clothing as a metaphor for something more abstract: poetry in the previous poem, the relationship between body and mind in this one. She does not offer commentary on contemporary clothing as we see in the writing of Johnson and Jones, but nevertheless she returns to fashion again and again as a means of rendering the abstract in concrete terms. In these lines she suggests that the mind enhances the body (which is plain without it), and yet she implies that it serves as mere decoration rather than some loftier purpose. In comparing the mind to the trimmings on a garment, Cowen echoes the gender-based self-consciousness of other women writers of the period, like Johnson and Jones.

In "Emily," Cowen begins by directly addressing Dickinson as though speaking to a lover:

> Emily,
> Come summer
> You'll take off your
> jeweled bees
> Which sting me
> I'll strip my stinking
> jeans

As with "I took the skins of corpses," Cowen uses clothing to allegorize her writing of poetry. While "jeweled bees" may not conjure up the image of a specific garment, it does present a concrete image and directly alludes to Dickinson's poem "Bees are black, with gilt surcingles." The image feels shining and precious, and Cowen is "stung" by its power. In contrast, she equates her own poetry to "stinking jeans"—an image that connotes the clothes of the Beats but also sounds worn at best and repulsive at worst. The contrast conveys Cowen's self-doubt about her abilities as a writer, particularly when contrasted with those she admired. And yet the poem has a positive thrust: she suggests both of them put their poetry aside: "Hand in hand / We'll run outside / Look straight at the sun / A second time / And get

tan" (26). The first lines imply a merging with her poetic model; it is hope-
ful in tone. Cowen suggests through shedding the things that hamper her
and connecting with her poetic model, she can write something purer and
thrive as a poet. The clothing in this poem is the poetry of the past, the
relic of a different time that shined under Dickinson's poetry but feels worn
and rotten under Cowen's. Shedding the clothing is shedding the past, look-
ing directly at the source of poetic inspiration, forging ahead creatively and
personally.

Although Cowen, like her contemporaries, appears to understand how
clothing can be a vehicle for self-expression within her poetry, she fails to
find the personal meaning that Jones and Johnson discover in bohemian
dress. Johnson imbues her long earrings with an almost magical power, and
Jones sees in her non-Western-inspired creations the artist's identity that
she could not express through writing. Cowen, however, sees the donning
of these surface signifiers as false promise, as pieces that cannot touch or
change the person within. Through Johnson's narrative, Cowen appears
restless, never able to negotiate her identity as it relates to her writing or
a community. The bohemian community that initially lured her away from
the life her parents wanted for her fails to deliver the freedom and sense of
empowerment it promised. Her dress, however, reveals Cowen as the ulti-
mate nonconformist among the group—her style the "assemblage of frag-
ments" that best expresses the confusing intersection of woman, lesbian,
artist, intellectual, and recluse. In her dissonant blend of bohemian-style
belt with Joan-of-Arc haircut and Peter Pan–collared shirt and black-
rimmed glasses, Cowen wasn't stylish, but she had a clear personal style.
Although she may not have found her place within a community, her poetry
and dress reveal an understanding, if not a complete acceptance, of herself.

By exhibiting their resistance to mainstream values through their clothing,
Beats exposed young Americans—as well as the fashion industry—to the
liberating potential of countercultural style. Yet in a way, street fashion and
antifashion, as expressed by the early Beats, serve the interests of a consum-
erist, trend-based, and trickle-up American fashion industry. The choice of
clothing among the Beats is not just a hallmark of their rebellion but some-
thing that marks them as different and, arguably, part of what made them
recognizable icons of what Joel Dinerstein terms "cool." Dinerstein explains
that while definitions of what it means to be cool fluctuate from generation

to generation, they share a single idea: "*You don't own me. You're never gonna own me.* Cool is an honorific bestowed on radical, rogue, free agents who walk the line of the law—that is to say, mavericks with a signature style" (236). Dinerstein's analysis of cool helps explain the symbiotic relationship between identifiable countercultural groups like the Beats, the clothing they wear, and the mainstream fashion industry as it has evolved since the late 1950s. Once a counterculture gains enough of a following, it develops an identifiable style. The fashion industry, which profits by setting trends, markets that style, establishing it as cool and associating it with that group rather than with the usual monuments of mainstream fashion—for example, an article in a fashion magazine will describe something emerging from a music scene or underground movement instead of the couture runways of Paris. If the group disassociates itself from that style, perhaps moving on to another, that shift also serves the interests of the fashion system, which will move to a different trend quickly to continue generating profits.

The Beats have thus had three distinct impacts on the fashion industry, impacts that contributed to the pluralistic, trickle-up fashion system that has prevailed since the 1960s. First, they revealed how fashion that derives from nonmainstream sources—that is, fashion that comes from the streets or various countercultural movements—can be liberating for the individual and become an effective, if merely symbolic, means of community building. Nowhere is this more apparent than in the community of Beat women, who learned to take what was, at the time, a symbol of their gender oppression and reinterpret it to express themselves in a creative way, to openly declare their rebellion as well as their artistry. The Beat women's style—the black tights, bold accessories, and non-Western patterns—became a vehicle for performance and experimentation. Although they may have been marginalized by the male-dominated Beat circles, their writing and art often dismissed or repressed, clothing became a way to try on a new identity, to advertise one's rejection of mainstream culture, and to explore alternatives to that culture. The fashion industry has certainly capitalized on each of these qualities, showing how simply donning a garment can signal one's affiliation to a group.

Second, the popularity of the Beats' writing established nonconformity and rebellion as "cool," signaling to fashion designers and journalists that they should look to the streets, to what the young people are wearing, to inspire higher-end fashions. Even some of the more conservative fashion houses began to feature street-style designs targeting a younger

generation. Two years after Yves Saint Laurent took over the House of Dior, the countercultural Summer of Love would inspire a host of new trends in *Vogue:* "pattern-mixed gypsy costumes; ethnic garments from Africa and Asia; bell-bottom jeans and fringed leather vests; monochromatic military surplus; thrift-shop castoffs; tie-dyed anything; flower-printed everything" (Hill 100, 102). This trend, while very different from Beat and beatnik style, nevertheless shows some parallels in its appropriation of non-Western cultural motifs, its association with counterculture identity, and its incorporation of pre-owned, recycled pieces purchased from thrift stores. The Beats' introduction of a style borne from resistance changed the course of American fashion, and arguably the fashion industry as a whole.

A third impact the Beats had on fashion was the introduction of non-Western and nonwhite styles into the mainstream spotlight—in some cases, in superficial and essentialist ways, and in others with more cultural sensitivity and awareness. Certainly, the fashion industry had engaged in this kind of cultural appropriation in the past: for example, the incorporation of Turkish and Persian motifs in 1920s couture designs (Hill 36), or the African influence on mid-1920s Art Deco designs (45). The Beats' incorporation of nonwhite and non-Western styles, however, was a little more complicated and varied. While Beat men and women who wore non-Western dress still engaged in cultural appropriation, the community also became a channel between obscurity and public exposure for the art, music, writing, and design of underrepresented cultures. Black artists and writers were a part of Beat creative circles. The most prominent among the Beats regularly patronized jazz clubs and wrote about the music and the musicians. The relationship between the whites who appropriated signifiers of non-Western cultures and the members of those cultures was still uneven, hierarchical. But the results and emerging relationships were different. When in the past, fashion designers had appropriated non-Western motifs, they had done so to reinforce a white/nonwhite hierarchy by creating an implicit contrast between modern and primitive, thereby underscoring the "civilised ways" of the wearer (Craik 36). And certainly, however unwittingly, Kerouac's wistful longing to be "a Negro . . . a Denver Mexican, or even a poor overworked Jap" (180) reinforces his privilege and fetishizes the oppression of nonwhite groups.[4] The Beat women who turned to non-Western dress, however, did so without this same attempt to romanticize the experience of oppression. Hettie Jones argues for the relative comfort and practicality of the non-Western patterns she uses to make her clothing (84); she and other Beat

women looked for alternate codes of dress when both the culture and the fashions of mainstream America felt stifling. Contemporary African designers and writers like Chimamanda Ngozi Adichie have made similar observations about the difference between African and Western fashion design, as I discuss in the next chapter. Jones also seems more attuned to her own relative privilege; in her poem "Dresses: Four of Mine for Naima Belahi," she pays homage to the Algerian designer even as she contemplates their vastly different lives and experiences of dressmaking.

While the Beat movement championed black artists, writers, and musicians, as well as a nonwhite, non-Western aesthetic, the emerging Black Nationalist movements of the 1960s would establish a distinct Afrocentric style, one that would have a lasting impact on the American fashion industry and challenge dominant culture standards of beauty. This movement, too, was heavily influenced by experimentation and popular music. Craik notes, "With the growth of popular music as the focus of youth culture, came recognition by white youth of the richness of black culture. Stylistic elements began to percolate through white fashion and culture" (40). This decade, she notes, saw the emergence of black style icons who fused dramatic fashion aesthetics with other affiliations, including music and politics. This shift would accelerate the American fashion industry's departure from traditional fashion paradigms. If the Beats helped steer fashion into less conventional, more experimental channels, the Afrocentric trend would ensure that the image of black resistance would reside permanently in the American popular imagination, forever impacting popular culture in all of its realms, including literature, print media, television, film, music, and fashion.

3

Afrocentric Fashion in the Writing of Walker, Morrison, and Senna

A dress down to the ground, in this hot weather. A dress so loud it hurts my eyes. There are yellows and oranges enough to throw back the light of the sun. I feel my whole face warming from the heat waves it throws out. Earrings gold, too, and hanging down to her shoulders. Bracelets dangling and making noises when she moves her arm up to shake the folds of the dress out of her armpits. The dress is loose and flows, and as she walks closer, I like it. I hear Maggie go "Uhnnnh" again. It is her sister's hair. It stands straight up like the wool on a sheep. It is black as night and around the edges are two long pigtails that rope about like small lizards disappearing behind her ears.

—Alice Walker, "Everyday Use"

IN THE ABOVE PASSAGE from Alice Walker's short story "Everyday Use" (1973), the narrator describes her estranged daughter's striking ensemble in a way that conveys awe and pain. While her description captures the brilliant color, the brightness, the shining accessories, the voluminous fabrics,

and the drama of her hairstyle, it also betrays the pain she feels during this initial encounter. She conveys this pain in a physical way—the dress projects "heat waves"; the clanging jewelry is noisy—and yet the jarring sensations mask a more buried emotional pain.

Through this encounter between mother and daughter, Walker captures the Black Arts Movement (BAM), also called the Black Aesthetic Movement, as it impacted black women and, later, mainstream fashion. This movement emerged as part of a nationalist paradigm that challenged white, Western normativity in culture, politics, and standards of beauty. As Hoyt W. Fuller describes in his seminal 1968 essay "Towards a Black Aesthetic," "Across this country, young black men and women have been infected with a fever of affirmation. They are saying, 'We are black and beautiful,' and the ghetto is reacting with a liberating shock of realization. . . . They are rediscovering their heritage and their history, seeing it with newly focused eyes, struck with the wonder of that strength which has enabled them to endure and, in spirit, to defeat the power of prolonged and calculated oppression" (8). A part of this affirmation, Fuller clarifies, was the "growing number of black people who are snapping off the shackles of imitation and are wearing their skin, their hair, and their features 'natural' and with pride." The signs of resistance to a mainstream aesthetic surfaced first in Afrocentric fashion (African or African-inspired clothing and styling) and in new techniques among visual artists, but as these styles became more popular, their initial meaning changed. Within the white dominant culture, the black aesthetic was co-opted as a trend, one that reified racial difference and echoed the primitivism of the Art Deco movement. And among African Americans, symbols of what was configured as "authentic" blackness by proponents of BAM became a means of signifying solidarity and promoting activism. Such signification helped build collective identity but often interfered with personal identity construction.

Feminists Audre Lorde and Patricia Hill Collins have argued for a form of community building among black women that does not interfere with the negotiation of personal identity or, as Walker represents it, a connection to family and ancestry. Instead, according to these writers, black women must negotiate both personal and collective identity, and thus any collective identity that restrains personal expression only replicates the oppression of the dominant culture. Lorde cautions against such oppression in her 1982 address "Learning from the 60s." While she acknowledges the value of forging an empowering collective black consciousness, she asserts that

redefining difference as empowering resulted in a monolithic definition of difference. She explains, "A small and vocal part of the Black community lost sight of the fact that unity does not mean unanimity—Black people are not some standardly digestible quantity. . . . Unity implies the coming together of elements which are, to begin with, varied and diverse in their particular natures" (136). Here, Lorde directly addresses—and refutes—the construction of an authentic version of blackness that emerged during this period, an essentialist notion connoting both physical and behavioral elements: vocal activism, natural hair (in the 1960s, usually Afros or "naturals"), Afrocentric clothing, African American argot, a pronounced masculinity for men and earth mother persona for women. Instead of creating such strict physical or ideological criteria for belonging, Lorde suggests, black community identity should have fluidity, allowing for variations in experience while maintaining a connection to history.

In a similar vein, in *Black Feminist Thought* (1990), Patricia Hill Collins discusses the need for self-definition among black women. This term connotes identity as a dialogic process, "the journey from victimization to a free mind" (112) rather than a finishing point or achievement. "Self-definition" conveys the process of constructing identity outside of the "controlling images developed for middle-class White women" (101)—the Mammy figure, for example—and instead cultivating "individual and collective voices" within safe spaces. Such spaces, Collins suggests, can be literal places of community (e.g., a church) or symbolic spaces (the mother/daughter relationship, blues music). Safe spaces also surface in the form of cultural traditions that allow for personal expression. However, Lorde's assessment of 1960s coalition building shows how the black community can create new, equally problematic controlling images that can penetrate these safe spaces. If only a monolithic definition of positive blackness is accepted and promoted, then all who fail to fit that limiting construction of authentic blackness will struggle with both self-definition and self-valuation. They will struggle to achieve what Barbara Christian has termed a "totality of self," a holistic identity, a fusion of personal, familial/ancestral, historical, and communal.

The authors I discuss in this chapter question black women's fashion and style as a potential tool for self-definition and thus an example of a symbolic safe space. They question whether styles associated with Black Arts—and Afrocentric fashion in particular—can be a vehicle for participating in an emerging collective activism, for constructing personal identity, and

for connecting to an ancestral legacy. These constructions of black fashion and style emerge within the context of the Black Arts and Black Nationalist movements, and therefore the codes of dress are repeatedly positioned in relation to the construction of blackness posited by these movements. Both Walker and Danzy Senna explore whether Afrocentric and other modes of black women's fashion (e.g., b-girl style) can be a safe space. Walker's story, I argue, cautions against adopting the aesthetic signifiers of black solidarity (African clothing and jewelry, Afro hairstyles, etc.) without understanding the meaning of these symbols and, more importantly, without reconciling what they represent with the values of previous generations of African American women. In *Caucasia* (1998), Senna characterizes black women's fashion as a safe space and site of bonding for women of color, yet acknowledges its limitations and even its potential to disrupt relationships among women (for example, a mixed-race daughter and her white mother). In contrast, Toni Morrison's *Tar Baby* negates the positioning of black women's fashion as a safe space. Instead, her narrative implies that black fashion and style have produced their own controlling images.

Ultimately, I show that in each of these narratives, fashion is most empowering when perceived as a means of performance. Like self-definition, performance is a process, a vehicle rather than a goal. In donning different fashion trends, the women in these narratives explore different facets of their identity; they inhabit, symbolically, different expressions of the black experience. Such performances are essential in the negotiations among personal expression, familial ties, and collective identity.

Despite their challenges to the black aesthetic as a space for self-definition, Walker, Senna, and Morrison acknowledge the need for its development as well as how black fashion and style have subverted a mainstream aesthetic. While even today, white, Western standards of beauty continue to dominate the fashion industry, BAM made an indelible impact on fashion journalism and other visual media, delegitimizing Eurocentric normativity and creating a space for nonwhite models, nonwhite designers, and other nonwhite pioneers in the fields of visual arts and design.

The first issue of *Essence,* published in May 1970, illustrates a few ways that an emerging black aesthetic challenged Western normativity. The cover boasts a series of headlines on the left side—"Sensual Black Man, Do You Love Me?," "Dynamic Afros," "Revolt: From Rosa to Kathleen," and "Careers: Data Processing"—establishing the magazine's early focus on black women's lives and style. The main feature of the cover, however, is

model Barbara Cheeseborough, her face half illuminated by a soft reddish light, her hair styled in an Afro, her full, glossed lips closed, not smiling. When she launched her career in the 1960s, Cheeseborough quickly became known for her Afrocentric look, and like many of her contemporaries, she challenged standards of beauty that had dominated American culture for centuries. Cheeseborough wasn't alone in making this look iconic. Other models, popular singers, and activists embraced natural hairstyles, including the Afro.

By challenging such standards, public figures like Cheeseborough and activist Angela Davis would contribute to an emerging "soul style," which "comprises African American and African-inspired hairstyles and modes of dress such as Afros, cornrows, denim overalls, platform shoes, beaded jewelry, and dashikis and other garments with African prints that became massively popular in the 1970s when 'Black is Beautiful' was a rallying cry across the African diaspora" (Ford, *Liberated Threads* 4). Tanisha C. Ford uses the term "soul style" to characterize a black aesthetic originating during the Civil Rights period but reaching a global diasporic community during the 1960s. She uses this term because in various spiritual contexts, "the soul is regarded as the mind, will, and emotions of a woman or a man. Many people of African descent on both sides of the Atlantic believed that the deep well of one's innermost thoughts and feelings could be imparted to food, clothing, and music, which would then evoke an emotional response from those who ate the food, dressed in the clothes, and listened to the music" (5). Afrocentric style was one aspect of this "soul style." In adopting prints, textiles, hairstyles, and other elements of various African cultures, African Americans connected these aesthetic elements with the nationalist, anticolonial rebellions in various African nations during the 1950s and 1960s. As the Afrocentric look became popular among a global black diasporic community, it impacted a Western mainstream fashion industry, which was rapidly globalizing.

Proponents of the Afrocentric style of the 1960s and 1970s attempted to diverge from a mainstream industry that not only appropriated garments and styles from marginalized cultures but also reinforced a Western hegemony over these cultures through that appropriation. They expressed this new aesthetic through non-Western dress, dramatic jewelry inspired by African styles, and natural hairstyles (styles that celebrated the natural texture of their hair). In his book *Welcome to the Jungle*, Kobena Mercer describes the significance of hair alone in rejecting the artificiality and conformity of

Western styles: "The historical importance of Afro and Dreadlock hairstyles cannot be underestimated as marking a liberating rupture, or 'epistemological break,' with the dominance of white-bias. . . . [I]n their historical contexts, they *counter*politicized the signifier of ethnic and racial devalorization, redefining blackness as a desirable attribute" (104). Mercer goes on to question whether these hairstyles were really so paradigmatic in that they were rapidly appropriated by a Western dominant culture: "within a relatively short period both styles became rapidly *de*politicized and, with varying degrees of resistance, both were incorporated into mainstream fashions within the dominant culture" (104–5). Mercer, as well as Paul Gilroy and other race studies scholars, weighs the empowerment associated with these non-Western aesthetics against the eventual appropriation and commodification of these styles.[1]

In the introduction, I discuss the term "cultural appropriation" and its relevance to American popular culture writ large as well as the fashion industry specifically. Since the early twentieth century, the fashion industry has turned to non-Western cultures for inspiration as designers pioneered new trends, and marketers and fashion journalists packaged exotic fashions with fantasy vacations and home decor. Today, journalists and organizations expose some of the most extreme examples of cultural appropriation, particularly when Western fashion designers misrepresent a sacred object or motif—the Indian bindi, for example, or the warbonnets worn by white women at Coachella (discussed in chapter 4).

Such examples of appropriation are necessarily complicated by the position of the appropriator. In *Dangerous Crossroads* (1994), American studies scholar George Lipsitz uses the term "strategic anti-essentialism"[2] to characterize a different type of appropriation: A marginalized individual or group can't express some aspect of their identity directly, so they express it through a disguise. Lipsitz specifically cites the example of indigenous groups in New Zealand who "started to adopt African-American styles and slang in the late 1980s" (63) because they recognized black cultural codes as simultaneously embodying their strength and their outsider status. This concept offers a way of distinguishing between, on the one hand, African Americans who adopt an Afrocentric look because it offers a template for forging a nonwhite, non-Western aesthetic and, on the other hand, a hegemonic white culture adopting an Afrocentric look as yet another trend in a rapidly evolving fashion industry. While black Americans in the 1960s had limited knowledge about Africa and its various regional cultures, they may

have identified with Africa on other levels: not only because of any ancestry claims, but also because of their identification with other cultures marginalized by Western imperialism. The movement also coincided with the decolonization efforts of African nations, as they worked to cultivate a sense of nationhood and assert their independence from European colonial regimes. African-inspired clothing and style, therefore, held a deep significance for black Americans still struggling to gain equality in the United States.

For white Americans and Europeans, the cultural capital of Afrocentric style was more superficial. White Western culture has historically adopted African motifs, textiles, and other cultural symbols to characterize a look as "exotic." Jennifer Craik explains two different connotations for "exoticism" within the context of fashion, as well as the function such exoticism can serve: "It can refer either to the enticing, fetishised quality of a fashion style, or to foreign or rare motifs in fashion. The incorporation of exotic motifs in fashion (across all cultures) is an effective way of creating a 'frisson' (a thrill or quiver) within social conventions of etiquette" (17). Craik's analysis helps clarify how Western culture has historically appropriated non-Western motifs to enhance its own capital. These trends have often coincided with Western imperialist conquests. For example, shortly after the Spanish American War in 1898, women in the United States and Europe began wearing heels inspired by Cuban shoes (Hill 179). These new styles appealed to consumers because they represented a new trend and symbolic exposure to a different, perhaps more exotic culture, but they also reinforced the West's hegemony over this region during the war. Similarly, during the Edwardian era of fashion, the industry promoted hats inspired by Congo natives, merry widow hats derived from Javanese plantation workers, and turbans appropriated from Japanese peasants (168). Nineteenth-century colonial expeditions into central and western Africa would fuel the Art Deco style of the early twentieth century, a style that flourished in fashion and home decor during the 1920s (Archer-Straw 16), later influencing the colors and prints of textiles (Hill 45). These forays into the garments and accessories of other cultures are often defended by the wearers as "honoring" the culture; however, these fashions coincided with and thus helped legitimize a conquering, imperialist West attempting to control non-Western groups while co-opting and decontextualizing symbols of their culture.

After World War II, white America exhibited a heightened fascination with African art and culture—one consequence, perhaps, of the nation's heightened involvement in international affairs and colonial exploits. Since

the 1940s, black folk art had gained increased popularity in the U.S., and though this art was not configured as part of an American art historical canon, it generated enough interest to secure fellowships and other forms of funding for international expeditions to Jamaica, Cuba, Haiti, and, later, Africa (Powell 96).[3]

Both the art world and the fashion world reflected this fascination with black diasporic culture. During the 1950s, *Vogue* began issuing lengthy features about Africa. Some fashion shoots continued to spotlight the colors and landscape while only featuring white, blond-haired models, as in a spread titled "Pucci's Africa: The Pure Wonder" in January 1965 ("Fashion: Pucci's Africa"). Other features included gorgeous photographic essays with color plates of African women in traditional clothing—for example, "Colour from Africa" in July 1951 ("Features/Articles/People") or "The Quest for Beauty in Dahomey" in December 1967 (Maquet). Advertisements in the 1950s promoted African safaris as family vacations, and features about "The New Grand Tour" in various African nations would include stunning photography and in-depth portraits of the people. *Vogue* began featuring the work of black writers and artists in these portraits of Africa, including an October 1950 article by dancer and anthropologist Pearl Primus. In this piece, titled "In Africa," Primus proclaims as she prays with the Congolese, "I knew then that I had not gone to Africa to study something, for I had become a part of that something. In me were the singing and the drumming . . . in me the hopes . . . the dances . . . the sorrow and the laughter of my people" (99). In early writings like Primus's, and later in the art and writing of black aesthetic artists like John Biggers, Africa emerges as the Source, the Motherland, the symbol of authentic blackness in the American and African American imagination.

These pilgrimage writings and the first issue of *Essence* are just two examples of BAM's influence. The movement also inspired many African American artists, including John Biggers, Eldzier Cortor, and Tom Feelings, to visit Africa. Such visits allowed black Americans to develop a deeper sense of cultural identity, to dismantle white constructions of Africa and replace them with empowering images. Because BAM focused largely on images—visual and other artistic representations of racial identity—it paralleled the political initiatives of black nationalist groups; in his book *Visions of a Liberated Future,* Larry Neal calls BAM "the aesthetic and spiritual sister of the Black Power concept," noting that it strove for a "radical reordering of the Western cultural aesthetic" (62). Proponents of BAM sought to

identify aesthetic elements that reinforced perceptions of white superiority, to deconstruct these elements, and to reconstruct an aesthetic allowing for a more positive black cultural consciousness.

As scholars like Fuller and later Ford indicate, interpretations of a black aesthetic style ranged from the "distinctive styles and rhythms and colors of the ghetto" (Fuller 10) to the practical, stylish leather jackets and turtle-necks of the Black Panthers (Ford 99) to African hairstyles and Afrocentric dress to a "set of aesthetic paradigms" that artist and anthropologist Nubia Kai identifies as "Awesome imagery," "Free symmetry," "Shine," and "High intensity color" (7–8). These last standards were closely identified with the AfriCOBRA artist collective, although they carried over into other artists, designers, and writers who identified with the movement. BAM artists drew from African imagery and themes, the colors brightened by their juxtaposi-tion with clashing tones to create bold stripes.[4] Over the next few centuries, these patterns would spread throughout West Africa and remain a part of African and African diasporic cultures even today. The African-inspired ele-ments of the black aesthetic therefore played a key role in the high visibility of BAM as it translated to fashion.

Despite the nationalistic emphasis of BAM, its art and fashions became a part of mainstream art and fashion. Their incorporation into the main-stream remains controversial. While examples of Afrocentric art and fash-ion in mainstream media often appear out of context, in other instances they offer an opportunity to challenge dominant culture standards of beauty and to destabilize a Euro-American paradigm. During the mid-1960s, Afri-can textiles became popular and even featured in *Vogue*. For example, the section "Vogue's Own Boutique" in a 1966 issue of *Vogue* includes a pho-tograph of kente cloth shoes, with the caption, "Africana—right down to the tippy toes." The section describes the shoes in detail and notes they are "part of a collection of shoes and boots all made of African fabrics by Mal-colm Arbita of L'Africana," who, the editor adds, "designs the floaty caftans of, natch, African fabrics" (262). The segment leaves the reader with the impression that such shoes and other "Africana" pieces are part of a prevail-ing trend, though it could also signify that mainstream media were making more concerted efforts to diversify their target audience.

This same mainstream emphasis on Afrocentric style surfaces in *Vogue*'s treatment of the "natural," or "afro." In a *Vogue* piece from February 15, 1969, two black models, Ro Anne Nesbitt and Carol La Brié, show off their "naturals," but the text reveals that they actually sport afro wigs designed

specifically for them ("Beauty Bulletin: Two Young Naturals" 106–7). In that same issue, in "Vogue's Own Boutique: A Head of Hair," white singer/songwriter Lotti Golden sports an afro wig over her straight hair and states, "when I wear it, people look at me—I can see they're thinking—'now is she or isn't she'—I love that. I feel really universal'" (143). The first example sends a mixed message—rather than using the women's natural hair, their natural hair texture is exaggerated by covering it with wigs. As a result, the photograph becomes less about two women of color embracing their natural beauty and more about the models' ability to sell a current trend. The second example reinforces Craik's reading of exotic fashion: donning the wig provides Golden with a temporary *frisson*. Her performance of blackness recalls whites visiting Harlem in the 1920s for a temporary escape, to indulge their primitivist fantasies without having to sacrifice the security of their white privilege.

Several months after the "natural" spread, *Vogue* featured a "Beauty Bulletin" about the Afro hairstyle with a glossy, two-page photograph of Marsha Hunt—a black model and actress most famous for her performance in the late 1960s rock musical *Hair* (fig. 7). The feature is titled "The Natural," with the subheading "The beat-beat-beat of Marsha Hunt, the zip of her looks, the froth of her hair" (134). The wording characterizes Hunt's style as fresh, innovative, cool, visually stunning. Yet this same feature shows Hunt naked, with her breasts fully exposed—unusual for a fashion shoot in the magazine; the writer also notes that Hunt is known as "London's prettiest golliwog."[5] The image is complicated in its implications. Hunt's posture and defiant facial expression exude self-confidence, an assurance of her beauty, but the feature nevertheless plays up her exoticism—she is not participating in the fashion magazine in the way the white models do, but as a curiosity for white readers.

Context matters for Afrocentric fashion. Hunt's photo spread would have made a different impression on the pages of *Essence,* and among black readers both her beauty and her difference were celebrated. Hunt's look fit with the black-is-beautiful ethos of the movement. Richard J. Powell indicates why such seemingly superficial marks of otherness could have a revolutionary impact: "Although many blacks scoffed at the idea that a hairstyle, an attitude, or an alternative worldview could advance black people in the same way that political revolts had liberated oppressed peoples in the past, others believed that revolutions began with these metamorphoses of the self" (144). The dominant culture approval of such Afrocentric trends

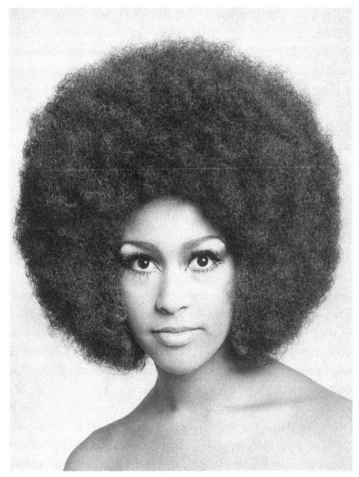

FIGURE 7. *Marsha Hunt's Afro,* a photograph by Mike McKeown,
January 1969. (Daily Express/Hulton Archive/Getty Images)

mattered far less than the symbolic resonance of these trends within the
black community.

The 1960s saw a generational split in how Afrocentrism was viewed.
As Alice Walker notes in a 2003 interview with her biographer Evelyn C.
White, the younger generation of African Americans eagerly embraced the
symbolic power of Afrocentric style. Walker explains, "We were so thirsty
for our African roots and our heritage, and we had denied them for such
a long time that we naturally—we embraced them" (*Alice Walker: A Stitch
in Time*). The pilgrimages to Africa that began in the 1940s provided blacks

with the opportunity to unearth a heritage that, for centuries, had been denied them. The problem, Walker clarifies, was that "sometimes in the embrace, we hurt the feelings of our parents and our grandparents, and the ancestors." In so eagerly embracing symbols of Africa as a means of representing the self and community, young African Americans simultaneously denied the heritage represented by their parents and recent ancestors. Powell notes that "this shift from the purportedly acquiescent 'Negro' to the seemingly assertive 'Black' was viewed by many older, more conservative African Americans with confusion, suspicion, and amusement," and yet "the younger and more outspoken members of the race saw the change as not only symbolic, but an emphatic proclamation of an oppressed people's psychological reorientation" (121). Both Walker and Powell acknowledge older generations' resistance to the Afrocentric iconography often associated with BAM, which Walker represents in her story "Everyday Use," discussed in the next section.

Walker, Senna, and Morrison directly engage the image of black authenticity that emerged through this Afrocentric rebranding of the 1960s. The authors reiterate the persistence of these images in the popular imagination. In her novel *Caucasia*, Senna highlights the strength of the movement by having her protagonists attend the Nkrumah School, an all-black institution meant to instill positive racial consciousness and knowledge of heritage in the students. Morrison, meanwhile, portrays a mixed-race privileged young woman's insecurity as she navigates her own race consciousness and distance from both African and African American heritage. Each of the three works discussed in this chapter shows the prevalence of an Afrocentric standard of beauty during and after BAM, as well as the unexpected consequences of cultivating such images. Walker, Senna, and Morrison reveal protagonists who long to cultivate multifaceted identities as black women, in the wake of a time "when African-Americans were looking to Africa for models of black style and modernity" (Ford, *Liberated Threads* 20), a time when black women were collectively drawing inspiration from a distant African heritage and celebrating their natural hair textures and skin colors. However, the authors reveal how an Afrocentric template for beauty and culture, when left unquestioned, can exclude other forms of African American beauty, experience, and heritage.

"Everyday Use"

In her interview with Evelyn C. White, Alice Walker explains her motivations for writing her short story "Everyday Use"—a story that encapsulates, she says, "the late sixties in the south." Walker explains that during this time, "many of the younger people . . . decided to return to Africa figuratively and culturally and ideologically by changing their names and changing their hair and changing their clothing and changing a lot of their behavior in a very disrespectful way to the actual ancestors that they knew" (*Stitch in Time*). Walker includes herself as part of this generation, for she recalls her curiosity about Africa, her eagerness, like so many others, to connect with what they perceived as a lost heritage. For generations African American women had found outlets for personal expression and spaces for forging community in their crafts and gardening, their churches, their music, their friendships with other black women, and their familial relationships (Walker, "In Search" 48–49; Collins 100–102). The artistic and anthropological forays into Africa during the 1950s and 1960s, however, provided black women and men with a new matrix for negotiating personal and collective identity. Walker acknowledges that she was not immune to this fervor for learning about her African heritage. Walker, in fact, wore African dresses of kente cloth and even visited Africa for a month. But unlike her literary counterpart, Dee, Walker never lost touch with the other part of her background—the heritage built by her ancestors in the centuries between Africa and the present, the heritage of women who toiled all day but still found ways to express themselves creatively, the heritage represented by her parents, grandparents, and great-grandparents.

"Everyday Use" is about this balance of relationships in black women's experience, but it is also a story about material—material for clothing and for quilting, material for use and for art. These seemingly opposite themes, relationships and material, function in a similar manner within the story, for both involve the act of construction. Walker shows how individuals can construct their own legacies through pieces of the past, even reconfigure the past in this self-construction. The quilt, in fact, can be read as a metaphor for such reconstruction and reconfiguration, as it is literally the piecing together of fragments from the past. Walker explains that when she wrote "In Search of Our Mothers' Gardens," she marveled at how women "who were denied the possibility of actually being the artists and the creators that they were because they had to work for fifteen hours a day" could

still find the means and time to create. In that essay, she says, "I wanted to show how my mother, for instance . . . had made quilts out of rags and pieces of clothing, and how they held together so much of the history of my family. And they were beautiful" (*Stitch in Time*). Perhaps to invest in her own heritage, Walker learned to quilt, and she describes taking some of her African dresses and making them into a quilt when she was writing *In Love and Trouble* (1973): "It's a way of connecting to so many generations of very wise women, and a few men," she explains. Her experience creating this quilt mirrors the fabric and composition of "Everyday Use": she acknowledges the meaning for so many young people behind discovering their distant African heritage; but she fuses this discovery with an emphasis on the more recent heritage represented by mothers, grandparents, and great-grandparents.

Walker portrays the struggle to balance individual creative expression with community and family in the encounter between Dee and her estranged mother and sister. In "Everyday Use," narrator Mrs. Johnson and her shy daughter Maggie await the arrival of Maggie's sister, Dee, who has gone off to college. Mrs. Johnson characterizes Dee as the prettier, smarter, yet more entitled daughter. She reveals these traits through her fantasies about their reunion, as well as her other daughter's nervousness: "Maggie will be nervous until after her sister goes: she will stand hopelessly in corners, homely and ashamed of the burn scars down her arms and legs, eying her sister with a mixture of envy and awe" (47). While Mrs. Johnson reveals some of her love and admiration for Dee, she also suggests that her daughter makes her feel ashamed and self-conscious, both about her appearance and about the poverty of their home. Dee negates any potentially well-meaning attempts to educate her less privileged family members by appearing frustrated and ashamed: "She used to read to us without pity; forcing words, lies, other folks' habits, whole lives upon us two, sitting trapped and ignorant underneath her voice. She washed us in a river of make believe, burned us with a lot of knowledge we didn't necessarily need to know" (50). The narrator relies heavily on the word "burn," employed in a more literal sense to describe Maggie's scars, the wellspring of her shyness and shame, and in a metaphorical sense to describe how Dee makes both Maggie and Mrs. Johnson feel. Mrs. Johnson characterizes Dee's attempts to educate her and her daughter as unnecessary, insulting, and ultimately self-serving: they represent Dee's attempts to mold them into respectability, not to make their lives better. Her efforts only succeed in deepening their scars.

Through Mrs. Johnson's narrative lens, Dee appears selfish, disconnected from and perhaps even ashamed of her family. Certainly, much of the scholarship on this story echoes such a reading of Dee.[6] And yet Mrs. Johnson's description simultaneously reveals Dee's yearning: her need for education, a chance to fulfill her creative potential. Shaimaa Hadi Radhi echoes this interpretation of Dee in her assessment of the novel's aesthetics, noting Mrs. Johnson seems to malign her daughter's insensitivity yet also exposes her "admiration of her as an artist. Dee is interested in aesthetics and this proves her as a self-creator" (123–24). Other scholars have taken a more cynical view of Dee as an artist. For example, in their article about quilts as symbols of communal bonding in Walker's fiction, Houston A. Baker Jr. and Charlotte Pierce-Baker suggest that Dee's status as an artist rests on following popular trends and therefore is more socially constructed than personally motivated: "Her goals include the appropriation of exactly what *she* needs to remain fashionable in the eyes of a world of pretended wholeness, a world of banal television shows, framed and institutionalized art, and Polaroid cameras—devices that instantly process and record experience as 'framed' photograph" (161). Baker and Pierce-Baker contrast Dee, whose commercial art is situated within a Western popular culture based on trends, with Maggie, "the emergent goddess of New World improvisation and long ancestral memory" (162), whose art remains within an ancestral African tradition of cloth making and piecing (156) as well as an African American tradition of improvisation (163).

Despite such critical views, Walker clearly positions Dee as the representative of her own struggle as an artist, one who in her art engages with a Western tradition while attempting to channel her experiences and traditions as a woman of color. In her reading of the story, Mary Helen Washington affirms this connection between Walker and "the 'bad daughter'": "Like Dee, Walker leaves the community, appropriating the oral tradition in order to turn it into a written artifact, which will no longer be available for 'everyday use' by its originator. Everywhere in the story the fears and self-doubt of the woman artist are revealed" (102). While Maggie and Mrs. Johnson represent the artistic traditions of Walker's mother and other female ancestors—those she pays homage to in "In Search of Our Mother's Gardens," in Dee she situates her own struggle—how to participate, simultaneously, in the Western literary tradition that provides her outlet for creative expression, the current investment in Afrocentric style represented by BAM, and the folk traditions of her family. When viewed in this light, Dee's

apparent self-interest and superficiality do not negate her positioning as a model for black women; rather, she represents the struggle to negotiate different facets of identity, as well as the potential pitfalls of neglecting a key component of that identity.

It is through Dee's initial appearance that the reader can see this tension, the beauty and potential of her individual expression as well as her potential to "burn" those closest to her. In her introduction of Dee, Walker weaves her own engagement with African culture and the black aesthetic into her portrayal of the character. Walker spotlights Dee's clothing, hair, and jewelry when this character first appears, as a means of alluding to her ideological leanings and her disregard for her family's feelings. As Walker herself notes, she speaks to the 1960s generation of African Americans in the South who, by embracing signifiers of African heritage, believed they were distancing themselves from a legacy of oppression. Dee announces that her name is now "Wangero"—the same name, in fact, that Walker was given when she visited Kenya.[7] Dee is wearing a beautiful dress made of African cloth; Walker acknowledges the number of African-style dresses and bolts of kente cloth she acquired during this period of her life (*Stitch in Time*). Through this scene, Walker reflects on the Afrocentric signifiers so popular during 1960s Black Nationalist endeavors, and she calls upon her black readership to question the meaning behind such signifiers—what they embrace, and what they exclude.

When Dee first appears, her dress overshadows everything else about the reunion with her family: "A dress so loud it hurts my eyes. There are yellows and oranges enough to throw back the light of the sun. I feel my whole face warming from the heat waves it throws out" (52). The overall impact is brilliant and overwhelming; the dress embodies the colors of the black aesthetic, and the style sounds similar to the West African kaftan—a garment championed by *Vogue* in the early 1960s when worn by Moroccan royalty (fig. 8). Mrs. Johnson describes the dress as "loose" and realizes, "I like it." The colors sound similar to those of kente cloth, which became popular among blacks in the United States in the 1960s as a marker of their African roots, a means of showing appreciation for a culture with which they had a connection that whites could not share. In this instance, however, what stands out is Dee's brightness and boldness: her presence seems to dwarf her relatives even as she draws their awe and admiration.

By combining so many elements of Afrocentric style, however, Dee belies her complete immersion within a trend. She has not simply embraced an

African textile as a show of her affiliation with BAM but rather has bedecked herself with symbols of African heritage: her enormous gold earrings, her "bracelets dangling and making noises when she moves her arm up to shake the folds of the dress out of her armpits," and her hair that "stands straight up like the wool on a sheep," styled with "two long pigtails that rope about like small lizards disappearing behind her ears" (52). The description mirrors Walker's description of what she calls "the phony part of Afrocentrism, the part that was only interested in the kente cloth." Walker uses the kente cloth as an example because, she explains, while the cloth was certainly a part of Africa, it didn't represent the African people writ large, but only a select, privileged few; it was a cloth worn by kings. Walker indicates that her visit to Africa was an attempt "to connect to a culture that we just discovered, really," and yet, through this visit, she says, "I discovered how American I really was." Part of connecting to this African past meant understanding more about herself as both part of this ancestral past and part of her African *American* ancestral legacy.

Indeed, Dee's adoption of these emblems of the black aesthetic, like Dee herself, has been read in both a sympathetic and a more incriminating light by critics. In her reading of the story, Susan Farrell pushes back against the majority of the scholarship, which suggests that Dee has only a superficial relationship with Africa. Instead, Farrell suggests that while Mrs. Johnson and Maggie have connected with one aspect of their heritage, Dee has connected with another: "While most readers see Mama and Maggie as having a 'true' sense of heritage as opposed to Dee's false or shallow understanding of the past, both Mama and Dee are blind to particular aspects of heritage" (183). Farrell acknowledges that Dee seems dismissive of her family's history, but notes, "Mama has much to learn about the history of African Americans in general, and about fighting oppression" (183). Walker's own statement about this meeting initially seems to negate Farrell's reading: she explains that Dee has come home "to show herself off, and to be a model of the new day to these extremely backward relatives" (*Stitch in Time*). Yet Walker also acknowledges that Dee, Maggie, and Mrs. Johnson are essentially "the same person"—they were all raised in the same place, with the same legacy, and all work to carve out a sense of self in relation to family and community. Her criticism of Dee stems not from her curiosity about this past, but her inability to fuse the art of her family, her folk heritage, with the art of her more distant ancestors. The story does not condemn Dee for wanting to connect with an African heritage, but for trying to force her

FIGURE 8. West African kaftan, H. R. H. Lalla Nezha of Morocco. (*Vogue*, June 1, 1963, pp. 86, 87, 143; ProQuest Vogue Archive)

relatives to feel that same connection and for failing to see her connection to those relatives.

Walker reveals how Dee's sense of fashion is entangled not only in her embrace of a black aesthetic, but also in her determination to better her circumstances, to achieve an education and eventually a successful career. As someone determined to graduate from college and forge a career as an artist, Dee implicitly strives for self-definition—she is not just trying to assimilate into the dominant culture but to determine her own fate. Dee's interest in material can be read as both material*ism* and as a desire to control the symbolic material of her own life, to piece together her own future. There is room even from Mrs. Johnson's perspective for both readings. Dee as a child, Mrs. Johnson remarks, "wanted nice things. A yellow organdy dress to wear to her graduation from high school; black pumps to match a green suit she'd made from an old suit somebody gave me. She was determined to stare down any disaster in her efforts" (50). Mrs. Johnson's diction here feels hyperbolic: she stresses the grandiosity of Dee's "efforts," yet Dee is not doing anything explicitly action oriented, but rather trying to procure items of clothing for a couple of different special occasions. Mrs. Johnson's diction, therefore, characterizes not Dee's actions but the feeling behind them. Even from a young age, clothing and style represent something different for Dee than they do for Mrs. Johnson and Maggie. Being willing to "stare down any disaster" seems extreme for the sake of being fashionable; clearly, constructing her own stylish clothes means something more powerful for Dee: the ability to express herself, her aspirations, her yearning for color and beauty.

Given this context for Dee's love of beautiful materials, we might read her Afrocentric style in the encounter scene differently. Certainly, the yellow African dress and Afro belie her investment in a trend; as Baker and Pierce-Baker argue: "Assured by the makers of American fashion that 'black' is currently 'beautiful,' she has conformed her own 'style' to that notion. Hers is a trendy 'blackness' cultivated as art and costume" (160). And yet Mrs. Johnson's narrative reveals that Dee has always yearned to make and wear beautiful clothing; even if she invests in trends, she seeks out the colors and styles that best express her inner self. Perhaps Dee has embraced this particular trend because she hopes to find herself within it.

Dee's interactions throughout the story echo this balance between her artistic interest in material and her more selfish interest in cultural capital. As Dee and her partner, Hakim, enter Mrs. Johnson's home, Dee reveals

some interest in her family heritage, but only as a way to have cultural cred-
ibility among her university friends. She asks to keep the hand-made butter
churn, remarking, "I can use the chute top as a centerpiece for the alcove
table . . . and I'll think of something artistic to do with the dasher" (56).
Mrs. Johnson sees that Dee wants to possess these items not to use them,
but to show them off as works of folk art. She therefore anticipates the
same sentiment when Dee demands her ancestors' handmade quilts. David
Cowart clarifies, "The visitor rightly recognizes the quilts as part of a fragile
heritage, but she fails to see the extent to which she herself has traduced
that heritage" (172). Like the African cloth, the quilts and butter churn have
an aesthetic value for Dee, both for their cultural capital and for the beauty
she sees in them. Walker explains, "She wants it because it is going to be
the art form of that period. . . . it's in the same way that she has taken the
African culture, the cultural artifacts of Africa—you know, the kente cloth,
the earrings, the hair—and if we could see her today, she would be probably
wearing bling bling; she hasn't really gone very deep into what is true and
what is not." Walker reinforces Dee as an appreciator of art but questions
the value of taste if it merely represents adopting the popular art for a given
time period. Dee's love for art does not enable her to appreciate the quilts
as Maggie would, for Maggie understands the personal history and the love
that went into these pieces. Unlike Dee, she sees herself in the quilts.

Walker does not ultimately condemn BAM or Afrocentric style through
her story, nor does she devalue its emotional and cultural significance for
African Americans. Revisiting this moment, she suggests in her interview,
is as much about her own reconciliation between two ancestral legacies as
it is about her character's confrontation with her past. In his reading of the
story, Cowart relates Dee's process of identity construction to the "minority
writer" seeking a culturally authentic means of expression beyond "the lan-
guage and literary structures of the oppressor." He asserts, "Only by remain-
ing in touch with a proximate history and an immediate cultural reality can
one lay a claim to the quilts—or hope to produce the authentic art they rep-
resent" (171–72). Though Walker certainly affirms Cowart's claim that per-
sonal and cultural authenticity rely in part on connecting to recent history
and ancestry, she does not dismiss the possibility that connecting with a dis-
tant ancestry can deepen that sense of authenticity. Rather, she asserts that
one can't connect with that distant past at the expense of the recent past.

When at the end of the story, Dee tells her mother that she (Mrs. John-
son) doesn't understand her heritage, and tells Maggie that she could make

something of herself, her words resonate in their irony. Maggie and her mother have already "made" themselves; it is Dee who is still under construction. Walker states that Dee needs to have "a breakdown . . . from which she can emerge as a truer person." Her mother's refusal to give her the quilts precipitates this turning point for Dee, a woman who is accustomed to having her own way. This confrontation, Walker implies, must happen for Dee to grow as a person and cultivate a deeper self-knowledge, and to embrace the process of identity construction essential to Walker's idea of womanism.

In her reading of Walker's concept of womanism, Patricia Hill Collins explains that the term has "two contradictory meanings"—one "rooted in black women's concrete history in racial oppression," and another that echoes "the Southern black folk expression of mothers to female children 'you acting womanish'" ("What's in a Name?"). Collins describes "womanish" women as "outrageous, courageous, and willful," which inevitably contrasts them with the feminine restraint so often exhibited by white women. Collins's description of the contradictory meanings of womanism shows the necessary arc of Dee in her self-fulfillment, her journey to self-definition. She has the drive, the courage, the willfulness necessary to push boundaries and achieve her creative potential, but she lacks the depth and context to give her journey meaning. The confrontation at the end of "Everyday Use," Walker suggests, may serve as the necessary catalyst for achieving this more well-rounded sense of identity.

Caucasia

In "Everyday Use," Walker characterizes how BAM illuminated the beauty of black folk art and engendered new forms of creative expression, even as she cautions against embracing the aesthetic at the expense of other aspects of identity. These same themes surface in Danzy Senna's *Caucasia*, a story of an interracial couple (Deck and Sandy Lee) with two daughters, one who appears white (Birdie), and one who appears black (Cole). When the couple splits, the lighter child goes with the white mother, a radical activist who takes her daughter into hiding and constructs false (and white) identities for them. Meanwhile, the darker child goes with her father and his black girlfriend, Carmen, to Brazil. Writing the novel in the late 1990s, Senna depicts the legacy of the black aesthetic after its peak and over a period of

about six years (from the mid-1970s to the early 1980s). Deck Lee, the father and an academic, embraces this aesthetic and the politics behind it. Birdie, the narrator, and her sister Cole come to recognize the signifiers of BAM as trendy and yet wielding an incredible symbolic power—the power to drive families apart, to catalyze communities, and to alter the race consciousness of a generation.

Much of the scholarship on the novel has tended to focus on its biracial narrator and to situate the text within the tradition of "passing" narratives.[8] These readings, Habiba Ibrahim's in particular, indicate how racial identity is performed in the novel—an appropriate interpretation given that so much of the novel focuses on Birdie and Sandy once they have gone into hiding. Because of my focus on BAM and my larger emphasis on fashion as a performance of identity, my interpretation of the novel concentrates on the beginning sections, set during the mid- to late 1970s, to illustrate how all of the characters perform racial identities, and to argue for fashion's central role in constructing meaningful personal identities in relation to race.

Senna introduces Afrocentric fashion in the novel in conjunction with the Black Power movement to characterize the dress and style of Deck and his new girlfriend, as well as to signify the growing barriers between the lighter and darker members of the Lee family. The novel opens in 1975 in Boston, which Birdie describes as "a battleground" (7): racial tensions are at an all-time high. In the midst of this hostile climate, Birdie's father, Deck, has begun to distance himself from his wife as he adopts the linguistic and physical signifiers of Black Pride. Birdie notices how he code-switches whenever he is in the presence of other blacks: "He would switch into slang, peppering his sentences with words like 'cat' and 'man' and 'cool.' Whenever my mother heard him talking that way, she would laugh and say it was his 'jive turkey act.' In the past year, he had discovered Black Pride (just a few years later than everyone else), and my mother said he was trying to purge himself of his 'honkified past'" (10). Birdie's recollection characterizes Deck's racial identity as a performance, one based on how he wishes others to perceive him. Senna suggests that Deck decides to leave his wife, in part, because her presence is the clearest evidence that his pride is practiced and inauthentic; he wishes to immerse himself in the black community and feels ashamed of his past forays into miscegenation.

Deck's fascination with Black Pride has two clear parallels to Dee's in "Everyday Use." First, both Deck and Dee are associated with the university (Dee is a college student, Deck a professor). Their connection to these

movements is something studied: their formal education has helped them recognize their racial affiliations as something of value. Like Dee, Deck picked up on a contemporary discourse in the university setting and decided to adopt it as he saw its power in the community. However, as Ford suggests, the African styles associated with Black Power often originated with college students—something both authors recognize (Ford, *Liberated Threads* 7). Second, by investing so fully in these movements—their symbolism and their politics—both Deck and Dee inevitably exclude, dismiss, and even negate the people who love them. Dee devalues her mother and sister and, by extension, her ancestors; Deck, meanwhile, abandons his wife and makes his light-skinned daughter feel unloved and ashamed.

Yet while Dee's interest in Afrocentric fashion and the art of BAM reflects, at least to some extent, her appreciation for art and beauty, Deck's investment feels rooted in masculine insecurity. When Deck cruises around with his friend Ronnie Parkman, Birdie observes how he speaks more deliberately in a black vernacular, as though needing his friend's validation. Later in the narrative, when he has left Sandy and begun dating Carmen, Birdie notes how Deck basks in the compliments of strangers—including a restaurant manager who compliments him on his choice of partner, remarking, "That's a fine sister for you, Deck" (90). Birdie does not completely fault her father, for she also notes the judgment he experiences as a black father to a light-skinned daughter, as when a couple sees them together in a park and assumes he has kidnapped Birdie. However, his attitude about his blackness is largely driven by the discourse of the time, a trend he wishes to embrace, a reflection of his own self-consciousness.[9] Deck, like Dee, has not commenced the difficult work of self-understanding.

Birdie's view of Deck's inauthenticity is not meant to belie her own deeply embedded investment in black culture. Her early childhood has been characterized by visits to the museum to learn about Africa, music by soul artists playing in the house, African American fashion and beauty magazines, and other cultural influences closely linked to Birdie's personal and familial development. Rather, Birdie recognizes Deck's sudden and deliberate shift to a new lingo and style, and, moreover, she connects it with her sense of alienation from her father, as well as a much more explosive rift within her family.

Deck's eagerness to embrace Black Nationalist signifiers extends beyond lingo and ideology to include Afrocentric style. Senna shows through Deck's other family members that members of his community participated in the

nationalist movement without taking it quite as literally in its aesthetic demands. In one of the novel's first scenes, Birdie and her sister go to visit their aunt Dot, who styles her hair "in a short, neat natural" (8), though in this particular scene her hair is tied in "an orange-and-purple African cloth that made her look regal" (11). Like Walker, Senna styles her characters in the prevailing trends of the black community, though while Dot blends her Afrocentric style with mainstream trends (platforms and a bright mini-dress, for example), characterizing her as less self-conscious in her adoption of Afrocentric signifiers, Deck seems more desperate in his attempts to blend in: Birdie observes, for example, "He had been trying to grow an afro, and it was crooked that morning" (25). Birdie does not seem threatened by her father's changes until he introduces her to Carmen: "She had glowing mocha-brown skin, a faint feminine mustache, and a small splotch of a birthmark flowering like a coffee stain on her left cheek. . . . Other than the mustache, I thought she looked like a black Barbie come to life" (89). Carmen embraces Cole like a new daughter, but completely ignores Birdie, refusing to even say her name correctly. Through her exchanges with Carmen, Birdie fully grasps her estrangement from her father and sister and gravitates closer to her mother.

Senna suggests that just as the lighter-skinned daughter feels alienated from her father, the white mother feels alienated from her darker-skinned daughter. Once Cole begins attending Nkrumah (called the "Black Power school"), a series of revelations about her appearance—that she needs to put lotion on her knees, that she needs to style her hair differently (49)—stimulates her resentment toward her mother. Cole, Senna reveals, is an avid consumer of black women's fashion: part of her bond with Carmen involves getting her hair done, exchanging fashion tips, and accompanying Carmen to the beauty parlor. Senna suggests that the teenaged Cole's understanding of fashion as a means of bonding for women and as a means of self-expression seems completely natural, yet it also deepens the fissure between her and her mother. Initially Cole turns to her mother for help when she glimpses a hairstyle she wants to try: "A copy of *Jet* magazine sat open before them, and a bright-eyed new sitcom star grinned up at us under the words 'Cute and Sassy Keisha Taylor Tells Her Beauty Secrets.' Cole had been obsessing over the picture for the past few weeks, and now the page fell open naturally to it. Keisha Taylor had tight cornrows with gold beads at the end. Just the way Cole wanted them" (50). When Sandy fails to comb and style Cole's hair properly, Cole begins to shut her mother out and turns

to Carmen as a maternal figure instead. She tells her sister, "They all laughed at me last week. Just like the time my knees were ashy. 'Cause of my hair. It looks crazy. They were calling me 'Miz Nappy.' None of the boys will come near me. Mum doesn't know anything about raising a black child" (53). In pulling away from her mother, in one sense Cole's comments and actions feel characteristic of a teenage child fostering her sense of independence. In the context of her concern about skin and hair, however, Cole suggests that she cannot connect to her mother because her mother cannot properly advise her on her appearance. While the rift here—unlike Birdie's with her father—initially seems superficial, within the context of Black Pride, Sandy's failure to learn how to instruct her daughter in these feminine rituals reflects on Sandy's naivete about racial and cultural difference. Sandy's privilege makes her blind to what she should know as parent to a black child, and Cole—perhaps rightfully—resents her for her oversight. Bereft of a parent figure to teach her how to care for her appearance and style herself, Cole seeks such models outside her home.

Cole finds these models in Carmen and in her black friends at her new school. When Birdie and Cole leave the sanctuary of home-schooling and begin attending Nkrumah, Senna demonstrates how cultivating a nonmainstream aesthetic can either alienate individuals from one another or bring individuals together. Despite her eagerness to learn about black culture, Birdie's light skin marks her as a cultural outsider. On the first day of her new school, Birdie's teacher explains the protocol to the class: "'Our tradition,' she said, looking directly at me, 'is that at the end of each class, everyone stands and says, "Black is beautiful." Loud and clear. You gotta be proud of where your people came from'" (44). Each student stands up and recites the mantra, and when Birdie says it, one of her classmates taunts, "Guess you must be ugly" (45). Ostracized by her classmates, Birdie finally takes measures to authenticate her race, much as her father has done within his community: she has her sister vouch for her racial identity; she begins wearing her hair in a braid "to mask its texture" (62); and with Cole's encouragement, she gets her father to buy her "a pair of Sergio Valente jeans, a pink vest, a jean jacket with sparkles on the collar, and spanking-white Nike sneakers" (63).

It is this last example that speaks to the potential for a nonmainstream aesthetic to forge healthy bonds among black women. The sneakers, vests, and jeans all speak to trends of the 1970s, specifically trends embraced by black women—Sergio Valente jeans, for example, were a hallmark of early

b-girl and fly girl style (Blount Danois 59; Edwoodzie 122). Birdie follows Cole's example to fit in with other girls at the school, and to remain close to her sister. In each scene with Birdie, Cole, and their friends, Senna includes details of the girls' attire and styling, grouping signifiers of black women's fashion—bright-colored boots, hoop earrings, jeans with designer labels (78, 89)—to show how these aesthetic details signify each girl's recognition of social codes of belonging within the school and the black community.

Birdie bonds with the girls at the Nkrumah school as she begins wearing these clothes and, more generally, caring about fashion and style. Senna depicts this teenage bonding as going beyond the superficial; rather, she implies the potential of styling and dress to bring young girls together. These clothes, unlike physical features like skin and hair, do not reinforce standards of beauty that exclude Birdie. The emphasis here is on the bonding as women within a particular culture and fashion moment; Birdie will later experience a similar phenomenon when she first bonds with Mona and her friends at the New Hampshire school.

The styles that Birdie and her Nkrumah friends wear, rather than fitting the Afrocentric look associated with BAM, reflect early b-girl and fly girl style of the mid to late 1970s. B-boy/b-girl style grew out of the dress worn by break dancers: predominantly black, Puerto Rican, and Afro-Caribbean dancers who were observed "top rocking, floor rocking, popping, locking, freezing, and generally 'going off' or 'breaking out' at dance parties" (Moore 63). In her book *Street Style in America* (2017), Jennifer Grayer Moore describes some of the clothing associated with b-boys and b-girls, noting that dancers wore clothing that would allow them to dance on the fly. Dancers wore hats conducive to head spins (like bandanas or Kangol hats), brand-name jeans, knit pants, tracksuits, "T-shirts, hooded sweatshirts, and windbreakers" (often with iron-on letters) high-top sneakers or other brand-named sneakers—often with brightly colored laces (Moore 65). These styles illustrate some of the positive repercussions of BAM and its impact on fashion, for the movement encouraged African Americans to look within various black diasporic cultures for codes of style and beauty. The b-girl and fly-girl styles represent one communal interpretation of streetwear and urban culture, one way that styles were flourishing outside of traditional white, Western spheres of influence.

Later in the novel, when Birdie and Sandy are in hiding, Senna demonstrates the powerful impact of these clothes—a reflection of music, dance, and other aspects of black culture—on Birdie, who has long been denied any

access to black culture. Sandy and her white boyfriend, Jim, take Birdie and her white friend Mona to New York for the weekend. As the two teens wait outside a museum, Birdie notices a crowd of black and Puerto Rican kids around the same age playing hip-hop music on a boom box; she describes it as "some kind of talking music, the first I had ever heard of its kind" (260). Birdie continues to observe them, ignoring her friend: "One of the boys, a lanky kid wearing a Kangol hat, stood up and started to dance. He jerked his body electronically and, with the encouraging shouts of the other teens, began to spin on one of his hands, his glove the only protection between his skin and the pavement. A chubby girl with straightened and dyed blond hair stood and clapped her hands, moving her hips. Her sweatshirt had her name, 'Chevell,' printed on it" (260). As Birdie watches them, she reflects on how in New Hampshire she "had never quite gotten used to the music, or the fact that people didn't dance" (260). The scene she witnesses trans-fixes her not only because she likes it, but also because it feels like home for her. When she is forced to leave, she still longs to be a part of this group, "fantasizing for a brief moment . . . that I lived in this kaleidoscopic city, and that my name was Chevell" (262). Senna suggests that the culture of Birdie's childhood has made a permanent imprint on her consciousness, and Birdie thus recognizes the familiar even in the unfamiliar. She consid-ers, for example, that although she has never heard "the talking music," before, "the underlying tune was somehow familiar, something I had known once, long ago" (260).

The scene shows how fashion can serve not only as a means of signaling racial pride and political affiliation, but also as a vehicle for both personal and cultural expression. The elements of b-girl/b-boy style Birdie identi-fies have an aesthetic as well as a functional dimension—the Kangol hats worn for head spins, or the iron-on letters for identifying individual danc-ers or crews. While the Afrocentric style that Deck adopts is characterized as superficial, a way of advertising his ideological leanings, these clothes represent to Birdie the culture that she is missing out on and still longs for. They recall key aspects of her early childhood, her missing family and estranged friends, her home—specifically, the early b-girl styles she and her Nkrumah friends wore and the soul music she listened to at home.

In emphasizing these social and aesthetic codes, Senna suggests that racial identity has a way of signaling interests beyond aesthetics to observers. And yet she also suggests, through Deck's and Dot's style, that racial identity—even racial pride—has a performative element, a voluntary adoption of

recognized signifiers to proclaim affiliation. In her reading of the novel as a "passing" narrative, Michele Elam evokes Walter Benn Michaels's argument about race as a false construct: "Social constructionism, in Michaels's view, includes those approaches that do not locate race in biology, soul, or any internal 'essence,' but which, instead, define race as 'performative'. . . . he believes that lurking within their theories of performance lies an unacknowledged investment in essentialism" (752). Elam asserts that one problem with Benn Michaels' theory—one that Deck reinforces later in the novel—is that it undermines the ways race plays a role in personal, ancestral, and communal identity politics. When later in the novel Deck lectures Birdie about his latest scholarly project, in which he argues "race is but a myth" (Elam 753), he "preemptively undermines" Birdie's own experience and her discourse about her experience (753). Deck even negates his own experience of race, which proved such a determining factor in his actions, his response to social conditions, and the dissolution of his family earlier in the novel.

Although race cannot be dismissed as a myth, neither can we deny its performative elements—so Senna's narrative suggests. In his reading of the novel in *Writing the Future of Black America* (2009), Daniel Grassian borrows David Hollinger's theory of postethnic identity to characterize race in *Caucasia* (117). Hollinger posits, as part of this theory, that unlike multiculturalism, postethnicity "favors voluntary over involuntary affiliations, balances an appreciation for communities of descent with a determination to make room for new communities, and promotes solidarities of wide scope that incorporate people with different ethnic and racial backgrounds" (Hollinger 3). Applying Hollinger's idea of voluntary affiliation to Senna's novel, we can see its usefulness as well as its limitations. When Birdie adopts signifiers of blackness to better fit in at the Nkrumah school, she practices a voluntary affiliation, using clothing and style to signal her belonging to her group of friends and the Black Pride ethos of the institution. Yet when Deck and Birdie go to the park and he is instantly read by bystanders as a kidnapper—a black man who has taken someone's white child—there is no choice involved. Skin color has created its own narrative in the mind of the observer; neither Deck nor Birdie have any agency in how they are perceived.

Acknowledging how the signifiers have power, albeit a limited power, in signaling racial and ideological affiliations, Senna shows how black fashion can alternately have positive and negative influences on individual identity

construction. Deck's sudden adoption of a trendy black vernacular and his attempt to grow an Afro read as phony—an attempt to mask his self-consciousness about having a white wife and light-skinned daughter and instead to project an authentic blackness. Birdie and Cole's embrace of black style, on the other hand, reveals how such measures of the Black Aesthetic Movement have successfully shielded young black girls from subscribing to white, European standards of beauty. The moments Birdie and Cole share reading fashion and beauty magazines, as well as the time Birdie shares with her girlfriends at the Nkrumah school styling their hair and makeup, are intimate and meaningful—they show the potential for black women's fashion and style to serve as a vehicle for self-definition. Birdie's model of beauty is not a white, blond-haired woman, but her sister. When after going into hiding, her mother loses weight and slims down to an acceptable dominant culture standard, Birdie recognizes that Sandy would now fit her mother's WASP-ish standards of beauty, but laments, "she had no butt anymore, just a flat board of a backside" (145). In the context of Birdie's narrative, of course, such privileging of any standard of beauty seems problematic, as her light skin color and straight hair make her feel excluded from this alternate standard. But within a larger context, it shows how successful this movement was in destabilizing a monolithic, dominant culture standard—how it became a first step in dismantling limiting and often unattainable standards of beauty.

Like Walker in her interview, Senna recognizes the cultural significance of BAM and the way it popularized an Afrocentric style. However, in her novel she shows how over time, it lost its primacy within black communal ideology and even style. Elements of this movement would continue to shape black fashion, decor, and other visual media, and other trends in African American fashion have since emerged from different cultural communities. Even a decade after the novel's opening, Senna demonstrates how one's attire, language, music, style, or decor could nod toward cultural heritage and pride without such symbols being a requirement for acceptance into the community.

Senna represents this distinction in the contrast between Maria's home, which Birdie visits early in the novel, and Ronnie Parkman's home, which she sees after returning to Boston. Maria's home echoes some of the cultural symbols of the first issue of *Essence* magazine: "The back wall was decorated with a velvet painting of two naked and afroed silhouettes—one curvaceous and female, the other muscular and male—intertwined in a lovemaking

ritual with a backdrop of a bright magenta-and-pink horizon" (67–68). The dominant image of the interior space recalls the headlines from that first issue—"Sensual Black Man, Do You Love Me?" and "Dynamic Afros." This image, Senna implies, is the visual marker that Maria sees every day in her home, and to some extent, it will shape her cultural identity. Later in the novel, Ronnie—now openly gay and partnered with a white, British man— has included some Afrocentric elements in his home decor, but they seem more an homage to one part of his identity rather than a definition of who he must be: "A framed poster of Diana Ross, looking like an afroed and ema-ciated princess, hung over the mantelpiece. . . . Candles stood in tall, gothic holders, and African cloths were strewn everywhere" (348). The nods to a black aesthetic (Diana Ross, a black fashion icon, as well as the African tex-tiles) are blended with both gothic and modern elements within his house-hold. Reflecting on the past, he tells his son that he was playing "the straight man" (350): the Black Nationalist ethos demanded a specific model of mas-culinity, one that prohibited Ronnie from being himself. He does not reject all the cultural symbols of this period, as his decor shows, but such symbols no longer dictate his identity.

Cole, too, reflects back on her past behavior and recognizes the way she allowed the prevailing trends of BAM and Black Power to dictate her personal choices. She tells Birdie, "I picked Carmen—this woman I didn't even know—over Mum 'cause she could do my hair and she looked like a woman who could be my mother, and she wore lipstick and didn't make scenes in public" (407). While Cole acknowledges her guilt in subscribing so wholeheartedly to Black Pride, at the expense of her relationship with her mother, Senna does not suggest she completely dismisses it as a move-ment. As Birdie's narrative reveals, the performance of racial identity is not the ultimate goal, but a step along the way in identity construction. Birdie's experimentation with different cultural signifiers aids her in reconfiguring her affiliations and situating herself within a network of familial and com-munal relationships.

Tar Baby

Both Walker's story "Everyday Use" and Senna's novel *Caucasia* attempt to capture a particular moment in American history: when young African Americans adopted physical signifiers of African heritage as a means of

proclaiming racial pride and cultural affiliation. This moment constituted a collective reckoning with a distant past, a heritage lost in the Middle Passage and reclaimed through pilgrimages, art, writing, and other Black Nationalist initiatives. Walker's and Senna's works indicate how some individuals involved with BAM used its codes of style, beauty, fashion, art, decor, speech, naming, and political or religious affiliation to collectively build a model of authentic blackness, to which black men and women should collectively aspire.

In her 1981 novel *Tar Baby*, Toni Morrison invokes two different cultural models of black authenticity: one the Afrocentric image embraced by characters like Dee, Deck Lee, and Cole, and the other a folk image epitomized by Mrs. Johnson and Maggie—the image Dee attempts to capture and display as artifact for her college friends. Both of these models emerge as imbued with pride and heritage yet exclusionary. The novel's protagonist, Jadine Childs, feeling acutely her own distance from a sense of cultural identity, considers and ultimately rejects both of these models of cultural identity.

Jadine lives a life of privilege with little connection to either an African or African American cultural legacy, aside from her relationship with her aunt Ondine and uncle Sydney. She has built up a small fortune and jet-setting lifestyle as a fashion model, nicknamed "The Copper Venus" because of her light skin. She has earned a graduate degree in art history (specializing in European art), dates white European men, and continues to book jobs for her successful modeling career. Despite her busy, jet-setting lifestyle, Jadine spends long stretches of time visiting her aunt and uncle, who work for a wealthy white couple (Valerian and Margaret Street) living in Haiti. When she visits, rather than staying with her relatives in the servants' quarters, Jadine is treated like a guest, given her own grand bedroom suite, and welcomed at the family table. In fact, she spends little time with her family and instead enjoys a sisterly relationship with Valerian's much younger wife.

The novel's central arc concerns Jadine's journey and self-reckoning, triggered by a series of personal encounters. Morrison suggests that despite Jadine's apparent contentment within a Western mainstream culture, there are cracks in her self-assurance as it relates to her privilege and self-distancing from any cultural legacy. By avoiding any negotiation with her black ancestry, Jadine has not yet constructed a meaningful, multifaceted identity but instead has created a void—a void that leaves her vulnerable to confrontations about her identity as a black woman. She bristles at the occasional racist comment from her benefactress (129); she grows defensive

when her benefactors' son suggests she study non-Western art instead of the white European artists she prefers (72); and as the novel progresses, she reveals her self-doubt through two key interactions: first with an African woman in a Parisian grocery store, and later with Son, an African American man who becomes her lover. Morrison employs these two characters, representations of a neglected African and African American past, to reference and interpret BAM, thereby considering its relationship to African American identity.

This journey implicitly means that Jadine must reconcile her interest in having a successful career (which the novel's black characters associate with assimilation) and her exploration of black identity (which, at least for Son, comes at the cost of her success and independence). Faith M. Avery connects Jadine's dilemma to "notions of racial 'selling out'" that critics seem to equate with her pursuit of success and independence; she explains: "However, selfishness is valenced throughout the novel in such a way that it requires Jadine and Morrison's readers to question whether selfishness in the name of autonomous selfhood is, in fact, synonymous with 'selling out'" (5). Avery's analysis helps frame Jadine's journey not as a binary choice between racial betrayal and racial solidarity, but as a complex negotiation of personal autonomy with a deeper understanding of community, culture, and heritage.

Morrison draws from African American folklore, fashion, and the visual arts to depict Jadine's journey: her questioning of her privilege, her attempt to immerse herself within a black community, and her final resolution to return to her life of privilege and independence, shutting off her tenuous connections to black heritage. The novel's folk motifs are implicit in the title, for within the novel, Morrison revises a famous story from a black folklore past and situates it in the present. In the Tar Baby folktale, Brer Fox attempts to trap Brer Rabbit by shaping tar into a baby. Brer Rabbit gets stuck to the tar baby, and the more he struggles, the more he gets stuck. When Brer Fox finds him, Brer Rabbit cleverly begs for any punishment except for being thrown into the briar patch. In this way, he tricks the fox: he makes him think the briar patch is his biggest fear, when actually it's his home, where he is most comfortable. Morrison uses this folktale to allegorize the future of American black women as they diverge into different cultural communities, communities connected to gender, region, education, family, career, economics, and other races. In an interview with Charles Ruas, Morrison describes her fear of the Tar Baby, and how this fear drew

her to the folktale as inspiration for her novel. In other interviews she has explained that in her novel, the white patron Valerian Street is the white man who makes the Tar Baby; Jadine is the Tar Baby, shaped by white Western culture, that ensnares the rabbit, and Son, the man who becomes her lover, is the rabbit trapped by the Tar Baby—the one who wants to return to the briar patch. Morrison poses the question: "Suppose somebody simply has all the benefits of what the white Western world has to offer; what would the relationship be with the rabbit who really comes out of the briar patch? And what does the briar patch mean to that rabbit?" (102). She adds: "Do you think she would go into that briar patch with him?"

Such questions assign the power and choice in the tale not to Brer Fox or Brer Rabbit, but to the Tar Baby. Son is attracted to Jadine despite his misgivings—he sees her as complicit in the white aristocrats' subjugation of black workers on their property, and he believes she has sold her soul to be accepted within white privileged society. Nevertheless, he finds himself falling in love with her, and Jadine with him. Their mutual affection forces them to ask key questions about their identity: Is Jadine willing to give up her privilege and independence to be with Son, and is Son willing to leave behind the culture of his upbringing, his home, and his perception of gender roles for the woman he loves?

Morrison renders this tension between Jadine and Son through a series of vivid images, drawing inspiration from the fashion industry, the African imagery of BAM, and African American folk art. Throughout the novel, she provides literary snapshots of Jadine's glamorous clothing and modeling shoots, the busy streets of New York, the lush tropical foliage of Haiti, and the rural charm of Eloe, Son's hometown. The novel's rich visual language situates the story within the larger context of BAM and contemporary fashion. Morrison began writing *Tar Baby* in the mid-1970s; the novel's imagery reflects the visual culture of the period, a culture that encompasses the American fashion industry, the painting style promoted by AfriCOBRA, and the prevailing trend of African American folk art associated with artists like Romare Bearden and Faith Ringgold. The era also marks the time when African American models were first beginning to appear on mainstream fashion magazine covers.

By portraying Jadine as a fashion model, Morrison points to a Western fashion industry that since its inception has privileged white standards of beauty. Non-Western societies had only figured into mainstream fashion journalism either as sources for cultural appropriation or as exotic locations

and people to titillate white audiences. In the mid-70s, when Morrison was writing the novel, model Beverly Johnson became the first black woman to appear on the cover of American *Vogue*. As a light-skinned black fashion model, therefore, Jadine not only wrestles with the usual gender exploitation women encounter in the fashion industry, but she also struggles with how she is exploited for her mixed-race appearance—positioned as exotic, but also "white enough" to appear in mainstream fashion media when such appearances were still rare and highly controlled. Working within an Anglo-dominated fashion industry thus leaves Jadine vulnerable to the judgment of others, especially other African Americans, about her success. In an early encounter with Son, he sees her stunning cover photo on a fashion magazine and taunts her, "How much. . . . Dick. That you had to suck. I mean to get all that gold and be in the movies" (120). His cruel accusation elicits a blind rage from Jadine, who screams at him and physically attacks him. Her violent reaction reveals how susceptible she is to his judgment, however, which seems surprising given how little she cares about him at this point in the novel. The encounter exposes her deep insecurity in her success and her privilege.

Son's accusation hits a nerve with Jadine because of the sexual insult as well as his implication that she has sold herself to white institutions of power. Here, Morrison establishes Jadine's insecurity about her blackness as an undercurrent of Jadine's narrative. Early in the novel, Jadine recounts how she feels pressure to embody a more authentic version of blackness. She explains how her white benefactors' son Michael felt that she was "abandoning [her] people" (72) by studying art history: "I think he wanted me to string cowrie beads or sell Afro combs. The system was all fucked up he said and only a return to handicraft and barter could change it. That welfare mothers could do crafts, pottery, clothing in their homes, like the lace-makers of Belgium and *voilá!* dignity and no more welfare" (73). The details espoused by Michael initially appear to reference the Afrocentric symbols of the Black Aesthetic (the symbols of someone like Dee in "Everyday Use") but then shift to symbols of a rural southern heritage (more closely related to characters like Mrs. Johnson or Maggie in "Everyday Use"). Valerian responds to Jadine: "He wanted a race of exotics skipping around being picturesque for him" (73)—an ironic accusation, given that Jadine, a model made famous by her exotic appearance—is a fixture in Valerian's mansion, and given that Valerian chooses to live in Haiti. Jadine continues: "I knew the life I was leaving. It wasn't like what he thought: all

grits and natural grace. But he did make me want to apologize for what I was doing, what I felt. For liking 'Ave Maria' better than gospel music, I suppose" (74). Because Michael is white and privileged, Jadine feels only a fleeting sense of guilt at his accusations, and Valerian assists her in dismissing his judgment. Jadine attempts to shrug off her self-doubt by reasserting her preference for canonical Western culture to black folk art or African culture.

Morrison presents an identity conflict for Jadine that contrasts the one Walker introduces in her short story. In "Everyday Use," Walker portrays the emphasis on folk heritage and culture as distinct from a connection with an African past. In her narrative, a white dominant culture is referenced but tangential to the identity politics playing out among Dee, Maggie, Hakim, and Mrs. Johnson. In contrast, Morrison brings African and black folk heritage into a kind of solidarity in *Tar Baby*, showing that Jadine has built her life outside of these ancestral legacies, thus aligning herself with a white dominant culture in her privilege and her values.

Jadine's insecurities come into high relief when she recalls an encounter with an African woman in Paris. This stranger, a beautiful woman in a grocery store, appears early in the novel and becomes a catalyst for Jadine's arrival in Haiti. While Jadine is struck by her physical beauty, she is simultaneously intimidated and threatened by the woman's presence: "The vision itself was a woman much too tall. Under her long canary yellow dress Jadine knew there was too much hip, too much bust. The agency would laugh her out of the lobby, so why was she and everybody else in the store transfixed? The height? The skin like tar against the canary yellow dress? The woman walked down the aisle as though her many-colored sandals were pressing gold tracks on the floor. Two upside-down V's were scored into each of her cheeks, her hair was wrapped in a *gelée* as yellow as her dress" (45). Initially, the most striking element of this passage is Morrison's play on color, the bold yellow of the woman's long dress and *gelée* against her "skin like tar." Through Jadine's eyes, the woman becomes a work of art, transfixing Jadine. The African woman approaches the checkout counter to purchase three eggs, which she displays in her hand. A moment after the woman leaves the store, she looks through the window, directly at Jadine, and spits at her.

This encounter proves so jarring that Jadine flees Paris, retreating back to her safe haven in Haiti. Morrison claims that this is the moment when Jadine "begins to feel inauthentic. That is what she runs away from" (McKay 147). The image provides a visual contrast between Jadine the Copper Venus and

the Black Venus in yellow—a woman who seems to have stepped right out of an AfriCOBRA painting. Instinctually Jadine acknowledges the woman's striking beauty yet also imagines her being rejected by a modeling agency—in other words, Jadine takes this woman whose beauty has so astonished her and then judges her within a framework of Western beauty ideals. It is only after the woman holds up the eggs and then spits at her that Jadine feels shaken and inferior, forced to reinterpret the interaction.

The repeated references to Jadine as a "Venus" echo a common theme from BAM, a pattern of depicting black women as representations of ideal beauty. During this movement, many black artists like Thomas Feelings and John Biggers depicted images of black women that epitomized beauty, strength, and spirituality, representations called the "Black Venus." These figures simultaneously challenged white, Western representations of ideal beauty and Western images of sexualized black female bodies, images exploited by white men to reinforce racial stereotypes and to objectify black women.[10] Beginning in the 1960s, the Black Venus became a symbol of ideal beauty and African heritage, reflecting the values of the Black Aesthetic, which aimed to break down white aesthetic standards to allow for positive racial consciousness. This positive racial consciousness coincided with a trend among black artists—including the highly acclaimed John Biggers—to visit and document Africa. These visits to Africa deconstructed myths of Africa as a Dark Continent; instead, it emerged as a source of creativity, spirituality, and culture.

The painter John Biggers was one of the pioneers for reconfiguring the Black Venus image and effecting change in cultural consciousness. Biggers first visited Africa with his wife in 1957, after receiving a UNESCO fellowship. They traveled to Ghana, Togo, Dahomey, and Nigeria (Wardlaw 47). Those who have studied Biggers's work, among them Alvia J. Wardlaw, have emphasized his interest in uncovering a pervasive female essence or "maternal spirit" and portraying this essence in his work. According to Wardlaw, he called this spirit *maamé*, a Ghanain word for "the Great Mother, the maternal spirit in all things." By focusing on *maamé*, Biggers developed his vision of a powerful female entity that served as a maternal, protective force for the community and existed in symbiosis with nature. He would continue to develop this concept in his later travels and artwork.

In addition to his depictions of Africa, Biggers's portrayal of black women helped to construct a positive image for black cultural consciousness and physical beauty separate from a Western ideal. In *Birth from the*

Sea (fig. 9), Biggers reworks a classic Renaissance depiction of ideal beauty: Botticelli's *The Birth of Venus* (ca. 1482–85). Instead of a white, blonde-haired woman emerging naked from the sea, Biggers portrays a Black Venus figure embodying physical beauty, strength, and synchronization with nature; her pose is active and tense unlike Botticelli's Venus. The composition also plays on the idea of "birth": while the Venus is a maternal figure, she is also being "born" herself. Other artists continued this pattern of visiting and portraying images of Africa, whether in the form of abstract patterns, colors, clothing and textiles, people, or scenes from daily life. These images reinforced the Black Arts objective of cultural nationalism. Thomas Feelings, for example, argues the need for the art to be meaningful to the African American community, noting that despite the heightened exposure from BAM, the visual arts were still too elitist, inaccessible to "the common Black man" (Feelings, in Lewis and Waddy 111). His painting *Sengalese Woman* portrays a beautiful African woman draped in bright yellow cloth that highlights the darkness of her skin. The woman bears a clear resemblance to the woman in yellow Jadine encounters in the grocery store, likely because images of dark-skinned women in bright yellow African garments were so prevalent during this movement.

Morrison's use of the nickname "The Copper Venus" for Jadine characterizes her as something separate from this figure—a beautiful woman, but one disconnected from constructs of authentic blackness and certainly from African heritage. Late in the novel, the character Marie Therese alludes

FIGURE 9. *Birth from the Sea* by John Biggers, 1964–66. (Mural, Houston Public Library, W.L.D. Johnson Branch; image from the John Biggers Papers, Rose Library Collection, Emory University)

to this disconnect; she tells Son to forget Jadine, adding, "She has forgotten her ancient properties'" (305). Morrison references this phrase in an interview with Judith Wilson for *Essence*. Wilson asks if privileged, educated women like Jadine "should feel guilty about themselves," to which Morrison replies, "No Black woman should apologize for being educated or anything else. The problem is not paying attention to the ancient properties—which for me means the ability to be 'the ship' *and* 'the safe harbor.'" Morrison concludes: "We have a special insight that can find harmony in what is normally, in this country, perceived as conflict" (J. Wilson, "Conversation"). Biggers's concept of *maamé* reflects Morrison's characterization of black women as "safe harbor"—as nurturing, strong maternal figures—but loses the connotation of the "ship." Both Walker and Morrison challenge the portrayal of black women as earth mothers, a portrayal popularized during BAM. Such a construct is incomplete; as Morrison argues, "Our history as Black women is the history of women who could build a house *and* have some children, and there was no problem." The *maamé* is only the safe harbor; Jadine, only the ship.

Jadine seems complacent when she is first introduced, but as her encounters with Michael, Son, and the African woman demonstrate, she also feels uncomfortable in her privilege, as though she has buried a part of herself. What initially reads as confidence and success quickly reveals itself as a facade. Jadine's relationship with Son allows her to explore her blackness in a new way, to perhaps rediscover her "ancient properties."

Morrison depicts Son as a beautiful, dark-skinned man from a historically black town in southern Florida. He arrives in Haiti almost by accident: he jumps ship and skulks about the Street property for several days, stealing food and glimpses at the sleeping Jadine, until he is caught hiding in the closet of Margaret Street (Valerian's wife). Initially, Jadine is disgusted by his filthy appearance, the muck of the swamp clinging to his exhausted body and unkempt dreadlocks. Yet it's not merely his appearance that unsettles her. Instead, she reflects, "He had jangled something in her that was so repulsive, so awful, and he had managed to make her feel that the thing that repelled her was not in him, but in her" (123). The stranger in yellow drove Jadine away from Paris, into the isolated Street home as a safe transition space, and Son disrupts her complacency once again, pointing to something inauthentic about Jadine. After Son bathes and cuts his hair, reemerging in the household as beautiful and polite, he transforms before Jadine's eyes: she sees African landscapes in his eyes and smile, and she characterizes him

as "crazy and beautiful and black and poor and beautiful" (186). Son, Jadine senses, may fill the part of her that's missing, the void left by her pursuit of privilege.

Son, meanwhile, views Jadine as a woman in need of rescue; he believes he can make her happy by shaking her out of her complacency and bringing her back to the proverbial briar patch. He plots her transformation, her immersion into black culture: "first tearing her mind away from that blinding awe. Then the physical escape from the plantation" (219); he imagines "insert[ing] his own dreams into her so she would not wake . . . but would lie still and dream steadily the dreams he wanted her to have about yellow houses with white doors which women opened and shouted Come on in, you honey you!" (119). Son's version of blackness, as implied in this passage, speaks to southern folk culture, more akin to the world of Maggie and Mrs. Johnson in "Everyday Use" than a model of the Black Aesthetic. Son's fantasy, then, is to marry Jadine and return with her to his home town, and for her to give up her current life and embrace his.

Critics have had polarized readings of this relationship: some see the union of Son and Jadine as potentially balanced and fulfilling; others view it as disastrous. In his article about the principle characters' "quest for wholeness," James Coleman suggests that Son and Jadine have the potential to fulfill one another, to balance one another's shortcomings and achieve a kind of personal wholeness through their relationship. During their initial move to New York, he suggests, "we see clearly that Son needs Jadine to direct him toward material achievement in life, and Jadine needs Son to give her a feeling of security and belonging" (65). Citing Jadine's observation that with Son, she feels "unorphaned" (Morrison 229), Coleman argues that Son offers Jadine "a feeling of security that she had never previously had" (66). However, such an interpretation underscores the patriarchal power dynamic Son imagines. In believing he will "rescue" Jadine, Son also believes that he knows what she needs better than she does, and that his identity is already fixed. Yet these characters see only what they need the other person to be; neither of the characters wants to change the way the other hopes. Jadine does not wish to disrupt her privilege nor lose the salary she can earn in the modeling industry, and Son paradoxically longs for both Jadine— independent, educated, modern—and the women he associates with Eloe. Their relationship, if successful, would lead not to self-realization for either character but rather self-denial. Son would have to surrender to the straight life of upward mobility and economic success that Jadine envisions for him,

or Jadine would have to surrender to the traditional gender roles and pro-
vincialism of Eloe.

It is the visit to Son's hometown of Eloe that foreshadows the couple's ulti-
mate dissolution and, ironically, triggers Jadine's journey to self-realization.
Morrison's view of identity construction here parallels Walker's in "Everyday
Use": both authors suggest that the journey to self-actualization requires a
confrontation, a trigger, to elicit such reckoning. Eloe, as Coleman suggests,
"is an all-Black, grassroots, folk community consisting of ninety houses and
385 people" (66); it is the proverbial briar patch. Jadine, however, sees not
the town of Son's nostalgic fantasies, but a backward place where she feels
like an outsider.

In Eloe, Jadine experiences the convergence of two nightmares, an older,
recurring nightmare in which she is attacked by large women's hats, and
a new nightmare in which all the black women in her life—the women of
Eloe, her aunt Ondine, the African woman—crowd into the room and bare
their breasts. As with the encounter with the African woman in Paris, Mor-
rison uses imagery rooted in the visual arts to depict Jadine's confronta-
tion. The *maamé* figure in Biggers's and other artists' African paintings has
an American counterpart in the form of the southern women depicted in
some of his more well-known work—for example, his painting *Shotgun, Third
Ward* (fig. 10), painted nearly a decade after his Africa trip. The hat night-
mare, despite Morrison's allusion to three white actresses, is reminiscent
of the southern women of Biggers's paintings and the colorful hats so cen-
tral to black women's church culture: "Large beautiful women's hats like
Norma Shearer's and Mae West's and Jeanette MacDonald's although the
dreamer is too young to have seen their movies or remembered them if
she had. Feathers. Veils. Flowers. Brims flat, brims drooping, brims folded,
and rounded. Hat after lovely sailing hat surrounding her until she is finger-
snapped awake" (44). Jadine's association of these hats with black identity,
as opposed to fashion, explains the fear they elicit. The black folk heritage
of Eloe is symbolically rendered in these hats, as the earth mother associa-
tion with African blackness is symbolically rendered in the women baring
their breasts.

Coleman and other critics have attributed Jadine's rejection of Eloe to
its wpoverty and provincialism: "Jadine emerges as a hard-driving, selfish,
materialistic Black woman with no strong connections to other people and
to the folk past, and Son as an easygoing Black man with great fraternal feel-
ing and strong connections with Black folk culture who is left unfulfilled,

FIGURE 10. *Shotgun, Third Ward #1* by John Biggers, 1966. (Smithsonian American Art Museum; museum purchase made possible by Anacostia Museum, Smithsonian Institution)

lonely, and unstable because of a tenuous connection with a materialistic future" (68). Such readings reduce Jadine's displacement in Eloe to material, superficial concerns. Certainly Morrison characterizes Eloe, at least through Son's eyes, as rich in a cultural heritage as a historically black town, but she resists presenting it as idyllic, even taking Jadine's biases into account. The relationship dynamic between Jadine and Son changes as soon as they arrive in Eloe; Jadine imagines their relationship shifting as they fall into more traditional gender roles and she loses her sense of autonomy. She cannot do her work as a model or historian in Eloe, and Son spends most of his time with his male friends, expecting her to fall naturally in with the women of the village. Morrison makes this gender commentary explicit when Jadine, accustomed to sleeping naked, is given a nightgown by Rosa, her host. After donning the slip, Jadine reflects, "No man had made her feel that naked, that unclothed" (253). Rosa has made her feel "obscene" (253) and forces her to inhabit her own clothing, implicitly asking that Jadine adopt her customs for as long as she stays in her home. When Rosa later appears as one of the women in Jadine's nightmare, intruding on her lovemaking with Son and baring her breast, it reads as an assertion

of her form of womanhood—maternal, traditional—over Jadine's modern, autonomous, and independent definition of womanhood.

Jadine's nightmare illuminates the problem with any projection of authentic blackness, whether the Afrocentric "earth mother" constructions of female beauty or Son's vision of rural southern black women. If, as Son implies, a white photographer transformed Jadine into the Copper Venus with "the six centimeters of cleavage supported (more or less) by silver lame," her hair "pressed flat to her head, pulled away from her brow revealing a neat hairline," and "her lips wet and open" (116), he only replaces the white man's role with his own: he wants to transform her into one of the woman at the pie table in Eloe. Similarly, if the early versions of the Black Venus were created by white men, the paintings of BAM were predominantly created by black men: they may have presented alternative standards of beauty, but they were still standards. Judith Wilson has indicated the complexity of the term "black aesthetic," which implicitly advocates racial essentialism and, when applied to art, risks "privileging a kind of singular view of African-American art that necessarily obscures the diversity of U.S. black artistic production" ("Shades of Grey" 26). Scholars, activists, and authors alike have responded to this problematic construction of blackness, including Audre Lorde, Barbara Smith, and Alice Walker, and Jadine's identity conflict shows how such constructions can be alienating. In the "Black is Beautiful" paintings by female artists from the 1960s and 1970s, the women, while breaking out of familiar images as weary victims of oppression, stretch the notion of what the familiar phrase means—in other words, applying "beauty" to concepts like African culture, motherhood, friendship among women, and other aspects of African and African American life. Later female artists, like Lorna Simpson and Faith Ringgold, would continue to expand non-Western concepts of beauty, constructing individual and multifaceted aesthetics rather than focusing on the body or promoting any singular standard. Some women, like Marsha Hunt, Angela Davis, and Barbara Cheeseborough, used their own images to defy Western ideals while also asserting their autonomy: they did not adopt an archetypal image but cultivated their own stylistic flourishes.

These female artists and models retain a connection to black culture even as they redefine its aesthetics, and this is ultimately Morrison's critique of Jadine: "She has lost the tar quality, the ability to hold something together that otherwise would fall apart—which is what I mean by the nurturing

ability. That's what one surrenders . . . in order to do this other thing—in order to go and get a degree in art history, learn four languages and be in the movies and stuff" (131). Morrison does not condemn Jadine's choice, as she quickly clarifies: "I'm only saying that the point is to be able to do both" (131). Jadine will not gain the ability to do both through her relationship with Son, for Son cannot teach Jadine how to connect with a culture that has not shaped her life. Jadine has no blueprint for the woman who can be what Morrison calls the ship and safe harbor: her aunt Ondine is nurturing but works as a servant for a white man; Jadine's own parents are dead, and she has no strong connections with any other black women in her life.

After her brief attempt to connect to an abstraction, Jadine goes back to Paris, where her narrative began, concluding that "she was the safety she longed for" (290). Given the free-spirited, sexually explorative nature of some of Morrison's other female protagonists, it seems strange and even dismissive to reduce Jadine's story to a rejection of her blackness, or even a failure to reconnect with her ancient properties. Instead, it is more useful to consider Jadine as a transitional figure, much like the Black Venuses of BAM. Both the Black Venus figures and the Eloe women show the need for alternatives and for individual agency—the ability to assert oneself through appearance, to align presentation with persona. Jadine rejects the limiting role of the earth mother in the interest of furthering her education and career, yet her path has been forged by white men, and she has lost the ability to connect with black culture. In her reading of the novel, Linda Krumholz suggests, "Morrison immerses readers in competing concepts of blackness to show the pitfalls in constructing meanings of blackness, while at the same time asserting the urgent need to engage with those meanings" (265). Certainly, Morrison resists asserting the Afrocentric vision of blackness of the woman in yellow or the image represented by the Eloe women as paragons of blackness; for that matter, she resists submitting *any* singular model of blackness to which African Americans should aspire. As Krumholz suggests, Jadine's journey is not so much one of conforming to a strict model of authentic blackness as to considering her relationship with her own racial identity. Both representations of blackness pave the way for exploration of alternative aesthetics and identities, whether in life or in the arts; both hint at Morrison's prophecy of modern, contemporary ways for black women to be ship and safe harbor.

Afrocentric Style and African Fashion

Morrison's *Tar Baby*, Walker's "Everyday Use," and Danzy Senna's *Caucasia* share a common thread: the authors represent fashion as a site of sisterly bonding, cultural solidarity, and personal expression—all facets of a fulfilling identity—and yet also the element that drives a wedge in the characters' relationships. The authors illustrate how the American ideals of individualism and upward mobility, often coded in stylish, expensive clothing, fail to encompass these characters' multifaceted identities and in fact challenge them to negotiate those identities. Yet just as mainstream clothing fails to encompass identity, so does the prevailing ethos and aesthetic of the black community. Conformity to community ethos, the authors imply, can create that same sense of alienation—worse yet, it can alienate individuals from loved ones as opposed to a white dominant culture. None of the young female characters in these novels—Dee, Birdie, and Jadine—fully achieve a balance between individual artist and part of a cultural community; however, by the end of each work, the authors have hinted at the possibility for such a balance in these characters, who are now set on journeys to self-awareness.

The Afrocentric clothing and styling in each of these novels feels ephemeral. Walker hints that Dee's look is simply part of a prevailing trend. By the time Birdie reunites with the rest of her family, the Nkrumah school has closed and trends in African American style have changed. Jadine returns to Paris—a city long recognized as the center for Western fashion—having consciously rejected Son and the ideal of blackness he represents, as well as the image of the woman in yellow. And yet each novel's confrontation with Afrocentric images has left its mark: a shift in consciousness, a questioning of Western values and aesthetic standards; a celebration of cultural heritage that resides outside of Western civilization. Afrocentric fashion impacted the way Americans think about beauty and culture, and it permanently impacted the fashion industry.

As the fashion industry has become increasingly globalized and digital, fashion and style have emerged as vehicles for nationalist solidarity and for building a global community that transcends the limitations of a traditional, Western fashion circuit. This change has surfaced in the work of contemporary authors, filmmakers, and other public figures. For example, in her 2013 novel *Americanah,* Nigerian author Chimamanda Ngozi Adichie depicts the centrality of blogging and other online platforms for bringing together black

women in solidarity through forums on hair, style, and fashion. The pro-
tagonist, Ifemelu, struggles with returning to her natural hair after relaxing
it for years, and she stumbles upon the website HappilyKinkyNappy.com.
The site proves transformative for her as soon as she sees the photographs:
"They had long trailing dreadlocks, small Afros, big Afros, twists, braids,
massive raucous curls and coils. They called relaxers 'creamy crack.' They
were done with pretending that their hair was what it was not, done with
running from the rain and flinching from sweat. They complimented each
other's photos and ended comments with 'hugs'" (262). Adichie illustrates
how platforms focusing on beauty and style can foster a supportive black
diasporic community, serving as a positive force rather than a destructive
one, particularly if the modes of styling and dress celebrate natural features.

In a more recent piece titled "My Fashion Nationalism," published in
the *Financial Times*, Adichie shows that African fashion has more to offer
African American women than a tool for strategic anti-essentialism. She
describes her disillusionment with American ready-made clothing: it rarely
has pockets, tends to be sleeveless, and doesn't accommodate women with
curvier figures. Adichie states, "I began to resist some standard ideas and
language of global—which is to say narrowly western—fashion. The depic-
tion of bright colours as bold or daring, black as the unimpeachable hall-
mark of sophistication, and beige as neutral, for example, were based on a
specific pale-skinned standard." For Adichie, the fashion industry's Western
bias extends beyond featuring white models or exoticizing the other; the
clothes themselves are constructed to suit white bodies, white features, and
white tastes.

Wearing Nigerian fashion exclusively began for Adichie as a project, an
attempt to support Nigerian businesses and grow the national currency,
but it evolved into something bigger. She gains something personal from
wearing these designs, a means of expressing herself creatively and taking
pleasure in what she wears. When reflecting on what had initially drawn
her to fashion, before moving to the United States, she remarks, "If I had
a style mantra, it was to wear what I liked." Investing in Nigerian fashions
became a way to contribute to the national economy, but it also meant cel-
ebrating local artists and designers, subverting notions that only Parisian
or Italian or American designers could create beautiful, innovative clothing.
She pushes back, too, against assumptions that all African clothing is tra-
ditional, an artifact to be appropriated by other cultures: "I have practical

hopes for my project, that it shows Nigerian fashion as it is, not a museum of 'traditional African' clothes but a vibrant and diverse industry, and that it brings recognition to the brands. But it is also a personal and political statement," she clarifies, calling her project "an act of benign nationalism, a paean to peaceful self-sufficiency." Adichie's gestures show the potential for fashion to be a safe space, a means of achieving self-definition with recourse to the personal, familial, and communal.

Implicitly, she cautions against the practices of the Afrocentric stylists of the 1960s; simply wearing a garment or piece of jewelry that reads "African" does not serve to express a holistic, purposeful identity, but merely to claim affiliation to a cause without understanding the signifiers. Rather, looking to non-Western fashion centers and independent designers, supporting those businesses that reflect one's communal and activist interests, and wearing what one likes can change clothing from a symbol of the oppressor to a site of liberation.

The 2018 popular film *Black Panther*, an adaptation of the Marvel comic, presents similar ideas about African and African-inspired fashion within a mainstream forum. The film's costume designer, Ruth E. Carter (who has designed for over forty films—most starring African or African American actors) drew inspiration from traditional and modern African designs for the colorful, dynamic clothing of the film. In an *Atlantic* piece written by Tanisha C. Ford, Carter explains, "The textile production, hand-dyeing, and beading techniques of the Tuareg, Zulu, Maasai, Himba, and Dinka peoples helped inspire an eclectic color palette; deep aubergine and crimson, effervescent chartreuse and tangerine, rich jade and silver"; she notes that she wanted to portray African fashion as modern and "cosmopolitan," not "frozen in the past" (Ford, "Why Fashion Is Key"). Carter's characterization of her design echoes Adichie's description of African fashion and provides an important contrast with the Afrocentric fashions of the 1960s. The earlier movement embraced the traditional elements of African fashion—many wearers cherished the notion of a continent "frozen in the past," awaiting their return, striking and different from what they knew in the West. Such visions of Africa fed into constructions of authenticity that fed the nationalist movement. And yet Carter and Adichie clarify the importance of resisting such constructions of Africa, denying the way it has changed over time—these characterizations reify perceptions of Africa as primitive or backward, disregarding the elements of African culture that have

flourished. Focusing only on traditional dress also dismisses the emerging designers and fashion scene that have exploded throughout the continent, especially over the past twenty years.

Like Adichie, Carter wanted to see the work of contemporary African designers showcased, the creative and innovative work disseminated. In the *Atlantic* piece she lists contemporary African fashion houses as primary influences in her work—Ghanaian Ozwald Boateng, Nigerian Ikiré Jones, South African MaXhosa by Laduma, Nigerian Duro Olowu (who, she notes, "dressed Michelle Obama"). Carter blended aspects of these and other contemporary African designers with traditional elements (headdresses, robes, makeup) and, in keeping with the comic book's portrayal of Wakanda as technologically ahead of the rest of the world, some futuristic elements. Her fusion of these elements reflects not only on the film's characters and the fictional country of Wakanda, but on Africa and African fashion: preserving elements of tradition while changing, modernizing, globalizing, looking to the future.

Adichie and *Black Panther* have not initiated the shift in African fashion, nor its changing position in a global fashion scene; rather they have tapped into a zeitgeist that began decades prior. In its 2015 Global Fashion Capitals exhibition, the Fashion Institute of Technology (FIT) Museum in New York recognized both Lagos and Johannesburg as thriving fashion capitals. According to the curatorial notes, Johannesburg's fashion scene exploded with the end of apartheid in 1994, when "designers embraced the city's vibrant, multi-ethnic culture"; the notes also give a sense of the range of South African styles, "from the avant-garde styles of Clive Rundle to dynamic streetwear brands, such as Stoned Cherrie, that move beyond the predictable African motifs of the established capitals to convey authentic, contemporary African fashion." With its first Fashion Week dating back to 1997, South Africa has since developed its own editions of mainstream periodicals like *Vogue* and *Elle*. The fashion scene in Lagos has emerged more recently onto the global scene, but its ascent has been rapid, with its first Lagos Fashion and Design Week in 2011, founded by Omoyemi Akerele, and Michelle Obama promoting looks by Maki Oh and Duro Olowu during Barack Obama's presidency.

These fashion capitals mark the emergence of African designers into global visibility, when in fact artisanal designers throughout Africa had established an international fashion network as early as the 1960s, as Leslie W. Rabine shows in her book *The Global Circulation of African Fashion*.

Rabine describes what she calls "the informal African fashion network," a network of artisans in Kenya, Senegal, Ghana, Nigeria, and other African nations who have developed careers as fashion producers without joining a global mainstream fashion circuit. These producers typically began their careers out of economic need, developed relationships with a consumer base largely composed of African Americans, and have marketed their goods from their homes, from suitcases when traveling abroad, and at various black cultural festivals and markets worldwide. From the 1960s when this informal market was in its foundling stages to the 1990s, Rabine notes, it came "to account for 60 percent of urban employment in Africa."[11] Rabine pushes back against neoliberal assertions that this informal market is a stepping stone to promoting African designs on the global circuit. In fact, she cautions against global marketing, arguing that mass market initiatives (particularly those propagated by the World Bank) will "destroy artisanal production and set up sweatshops in export-processing zones that have no physical or cultural resemblance to the African life in the rest of the country." In addition to taking the production away from artisans, leading to a more exploitative form of labor that shifts profits from producers to foreign investors, Rabine suggests that the global circuit will separate producers (African artisans) from consumers (African Americans) in a way that disrupts a mutually beneficial relationship. She uses the example of J. C. Penney's "authentic African" fashion campaign. Before this campaign, "African American consumers were helping African fashion producers develop economically while African producers of fashion, both in Africa and in the United States, were helping Black people construct an African American cultural identity." For Rabine, shifting African fashion from the informal network to the global circuit would mean ceding profits to foreign investors, taking production from artisans, dismantling the autonomy of "the informal African fashion network," and allowing investors and marketers to determine what represents "authentic" African fashion.

The ascendance of African cities as fashion capitals and the dissemination of African designs by Africans and African Americans reveal a possible balance, a means for African producers to retain profits as well as control over how their designs are manufactured and marketed. In the past two decades, online marketing, blogging, and other developments have opened up new opportunities for producers within the informal African fashion network, some of whom have made international names for themselves within the mainstream fashion circuit. Rather than allowing foreign investors to

determine definitions of "authentic Africa" and sell these constructions to a black diasporic community, African designers like Ikiré Jones, Duro Olowu, and Laduma Ngxokolo have offered up their own culturally inspired creations for a global market, using social media, product and fashion blogs, and other contemporary venues to widen their consumer base and bring attention to other local designs.

Promoting contemporary African designers means giving them more agency in how traditional motifs and textiles are represented and incorporated into modern looks; it takes away some of the power of Western designers who attempt to do the same. Over time, Africa's prominence in a global fashion market will ensure that this practice ceases to represent examples of cultural misappropriation, or the temporary *frisson* described by Jennifer Craik. By loosening European and American hegemony over an increasingly global industry, African and African American designers can have more control over the means of production, the environmental repercussions on local culture, the way their materials are marketed, the terms of any corporate partnerships they enter (e.g., Duro Oluwo for J. C. Penney, or Laduma Ngxokolo for IKEA), and the stories behind their designs. Moreover, rather than packaging and marketing a specific idea of "authentic Africa," these designers represent contemporary cultures throughout the continent in a modern, global market.

4

American Indian Literature and a Legacy of Misappropriation

Two white women, Betty and Veronica, had somehow
found their way to the reservation and showed up at
every rehearsal. They even parked their car outside Irene's
Grocery and set up camp. Betty slept in the front seat and
Veronica slept in the back. Both had long blonde hair
and wore too much Indian jewelry. Turquoise rings, silver
feather earrings, beaded necklaces. They always appeared in
sundresses with matching Birkenstocks.

—Sherman Alexie, *Reservation Blues*

SPOKANE-COEUR D'ALENE INDIAN AUTHOR Sherman Alexie introduces
the white female characters of his 1995 novel, *Reservation Blues,* in a way
that establishes the novel's theme of popular misrepresentation and cultural
misappropriation in mainstream American culture. The women, Betty and
Veronica—an allusion to the all-American characters of the *Archie* comics—
bedeck themselves in the cliché garments and jewelry they associate with
American Indians: feathers, turquoise, and beaded necklaces. They do so to

signify their New Age personas rather than to honor or understand tribal identity.

Alexie satirizes this practice of appropriation, hinting at privileged consumers' responsibility to the cultures they appropriate. Yet Alexie also looks beyond the consumer—in this case, the well-meaning white women—at the more exploitative institutions behind appropriative practices in American popular culture. These institutions, often represented by corporations in Native American literature, threaten indigenous culture in numerous ways: in how they exploit individuals to enhance their own profits; how they misrepresent tribal cultural practices and thereby disseminate false stereotypes within American popular culture; and how they disregard sacred practices and motifs in tribal culture for the sake of pandering to consumer interests. In Alexie's novel, for example, he questions how indigenous groups can build careers from their passions yet somehow avoid the corporate machine that exploits such talents to capitalize on current trends. The epigraph brings to mind the multitude of companies that sell "Native American–inspired" products that misrepresent tribal cultural practices and perpetuate false stereotypes to an American dominant culture.

Cultural Misappropriation in Fashion

Alexie isn't alone in satirizing these practices. Contemporary American Indian artists and journalists regularly use online media to expose some of the most pervasive or offensive examples of cultural misappropriation. In January 2013, Chippewa fashion blogger Dr. Jessica R. Metcalfe published a post titled "Misappropriation and the Case of the Yellow Crotch."[1] In this post, Metcalfe excoriates a fashion line by collaborators Jeremy Scott and Adidas on two accounts: first, the designers claimed the line was inspired by Native American totem poles, and second, the designers did a poor job of representing totem poles, thereby cheapening this sacred artifact of indigenous culture in the eyes of uninformed consumers. Metcalfe does not merely discredit the fashion line's authenticity as Native-inspired, however. She also clarifies, for her readership, the cultural meaning behind totem poles: "Totem poles tell stories, and relay information about our lineage, heritage, and history. . . . The images on these poles are owned by the various families and clans they represent, and unauthorized copies are seen as infringements upon rights." Her shift between discrediting the misappropriator and

shedding light on legitimate cultural representations surfaces in many of her *Beyond Buckskin* posts. This technique—teaching about and celebrating indigenous culture while protesting illegitimate appropriations of indigenous culture—reflects a common theme in contemporary American Indian writing and fashion design. Through the *Beyond Buckskin* blog, Metcalfe champions contemporary American Indian designers and artists, fosters a sense of community and cultural awareness, and speaks out against instances of cultural misappropriation and exploitation—all while holding the perpetrators accountable. Similarly, contemporary indigenous writers often satirize or denigrate dominant culture Americans who misrepresent tribal culture while celebrating their authentic tribal cultures as they have persisted and evolved over time.

As I note in the introduction, cultural appropriation refers to the practice of privileged people or institutions using decontextualized material from the culture of a less privileged group to advance their own pleasure, power, or status.[2] Often, the term "cultural misappropriation" is used interchangeably with the term "cultural appropriation"; however, the terms have slightly different connotations. Metcalfe specifically uses "misappropriation" to imply that the person appropriating Indian motifs (like totem poles) misuses or misrepresents those motifs. A non-indigenous person who buys an authentic Gitxsan totem pole and displays it in their home as a sculpture may be engaging in cultural appropriation (the possession of the item confers status but does nothing to better the conditions of oppressed indigenous populations), but Jeremy Scott, by misrepresenting and even sexualizing totem poles in his clothing line, engages in cultural misappropriation. Both constitute problems of exploiting marginalized cultures for personal gain, but misappropriation connotes both economic exploitation and misrepresentation. Cultural appropriation is inherently more complicated in the context of American Indian transactions with whites. Native tribes have engaged in trade for at least half a millennium, and many Indians earn a living by selling nonsacred items (jewelry or hand-beaded moccasins, for example) in stores, online, and through trading companies. If instead of a sacred item like a totem pole, the aforementioned collector purchased a nonsacred item from an indigenous designer or craftsman, the treatment of that item would carry a different connotation.

The appropriation of indigenous culture in the United States dates as far back as the Revolutionary War period, arguably to the Boston Tea Party, when Boston colonists donned Indian dress to assert an identity distinct

from Britain (Deloria 2). These early instances of appropriation allowed whites to perform a non-British American identity during the years surrounding American Independence. Literary scholar Joanna Ziarkowska argues that such examples of donning native dress became more widespread during the industrial period of the late 1800s, reflecting how as the nation was undergoing rapid economic and organizational change, American anxiety about these changes intensified: "the dynamism of rapidly modernizing American society and the ensuing crisis of identity created a sense of nostalgia for origins, best illustrated in the fascination with the primitive" (102). The nineteenth century is saturated with examples of cultural appropriation in plays and novels written by white Americans.[3] At the turn of the century, baseball teams began appropriating American Indian images and tribal names, and fans wore (and continue to wear) misappropriated signifiers of these tribes. Looking at the larger spectrum of these appropriations, Philip J. Deloria suggests that the performance of Indian identity "has clustered around two paradigmatic moments—the Revolution, which rested on the creation of a national identity, and modernity, which has used Indian play to encounter the authentic amidst the anxiety of urban industrial and postindustrial life" (7). The Boston Tea Party exemplifies the former: the appropriation of Mohawk garments was intended to assert a distinct American identity in the protestors' rebellion against Britain. The latter we can find in the familiar trope of the noble savage that simultaneously aims to "critique Western society" and justify "a need to despise and dispossess" the indigenous population (Deloria 4). Today, this trope surfaces in Hollywood films like *Avatar*, in which a white savior protagonist embraces elements of an indigenous culture (albeit a fictional one) while retaining the benefits of his white male privilege, and in fashions meant to connote a "hippie" or "New Age" identity.

In fashion magazines, American Indian motifs began appearing at the beginning of the twentieth century; however, these early examples were more anthropological in nature—for example, a feature titled "The Navajo Blanket" appeared in an April 1903 issue of *Vogue* ("Features: The Navajo Blanket"). During this period, more white Americans were moving to New Mexico, which would become a state in 1912, and these demographic changes may explain why *Vogue* first began featuring articles about the Navajo and, after 1900, selling Navajo items like rugs and blankets. By the time New Mexico became a state, Navajo themes were promoted by the magazine as home decor, although during the early twentieth century there were only limited

examples of Navajo and other indigenous pieces in mainstream fashion. However, non-indigenous companies would copy various American Indian patterns and motifs in later years, mass-producing native-print textiles during the 1920s for corporate profits (Hill 45).

Fashion journalists did not really begin promoting American Indian motifs beyond textile prints until after World War II, when such motifs became associated with the music industry. The music industry is rife with examples of cultural appropriation, but the Bob Mackie designs for Cher constitute one of the most widely recognized examples. In Cher's video performance for "Half Breed," which first aired in 1973 on *The Sonny and Cher Comedy Hour,* the artist sits on a horse in a sparkling bikini wearing a Plains Indian warbonnet (fig. 11). Although the song is ostensibly autobiographical, the lyrics, and especially the video performance, are problematic for several reasons. First, Cher's sparkling bikini underscores a colonialist pattern of sexualizing native women, a pattern that still impacts indigenous women today. Costumes like Cher's, as well as "sexy Indian" Halloween costumes and other examples of sexualizing and misappropriating indigenous dress, reinforce a Western perception that has sexually objectified native women for centuries; today, one out of every three native women are victims of sexual assault (Tioleu).[4] Second, Cher claims to be half Cherokee as she laments her difficult childhood of being ostracized from whites and Indians; however, her mother was not a full Cherokee as the song implies— in fact, critics of the song indicate her Cherokee heritage may be fabricated ("Controversy of Cher's Heritage"). And third, Cher is claiming to be Cherokee, and yet she wears a warbonnet—an imitation of a sacred garment from the Northwest Plains tribes. In a 2012 *Huffington Post* piece, Metís Indian Chelsea Vowel explains that the warbonnet is a sacred and "restricted item": anyone wearing the garment should either be "a native male from a Plains nation who has earned a headdress" or someone "given permission to wear one (sort of like being presented with an honorary degree)." The warbonnet has traditionally been made of eagle feathers placed in a formation to emulate the sun, as eagles were viewed by Plains Indians as "chief of all birds and associated with Thunderbird . . . a representative of the sun and subsequently the most potent sky creature" (Dubin 245). Wearing a warbonnet without earning it, for native peoples, is the equivalent of wearing "a medal of honor or a purple heart" without earning it (Tioleu). In recent years, therefore, native bloggers and even mainstream news sites have spoken out on numerous occasions against the misappropriation of the warbonnet.

FIGURE 11. Image still from Cher music video for "Half Breed," performed on
The Sonny and Cher Comedy Hour, 1973.

Bob Mackie's headdress designs for Cher are some of the most widely rec-
ognized and iconic in popular music lore: they are glamorous, larger-than-life,
and—perhaps because they recall Cher sitting half-naked on a horse—
highly sexualized. Cher still wears them on occasion, and *Vogue* has pro-
moted them as sexy fashion accessories as recently as the 1990s, when
Linda Evangelista sported a bright red warbonnet in a nostalgia piece on
Cher's style. Today, the warbonnet is a popular accessory at the Coachella
Valley Music and Arts Festival, where every year young scantily clad women
wear warbonnets they've purchased from nonnatives on Etsy or through
retailers like Novum Crafts.

Such practices of cultural appropriation in American fashion and music
are satirized in this chapter's epigraph from *Reservation Blues.* The epi-
graph usefully frames the contemporary works discussed in this chapter,
including Alexie's novel, Winona LaDuke's *Last Standing Woman* (1997), and
Joseph Boyden's *Through Black Spruce* (2008).[5] Alexie alludes to examples
of cultural appropriation on two levels: an individual level that at first
glance may seem harmless, and a more explicitly hegemonic institutional
level. Betty and Veronica represent the type of misappropriation seen at
Coachella, harmful in action but not in intent, while as I discuss in the next

section, the novel also introduces a more institutionalized and damaging form of cultural appropriation. Alexie and several other writers discussed in this chapter connect such attempts to corporatize tribal culture with a whole legacy of white exploitation through deceptive dealings, usually in the form of treaties and land contracts. By evoking this legacy, these writers shed light on contemporary indigenous artists' choices to opt out of corporate deals: because of a resistance to mass production and a suspicion of institutional exploitation for profit.

The authors discussed not only expose a legacy of misappropriation, but they also replace misrepresentations with more accurate representations of indigenous culture in earlier and contemporary contexts. Through these representations, the authors recognize indigenous cultural continuity and tribal diversity. The novels refute the damaging Western construction of the "Vanishing Indian" (which suggests, among other things, that indigenous culture is dead or dying) and instead illuminate native cultures as thriving and continuous, even if tribal cultures have changed through contact with other populations. Such themes of continuity and tribal distinctiveness dominate contemporary novels by Anishinaabe writers, including the work of acclaimed novelist Louise Erdrich and environmental activist Winona LaDuke. Each author portrays the poverty and struggle of reservation life with frankness, yet also indicates how contemporary problems are rooted in contact, and how a living, breathing indigenous culture continues to thrive and evolve despite the oppressive actions of individuals and institutions.

These tribal cultures are diverse, not monolithic. Alexie and LaDuke push back against the essentializing tendencies of the dominant culture, as whites tend to assume all tribes have the same history, dress, and cultural practices; the novels thus emphasize practices or themes distinctive to their respective tribal cultures. Such differences often surface through clothing, as the dress of a particular tribe is connected to that tribe's environment, climate, and traditional means of sustenance. In the context of fashion, therefore, these novels reveal how practices that may seem superficial and disposable to a mainstream American culture that thrives on temporary trends has a more serious, even sacred, significance to a tribal member. The authors' attention to the details of tribal dress clarify the stakes in contemporary debates about cultural appropriation. When a white person dons a warbonnet and dismisses accusations of cultural insensitivity, that person reinforces the notion that the sacred rituals of a tribal culture don't matter.

Finally, these authors hint that healthier relationships between white and native populations are possible. This change, they suggest, can only come through struggle and education: the self-assertion of tribal members, who must interact with aspects of the dominant culture while preserving tribal culture; the willingness among whites to educate themselves about tribal identity and cultural sensitivity; and the purging of exploitative endeavors from the government, both tribal and federal. Ultimately, the novels in this section have a kind of dual trajectory. They seem tragic in the way the characters "fail" to achieve a dream that fits with a dominant culture mythology of material success. However, they are hopeful, even triumphant in that the characters achieve self-discovery and a sense of higher purpose. That purpose is intricately connected to the traditions they associate with their tribal cultures, their community, and a history of struggle.

In negotiating the issues surrounding cultural appropriation in American fashion, the authors on the one hand reject false representations but on the other hand resist setting forth a construct of authentic identity or representation. Instead, they present tribal identity as performed, reinterpreted, and fluid, adapting over time in accordance with environmental, generational, and political shifts. Given that contact began at least as early as the fifteenth century, tribal identities have been in steady fluctuation for at least five hundred years. The authors' emphasis on fluidity and performance recalls Judith Butler's argument of gender performativity in *Gender Trouble*, in which she rejects notions of biologically inscribed gender identity in favor of gender performativity: in other words, she suggests that no authentic or original version of "masculine" or "feminine" exists, but instead, by performing these concepts, people establish normative behaviors associated with each term. In her article on ambiguous identities, cultural studies scholar Loran Marsan applies Butler's theory to the performance of "Othered identities" (47), indicating the various ways that "popular culture challenges authentic or originary identities in order to interrogate how certain images or people within it might divert mainstream culture away from ideals of authenticity and thus also away from the identitarian 'truths' that reinforce oppression of those in the 'Othered' categories" (49). When notions of "authentic" indigenous identity are challenged, for example, mainstream cultural institutions can no longer create a recognizable indigenous monolith and fetishize objects or ideas associated with that monolith. In other words, as tribal members become more visible in their performance of tribal identity, they challenge white dominant culture

performances of indigenous identity. As the novels I discuss demonstrate, the authors destabilize authentic or originary identities propagated by a white dominant culture that aims to position constructions of the primitive as authentic for its own benefit. However, the novels also challenge any monolithic constructs of tribal identity. In doing so, they suggest that even claims to indigenous identity can and must be continually reassessed and questioned. Indigenous cultural identity must at the same time be strong enough and flexible enough to withstand the ongoing crucible of a white mainstream culture that has consistently sought to exploit it.

Institutional Exploitation in *Reservation Blues* and *Through Black Spruce*

In November 2015, the Peabody Essex Museum (PEM) debuted the first major U.S. American Indian fashion exhibit, titled "Native Fashion Now." The exhibit ran from November 2015 to March 2016 at the PEM before traveling to other cities throughout the next year. In an article posted on the *Racked* fashion/retail blog, several of the featured designers are quoted as remarking on the personal and cultural significance of their designs, their use of social media to promote their work, and their decisions *not* to sign contracts with major retailers. The author of the post, Chavie Lieber, explains this choice: "This isn't just a matter of bypassing corporate bureaucracy nor is it reflective of their ability to actually get picked up by these stores. Many Native designers see their work as wholly unique, and while they are keen on making a profit, they aren't looking to scale up." In the same post, Lieber quotes former *Project Runway* contestant Patricia Michaels and another designer, Sho Sho Esquiro, both of whom resist mass-producing their garments; Esquiro explains that her designs "are special, handmade, and take like 300 hours to make." Esquiro also indicates the environmental cost of mass production, noting, "The world of fashion is becoming so disposable and I don't ever want my clothes to contribute to that. I don't want to leave that kind of carbon footprint" (qtd. in Lieber). Michaels, from Taos Pueblo, New Mexico, uses treatments like hand-dyeing and hand-painting, as well as motifs reminiscent of her native Taos Pueblo. In her garment titled "Herd Passing Through Aspen Breeze" (fig. 12). Michaels uses silk satin, stretch silk, and silk organza to create a draping effect meant to represent breeze and mist, conveying a shift in the seasons. The work contains images and

FIGURE 12. Patricia Michaels, "Herd Passing Through Aspen Breeze," 2019.
Silk satin, silk organza, and stretch silk. (Image provided by designer Patricia
Michaels)

motifs from the natural world, including hand-painted elk antlers in the
base layer. The garment shows the level of care, thought, and craftsmanship
that Michaels puts into a single piece, as well as how she draws from her
home and tribal culture in her designs and techniques.

Despite their attempts to create for themselves and opt out of a corpo-
rate culture, these designers often still see their work misappropriated by

mainstream designers and corporations. In 2015, Northern Cheyenne/Crow fashion designer Bethany Yellowtail saw her work plagiarized by the KTZ brand during New York Fashion Week. Cherokee scholar Adrienne Keene clarifies why such misappropriations are so problematic: "Bethany's design is not just a collection of abstract shapes, she utilized Crow beadwork that had been in her family for generations for her design. The colors, the shapes, and the patterns have meaning, origins, and history. They belong to her family and tribe. They are cultural property, not designs that are free for the taking."

Designers like Yellowtail, Esquiro, and Michaels indicate several reasons for avoiding major corporate entanglements in their careers as artists and fashion designers. First, they consider their creations individual works of art; both Esquiro and Michaels use phrasing like "individuals" and "special," emphasizing the uniqueness of each piece and their resistance to seeing cheaply made versions of their clothing. Second, they resist the wastefulness and environmental damage that comes with fast fashion and mass production. Metcalfe indicates a third reason in a May 30, 2016, *Beyond Buckskin* post: the major retailers like Urban Outfitters and Forever 21 who tend to sell "Native-inspired" clothing and accessories have a history of taking business away from tribal designers. She explains that approximately one third of American Indians "are either practicing or potential artists" ("I Don't Like Etsy"). Here, she shows how even a site like Etsy, which has served as a platform for individual native artists to promote their work, has been complicit in allowing nonnative designers to promote their work as "native" in violation of the Indian Arts and Crafts Act. These artists, through their acts of cultural appropriation, detract from the business of native designers. However, the major designers and retailers (Metcalfe lists "Pendleton, Ralph Lauren, Urban Outfitters, Minnetonka Moccasins, Forever 21, and basically any brand with a 'Navajo' collection that has nothing to do with Native people, and so many others") are especially damaging in that they reach—and thus mis-educate—a broader range of consumers, and in that they achieve a much higher profit margin, thus taking that much more income away from native artists.

These perspectives are useful in establishing a context for the novels in this section, all of which caution against the American mythology of self-interest and upward mobility at the cost of the community or environment. In her analysis of LaDuke's *Last Standing Woman* and Erdrich's *Antelope Wife*, Esra Körpez argues that the windigo, a figure of Anishinaabe oral narrative, symbolizes the threat of mainstream American values to the

continuity of indigenous culture. Körpez describes this figure as a "cannibal ice monster . . . believed to be a malignant spirit who stalks the desolate forests of North America during the long winters of impending starvation" (349); thus the windigo has historically symbolized the person who, in the face of desolation, is driven to desperate and destructive measures. Yet the oral narrative has continued and changed over time, and this figure now represents a more universal idea about human nature: Körpez suggests that oral narratives about the windigo teach "the value of self-denial for the public good" (350). The narrative contrasts indigenous values with mainstream values, for it privileges the Anishinaabe perception of "humans as always dependent on the goodwill and guardianship of Mother Earth and her spirits" over "the Judeo-Christian tradition that elevates humans to the images of God" (350). The windigo narrative thus parallels the ideas of the fashion designers: both argue for putting the public good and environment first, individual needs second. Individuals cannot pursue Western ideas of success, upward mobility, or self-interest without considering cost to family, community, and environment.

Both Alexie's 1995 novel *Reservation Blues* and Joseph Boyden's 2008 novel *Through Black Spruce* feature individuals pursuing American ideas of success, ideas rooted in the desire for money, fame, and material goods. In each novel, an indigenous character is faced with the opportunity to achieve fame and wealth by signing a contract with a corporate executive: in Alexie's novel, a record contract, and in Boyden's, a modeling contract. However, both opportunities come with a price, forcing the characters to weigh the materialism and glamour they would bring against the community and culture they have left behind. Fashion and clothing initially surface as the trappings of a materialist mainstream; however, the authors reveal the indigenous relationship with clothing to be more complex, distinguishing between material for self-promotion and material imbued with history and meaning.

Alexie's novel only grazes the surface of the fashion world; however, he fuses references to fashion with references to music, film, and other forms of popular culture to illustrate how reservation Indians actively engage with an American mainstream. Although protagonist Thomas Builds-the-Fire embraces aspects of tribal culture (he's a compulsive storyteller, he interprets his dreams, he participates in tribal powwows), these aspects of his life are balanced with his knowledge of and interaction with mainstream culture. Fashion, in this context, represents not the American fashion

industry, but rather personal and cultural versus institutional control of an image. Alexie illustrates how dominant culture institutions control public images of indigenous identity, a control that trickles down to white New Age bookstore owners and even indigenous people themselves. By opting out of the contract yet continuing to engage with mainstream culture, the indigenous characters continue to challenge and destabilize the monolithic image of indigenous Americans that saturates our popular media.

Reservation Blues opens when the legendary guitarist Robert Johnson arrives on the Spokane Indian reservation, having supposedly faked his death back in the 1930s.[6] He gives his magical guitar to Thomas Builds-the-Fire, who quickly realizes that this guitar allows him to play with stunning virtuosity. Thomas comes to fear the guitar's power, however, when he realizes the Devil speaks through it. Seeing the potential for creating powerful new music, Thomas becomes the lead singer of an all-Indian band, Coyote Springs, but out of caution, bequeaths the possessed guitar to resident bully, Victor. They are joined by Junior (drummer) and later Flathead Indian women Chess and Checkers Warm Water (vocalists).[7]

When the band begins booking gigs, they stir up a local controversy, as white women first begin flocking to their shows. The white female characters Betty and Veronica, who initially follow but later join the band, represent a familiar, prevalent form of cultural appropriation: the women seem harmless, and they perceive themselves as flattering the band and "honoring" their culture with their appreciation for native symbols and garments. The women are white, middle-class folk musicians and proprietors of their own New Age bookstore. They wear feathers and turquoise jewelry to enhance their public identities as New Age, spiritually connected women; they have absorbed dominant culture messages about American Indians that label them as collectively wise and close to the earth. They have no knowledge of the poverty and violence of reservation life, and they exhibit no intention of attempting to change socioeconomic hierarchies. Their appropriation therefore appears escapist and self-serving. When Thomas Builds-the-Fire is interviewed about Coyote Springs, he explains his concerns about Betty and Veronica following the band: "Look at them. They got more Indian jewelry and junk on than any dozen Indians. The spotlights hit the crystals on their necks and nearly blinded me once. All they talk about is Coyote this and Coyote that, sweatlodge this and sweatlodge that. They think Indians got all the answers" (158). Thomas's criticism speaks to several different problems with Betty and Veronica's misappropriation: the women illustrate

a lack of understanding of tribal culture; they fetishize native identity; they exploit popular culture understandings of tribal identity to reinforce their own identity as New Age and spiritual; and their fascination with Native culture does nothing to change the marginalization of tribal culture in the United States.

In addition, the women seem to know nothing about actual tribal dress specific to Plateau Indians like the Spokane. Like the women at Coachella, they prefer to wear what they consider signifiers of a monolithic American Indian culture blended with clothing associated with hippies or New Agers (like their crystals and Birkenstocks). Had they really wanted to dress in the traditional style of the Plateau Indians, they would have worn more woven elements. The clothing of Spokane and other Plateau tribes has traditionally reflected the centrality of weaving to their tribe's precolonial means of survival: they derived their primary sustenance from fishing and digging camas roots, and thus they needed nets and baskets (Dubin 348). While some Plateau tribes would eventually use beads gained through trade, Plateau Indians have traditionally used beads to embroider patterns of the local "plants, flowers, and animals that sustained human life" rather than stringing necklaces with them (348). Betty and Veronica's references to the coyote reflect a more specific understanding of the local tribes, whose central figure is the coyote (hence the band's name Coyote Springs). However, Thomas's frustration implies that Betty and Veronica do not actually understand the relationship of this figure to the tribe, or that they do so in a superficial manner. Alexie has humorously expressed his frustration with such misconceptions and misrepresentations in multiple interviews, including a 2008 interview with Stephen Colbert: "Everybody thinks we have magical, spiritual powers. . . . I cannot talk to animals." Alexie characterizes the tribe's relationship to the Coyote in a more fluid way. When Thomas considers the band's use of Coyote in its name, he writes down three different definitions in his journal:

> Coyote: A small canid (Canis latrans) native to western North America that is closely related to the American wolf and whose cry has often been compared to that of Sippie Wallace and Janis Joplin, among others.
> Coyote: A traditional figure in Native American mythology, alternately responsible for the creation of the earth and for some of the more ignorant acts after the fact.
> Coyote: A trickster whose bag of tricks contains permutations of love, hate, weather, chance, laughter, and tears, e.g. Lucille Ball. (48)

The first definition is biological, but Thomas compares the cry of the animal to a black jazz musician and a white blues musician, both of whom he admires. The second definition is more traditional; the third blends the traditional (Coyote is a trickster figure in Plateau tribal culture) with contemporary mainstream popular culture (Thomas compares Coyote to Lucille Ball to explain his role as trickster). His understanding of Coyote complicates Betty and Veronica's perception of tribal culture as something primitive, insular, and frozen in a precolonial time. Contemporary tribal culture, Alexie suggests, cannot be divorced from its history of contact, and he represents this hybridity in how traditions are reinterpreted in the present and even in the band's appearance: both Thomas and Junior wear their hair long, in more traditional styles, but they dress in contemporary mainstream clothing (aside from Victor, who wears 1970s disco clothing).

Although Betty and Veronica seem to love and appreciate tribal culture, they actually demean this culture by refusing to understand it except insofar as it reinforces their preconceptions. In her analysis of how American Indian writers represent the "marketing" of tribal culture and people, Ziarkowska suggests the white women approach Indian culture as a form of "weekend entertainment": "Their brief forays into the Spokane Reservation are manifestations of cultural tourism which, as a neo-colonial enterprise, 'extracts' the cultural resources needed to resuscitate the connection with the primitive while at the same time consistently refuses to acknowledge less appealing aspects of reservation life, such as poverty, unemployment and alcoholism" (105). Betty reinforces this notion of connecting with the primitive when she tries to explain the appeal of Indian culture for her and Veronica: "White people want to be Indians. You all have things we don't have. You live at peace with the earth. You are so wise" (Alexie, *Reservation Blues* 168). Betty's litany of clichés suggests that the women's attitudes reflect a broader American tendency to essentialize indigenous culture. As Betty relates her reasons to Chess and Checkers, she describes only the ideas she brought to the reservation, not the destructive elements she has encountered—her boyfriend's battle with alcoholism and depression, the poverty and violence surrounding her, the lamentable quality of government housing and rations on the reservation. When Betty and Veronica are forced to confront the reality of reservation life, they express their surprise and disappointment, and yet their disillusionment fails to permanently disrupt their perception of tribal culture.

Alexie contrasts Betty and Veronica's naive misappropriation of indigenous culture with the more acquisitive and exploitative record executives who approach the band later in the novel. At this stage in the narrative, Coyote Springs has developed a following among fellow Indians as well as whites, but their visions of fame and lucre escalate quickly when contacted by these executives, Phil Sheridan and George Wright (whose names recall two soldiers known for their cruelty toward American Indians). The executives begin to court the band, hoping to capitalize on what they have identified as a popular culture trend, as they report to their boss (Mr. Armstrong—an allusion to George Armstrong Custer). They assess the band's viability for the corporation by comparing their sound and appearances to the tastes of a popular American audience: "Overall, this band looks and sounds Indian. They all have dark skin. Chess, Checkers, and Junior all have long hair. Thomas has a big nose, and Victor has many scars. We're looking at some genuine crossover appeal. We can really dress this group up, give them war paint, feathers, etc., and really play up the Indian angle. I think this band could prove to be very lucrative for Cavalry Records" (190). Like Betty and Veronica, Sheridan and Wright refuse to accept the band they encounter as "authentic" Indians and instead conspire to correct the band members, to make them resemble what they deem a more recognizable representation of American Indians. Ziarkowska notes that their interest in the band's appearance speaks to their "potential to fulfill the fantasy of exotic warriors with warpaint and headdresses" (104). They care neither about the sound nor even the style of the band members, but rather the blank canvas of their identity. They arrange an audition in New York with the intention of signing them with their label, the aptly named Cavalry Records. The band members must grapple with what that contract represents for their future and, more symbolically, the future of the Spokanes and their interaction with mainstream culture.

When the band's audition is a failure, the disappointment of missing out on wealth and success infects the band members; however, Alexie resists characterizing their failure as loss. The fate of the other musicians referenced in the novel (including Elvis Presley, Janis Joplin, and Jimi Hendrix, among others), all of whom signed record contracts, became famous, and died well before their time (at forty-two, twenty-seven, and twenty-seven, respectively). Thomas comes to realize that signing a contract would have placed him at the mercy of the executives—who, Alexie reveals later, decide to mold Betty and Veronica into the Indian band they failed to create with

Coyote Springs. When the women send Thomas their demo tape, Thomas hears "a vaguely Indian drum, then a cedar flute, and a warrior's trill, all the standard Indian soundtrack stuff" (295). Ziarkowska observes, "Ironically, the trivialization of Indian culture demonstrated by Betty and Veronica, instead of being dismissed as an example of selective appropriation of the most appealing and superficial cultural elements, is enthusiastically embraced by the cultural mainstream as the only approach to Indianness which in fact generates profits" (105). Betty and Veronica's worship of pseudo-tribal culture has paid off in material gains for themselves and for the record executives, while conditions on the Spokane Reservation remain relatively the same. However, Alexie also hints that Betty and Veronica will become victims of corporate structure as well, becoming voiceless as they cede control of their careers, their lyrical content, and their physical appearance to Sheridan and Wright.

Alexie implies that the band's failure at the audition was necessary for Thomas, Chess, and Checkers to achieve the balance and self-awareness that has eluded them throughout the novel. They return to the reservation for a powwow, reconnect with their friends and their mentor Big Mom, and then decide to move off the reservation, together. This departure, however, does not represent an abandonment of their tribal identity, but instead the necessary mixed and improvisational identity that Alexie uses to replace any construct of authenticity or "pure" tribal identity—especially those imagined and perpetuated by an oppressive dominant culture. In his essay about the cultural sovereignty of Native American authors, David Murray suggests that in the novel's closing scene, in which Thomas, Chess, and Checkers drive away and see "shadow horses running alongside the blue van" (*Reservation Blues* 306), Alexie attempts "to blend together the traditional and the modern, to refuse the dichotomies within which Indians and Indian culture have been (mis)represented" (Murray 92). David Murray's analysis clarifies why Alexie may have chosen to have Thomas leave the reservation rather than return to it after the failed audition: staying at the reservation reinforces purist notions (in both tribal culture and mainstream culture) that American Indians must live on the reservation to preserve their tribal cultures. Alexie implies such an expectation is unrealistic—moreover, it's harmful; it suggests that "real" Indians have completely insulated themselves from American mainstream culture rather than having a hand in shaping it.

In a 2007 interview, Alexie clarifies his position on native fears about assimilation: "people who are worried about assimilation are always

worried about some romantic notion of purity. With assimilation, people always assume that it's a one way bridge—Native Americans . . . have had influence and been influenced by the common culture, we've all worked together to create it" (Mellis). In his autobiography Alexie takes this statement a step further: he suggests that not only have Native people shaped American culture, but they have claimed elements of it for themselves: "Don't you white folks understand that Indians turn everything we do into something Indian? That's how we reverse colonialism. By taking back most of the good things that were stolen from us and grabbing some of your good things, too" (*You Don't Have to Say* 337). The powwow at the end of the novel exemplifies such notions of cultural hybridity: powwows, which historian Rachel Buff refers to as a "cross-cultural form" (88), became popular during the mid-twentieth century as a means of reasserting tribal identity—and yet, these gatherings represented a blend of remembered Native traditions and new elements gleaned from popular culture, including Buffalo Bill Wild West shows (Furlan 64). In returning temporarily to the reservation for a powwow, then, Thomas and his band members are not retreating into a sanctuary of tribal purity, but to a newer tradition that exemplifies the cultural hybridity of contemporary native life. The members of Coyote Springs have learned that they can opt out of a contract that would have ceded control over their bodies and careers and yet still find another means of interacting with mainstream culture—establishing a relationship with that culture while still maintaining tribal connections and a sense of self- and community awareness.

Neither Alexie nor Canadian author Joseph Boyden, discussed below, idealize reservation or tribal community life.[8] Alexie is careful to show how reservation life is fraught with poverty, alcohol, and violence, a characterization echoed in his other novels as well as his autobiography. Reservation life bears the visible scars of colonialist rupture. For example, early in the novel Thomas alludes to his ancestral identity as a salmon fisherman, an identity so ingrained it has shaped his physical appearance. Yet because of how Euro-Americans have changed the landscape, constructing dams and developing cities, he and his tribe no longer sustain themselves from fishing but mainly live off of government rations like powdered milk and other canned goods. He makes it clear how the harmful aspects of reservation life are largely a product of contact—the reliance on government staples; the poor, unfinished housing; the omnipresence of alcohol; and a corrupt tribal government. Alexie balances these realities of reservation life with

the positive aspects of tribal and American popular culture—the music, benevolent leadership figures like Big Mom and the priest Father Arnold, storytelling, powwows, and Indian fry bread. Like Alexie, Boyden does not portray the tribal community as idyllic, but rather as a balance of the harmful legacy of colonial contact with persisting, positive cultural practices. Boyden's family ties, unlike Alexie's, are very present and positive. His novel's tribal community is gathered not on a reservation but in a small town, with occasional sojourns into the bush. These sojourns, Boyden implies, serve to test the persistence of Subarctic tribal practices, the ability to survive out in the wilderness, as well as to provide a kind of spiritual retreat from the chaos of the modern world.

While Alexie uses the contract to allude to a flawed history of tribal interactions with mainstream culture, in *Through Black Spruce* Boyden imagines what happens when the indigenous character signs the contract. In Boyden's novel, the narrative is divided between Annie Bird and her uncle, Will. Both are Cree Indians living in Moosonee, Ontario, and the story begins when Annie arrives home with her "protector," Gordon, to sit at her comatose uncle's bedside. The narrative alternates between their memories—Uncle Will's feud with a violent neighbor, and Annie's search for her older sister, Suzanne, a New York fashion model. In the Uncle Will chapters, Will lies in a coma yet retreats into his memories, addressing Annie in his unconscious state and telling her about the mounting tensions with his enemy, Marius Netmaker. These tensions culminate in several violent encounters that lead to Will's current unconscious state. Meanwhile, in Annie's chapters, she reacclimates to being home in Moosonee and following her traplines, while teaching Gordon how to hunt and trap. For most of her narrative, however, she sits at her uncle's bedside and recounts her own memories of a prolonged international search to track down her sister.

The contrast between Annie's story and her uncle's serves to highlight the traditional ways of the Anishinaabe people, practices that reflect a comfort with the local environment and a sense of purpose behind each action, and the culture of the contemporary American city, in which people insulate and ultimately lose themselves. Life in Moosonee is not idyllic, but Annie and Will exemplify a blend of traditional practices with the competing lifestyle that the modern world demands. Those who have succumbed to the modern world suffer the most both psychologically (from a lack of community or identity) and physically, as Annie points out: "In their lives, they've gone from living on the land in teepees and *ashikans*, hunting,

trapping, trading in order to survive, to living in clapboard houses and pushing squeaky grocery carts up and down aisles filled with overpriced and unhealthy foods" (36). Although Will has avoided such a fate by taking occasional long-term sojourns into the wilderness, returning to traditional survival methods, he, too, suffers from the changes across generations that began at contact. He and his friends indulge in self-destructive behaviors: Will's battle with alcoholism has brought about several major disasters in his life, including plane crashes and, indirectly, a fire that tragically killed his wife and child.

And yet, the Birds still uphold many of the old ways, and these traditional practices mark the moments in the novel when the characters seem happiest, most connected to one another, and most confident. These practices may overlap with some of the Northern Plains tribes (the Anishinaabe represent Plains, Northern Woodlands, and Subarctic tribes) but primarily reflect the traditions of the Subarctic Indian tribes. At different times in the novel, the characters hunt, trap, skin, and make clothing in ways that reflect Subarctic tribal values, which Lois Sherr Dubin indicates combine the sacred and the pragmatic: "A reverence for beauty was as essential to survival as the clothing that protected against extreme conditions" (112). Dubin explains that in an environment of such frigid temperatures, hunting could be unpredictable as animals migrated in search for food, and the people, too, typically led nomadic lives (112). In such extreme temperatures, clothing has held an essential role in tribal culture. As nomadic people, the Subarctic tribes kept few possessions, and their clothing was a means of survival. It had to be warm, of course, but the tribes also indicated the clothes' sacred importance with beautiful handiwork. Dubin observes, "A man's dignified appearance was amplified by his wife's handiwork and lent an elegance to Subarctic life"; after fur trade with the Europeans began, she continues, "Women embellished smoked hides with newly available silk threads and glass beaded embroidery. In this seemingly unlikely environment, flower motifs became predominant, which sparked a remarkable and enduring indigenous tradition" (112). Contemporary indigenous fashions in this region, therefore, reflect a blend of more traditional, precontact elements—animal hides, furs, "close-fitting sleeve cuffs and necklines, and combined legging-moccasins," fringes whose movement could flick off insects—and postcontact elements like elegant embroidery with glass beads and silk thread (116). Clothing in Boyden's novel emerges on a spectrum—furs and hides tend to represent precontact tribal practices, beading and embroidery represents

postcontact tribal practices, and the clothing Annie wears in New York represents mainstream American practices of style and dress.

Even the novel's traditional clothing, therefore, alludes to a history of trade with white, Western companies dating as far back as the 1500s (Dubin 120), as well as the suspicion that necessarily accompanies these interactions. At home in Moosonee, Annie returns to her family's practice of following traplines and trading furs; in one passage, she proudly surveys the fifteen martens she has trapped, skinned, and stretched on plywood to sell (Boyden 172). When Annie meets with the trader at the Northern store, she grows frustrated with the trader's patronizing attitude, and she feels he tries to shortchange her because she's a woman—perhaps because historically, the fur trade was dominated by men, with women participating mainly as seamstresses working the hides (Dubin 134). Annie finally gets a better price when she threatens to leave and take the beautiful pelts with her. Later, to her mother, she demands, "He totally tried to rip me off. Why? Because I'm a woman? Because I'm an Indian?" Annie's frustration confesses her pride in these practices, for they underline her connection to the materials, though the trade brings her far less money than she has made modeling. Her interaction also points to how even traditional ways adapt over time. Uncle Will has taught his nieces a trade historically practiced by men, while Annie reveals that the men, including her grandfather/ *Moshum*, are also taking on women's trades: "He stitches pieces of moosehide together, hide that he home-tanned over a rotten-wood fire. He makes moccasins for Suzanne and me, has just finished a hat for you, of moose and beaver fur, for the coming winter. I think it's funny watching him sew. Only old ladies do that" (346). Annie's memory indicates that her grandfather has laid the groundwork for shifting roles even within traditional tribal practices. Through these shifts, Boyden resists the notion that non-Western cultures are backward or inherently patriarchal. Like Alexie, he asserts that tribal culture is living and evolving; he undermines ideals of purity and authenticity.

Annie's experiences trapping and skinning are juxtaposed with the more traditional tribal women's practices of beading and sewing. After returning from the trader, Annie examines the moosehide slippers her mother is making in the living room, to be decorated with beading and beaver fur trim: "The scent of fresh-tanned moosehide, one of my favourite smells in the world. Tiny multicoloured beads pepper the glass top of her coffee table. Long, thin beading needles lay neatly in a pile beside thread. I look at

the moccasin top she's been beading. Pretty James Bay flowers. I pick up a piece of moosehide and bring it to my nose" (174–75). Through the details of Annie's description, she illuminates the sense of comfort she feels in these beautiful pieces, but she also accentuates the immersive nature of tribal clothing. Historically, Subarctic tribal clothing made from hides would have retained the shape of the animals from which they came (Dubin 118); this direct relationship with the source—in the smell of the hides, the colored glass reflecting the shades of flowers they depict—gives the clothing both a practical and a sacred significance and was believed to transfer the animal's power into the wearer.

Boyden contrasts Annie's relationship to clothing and trade in Moosonee with her immersion in the image-driven fashion scene of New York City. Critics have, by and large, panned the New York City portion of the narrative, calling it "boring," "blandness," "inert chick lit."[9] And yet the New York sections of the novel most clearly allegorize a historic pattern of exploitation in mainstream American culture. As Alison Calder observes in her review, "Colonization is still ongoing; it just wears new disguises" (209); Boyden, she argues, illustrates this phenomenon through the multiple narratives woven throughout the book. It is Annie's search for Suzanne that leads her to New York, where Suzanne was modeling up until she disappeared. Annie is accompanied by Gordon, a silent man who becomes her protector after he prevents a man from beating and sexually assaulting her. The city becomes the site of her own rite of passage, in which she loosens the ties that bind her to home and community and succumbs to the temptations of self-interest, the American values of money, success, fame, and individualism. Annie characterizes her time in New York as a period of her own disappearance, out of necessity: "This became a time for me to explore, to test my powers, to live in someone else's skin, it felt like, for a while" (177). During her New York interlude, the word "skin" takes on a literal and symbolic meaning: she symbolically attempts to inhabit her sister's life and body, even losing weight and taking on her agent and group of friends; she also wears her sister's "skin"—her clothing, her moosehide hat, her accessories.

Boyden thus portrays Annie's time in New York as a period of deliberately losing herself by performing her sister's identity. During this phase of her life, Annie frequently describes looking at herself as though through someone else's eyes, or feeling disconnected from her body. After arriving in New York, Annie falls in with a group of Suzanne's model friends, who put her up in an apartment, arrange for her to shoot a portfolio, and get

her signed with an agency. Annie exercises little control over her life here but instead flows with the direction of her friends, even allowing another model to set up and manage her bank accounts for her. During her first night out with a new group of friends, they nickname her "Indian Princess" (181) and style her in her sister's clothing. In this passage, Annie allows the women to dress her as she clutches her grandfather's moosehide hat, which she has found among Suzanne's possessions: "I hold the hat out to them, show them the stitching, the beaver fur, how the flaps go down over your ears when it's really cold. Holding it warms my hands" (182). The hat seems to ground Annie and keep her comfortable as she is dressed in strange yet beautiful couture—a T-shirt "so soft it feels like a spiderweb" (182) and "a black skirt, red, red roses all across it. Vines of roses, intricately stitched. I want to run my fingers over them. They glow" (183). Interestingly, Boyden does not directly contrast the feel of Suzanne's couture clothes with the immersive experience of holding the grandfather's hat. Instead, as with her mother's beading, Annie has a multisensory response as she recognizes— and appreciates—the workmanship. She admires the couture and yet does not feel warmed by it; her only personal connection with the clothing stems from knowing her sister wore it.

The sense of displacement and passivity Annie feels when the women dress her is magnified when she first sees herself in print. Her model friend Violet and a man named DJ Butterfoot talk her into doing a portfolio, and during the shoot, Annie emphasizes how she looks like a copy of herself: "When the makeup artist's done, I stare at myself in the mirror. I look like myself still, but maybe an improved replica" (150). In these passages, Boyden uses language like "replica," "mirror," and other wording to suggest Annie is less herself, reflecting the familiar indigenous trope of photography taking away a person's soul.[10] In this context, however, the reflection characterizes Annie's drive to remain in New York for a time—to lose herself, to try to inhabit the world of her sister so that she might discover her whereabouts.

What Annie attempts to do on her own, however—erase herself and become her sister—others attempt to do for her, taking away her agency and, potentially, her ability to reinhabit her body and her life and return to Moosonee. With her model friends, she regularly binges on vodka, champagne, and ecstasy and stays out all night dancing in clubs. Annie reflects, "It's easy to get lost in their world, this place of late, late nights at different clubs, treated like a starlet when I am with Suzanne's model friends. . . . Getting home as the sun wants to rise, the other girls sleeping past noon,

it's something I've not done before" (196). Her commentary underscores her sojourn as a phase, almost a rite of passage: she finds it necessary to inhabit the specter of her sister. As Annie's behavior grows more reckless and she cedes more control to her friends and manager, however, Boyden leaves the reader questioning whether Annie can still reinhabit her life. Rather than becoming her sister, Annie begins to lose herself.

Here, then, Boyden reveals how contemporary corporate culture mirrors the impacts of colonization, wreaking the same psychological havoc even when disguised as economic opportunity. The representatives of the fashion industry—the photographer, the agent, the high-demand supermodels—take what they perceive as an "authentic" identity (Annie is viewed as an authentic Indian, a stand-in who can represent any number of tribes and other nonwhite personas), and they remake it into a commodity that they can sell to consumers. Survival, in this context, ceases to mean the literal survival associated with colonial practices of the eighteenth century and instead refers to a more abstract concept of survival: survival of tribal culture, survival of family traditions, survival of the "soul." For Annie, a career in the fashion industry drives her to a reckless nightlife and drains her sense of identity as an individual and Oji-Cree. Her photographer considers how she might become other ethnicities for modeling shoots as he dresses her in different clothes: "'You might pass for Asian,' the agent says. 'Or Spanish. Or even a beautiful Eskimo.' I laugh at that. The few raw-flesh eaters I know are short and have bad skin." Annie considers that "he is ready to sell" her, as he considers the marketability of her exotic looks (151). In his commentary, the photographer erases her tribal distinctiveness and begins plugging other ethnic personas into what he sees as the canvas of her looks. Like Alexie, Boyden shows how white Americans privilege their simulacra over the reality of any nonwhite group. He depicts the dehumanizing that occurs when ceding control of one's image and career, the consequences of signing a contract.

This new version of colonization, Boyden implies, threatens to erode cultural identity and community, replacing cultural knowledge with popular representations of that culture. Boyden portrays such erasure at the community and individual levels. For example, when Annie finally sees a photograph of herself, she questions, "What has happened?" (183). She sees not herself but her sister reflected in the picture, and as she combs through her portfolio, she sees a series of images from which she feels wholly disconnected: "A face, in close-up, stares back at me"; "I stop at a picture of me

sitting in a chair in a tight T-shirt and the tight leather pants, my legs open like a boy's and my elbows resting on my knees"; "I am naked in another, the picture taken from a ladder above, me on the floor with my legs and arms crossed. . . . I remember feeling scared, but this photo makes me look like I am hungry" (198). As Annie flips through these images, she sees herself through the eye of the photographer as sexy, exotic, aloof, and lifeless. The last image reveals how the camera misrepresents her emotions, separating the shell of her appearance from what's inside.

During her time in New York, Annie struggles to balance her sense of awareness with her attempts at self-erasure. To maintain her self-awareness, she reminds herself repeatedly that her modeling and partying are an experiment, a means of finding her sister. However, as sinister figures from her sister's life surface in her world, she realizes that through inhabiting her sister's body and life, she may be putting herself at risk of her sister's fate: "The fear worst of all is that I'm losing myself. The fear is that where I am going is where my sister has ended" (200). She begins reasserting herself in small ways and searching for traces of herself to stay grounded. These efforts include speaking Cree, especially when she feels drunk or high (233). In her review of the novel, Calder suggests Annie does this as a means of both self-protection and subversion: "she makes a point of 'protecting' herself by speaking Cree to people who want her to perform her Indian Princess identity: what her listeners don't know is that she is insulting them" (208). As Calder implies, Annie resists succumbing to the models' projection of her identity by pretending to perform that identity; in the act of performance, she reminds herself of its inauthenticity. Her actions drive her to begin questioning why she's modeling at all: "I show up at the address on the given day. . . . I sit and stand in front of a camera. Something that I've hated since I can remember. So why am I doing this?" (249). Her questions expose the sharp contrast between the Annie of New York and the Annie in Moosonee who angrily bargains with the fur trader—in her New York environment, Annie does not assert herself or try to control the price, but submits to what her white friends and manager tell her, resisting only in the smallest of ways. Boyden thus highlights the atmosphere of dependence fostered by the city and the modern world, reflecting a corporate culture that encourages individuals to put their trust in strangers.

Ultimately, Annie's contract with the modeling world brings her to the very brink of destruction: she becomes increasingly complacent, voiceless, and addicted to the glamorous lifestyle of the models. Although she claims

to stay for her sister, toward the end of her time in New York she acknowledges, "It's more than I've ever made in a whole season of trapping beaver and marten. . . . If Suzanne really is dead, then I will live for her. I'll be her, if need be" (250). The money keeps Annie in the modeling world even though she knows she's being used by both the companies and her group of friends, who see her as "an accoutrement on [their] wrist" (253). Even Gordon becomes more assertive and cautions her, "*Your friends aren't really your friends. They're going to hurt you*" (273). The danger of losing herself, ironically, is thwarted not by Annie or Gordon, but by the models, who abruptly lose interest in her and the novelty she brings to their group. Annie's glamorous lifestyle comes to an abrupt halt when the leader of her group of friends cuts her off both socially and financially. She is evicted from her apartment and her bank account is drained. As she scrambles to leave town, she comes face-to-face with the danger that drove her sister into hiding: a man named Danny, an associate of the same Netmakers who attacked Uncle Will. Boyden suggests Annie is vulnerable not only to a hostile corporate culture that wants to exploit her, but also to members of her own community who have already been corrupted and interpellated by that culture. Annie narrowly escapes: Danny beats her up and threatens to kill her before she is once again spared by Gordon's arrival.

While this closure to the episode in New York feels perhaps too neatly wrapped up, Annie's near self-destruction in the city bears some neat parallels to the New York journey in *Reservation Blues,* as well as the windigo narrative described by Körpez: "Humans who turned into windigos were perceived as frantic individuals possessed by their own self-indulgences, ready to endanger the well-being of the whole community" (350–51). Annie's pursuit of her sister devolves into a blind, emotionless pursuit of wealth and fame; her actions in New York, like Coyote Springs' pursuit of the record contract, does threaten to harm people close to her and further reinforces misrepresentations of her community; moreover, her actions erode and nearly destroy her. Yet again, her protector Gordon intervenes. Although Gordon initially seems to fit the role of a patriarchal cliché—a knight in shining armor—he can also be read as a metaphorical link to her Anishinaabe community: he disappears for much of her action in New York, slinking into the shadows or resurfacing to issue a silent warning. And yet when her life is threatened, he brings her back to herself and, eventually, her family.

This violent conclusion to Annie's modeling career and experiment in self-immolation drives her to reinhabit her former self and to wrest control

back from the inimical forces of the modeling scene. She and Gordon return to Moosonee, and to her uncle's bedside. Thanks to Annie's own suspicions about her circle of friends in New York, she kept some of her cash stored away—a sign that some part of herself stayed alert despite the control she surrendered. Being at her uncle's bedside, surrounded by family, teaching Gordon how to hunt, trap, and skin—these parts of her life recenter her, bringing her back into her own skin. As she sits by her uncle's side, the two exchange stories: Annie recounts her time in New York as her uncle unconsciously tells her his own story: both, over time, seem healed by this exchange.

Both *Reservation Blues* and *Through Black Spruce* conclude with a gathering, whether tribal or familial. Both reinscribe the values of cultural tradition and community in the protagonists; however, neither Alexie nor Boyden suggests that the protagonists must confine themselves to reservations or tribal communities to retain this sense of cultural identity. Thomas Builds-the-Fire leaves the reservation with his girlfriend Chess and her sister Checkers, and while Annie and Suzanne return for a family gathering, Boyden leaves the reader with no guarantees that their stay is permanent. By refusing to advocate full insularity or immersion, the authors acknowledge the need for interaction with a cultural mainstream, while ensuring that tribal members stay connected to their home and culture. Annie will likely continue to sell the furs she traps, to purchase products, perhaps to travel or work outside of her community, and Suzanne may return to a modeling career; however, Annie's narrative ends with her reconnected, reinvigorated, and reunited with her family.

In each novel, the authors indirectly invoke and challenge the familiar trope of the Vanishing Indian—a white myth of a vanished indigenous culture brought on by the genocidal practices of colonization, as well as the assimilationist efforts of missionaries, boarding schools, and other organized interventions with tribal culture. While the myth may accurately depict the dominant culture's destructive impact on tribal culture, as well as the genocide wrought by colonization and U.S. territorial expansion, it is deeply flawed.

Although the American Indian population in the United States has been increasing rapidly since the nineteenth century, the concept of the vanishing or dying native has persisted as a trope in American literature. In *The Vanishing American: White Attitudes and U.S. Indian Policy* (1982), Brian W. Dippie calls this concept "a constant in American thinking" (xi)

that has historically "represented a perfect fusion of the nostalgic with the progressive impulse" (xii). In the early 1800s, writers of Romantic literature took a nostalgic, seemingly sympathetic attitude toward dwindling indigenous populations as the United States further infringed upon their land. Authors like William Cullen Bryant and James Fenimore Cooper portrayed American Indians as wise and close to the earth, a nostalgic representation of a simpler time. Dippie characterizes this trend in literature as a vehicle for glorifying the dwindling wilderness of the frontier (19–20). Such depictions of the wilderness and the indigenous who lived there, Dippie explains, ultimately served a white majority: "The myth of the Vanishing American accounted for the Indians' future by denying them one, and stained the tissue of policy debate with fatalism" (xii). In other words, the depictions reinforced an idea that the loss of tribal populations was not only occurring but also inevitable because of their "primitive" ways; such depictions thus justified rather than undermined oppressive policies that impinged upon their liberties and land.[11]

The Vanishing Indian myth also helped Americans gain international acclaim, for the primitivist noble savage trope was extremely popular with both white American and European audiences. The noble savage, though introduced in the nineteenth century, has continued to permeate American literature and, more recently, television and film. Even today, this concept serves to perpetuate an idea of the "authentic" Indian who no longer exists in popular media and consumer marketing; for example, the company Novum Crafts, mentioned earlier as a cultural misappropriating company, explains their choice to create and sell Indian headdresses on their website: "[the headdress] gives off a pure vibe, like being closer to natural matter—wind, fire, mud, trees, and everything un-void. It lets us experience the majestic world of the warriors they depict and in turn, paints new possibilities for us" ("About Us"). The company's promotional text reiterates in a contemporary context the noble savage of nineteenth-century Romantic literature. It implies that the Indian and any sacred garments associated with the Indian are archaic, symbols of lost natural beauty, but also things that can be mined for white creative endeavors.

But this trope carries a second problematic assumption: that indigenous traditions are slowly disappearing; that tribal cultures are on their last legs. Alexie, Boyden, and LaDuke (discussed in the following section) do more than refute such a misconception: they replace such a construct of the disappearing native with a more fluid concept of indigenous identity.

Over the past few decades, American Indians have reinforced these more positive and fluid representations through numerous cultural venues: exhibitions at American Indian museums (including the Smithsonian Institute's National Museum of the American Indian, which opened on the National Mall in 2005); a range of cultural festivals open to tribal members as well as the public; a sustained activism through boycotts, protests, and journalism; the use of the internet to showcase and promote native-made products and artwork (while exposing nonnative rip-offs); and, of course, a body of literature, music, and art that characterizes American Indian culture as very much alive and ever evolving.

Cultural Continuity and Tribal Distinctiveness in *Last Standing Woman*

In his article about the windigo figure of Anishinaabe oral narrative, Körpez links Winona LaDuke's *Last Standing Woman* and Louise Erdrich's *Antelope Wife* through their incorporation of this mythical character. In these novels, he explains, "the traditional windigo narrative functions as a cross-cultural site that asks the reader to reevaluate contemporary problems of daily existence in the light of an Anishinaabe myth" (351). LaDuke's narrative more blatantly configures a white colonialist culture into the windigo myth; Körpez suggests that "LaDuke asks the reader to interpret this windigo story in the context of the larger story of Euro-American colonialism of American Indian land and identity" (351). Körpez's reading of the two authors' works reveals two common threads: first, the appropriation of a figure central to Anishinaabe oral narrative within a contemporary context, and second, the juxtaposition of Western values of human self-interest and indigenous communitarian values.

Körpez's analysis is useful for the interweaving of these threads, the illustration of how indigenous writers use figures and tropes from tribal culture to destabilize Western narrative structures. As Körpez acknowledges, the windigo is one example of such Anishinaabe cultural references in LaDuke's work, which relies heavily on oral narrative, cultural motifs, and allusions to indigenous historical figures. Even more pervasive than these allusions, however, are LaDuke's references to tribal clothing, weaving, and beading. LaDuke opens *Last Standing Woman* with an epigraph about fashion, establishing clothing as a key theme in the narrative. The materials and garments

referenced in her novel speak to identity politics, contact between tribes or between indigenous and white characters, illustrations of tribal distinctiveness, and evidence of cultural continuity.

The emphasis on cultural continuity that surfaces gradually in *Reservation Blues* and *Through Black Spruce* takes on a more central role in *Last Standing Woman*. In LaDuke's historical novel, she chronicles the history of White Earth, a region and later a reservation of Ojibwe Indians, through the narrative of Ishkwegaabawiikwe ("Last Standing Woman") and her descendants. The novel is a fictionalized account of the land's history, the Ojibwe struggle to resist the exploitation of white Americans who settled in the region, and the triumphs of tribal activism that led to major concessions in more recent decades. The novel is divided into four main sections. Part 1, "The Refuge," traces the White Earth's roots to the early 1860s, when white Americans first began seizing native lands through deceptive "treaties," exploiting White Earth's resources, and dispatching missionary priests to indoctrinate tribes into Christianity. Part 2, "The Re-Awakening," coincides with the rise of the American Indian Movement and therefore marks the beginning of organized activism and resistance to oppression. In part 3, "The Occupation," LaDuke narrates the successful occupation and protest by the White Earth people, which marks the beginning of the triumphs, large and small, resulting from their continued resistance efforts. Lastly, part 4, "Oshki Anishinaabeg," hints at a positive change in relations between indigenous people and white Americans, including the government.

LaDuke saturates her novel with references to fashion, beginning with an epigraph by Franz Blom: "I want to die before all the Indians wear polyester and all the gringos wear Indian clothes . . ." On the surface, the epigraph uses clothing figuratively to indicate fears of assimilation and cultural loss among American Indians, while alluding to patterns of cultural appropriation among whites. Yet the use of clothing to convey these exchanges adds a visual component to the abstract concepts of assimilation and appropriation—it forces the reader to see concrete, almost dystopian representations of these concepts. For LaDuke, as the epigraph suggests, clothing serves as a barometer to indicate the current temperature of indigenous/white relations, to measure an indigenous commitment to cultural preservation and activism as well as a dominant culture sensitivity to indigenous practices and people.

For the title character, Ishkwegaabawiikwe, clothing represents both this cultural persistence and the personal meaning behind different types

of indigenous dress, revealing values and traditions specific to the Anishi-naabe tribes as well as Ishkwegaabawiikwe's skill and character. For the Ojibwe and other Plains tribes, the beauty of a garment or other handmade item conferred status and respect upon its maker, as Dubin notes: "Traditional values upheld the importance of women's craftwork: quilling, beading, and tanning hides. In all tribes, women gained status for the excellence of their work, often specializing in a particular craft" (239). LaDuke ensures these values surface through the seemingly minute details of Ishkwegaa-bawiikwe's life, beginning with the knife she brings to her marriage: "She had got the skinning knife long ago at the trading post far away, paid for it with furs she had skinned. The knife was as sharp as the winter was cold, and she had a case for the blade quilled by her mother. Ishkwegaabawiikwe had taken all of this with her to her marriage. Her knife was her pride" (27). Though the passage seems to focus on the knife, the details illuminate the value of beautiful craftsmanship—Ishkwegaabawiikwe's adeptness at trapping and skinning, her mother's quillwork, and the resourcefulness with which she approaches her crafts. When Ishkwegaabawiikwe's first husband beats her, "she took herself back" (28) by threatening him and, later, by signaling the change in their dynamic through the clothes she makes: "Moccasins she still made for him: it was the duty of a wife. . . . But leggings and shirts he could fashion himself. And her beadwork designs changed ever so slightly, the flowers of her beadwork becoming bitter and sharp. He would not notice, but she knew. A woman would know" (28). The barely noticeable changes Ishkwegaabawiikwe makes to these clothes become a testament to fluctuations in her feelings and her relationship, as well as a means of communicating those changes to other women. In this way, Ishkwegaabawiikwe records her life through the clothes she constructs and designs.

LaDuke connects the Ojibwe tribe's relationship with traditional clothing to a larger narrative of colonization and exploitation. Early in the novel, Ishkwegaabawiikwe's second husband, Namaybin, invokes a saying that clothing and trade were the "downfall" of the Anishinaabe tribes: "Trade goods, that was how it started. Someone once said that the love of fabric was the downfall of the Ojibwe women. Yard goods, black velvet, bolts of trader's wool all soothed the *Anishinaabekwewag* fingers. Smooth as a mink or beaver pelt, smooth as a brain-tanned hide, smooth as could be. Small glass beads mixed well with porcupine quill work and tufted moose hide. The most intricate designs, and the arrays of colors expanded their artistic universe immeasurably" (41). In this passage, Namaybin sympathizes

with his wife's attraction to traded materials; he lingers on the sensory details while offering a vision of how these new items could blend artistically with the materials the women already possess. Given that the patterns and garments the women created reflect their skill and character, such new colors, textures, and materials present an opportunity for both artistic and personal development. Although in this interaction, Namaybin is an indigenous trader who uses the materials to court the women, the saying about fabric alludes to a larger pattern of trade with outsiders. The Ojibwe, LaDuke suggests, embrace change and the integration of outside materials into their traditions, but such transactions have also allowed outsiders to exploit them.

LaDuke contrasts the meaning and beauty of traditional clothing from a tribal perspective with the church's view, thereby setting up a metaphorical opposition: the white clergy who appear on White Earth land, as well as the religion they represent, are conflated with colonialist oppression; their condemnation of tribal clothing and sacred objects connotes their treatment of the White Earth people. During the first decades after the church arrival, locals who join the church seek out ways to blend its teachings into their cultural practices, as LaDuke suggests through their clothes: for example, indigenous women wear "calico dresses with high collars and bonnets"—modest Western clothing—yet "beadwork remained on some of the outfits" (48). The priest, Father Gilfillian, notices such attempts to blend the two cultures and immediately perceives them as a threat: "A few of the men had bandoleer bags, the large, intricately beaded bags worn for social and ceremonial events and dances. He would have to write a sermon on the need to abandon such trinkets and remnants of the past" (48). Father Gilfillian considers even the donning of tribal clothing or jewelry as a "frenzy" and reflects: "The danger of losing converts was grave. He paused before he spoke. 'We must outlaw the heathen rituals'" (53). Such superficial forms of censorship prove to be a Pandora's box of problems for White Earth. By writing such an expansive narrative, from colonial contact to the present, LaDuke articulates the long-term effects on tribal life stemming from these early forms of erasure and control. As tribal clothing is prohibited, the White Earth people become dependent on Western clothing and materials. As the church solidifies its control in the region, children are forcibly taken away to Catholic boarding schools, where they are stripped of any vestige of tribal identity (including contact with their families for most of the year) and sexually abused by the priests.

LaDuke spotlights the corruption and abuse in the boarding school in a way that allegorizes a larger history of violence against indigenous populations as well as of Western attempts to devalue and erase tribal culture. Young boys are literally snatched from their homes and taken to the schools, lined up in front of the priests and then stripped of their clothing: "Other priests loaded their arms full of the beadwork vests, leggings, and moccasins, and then disappeared. In their nakedness, the boys pulled close together" (80). As LaDuke describes the miserable treatment of the young boys, she conveys their fear and humiliation, but she also emphasizes the careless treatment of their clothing as part of their degradation. Indigenous clothing, the narrative has shown, is not "fast fashion"—it is not the easily discarded material of Western culture; by tossing these garments away, the priests are discarding hours of labor and love that went into preparing, sewing, and beading each item. Taking the boys' clothing and cutting their hair means erasing aspects of identity. LaDuke juxtaposes these moments of cultural erasure with the even more disturbing accounts of sexual abuse at the boarding schools. Through this juxtaposition, LaDuke shows that no act of oppression is harmless or innocent: certainly, the sexual assault begins a horrible cycle of abuse that persists for generations after the return to White Earth, but even the stripping away of traditional dress conveys a cruel, sadistic attempt to eradicate a culture and way of life.

LaDuke thus uses clothing in these chapters to portray the loss and exploitation of the White Earth people; however, the clothing also hints at the persistence of a people who cherish their traditions and practices even in the face of seemingly insurmountable opposition. As an example, LaDuke includes the story of a young girl in 1920 who lives in a sanitarium, where her sister has just died. She knows how her sister's body will be handled by the caretakers and thus takes it upon herself to prepare her sister for the afterlife: "As best as she could, Charlotte attended to preparing her sister for the journey to the Land of Spirits. From a trunk, she had retrieved a paisley dress with a beaded yoke and moccasins of smoked deerhide and black velvet with small beads sewn on the top, a pair of moccasins her mother had made before she had passed on. Now they were to be Margaret's traveling shoes to the next world" (76). Even as a young girl surrounded by whites and removed from her cultural community, Charlotte has absorbed the values of her Ojibwe heritage and has managed to preserve the garments (a blend of Western and indigenous dress) for her sister's burial. Through narratives like this, scattered throughout the first

section, LaDuke shows how the White Earth people's values are transmitted to the next generation, despite cultural changes and constant pressure from a white dominant culture. In the first section of the book, therefore, LaDuke establishes how contact with whites precipitates a series of tragedies for the White Earth people, yet she illustrates that this contact does not result in Western culture vanquishing indigenous culture, but rather in an ongoing power struggle. Rather than ending her narrative with this turn-of-the-century power struggle, LaDuke shows how the struggle transforms and produces consequences for later generations. The power struggle and the persistence of White Earth traditions ensures that eventually the White Earth people will fight back.

LaDuke sets the novel's second section, "The Re-Awakening," during the American Indian Movement (AIM) in the mid-twentieth century; however, rather than focusing the entire section on activist efforts, she introduces new setbacks and challenges for indigenous groups in the United States. She opens this section with the character Jim Nordstrom, an Indian "discovered" by Hollywood who becomes typecast as an indigenous everyman: "he was prolific in roles as Comanche chiefs, Apache warriors, Sioux braves, and even one part as an Eskimo hunting polar bears" (108). In her account of Nordstrom, LaDuke indicates the way that white screenwriters and directors mold him into the idea of the Indian that suits them and their target audience: "By and large, Indians were mostly action figures, evil characters, and backdrops to the drama of the white man" (108). Here, LaDuke speaks to a history of white representations of Indians that dates back to the pre–Civil War era, first through stories, paintings, and plays, and later through film, television, and other popular media. LaDuke suggests through Nordstrom's daughter, Alanis, that such false popular portrayals are extremely damaging: they reinforce inaccurate dominant culture perceptions of tribal culture, and because these depictions are so pervasive, they can even influence self-perceptions among native people.[12] Nordstrom's daughter, Alanis, has conflicted ideas about American Indian identity in part because of her family's removal and distance from White Earth, and in part because of popular culture representations of Indians—representations in which Nordstrom is complicit. Her memories of her father are mediated by white popular culture: "He was stunning. His black wig of braids was long, thick, and sleek. His skin was shiny from a coffee-colored paint that made the actors' skin color even-toned and more *authentic* for the film. Then there was the fringed buckskin outfit and the full Hollywood headdress made of turkey

feathers. . . . Her father was an image made in Hollywood, an image for-
ever set in her mind" (109). These images of Alanis's father intervene, even
compete, with her cultural knowledge of the White Earth people; in a way,
her childhood sets Alanis on a path to self-discovery, beginning with these
images of her father.

Though Jim is complicit in these white cultural myths, he exhibits agency
in his interactions with mainstream culture. He seems to understand, in
fact, the types of characters that whites want to see him play, and he chooses
to capitalize on their misconceptions. Certainly he does so through his roles
in Hollywood, and later he plays on popular notions of Indians as spiritual
and wise by charging people for advice: "He offered Indian wisdom for a
small price. . . . Words from a wise Indian filled a hole in the spiritual world
of the adventuresome hippies, deadheads, or dabblers in eastern religions
who had landed once again reluctantly in the western hemisphere" (110).
Jim's actions belie his awareness of such cultural misrepresentations and
stereotypes, and his performance of these roles exposes them as inauthen-
tic. While Jim seemingly performs these roles to serve his own interests—
reinforcing stereotypes for his own financial gain, within the framework of
the novel such performances highlight the dissonance between lived indig-
enous experience and popular culture clichés.

The framing of this section of the novel with the popular images of the
Vanishing Indian and wise/spiritual Indian cherished by the American pop-
ular media provides an interesting contrast with the state of White Earth
during this period. LaDuke introduces the period as a historical low point
for the tribal community—impoverished, dependent, and consistently
exploited after a century of oppression and deceptive deals brokered by cor-
porations and the government. While the first part of the novel focuses on
exploitation by the church and the government, this section introduces the
tensions between the American Indians of the White Earth land and
the whites who feel entitled to the land (i.e., who have bought tracts of land
as private property and built homes and businesses). LaDuke highlights
this tension in a chapter set in 1980 titled "Indian Hating." She explains:
"There is a peculiar kind of hatred in the northwoods, a hatred born of the
guilt of privilege, a hatred born of living with three generations of complic-
ity in the theft of lives and land" (126). She clarifies that "Good Indians"
are, essentially, assimilated; they work for white individuals or businesses
and accept their socioeconomic status. She contrasts the whites' attitude
of entitlement with the attitude of "knowing" the land exhibited by the

older White Earth Indians: "They knew exactly when to go to a stream in the spring for spearing, when the berries were ripe in each area, where the deer would go and how many to take. They knew both of their traplines because their lives depended on it. . . . they knew when to give the land a rest" (140). The section portrays the escalating tensions between two cultures and two ways of relating to the land, as well as the discord that emerges from the whites' ethnocentricity. The locals assume that their ideology of ownership and acquisition is the norm, the standard to which all laws apply and all people must aspire. The notion of sustainability feels foreign to them; they assume, instead, that the Indians share their mindset yet want something for free. The white majority equates the Indian refusal to accept dominant culture values of self-interest and opportunism with the Indians' inevitable extinction.

On the surface, then, LaDuke implies that the fate of the Vanishing Indian seems possible, particularly with so many forces working against them. And yet, this period serves as an important turning point for White Earth and other tribes, for it marks the beginning of the American Indian Movement, a period of sustained pan-tribal activism. LaDuke alludes to this shift through the character of Elaine, who harbors a deep love for the land and ways of the White Earth people. Through Elaine, LaDuke challenges a false perception that indigenous people who leave the reservation forget and ultimately abandon their culture. Elaine maintains contact with her family home, and her return visits keep her grounded: "A trip home to Ponsford for ricing or deer hunting made all the difference to Elaine. The food tasted clean in her mouth, the rice tasted like Basswood Lake, and Elaine never once forgot the smell of maple sap boiling in her grandfather's kettle in the woods" (123). Elaine's relationship with White Earth parallels the connections other authors have portrayed between the individual and the reservation—for example, Alexie's portrayal of the Spokane powwow in *Reservation Blues* and Boyden's portrayal of the family reunion in *Through Black Spruce*. At the same time, LaDuke resists characterizing a reservation as frozen in time, for Elaine also records how the White Earth community has changed: "The Indian community became more organized and vocal as Elaine grew up. She remembered being dragged to a protest of police brutality against Indians, she recalled how her aunt and uncle changed their hair styles and finally grew it long by the time Elaine was ten years old. The American Indian Movement had started to grow in the cities" (123). Elaine's attitude toward home, then, blends a sense of persistence with a recognition of change. The persistence

relates to their traditions and their relationship with the White Earth land, while their change relates to how they engage with non-indigenous people and institutions.

To illustrate the persistence of traditional tribal values and attitudes toward the land, LaDuke closes part 2 with two chapters about resistance, both set in 1990; in these chapters, she focuses on the character of Lucy St. Clair, a descendant of Last Standing Woman, and she returns to her symbolic use of clothing: "Lucy St. Clair's glossy black jingle dress shimmered in the hot sun of the June fourteenth powwow. As she moved rhythmically, the silver cones sang her name and punctuated her steps. . . . Her dance outfit, dreamed of and made from her own hand, included a lavishly quilled pouch for a skinning knife and a small hatchet with an intricately beaded handle" (145). The details of this passage immediately establish Lucy as a defiant character, a leader in the resistance against exploitative American policies. LaDuke reveals that Lucy has made her own dance outfit, thereby continuing a tribal tradition and taking pride in exhibiting her handiwork. The dance outfit incorporates traditional beading and weaving yet includes Western materials, alluding to the changes engendered by contact. And like her ancestor, she carries her skinning knife, a source of pride, wrapped in her handmade case. Each item mentioned is one of a kind and carries a personal meaning.

LaDuke's references to clothing take on a different metaphorical role in part 3, "The Occupation": they serve to indicate changing relationships—within tribes, among tribes, and between Indians and whites. In addition, the clothes redifferentiate among tribes brought together through the pan-tribal activism of the American Indian Movement, which, to some extent, elided tribal distinctions in the interest of advocating for common causes. The clothes, jewelry, and other materials in Part III thus offer subtle means of alluding to tribal differences. Whereas part 2 opens with Jim Nordstrom, whose public performances of being Indian made native identity into one collective mishmash of symbols, part 3 begins with Jim's daughter Alanis, a journalist who, over the course of the section, journeys to learn her tribe's distinctive history.

When Alanis is introduced in the first section, LaDuke hints at her awareness of these tribal distinctions through her interactions with individuals from different tribes, and especially through the details of their dress. When Alanis hears of the White Earth occupation of the reservation, she visits Linda Chavez, her friend at the library, and offers the following description:

"Almost opposites in color and shape, Linda Chavez was a Pueblo, short, and the brown of a walnut shell. She was dressed in a floral polyester outfit highlighted by turquoise jewelry" (163). LaDuke immediately indicates that the women's tribal and regional distinctions (Ojibwe and Pueblo) have made them physically distinctive, while also alluding to some of the traditional attire of the Southwestern tribes. Later, when Alanis visits Browning, one of the resistance leaders, she observes his beautiful ribbon shirt: "Browning was an impeccable dresser, thanks in part to his wife, who painstakingly prepared his wardrobe for business and socials. 'You know those Otoes,' he said, referring to his wife. 'They're such perfectionists'" (164). In each of these moments, LaDuke uses clothing to spotlight different practices and styles of each tribe. Like the food they eat and the rituals they observe, clothing has both a sacred and practical significance to each tribe. Because Linda comes from a Southwestern tribe, she looks darker in appearance and wears the turquoise native to that region of the country. Browning, on the other hand, wears ribbon shirts designed by his Otoe wife; ribbon shirts originated among the Great Lakes tribes (which include the Otoe) during the 1700s, when French and English traders brought silk into the region (Metcalfe, "Some History").

Through the narrative of Alanis, LaDuke also indicates the potential for changing relationships within the tribes. Alanis has lived, for the most part, outside of reservation life and tribal culture. When news of the occupation reaches her at her job in Denver, however, Alanis feels a pull to return to White Earth: "Her breathing stopped short when she saw it was about Indians, *her* Indians" (162). As Alanis travels to White Earth, she tries to recall her young memories of the land: *"Smell of wood fires, old cars, old women who pinched her cheeks"* (166). She questions her position as both insider and outsider, as someone who shares memories of the land and people and has fully immersed herself in a mainstream culture, earning an economics degree from Stanford (162). She worries that she has lost her connection to the land and people: "It was her greatest fear that she would return as a ghost, haunting the remotely situated motels of Indian country border towns, credit card in hand" (166). Alanis's reveries offer an interesting parallel to Elaine in the previous section; while Elaine has stayed fully connected to White Earth, Alanis feels the loss and worries about her ability to reconnect.

By focusing on two women outside the reservation, LaDuke characterizes contemporary tribal life among Plains Indians, where tribes continue

their traditions. Dubin characterizes tribal life in terms of their relation-
ship with clothing as well as with motion, two elements that have always
played an important role among Plains tribes: "Most participate in some
traditional activities, including bead and quillwork, hide tanning, and cer-
emonials. Plains people still believe that decorated apparel given to relatives
or friends will bring health and prosperity. . . . Urban-based tribal members
make frequent trips to the reservation and consider it home. Movement
is still a central principle of Plains lives. Although the car has replaced the
horse, people think nothing of traveling hundreds of miles on a weekend to
visit family or attend a powwow" (274). Dubin's characterization of contem-
porary tribal life clarifies why Alanis feels the potential to reconnect with a
culture she has never really known. The immediate pull Alanis feels shows
how this connection cannot be fully eradicated by leaving the community.

As Alanis joins the occupation and covers it, she becomes increasingly
immersed in the plight of her people. Her objectivity is shattered when
some of the white protestors try to shoot her, mistaking her for one of the
locals: "And now her image of herself as the objective, professional news-
paper reporter became confused with her image as the gunman saw her,
as an Indian, as an enemy, as someone to shoot. The bullets had destroyed
the boundaries in her mind, and the ricochet reverberated through her
very soul" (187). Alanis does not reforge her connection by adopting tradi-
tional tribal practices, but by participating in a contemporary movement,
experiencing firsthand the activist efforts of a group fighting for its rights.
Through resistance, Alanis rediscovers her ties to tribal culture. She falls
in love with one of the White Earth men and, like Elaine, begins making
frequent returns.

The occupation and Alanis's reconnection with White Earth coincide with
a series of changes to the relationship between the Indians and whites of
the region. These changes are chronicled in part 4, "Oshki Anishinaabeg"—
a heading with several different translations, including "the natives," "the
first people," "the Ojibwe," and, perhaps most apt given the content of this
section, "the good people." LaDuke indicates ways that whites and Indi-
ans have begun to work together. For example, several of the Indian men
have begun "leeching," or catching leeches to sell to white fishermen, and
LaDuke explains the practice through a conversation between an Indian
and "a white supporter of the land rights struggle" (225). One of the White
Earth citizens, Moose, reflects, "Leeching was also a hell of a lot better than
a casino job, waiting on retired farmers or school-teachers dumping their

nickels into the slot machines in a trancelike state" (226). Although the
casinos bring income to reservations, the leeching business allows a contin-
ued interaction with the land and balance of nature; it marks a continuity
of old practices adapted to changing times and demographics. In a second
example, LaDuke indicates that "a natural resource management committee
established a program of selective cutting and habitat restoration" (251)—a
committee that "planted medicinal plants," "reintroduced animals," and
"strictly limited hunting." Such practices and committees curb and even
help reverse the damage wrought by centuries of careless treatment.

LaDuke parallels these changes by introducing the "Rummage Queen,"
Danielle; this character alludes to the "Ojibwe love of fabric" introduced in
part 1, but reconfigures that desire within a contemporary context: "Dani-
elle had a world-class collection of fabric. There were bolts of cloth stuffed
into her closet and folded pieces of material overflowing into five or six
boxes under her bed and around her room. Twills, velvets, prints, paisleys,
polka dots, stripes, African and Guatemalan patterns all danced a rainbow
of colors and patterns that caught Alanis's eye everywhere she looked. She
remembered that someone had once told her that the love of fabric was the
downfall of the Ojibwe women" (260). The passage serves several purposes.
First, the Rummage Queen represents current indigenous efforts to resist
wasteful consumption and fast fashion, much like the indigenous designers
discussed at the beginning of this chapter. Rather than contributing to the
consumption waste generated by the American fashion industry, Danielle
collects clothing from white donors, and the clothes become raw materials
for new creations—rag rugs, for example—that are then sold back to the
community, mainly purchased by white consumers. Secondly, the fabrics
described above also allude to increased globalization of the fashion indus-
try, with the references to "African and Guatemalan patterns" mixed in with
the Western prints and materials. And third, the description illustrates
Danielle's sensibility, her knowledge of material. When a woman contacts
her looking for a mink stole that she donated by mistake, both Danielle
and Alanis immediately identify the fur as beaver, knowing the fur feels too
coarse to be mink (265).

The Rummage Queen represents an optimistic future for the White
Earth people: more balanced transactions with whites in the community;
innovative practices for reducing waste and promoting sustainability; forms
of employment that fit with tribal values; and increased efforts to preserve
history and culture that are reinforced, not negated, by cultural outsiders.

The White Earth of the present is ever evolving yet respectful of its traditions. LaDuke underscores this hopeful vision for the White Earth people through the occupation, the characters' new means of employment (like leeching and recycling), the "new tribal enrollment provisions" for membership, which require "a commitment to language and culture" (251), and the return of American Indian dead from the Smithsonian to their burial site at White Earth. LaDuke draws from these elements to imply a changing dynamic between whites and Indians in general, outside of the familiar space of White Earth, extending to include even the federal government: in the chapter "The Indian Inaugural Ball," set in 1997, a group of White Earth Indians toast "the newly elected Great White Father" in recognition of Bill Clinton's reelection because of his promises to protect the rights of indigenous citizens.

In the inaugural ball chapter, one of several that offers a hopeful future for white/indigenous relations, the indigenous characters convey their own optimism through their formal dress. Lucy wears "a navy velvet dress adorned with a simple but exquisitely placed spray of floral beadwork" (266). This gown shows Lucy's willing engagement with mainstream codes of propriety and fashion. And yet she does not simply conform to these codes: LaDuke suggests the gown will not be worn once and then discarded or forgotten, for Lucy has decorated it in a way that exhibits her skill and cultural ties—floral beadwork has been an Ojibwe tradition since the late nineteenth century (Dubin 274). Kway Dole, her friend, dresses in a similar way, "sporting, uncomfortably, a tuxedo shirt under an ornately beaded vest" (266). Like Lucy, Kway attempts to show respect for her hosts' cultural codes by wearing Western formal dress (the tuxedo shirt) while exhibiting her cultural identity with the vest, as well as her fluid gender identity (though she uses female pronouns, she tends to dress in men's clothing); for Kway, however, the combination is not comfortable. While LaDuke may include this detail just to reference Kway's physical discomfort, the word choice emphasizes that such cultural blending *is* uncomfortable, even painstaking. The setting itself feels uncomfortable even in its apparent triumph—Clinton's promises and invitation are hopeful signs for a changing relationship with the government, but the transition is an uncertain one, the characters grateful yet wary.

In combining Western formal dress with Ojibwe beadwork, Lucy participates in a performance of identity. Yet this identity is neither Western/assimilationist for the sake of the occasion, nor Ojibwe for the sake of tribal

representation. Although Kway's shirt may be uncomfortable, LaDuke's ref-
erences to velvet and other Western fabrics throughout the novel suggest
Lucy exercises control in her adoption of Western dress: she loves the fabric
and wears it because it suits her, and she strategically balances it with per-
sonal and tribal elements. Through her ensemble, she presents an allegiance
to country, cultural community, and herself.

Reservation Blues, Through Black Spruce, and Last Standing Woman reflect the
cultures of three different tribes and tribal regions—Plateau, Subarctic, and
Northern Plains, respectively—and yet all three allude to American popu-
lar culture's misappropriation of indigenous culture through the medium of
clothing. While for Western culture, clothing can be beautiful and expres-
sive, it is also disposable, often experimental, a means of exploring indi-
vidual identity and signifying values for a public audience. For the white
characters in these novels, indigenous garments might represent a novelty,
a taste of the exotic, a connection to spirituality, or a signifier of New Age
or some other nonconformist identity. In contrast, for the indigenous char-
acters of these novels, tribal clothing carries a symbolic meaning within the
context of the narrative, but not necessarily for the characters. In the narra-
tive such garments might signify cultural continuity, resistance to cultural
erasure, tribal identity, or a specific character's talent and strength, but for
the individuals they carry only the meaning that the wearer confers. In Res-
ervation Blues, the indigenous protagonists do not wear traditional cloth-
ing (though some wear their hair in traditional styles), and in Through Black
Spruce and Last Standing Woman, traditional clothes are often worn because
they are beautiful or because they were bestowed on the wearer with love.

These novels thus clarify key distinctions between tribal clothing and
Western fashion, as well as why misrepresentations of indigenous garments
are so problematic. In a sense, the story of native clothing is a story of con-
tact with whites, a story of trade, of changes to native crafts and garment
ornamentation, but also a story of misunderstanding and exploitation. The
novels may on the one hand offer critical portraits of mainstream American
fashion: it misappropriates other cultures to stay new, it is wasteful and
damaging to the environment, it often seems more concerned with sign-
exchange value than the care or workmanship that went into a specific
piece. On the other hand, the novels reveal how engaging with Western cul-
ture has shaped contemporary native identity: the fluid nature of tribal

culture has responded to and incorporated elements of mainstream American culture. In her article on Louise Erdrich's *Antelope Wife,* Laura M. Furlan notes that history scholars "have argued that dealings with the French fur traders catalyzed Ojibwa identity" (59). This is not to say that the Ojibwe did not have a cultural identity before the fur trade, but rather that the centrality of material to Ojibwe culture for the past few centuries—including garment making, trading, hunting, trapping, and working hides through beadwork and other ornamentation—is central to Ojibwe identity, and yet contact and conflict with Western nations have influenced that identity. The style of tribal garments changes with the acquisition of new materials through trade, whereas the trends in the Western fashion industry often change with the appropriation (or misappropriation) of new cultures.

One example of this juxtaposition can be found in the Smithsonian Institute's National Museum of the American Indian: a pair of beaded sneakers crafted by Kiowa artist Teri Greeves (fig. 13). The curatorial text explains that she made the sneakers "to honor the Aw-day (Favorite Children), who in preparation for tribal leadership traditionally lead the Kiowa Black Leggings Warrior Society into the dance arena." The sneakers are Converse, a very popular American brand; the intricate beadwork is reminiscent of Plains tribes' ceremonial regalia (Dubin 274); and the individual touches— the portraits of her children—infuse the sneakers with personal meaning. In her artist's statement on her website, Greeves writes:

> I am a beadworker. I've been beading since I was about 8 years old. I am compelled to do it. I have no choice in the matter. I must express myself and my experience as a 21st Century Kiowa and I do it, like all those unknown *artists* before me, through beadwork. And though my medium may be considered "craft" or "traditional," my stories are from the same source as the voice running through that first Kiowa beadworker's needles. It is the voice of my grandmothers.
>
> To all the Kiowa women who labored over their families most beautiful and prized objects, who gave us such an awe inspiring canon of expression to be born from, I thank them. Ah-ho.

Greeves's words underscore the importance of beadwork to her tribal community and her family, and like the indigenous designers discussed earlier in this chapter, she characterizes beaded creations as works of art, their makers as artists. Although Greeves claims she has "no choice in the matter" of creating beadwork, in the next sentence she states that she "must express

FIGURE 13. Teri Greeves, *Kiowa Ah-Day,* 2004. Canvas, glass beads, and commercial rubber. (Smithsonian Institute, National Museum for the American Indian; purchased from Thirteen Moons Gallery, 26/3325)

[her]self"; such a paradox—the uncontrolled compulsion and the freedom of personal expression—characterizes the sense of intimacy between artist and creation. The artist feels compelled to create, but enjoys the intimacy of personal expression while creating the piece without restraint. In indigenous literature, such intimacy is often portrayed through the care put into individual pieces: characters work on a piece for lengthy swaths of time (in Erdrich's *Antelope Wife,* the twins that frame each section are literally beading for a lifetime). Such garments contradict the Western concepts of mass consumption and fast fashion, and yet, they make use of Western pieces.

Today, indigenous fashions are also an important source of individual and tribal autonomy. The callous corporate culture portrayed by Alexie and Boyden parallels both historical institutions of exploitation and a more literal corporate fashion culture in the United States today. When a company reinforces a popular culture misrepresentation of tribal culture, it disseminates false information and profits off of this misinformation, all while taking away income from tribal members who make their livelihoods from selling crafts or garments. The defense that such "Native inspired" crafts are "honoring" or paying homage to indigenous culture seems ludicrous in this context: they reinforce the very stereotypes (e.g. of the Vanishing Native)

that have justified oppressive government policy in the past, and they force independent indigenous sellers or small businesses to compete against large corporations with enormous marketing budgets to sell their wares.

By telling stories through clothing, the authors allude to the longer narrative of Western fashion, a story of contact and acquisition as well as a struggle for meaningful identity. The authors also allude to a parallel narrative, reclaiming tribal clothing to offer a public declaration of what sacred and secular garments mean to them and their communities.

The significance of this public declaration is twofold. First, the clothes represent the fusion of American and tribal identity within the individual—the traditions sustained over centuries with the history of contact and trade with European, then American, citizens. Second, the clothes represent a direct confrontation with popular representations of indigenous identity. Writing about the clothes becomes a way of correcting, challenging, questioning, and outright refuting the connotations that an American mainstream fashion industry has attached to tribal sacred and secular garments.

In the next chapter, I consider the role of clothing as a public declaration in a different context, but with some of the same concepts. In the context of transgender literature, clothing becomes a way of questioning one's gender identity—temporarily experimenting with or exploring the facets of gender—as well as curating a public presentation after an individual has negotiated their gender identity. As the narratives in chapter 4 have challenged popular representations of indigenous identity and a larger pattern of misappropriation, the narratives in chapter 5 challenge popular notions of gender identity.

5

Gendered Fashion and Transgender Literature

I felt that I was not the kind of daughter my mother wanted. Once I returned from my father's wearing a Lacoste shirt he had bought me. It was a boy's polo, and my mother flipped out. She probably thought that my dad encouraged my boyishness rather than that he just let me be myself, which is what I believe he did. The boy I felt I was inside just didn't match what she wanted—or had planned—for her daughter. The fights and, later, snide comments about my clothes, hair, and jewelry lasted into my twenties.
—Chaz Bono, *Transition: Becoming Who I Was Always Meant to Be*

I stared down at the bra. I saw the barely visible etchings of flowers in the white material. I saw the sturdily lined, ample cups, whose very shape implied so much. I saw the white loops for lovely shoulders.
—Jonathan Ames, *The Extra Man*

IN HIS CHRONICLING OF fashion history titled *Tim Gunn's Fashion Bible: The Fascinating Guide to Everything in Your Closet,* fashion professor and television icon Tim Gunn laments the industry's failure to resuscitate skirts as part of men's fashion. He notes that up until the 1500s, "men—priests, academics, judges, merchants, princes, and many others—wore skirts, or robes" (100). For these men, the skirt was a symbol of their higher social status. Gunn continues: "This is still true for men in high positions. After all, can you imagine the Pope, or Professor Dumbledore, wearing *trousers?* Have you ever seen a depiction of God wearing pants?" (100). His joking aside, Gunn notes that over the years, many fashion designers have tried to bring back the men's skirt, including Jean Paul Gaultier, Vivienne Westwood, and Dries van Noten (105). More recently, men's skirts and gowns have enjoyed red carpet moments, as with Billy Porter's Christian Siriano tuxedo gown worn to the Met Gala. Men's skirts and dresses enjoy their moments on the runway and red carpet, but unfortunately for Tim Gunn, they have not gained enough consumer appeal to attract the attention of retailers. Gunn points out the acclaimed designer Marc Jacobs wears skirts himself yet does not always make them part of his design portfolio. "Apparently, even he recognizes that, at least for now, the man's skirt is not a profitable item for mass production in the Western world" (107), Gunn reflects, a note of regret in his tone.

Fashion, Gender, and Transgender Identities

Gunn's contemplation of the skirt for men speaks to a tradition in clothing design of blurring gender lines. True, historically speaking, fashion has tended to serve the opposite purpose. The corsets associated with Victorian fashion, for example, exaggerate an hourglass shape to heighten women's femininity while also rendering them physically weakened, limiting their physical activity—hence Thorstein Veblen's claim that corsets, a staple of upper-class women's fashion, were signs of "conspicuous leisure" (181–82). Conversely, the men's suit, even from its origins in the 1800s, was designed to make men look taller and physically stronger. From foundation garments to high heels to suits to accessories, indeed, a host of garments serve to reinforce traditional gender roles as well as a binary understanding of gender identity.

And yet, fashion has also offered an arena for challenging these roles, for breaking the rules of what defines masculinity and femininity. In some cases, these challenges have emerged from the industry itself—Coco Chanel designing riding pants for women in the 1920s to allow them to straddle horses instead of riding sidesaddle; Hollywood stars like Marlene Dietrich and Katherine Hepburn embracing androgynous tailored styles; Jean Paul Gaultier featuring men in bridal wear for his 2011 runway show. Style icons in the music industry have used fashion to blur gender lines—Annie Lennox in her masculine suits; Prince in androgynous New Romantic styles; David Bowie in 1970s Glam Rock fashions; Kurt Cobain performing for Nirvana in dresses and skirts.

While fashion's relationship to gender has fluctuated over the years, fashion's relationship to genderqueer and transgender identities has been even more complicated. Historically, fashion has served as a vehicle for bringing transgender discourse into a public dialogue. As an example, when Christine Jorgensen, one of the first Americans to undergo gender confirmation surgery, returned to the United States in 1953 after her surgery and recovery in Denmark, much of the news coverage of her first press appearance centered on her clothes, as she quotes in her autobiography: "'Fur collar, pearl earrings set off her beauty' 'Chris back home, perfect little lady' 'Christine teeters on high heels, leaving the plane'" (175). The press headlines are remarkable both in terms of their focus on her stylish clothes (as opposed to her landmark surgery) and their immediate inscription of Christine into standards of femininity. Similarly, when Caitlyn Jenner debuted her post-transition look for the public, she did so on the cover of *Vanity Fair* wearing a fitted bodice, additionally posing for a fashion shoot within the same issue. Both of these media-saturated reveals have a fairy tale connotation, hinting at a long struggle of feeling repressed "before" while celebrating the feminine beauty of the post-transition "after." The hyperfeminine fashions of the "after" assuage the anxieties of public reception, for they ensure that while boundaries have been crossed, gender binaries have been preserved.

For the sake of this chapter, I use the term "transgender" to refer to individuals whose sex assigned at birth does not align with their gender identity or gender presentation. The term does not necessarily imply physiological changes, but the term can refer to transitioning individuals (including pre-transition) as well as gender nonconforming people who do not choose to alter their appearance or physiology. I use the term "transsexual" when

specifically used within a narrative I discuss; this designation is "an older term that originated in the medical and psychological communities" and "is still preferred by some people who have permanently changed—or seek to change—their bodies through medical interventions, including but not limited to hormones and surgeries" ("Ally's Guide to Terminology"). The terminology itself, as I demonstrate, is fluid and continues to change, as gender identity is further complicated by its relationship with endocrinology, surgery, contemporary understandings of the relationship between sex and gender, and gender-specific clothing and styling.

Fashion does not play a role solely in the transition process for transgender individuals. Rather, clothing is part of the transgender narrative and experience from the beginning, as the authors in this chapter attest. In some cases, clothing is the first thing to signal to an individual that their gender presentation or assigned sex does not match their gender identity. For instance, in his memoir *Transition: Becoming Who I Was Always Meant to Be* (2011), Chaz Bono describes feeling far more comfortable in the boys' clothing his father allowed him to wear than "the super-girlie clothes of puffy pink dresses, white gingham jumpers, red velvet pantsuits" (10) he wore with his mother. He explains, "My father treated me like the boy I felt myself to be. When I was at his house, I wore boys' clothes, played with boys' toys, and went by the nickname Fred" (15). Bono conflates his resistance to and comfort in certain types of clothing with gender behavior, illustrating the centrality of clothing to negotiating gender identity.

As the epigraphs by Bono and Jonathan Ames suggest, the role of clothing in shaping these characters' identities is influenced by a number of factors, including race, class, and culture. In Bono's and Ames's narratives, as well as others I discuss, white individuals are interpellated into white constructions of masculinity and femininity, which are often derived from white dominant culture images and clothing (white Lacoste polo shirts, expensive lacy bras, fur coats, fitted bodices). Race and culture thus dictate, to some extent, the selection of texts in this chapter. Janet Mock's memoirs, also discussed in this chapter, disrupt these white constructions of masculinity and femininity by drawing from African American, Hawaiian, and other cultural constructions of masculinity and femininity (e.g., those she identifies at house balls, among her Hawaiian friends and family members, and in hip-hop videos and other popular culture images). Leslie Feinberg's narrative, on the other hand, reveals the influences of class in

shaping aesthetics of masculinity and femininity, as her protagonist is alter-
nately drawn to men's suits and to garments like jeans, white T-shirts, and
motorcycle jackets.

Within these narratives, clothing runs the gamut of emotional residue—
garments are described alternately as instruments of torture and euphoria.
Theoretically, the relationship between the transgender protagonist and
clothing is fraught with complications: first, because of the societal con-
fusion of "transgender" and "transvestite"; second, because of the varying
relationships that transgender individuals have with clothing, often dat-
ing back to childhood; third, because of the divergent preferences among
transgender people for gendered versus gender-neutral clothing; and
fourth, because of the medical community's standard of practice that, in the
past, recommended a Real Life Test (RLT) or Real Life Experience (RLE), in
which a transgender individual was required to live as the other gender for
a period of time before they were eligible for surgery. These complications
only accentuate the importance of fashion's relationship to negotiating gen-
der identity, including transgender identities.

Throughout this book I provide literary examples of how clothing offers
a vehicle for performing identity, allowing individuals to try personas on
for size to see if they feel true to their personalities. Discussing this pat-
tern becomes slippery when engaging the journeys of transgender people,
whose identities have historically been collapsed into the same categories
as cisgender people who cross-dress or butches and drag queens—identities
explored in depth within the texts I discuss in this chapter.[1] In her intro-
duction to the *Transgender Studies Reader* (2006), Susan Stryker references
a common point of confusion about Judith Butler's discussion of gender
performativity—many readers, she notes, misunderstand this concept as a
deliberate, conscious *performance* of gender, thus contributing to the larger
societal confusion of transgender and transvestite. Critics who read Butler's
work this way "misguidedly" believe that her argument suggests "that gen-
der can be changed or rescripted at will, put on or taken off like a costume,
according to one's pleasure or whim" (10). Stryker goes on to clarify that
transgender people "consider their sense of gendered self *not* to be subject
to their instrumental will, not divestible, not a form of play. Rather, they
see their gendered sense of self as ontologically inescapable and inalienable"
(10). Here, Stryker works to correct these misinterpretations of gender per-
formativity while also clarifying the perspectives of transgender individu-
als. A transgender woman may emulate traditional gender roles or engage

in harmful patterns of gendered behavior, believing these behaviors to be "natural" and necessary to embracing her identity as a woman.

Performance of gender is a stickier concept than gender performativity. It implies choice or even, as Stryker suggests, play. Invoking this concept risks reinforcing a stereotype about the deceptive transsexual perpetuated by American popular culture in the 1990s (examples include Elle from the television series *Beverly Hills, 90210* and Lois Einhorn from the film *Ace Ventura: Pet Detective*).[2] In this chapter, therefore, I want to clarify that while I am discussing both gender performativity and gender performance, I am not doing so to reinforce such misconceptions of the deceptive transsexual. Instead, I argue that putting on clothes and the temporary performance that ensues represent a key stage in negotiating gender identity within transgender narratives.

Transgender and genderqueer literatures teem with these temporary performances of gender—in works written by Aleshia Brevard, Jonathan Ames, Chaz Bono, Janet Mock, and Leslie Feinberg, to name a few. In many instances, cross-dressing marks a moment of transgression as well as a glimmer of clarity, for in such moments, the narrator acknowledges a facet of their identity that social norms have forced them to bury. In *Transition*, Chaz Bono describes playing a male character, Peter Quince, in a play during his senior year of high school, when he was still presenting as Chastity. While preparing for the stage, he "aged and bearded [his] face with stage makeup and wore a large fake stomach under [his] sacklike toga in order to conceal the fact that [he] had breasts." Chaz reflects on this experience: "This character was probably the one least like me that I had ever portrayed, and yet the simple fact that he was male completely eradicated that strange, uncomfortable, out-of-place feeling that I felt whenever I was portraying a female character." At the time, Chaz/Chastity identified as a lesbian, but looking back on this period in his life, Chaz implies that the action of performing female and male roles on the stage aided him in negotiating his gender identity.

In Jonathan Ames's novel *The Extra Man* (1998), the narrator, Louis, describes a moment in his youth when he tries on his mother's clothing, an experience he describes as erotic and stemming from a deep-rooted desire to be a "pretty girl." He recalls, "I then put on a light cotton skirt and I walked around my parents' room. The unfamiliar feeling of air moving between my legs made me feel vulnerable and sexy. I wanted to be a girl! And most of all I wanted to be pretty" (63). While as a child and as an adult, Louis relishes

the feeling of wearing women's undergarments, he feels shame and disgust when he sees his reflection, noting the marked contrast between his masculine features and the femininity of the clothing (64).

In both of these examples and many others, the experience of performance centers on the vehicle of clothing, of dressing up, the sensation of inhabiting the body of the opposite sex. For Bono, the performance reaffirms sensations that the female Chastity has already begun to recognize; it illuminates the reality that she feels more comfortable, even on the stage, when inhabiting the body and persona of a man. For Louis, who throughout the novel remains confused about his sexuality and his gender identity, the performance only deepens his confusion, which in turn deepens his sense of shame. These examples also reveal different attitudes about transitioning and gender fluidity: Bono, like Aleshia Brevard and Christine Jorgensen, seemingly reinforces binary constructions of gender by repeatedly invoking feelings of being trapped in the wrong body; whereas Louis, like Feinberg and others who identify as "genderqueer," deconstructs binary concepts of gender identity. This is not to say that the latter category of texts is more correct, more positive, or better informed about contemporary understandings of gender. Rather, examining this range of texts together exposes a larger spectrum of gender identity that exposes a gender binary as socially constructed. In identifying as a masculine man, Bono in no way undermines or threatens another transgender person's identity that falls toward the middle of the spectrum.

Fashion and Transgender Literature

In this chapter, I argue for the central role of clothing in transgender literature, including its relationship to binary constructions of masculinity and femininity. In the section on Brevard and Mock, I discuss clothing as it relates to both gender performativity and gender performance in transition narratives, focusing on Brevard's 2001 memoir *The Woman I Was Not Born to Be* and Mock's memoirs *Redefining Realness* (2014) and *Surpassing Certainty* (2017). In the last section, I discuss specific items of clothing as symbols within the transgender narrative, illustrating the ways that the gender binaries initially presented within these narratives begin to collapse on themselves, in Feinberg's novel *Stone Butch Blues* (1993) and Ames's novel *The Extra Man* (1998).

It's worth noting that neither Feinberg's *Stone Butch Blues* nor Ames's *The Extra Man* fits the narrative form of the transition story, whereas the works by Bono, Brevard, Jorgensen, and Mock do. I include both transition and nontransition narratives, as well as fictional and nonfictional narratives, in the category of transgender literature. This shift to fictional and nonfictional memoirs reflects how much of the narrative work published on transgender and nonbinary individuals is written in the form of memoir. Even fictional works like Feinberg's are often semiautobiographical and read like a memoir. The main reason for this pattern, as I discuss later in this chapter, is that these first-person perspectives reflect the publishing market. The trend in transgender literature speaks to a public fascination with physical transformation but also serves to elicit empathy and offer a reading public insight into the diversity of experiences among transgender and gender nonconforming people.

Placing these texts in dialogue better captures the multiplicity of perspectives both within and surrounding the transgender community. Authors like Bono, Brevard, and Mock write from personal experience, yet they speak from specific vantage points—as a child of a celebrity, as a stage performer, and as an African American growing up in Hawaii, for example—rather than claiming to speak for an entire community of transgender people. Mock asserts that her experience of being both black and transgender is atypical compared to other black transgender individuals; in the wake of her success as an author and public figure, she states, she feels "survivor's guilt" (xvii).[3] Ames, in contrast, does not present or identify as transgender, but rather was inspired to write about transgender people after a flirtatious encounter with Aleshia Brevard. Later, Ames would publish an anthology of transgender literature, *Sexual Metamorphosis: An Anthology of Transsexual Memoirs* (2005).

None of the authors discussed claims to represent a standard transgender perspective—in fact, each is careful to delineate the ways their perspective may be atypical by highlighting such factors that distinguish the narrator's experience, including racial or socioeconomic background, relatively progressive or conservative setting, or relative certainty or uncertainty about gender and sexual identity. The authors resist writing a kind of manual for the transgender experience; instead, they aim to add their voices, their unique journeys, to a larger community of transgender and gender-nonconforming experiences.

One common element of these narratives is their careful attention to clothing and style as central to the major milestones in their transition or

identity construction. Clothes play a controversial role in various trans-
gender literatures in part because transgender individuals are so often
perceived as "passing"[4]—that is, presenting as their chosen gender while
hiding all traces of their assigned birth sex. Sandy Stone affirms this percep-
tion of trans people in her 1987 piece "The *Empire* Strikes Back: A Posttrans-
sexual Manifesto"[5]: "The essence of transsexualism is the act of passing"
(232)—that is, rejecting the liminal and implicitly reinforcing the binary
constructions of gender widely accepted by Western culture. She indicates
some of the problems with this concept of passing for the transgender indi-
vidual: "Passing means the denial of mixture. One and the same with pass-
ing is effacement of the prior gender role, or the construction of a plausible
history" (231). Stone's comments reveal two challenges facing the transgen-
der individual whose goal is to pass: first, this goal necessitates, on some
level, delegitimizing the experiences the individual had in the body of their
assigned sex; and second, the goal reinforces a template for transitioning
that positions liminality and gender fluidity as a phase, a stepping stone on
the way to the fully realized transgender individual. As Stone explains, "It
is my contention that this process, in which both the transsexual and the
medicolegal/psychological establishment are complicit, forecloses the pos-
sibility of a life grounded in the *intertextual* possibilities of the transsexual
body" (231). Passing as a goal is not merely reinforced by many transition
narratives but also by the medical and psychological standards of prac-
tice for treating individuals who desire to transition. In some transgender
texts, the author invokes the passing trope to subvert it, to critique pass-
ing as a goal—in *Stone Butch Blues,* for example, Jess feels safer when she
takes hormones and passes, yet she feels uncomfortable in her own skin,
no more in line with her gender identity than presenting as a woman. In
other narratives, the protagonist reaffirms passing as a goal of transition-
ing. In one scene in Chris Bohjalian's novel *Trans-Sister Radio* (2000), the
female-presenting Dana smirks after comparing herself to a nervous and
embarrassed cross-dressing man in a dressing room, quipping smugly to her
partner, "And that, dear hearts, is the difference between a transvestite and
a transsexual" (116).

Many such transition narratives, however limited in the perspective
they offer, promise a path toward reconciliation for individuals confused
about gender identity. Stone observes how transsexual autobiographies like
Lili Elbe's *Man into Woman* (1933), Hedy Jo Star's *I Changed My Sex* (1955),

Jan Morris's *Conundrum* (1974), Jorgensen's 1967 autobiography, and others have offered a kind of blueprint for the experience of transition when so few personal accounts were leaking into the public realm (224). Indeed many contemporary transition narratives include allusions to earlier published accounts as a key part of their story, as the narrators see themselves in these accounts. In *Transition,* for example, Bono describes how the film *Boys Don't Cry* (1999) "was part of what enabled me to think that transitioning was a possibility" (137). In each of the narratives described by Stone, the narrator transitions from a man to a woman. She notes, "Besides the obvious complicity of these accounts in a Western white male definition of performative gender, the authors also reinforce a binary, oppositional mode of gender identification. They go from being unambiguous men, albeit unhappy men, to unambiguous women" (225). Caitlyn Jenner, perhaps one of the more well-known public figures to undergo an MTF (male-to-female) transition, exemplifies Stone's point. When Jenner appeared on the cover of *Vanity Fair* in June 2015—photographed by Annie Leibovitz in a fitted white satin bodice, her hair in Hollywood-glamour cascading curls—some praised her bravery in making her transition so public. Others, though, expressed concern about her transition from a paragon of heteronormative masculinity (as a family man and Olympic athlete) to a paragon of femininity (as a glamorous cover girl). In the narratives that Stone provides, not only do the protagonists wish to erase any trace of their anatomical sex, but they also embrace a female gender identity restricted by traditional gender norms (227). Stone makes a fair point, one echoed by Jenner's children who, Jenner admitted in a *USA Today* interview, said the bold, feminine cover look was "a little too much." In response, she explained, "I had suffered for 65 years, OK? To have a beautiful shot of my authentic self was important . . . I wanted to end the old Bruce, my old life . . . and that picture did it" (Deerwester). Jenner characterizes this initial shoot as, at least in part, a reaction to repression, an admittedly extreme but justifiable means of breaking away from a hypermasculine past self. Perhaps as societal gender expectations of men relax, the norms for MTF transitions will change.

Narratives like Jenner's public account, as well as those described by FTM (female-to-male) transsexuals, also participate in a complex web of relations between medical professionals and administrators who ultimately play the role of approving or disapproving various stages of the transition process, including hormone therapy and certain surgical procedures. Stone

explains that researchers and medical practitioners rely on the commonly accepted concept of "gender dysphoria" or the feeling of being in the "wrong body"—a phrase Caitlyn Jenner rejected in her televised interview with Diane Sawyer—to establish best practices for individual treatment. Fitting transsexual patients into a gender binary simplifies the daunting task of assessing whether any given patient is ready for gender confirmation surgery. Unfortunately, having these strict standards of practice can encourage transgender individuals to emulate existing narratives rather than to construct their own, as Bernice Hausman notes in a 1995 essay: "In a context where telling the right story may confer legitimacy upon one's demand and the wrong story can foil one's chances for sex change, the autobiographies of those transsexuals who have successfully maneuvered within the strict protocols of the gender clinics constitute guide-books of no mean proportion" (337).[6] Indeed, transgender individuals interested in proceeding with gender confirmation surgery may feel pressured to give the "right" narrative of their experience to expedite the process and, at least until recently, avoid the RLT.[7]

Resistance to the RLT, also called Real Life Experience (RLE), influenced the seventh version of the World Professional Association for Transgender Health (WPATH) Standards of Care (SOC), published in 2011, which only requires a referral letter rather than an RLT or RLE. These SOC recommendations made their way into many transition narratives and were typically met with anxiety. Jorgensen, for example, expresses that she had no desire to wear women's clothing before her surgery but preferred to wait until her legal status had changed to female (162). Decades later, Janet Mock would express relief when her doctor did not adhere strictly to the protocol of the SOC guidelines: "Dr. R believed in self-determination and diversity in gender and bodies, which is not the norm in the medical establishment. In order for trans people to gain access to hormone replacement therapy and gender affirming surgeries, these procedures must be deemed 'medically necessary' from the standpoint of mental health professionals" (*Realness* 136). In her memoir, Mock calls into question the RLE as well as the recommendations, which require transgender people to "be pathologized, diagnosed with 'gender dysphoria'. . . . These diagnoses stigmatize transsexual patients as mentally unwell and unfit" (136). The RLE can create additional anxiety for those transgender people who prefer to avoid public scrutiny, meanwhile contributing to the social and medical stigmas attached to the transgender community.

* * *

Since Stone published her essay, more transgender narratives have emerged, and more transgender individuals have come out—some in a very public way. These newer transgender narratives, whether fictional or autobiographical, have offered a broader range of experience: The aforementioned Ames novel *The Extra Man,* for example, describes a man who feels constricted by the possibilities before him: he longs to be both a "young gentleman" and a "pretty girl" (61). Feinberg's *Stone Butch Blues* describes a butch woman who, for a time, passes as a man, only to discover that her identity conformed to neither traditionally masculine nor feminine parameters, thus embracing a more fluid construction of gender. Feinberg, in fact, is often credited with introducing the term "transgender" into queer self-identifying lexicography, and yet in doing so, ze also stressed the term's fluidity. In hir 1992 pamphlet "Transgender Liberation: A Movement Whose Time Has Come," Feinberg defines the term as "a 'pangender' movement of oppressed minorities—transsexuals, butch lesbians, drag queens, cross-dressers, and others—who all were called to make common revolutionary cause with one another in the name of social justice" (205). Although many contemporary queer scholars stress the differences between, say, cross-dressers and transgender people, Feinberg collapses them into the same umbrella category, noting that each of these identifiers represents a group who rejects traditional gender restrictions—including the assumption that anatomy can define gender identity. Transgender and genderqueer literatures, then, have become a site at which to negotiate these labels and categories, to illustrate their fluidity, to show how these terms queer themselves.

Performativity and Performance: Aleshia Brevard and Janet Mock

In current discourse about transgender identities, scholars and activists have been careful to distinguish the often-confused categories of "transgender" and "transvestite" (a term that the Gay & Lesbian Alliance Against Defamation [GLAAD] advises not to use "unless someone specifically self-identifies that way"). GLAAD, a media-monitoring organization protecting and advocating for LGBTQ+ rights, explains on their site that the term "cross-dresser" replaces "transvestite" and designates a category of people,

mostly men, who "typically identify as heterosexual" and style themselves (through clothing, hair, adornments, makeup, etc.) as women. The site distinguishes cross-dressers from drag queens, noting that cross-dressers style themselves in this way for the purpose of "gender expression" rather than "for entertainment purposes," whereas "drag queens are men, typically gay men, who dress like women for the purpose of entertainment" (GLAAD). Contemporary scholars and LGBTQ+ activists have echoed GLAAD's distinctions among these groups, pushing back against stereotypes—perpetuated by popular culture—that confuse and elide these categories.[8]

And yet, by insisting on these distinctions, LGBTQ+ scholars and activists risk falling into the trap of heteronormativity, establishing boundaries for queer identities. The narratives in this chapter queer these distinct categories and complicate the clean-cut definitions provided by GLAAD and other organizations. Many of these same scholars and activists acknowledge the intermingling of transgender and drag within the house ball circuit, for example, a scene Mock describes in detail in *Redefining Realness*. Given the importance of clothing to each narrative, the writers illustrate how clothes—so often deployed to regulate gender—can serve a more self-actualizing function within the transgender community. Clothes become a point of entry into queer culture; a symbol of empowered femininity or nontoxic masculinity; or an outlet for self-expression that might not otherwise be available in a repressive environment. In some instances, the categories of cross-dressing, drag, and transgender or transsexual identity overlap, with clothing signaling the intersection of these usually distinct designations.

Clothing influences not only the performance of gender, but also gender performativity. The authors discussed in this section—Aleshia Brevard and Janet Mock—both recall identifying models of femininity among famous performers: for Brevard, Hollywood legends like Ginger Rogers and Marilyn Monroe; and for Mock, Beyoncé. These models would shape the women Brevard and Mock would become. For Brevard, coming of age in the 1950s, her role models fueled her polarized ideals of femininity (vampish vixen and demure housewife). The music icons of Mock's youth, in contrast, taught her to embrace her sexuality in a way that ultimately empowered her and gave her a positive view of her racial identity and physical features, as she notes of Beyoncé: "She was my style icon, the epitome of a graceful, talented, strong woman. She was the mold for me. She made me love being brown, she made me love my adaptable curly hair, she made me love that my

thighs touched" (*Realness* 194). These icons gave Brevard and Mock ideals of womanhood to emulate, in terms of both physical appearance and attitude.

Although their icons may have given Brevard and Mock physical models of femininity to which they could aspire, in many ways, these authors absorbed messages about gendered behavior from their social surroundings as well as from popular culture. As with ciswomen, gender for the transitioning Brevard and Mock is performative. Judith Butler characterizes gender performativity as how "words, acts, gestures, and desire produce the effect of an internal core or substance, but produce this *on the surface* of the body, through the play of signifying absences that suggest, but never reveal, the organizing principle of identity as a cause" (136). In other words, women (and men) unconsciously perceive these signifiers—and thus gendered behavior—as stemming from a biological or physiological source, and as members of that gender group, unconsciously reproduce these same surface signifiers. Butler continues: "Such acts, gestures, enactments, generally construed, are *performative* in the sense that the essence or identity that they otherwise purport to express are *fabrications* manufactured and sustained through corporeal signs and other discursive means. That the gendered body is performative suggests that it has no ontological status apart from the various acts which constitute its reality" (136). Although in the case of Beyoncé or the Hollywood darlings that Brevard admires, the women may have deliberately imitated mannerisms or styles as a means of cultivating their own sense of femininity, Brevard and Mock nevertheless absorb other, less obvious, codes of femininity: chronic imposter syndrome; an obligation to be pleasing; a desire or need for male protection.

Early in her memoir, when Brevard works as a female impersonator for Finocchio's, she relates how she and her fellow "queens" behaved in relationships with cisgender men, describing her friend Stormy's relationship: "She knew no bounds where her man's creature comforts were concerned and played her subservient role to the queenly hilt. . . . As a 'gay wife' Stormy cooked, cleaned, and waited on her husband, hand and hoof. She was the 'femme' in a butch/femme relationship modeled on the heterosexual prototype of the time" (49). Rather than expressing surprise or concern, Brevard seems resigned, acknowledging that she would behave in much the same way with her partners: "Like much of society, I thought a good woman must also be docile and long-suffering. The women I knew, genetic and generic, all agreed that the nurturing of love and romance was woman's most ennobling endeavor." Having grown up in the 1950s, during an era when women

were pressured by popular media and social norms to aspire to the role of dutiful middle-class housewife, Brevard, too, absorbed these codes and perceived them as endemic to womanhood. In many instances, these codes led her into situations that posed physical and emotional harm. She describes an incident after her transition in which a man attempts to sexually assault her in his car: "I was afraid to slug him—that might not be ladylike. . . . God, what a neophyte! I was trying to protect the feelings of a would-be rapist because he'd spent money getting me drunk" (111). Brevard has accepted drinks from the man, believing that to be the polite and feminine thing to do, and later accepts a ride home with him, believing herself a damsel to be protected. The incident makes her more aware of the social cost of presenting as a feminine woman, as well as how completely she has absorbed the feminine imperative of being pleasing, of sparing a man's feelings above all else.

Unlike Brevard, Mock grew up in a progressive social environment (especially after her return to Honolulu), yet she echoes the same trappings of gender performativity Brevard describes. In one passage in *Redefining Realness,* Mock relates the appeal of being a "secretary" when she was younger and still presenting as a boy. She develops this career interest when she notices a secretary attached to every important male figure in films: "*That's so me,* I thought, attracted to the elementary hyper-feminine, submissive depiction of womanhood—a sharp contrast to the masculine world where I lived with my father" (37). Mock later acknowledges her "youthful understanding of gender roles," noting that she "actually wanted to be Clair Huxtable" (37). Nevertheless, the instance shows how even before she began identifying as transgender, Mock was interpellated by patriarchal constructions of femininity that suggested being a real woman meant serving a more powerful male figure. She would later learn "to stand firmly at the intersection of blackness and womanhood, a collage of my lived experiences, media, pop culture, and art" (248–49), citing influences in her own family as well as Clair Huxtable, Beyoncé, Audre Lorde, and Michelle Obama. As a young transgender woman, however, Mock was not immune to the passive absorption of feminine behaviors—in fact, Butler suggests that transgender individuals essentially *prove* the existence of gender performativity, demonstrating the superficial (as opposed to biological) nature of gender.[9]

This absorption of gendered behaviors made it difficult for Mock to recognize the behavior of Derek, her father's girlfriend's son, as sexual abuse. Mock describes the sexual molestation she experienced as a young boy, as

well as why she did not reject his advances: "Derek made me feel special when no one else was around, and especially when no one else validated the girl-child inside of me. Derek treated me like a girl, I thought, so I understood him to be my only ally. . . . I made excuses for him, from blaming my femininity to blaming his age" (45). Mock spends several pages analyzing this experience, perhaps recognizing how pervasive it is among transgender youths and hoping to bring awareness to the oppressive power dynamics and manipulation it entails. In hindsight, she reflects, "I blamed myself for years for *attracting* Derek. That I, the victim, had *asked* for it. As I write this, it sounds ridiculous, but as a survivor of sexual abuse, I have to forgive myself for how I coped and how I learned to see and internalize the abuse" (47). Many factors influenced Mock's response to Derek's sexual assault: her gratitude for being seen as female when she couldn't present that way in public; her innocence and lack of understanding that Derek's behavior was abusive; her desire to be attractive; her sense of guilt and shame. Like Brevard, her sense of violation was overwhelmed by an internalized desire to be pleasing, to accommodate the men around her.

While these and other episodes in Brevard's and Mock's memoirs illustrate how the women internalized repressive gender norms, they also complicate Butler's theory of gender performativity by recounting numerous examples of gender performance—moments in which they consciously *dressed up as* or *pretended to be* women, recognizing that the role was, for the time being, a temporary one, experimenting with public reception of their still-repressed transgender selves. Butler and other gender studies scholars are careful to distinguish performativity from performance. For example, in an excerpt from *Second Skins: The Body Narratives of Transsexuality* (1998), Jay Prosser notes how Butler refutes the equation of "gender performativity" with "gender theatricality"—the notion that "gender, like a set of clothes in a drag act, could be donned and doffed at will, that gender *is* drag"; rather, he clarifies, "Butler had carefully argued against any conceptualization of gender as something that could be chosen at will" ("Judith Butler" 262). At the same time, such statements are complicated when, within a transition narrative, the speaker describes doing just that—*temporarily* adopting clothes and other surface signifiers that feel more aligned with their gender identity and then shedding those signifiers, code-switching, when needed. In addition, the narratives complicate the notion of gender performativity by positioning femininity as potentially empowering. In *Redefining Realness,* Mock pushes back against the negative associations with femininity

perpetuated by feminists like Betty Friedan, arguing that while many peo-
ple perceive femininity "as frivolous" or behaviors like putting on "a dress,
heels, lipstick, and big hair" as "artifice, fake, and a distraction," for some
transwomen these behaviors can feel liberating and self-affirming: "I knew
even as a teenager that my femininity was more than just adornment; they
were extensions of *me,* enabling me to express myself and my identity.
My body, my clothes, and my makeup are on purpose, just as I am on pur-
pose" (147). Both Mock and Brevard, in identifying femininity as empow-
ering, blur the boundaries between feminine behaviors as extensions of
submissive acts of gender performativity and as empowering acts of defi-
ance and self-assertion.

As a performer, author, and longstanding aficionado of Hollywood glam-
our, Brevard exemplifies the blurring of performativity and performance in
her autobiography. Born Alfred Brevard Crenshaw in rural Tennessee, Bre-
vard lived most of her life without the discursive LGBTQ+ community that
has developed over the past few decades, but rather puzzling out her gender
identity as a personal, private journey. Over the course of her life, Brevard
would become a popular drag performer, a *Playboy* bunny, a film and televi-
sion star, and one of the first individuals to undergo gender confirmation
surgery in the United States.

One of Brevard's earliest childhood memories centers on an article of
clothing: her grandmother's shawl (17). Although Brevard describes her
early childhood years as "happy" (16), she also recalls the secrecy with which
she engaged in her imaginative play, envisioning herself as Ginger Rogers
whirling about while her grandmother napped and the rest of the family
was away: "I danced in Gran's gray crocheted shawl with the rust scalloped
trim. Gran's bed shawl was my lovely long skirt. When closed, the one throat
button caused the garment to fit snugly around my waist. With my skirt
secured, I would twirl and twirl around the guest room, now and then catch-
ing a glimpse of myself as I swirled past the chifforobe's full-length mirror"
(17). As a child of the 1940s, Brevard was born into Hollywood's heyday of
glamour, when American film actresses first became international icons
of style and beauty. These women thus became Brevard's early models for
femininity, their physical beauty inextricably linked to their dramatic perfor-
mances. This early exposure to Hollywood icons, combined with her feelings
of dissonance with her assigned sex, influenced her ideation of womanhood.

Brevard's narrative also highlights the importance of clothing cata-
logs to her developing gender identity. Clothing catalogs, first introduced

by Montgomery Ward in 1873 (Ewen and Ewen 42), became a bridge between major retailers—many of which were beginning to develop their first ready-made clothing lines—and consumers living outside of major cities. These consumers, often in rural areas, could purchase patterns and, eventually, whole garments through these catalogs, especially as improvements in manufacturing technology made mass production possible and stylish clothing affordable. By the 1940s, most Americans purchased ready-to-wear (RTW) garments, although high-end designers would not begin making RTW lines until the 1950s. The catalog, for Brevard, was a site of fantasy and an inspiration for imaginative play. She describes sitting on a swing as a child with her close friend Helen Leigh: "Swinging together, out by the beehives, we played at being grown up, assisted by a well-worn Sears and Roebuck catalog. . . . First, Helen and I would plan a marvelous trip, then we'd turn to Sears and Roebuck, looking for just the right outfits. Helen didn't mind that I picked out a woman's ensemble" (19). These moments with Helen illustrate how the disparate categories of cross-dressing, drag, and transgender identity intersect in Brevard's identity formation. She puts on her grandmother's clothing in secret yet fantasizes about life as a performer, and with her friend, she develops a sense of trust because Helen does not challenge Brevard's imagining of herself as a woman going on trips, wearing women's fashions.

When Brevard finally has the opportunity to purchase clothing for herself, she describes the process as "shopping," even going so far as to emulate her mother's process of selecting a garment rather than just picking the first item that fits her needs. She depicts the experience of shopping for a jacket in Nashville: "Alone and feeling very mature, I followed a shopping pattern learned from my mother. I went to every store in town, then had lunch in order to reflect on what I'd seen" (23). Her selection, she continues, was a "shocking jacket" in *"pink*—not an acceptable choice." Despite the gender taboos against men wearing pink, however, Brevard states, "I wore that damn pink jacket for the rest of high school" (24). Brevard connects this experience with her "gender satisfaction" during her high school years, and it's worth noting that each of these small rebellions against gender norms that she recollects is associated with clothing—the fantasy of clothing, the experience of shopping, or the imagined stage performance in glamorous garments.

Mock, too, describes how she first donned women's clothing at a young age for the sake of a temporary performance, only she did so to entertain her friend Marilyn during a game of Truth or Dare. For her "dare," Marilyn

directs Janet (then Charles) to put on her grandmother's floral pink muu-
muu and run around in it. As Janet/Charles makes her dash, she reflects,
"I felt lovely in the muumuu, which flirted with my skin as the Oahu trades
blew moist kisses at me." Infused with a sense of confidence, she performs
for her friend: "At the trash bin, I did a little Paula Abdul move to my
inner DJ's spin of 'Straight Up' for Marilyn's delight" (18). When Janet's/
Charles's grandmother catches her, she gives her a spanking. Later, Mock
recalls her mother being more sympathetic: "She wasn't reprimanding me.
She was just telling me the way things were. . . . In her learning, what I did
by openly expressing femininity as her son was wrong and, in effect, from
Cori's cackle to Grandma's smack, taught me that my girlhood desires were
inappropriate" (21). Mock notes that her mother did not necessarily think
Janet/Charles was "wrong" for having such desires but knew the ridicule
and violence she would encounter if she openly expressed those desires.
The pink floral muumuu is symbolic in Mock's transition narrative, for it
represents her first flirtation with femininity, with women's clothing that
through mere contact and sensation gave her a jolt of self-assurance, while
at the same time becoming a source of humiliation and punishment.

Brevard and Mock describe many such dalliances with cross-gender
clothing, as well as incidents of temporarily adopting female personae
in early childhood, then "switching" when the presence of (usually male)
authority figures disrupts their play. These moments feel more in line with
the concept of performance or experimentation than what Butler character-
izes as gender performativity. Nevertheless, Brevard and Mock reveal how
such seemingly superficial and temporary adoptions of feminine clothing
or behavior belie a more ingrained, socially constructed feminine ideal of
behavior, one often associated with sexual objectification and submissive-
ness. Such moments are more pronounced in Brevard's narrative, as she
focuses on her "becoming" from the 1950s to about the 1980s, when oppor-
tunities for women were far more limited and the discourse of gender equal-
ity perceived as antithetical to femininity, and yet, as noted earlier in this
section, both experienced sexual assault, in addition to their more everyday
experiences of sexism in relationships, in the workplace, or in the education
system. Both Brevard and Mock reflect back on these incidents with the wis-
dom of hindsight, as well as with confident, secure voices that indicate their
personal growth since these events.

As Brevard was internalizing social messages about what it meant to be
a woman and behave like a woman, she was also afforded a chance to dress,

sing, and act like a woman on a temporary basis in a space where such a performance was socially sanctioned. In the portion of her memoir focused on her career at Finocchio's, Brevard characterizes the experience with some ambivalence: on the one hand, she enjoys the beautiful clothes and the opportunity to be in the spotlight, but on the other hand, she feels as though she is settling for something less than, or at least different from, her true gender identity in becoming a drag queen: "I was still stuck with someone else's concept of gender-appropriate behavior, but the conventional path I'd been following had suddenly made a sharp turn to the left. I was a drag queen. Correction! I was a celebrated, union-carded, female-impersonating entertainer" (43). Part of Brevard's pleasure in the performance was a sense of acceptance as well as a sense of pride in her appearance as an attractive woman. She reflects, "For me, Finocchio's offered the first sense of true acceptance I'd ever known. As Lee Shaw, drag diva, I was notable, and nothing was demanded except that I look incredible—and I have a modicum of talent. As the blonde ingénue of the San Francisco nightspot, I was almost complete" (4). Brevard experienced moments of dressing and behaving in a way that felt more natural to her, if a little stylized or exaggerated. And yet she knew such performances were temporary—that she was playing a role, not living her reality as a transgender woman. In the 2005 Susan Stryker/ Victor Silverman documentary *Screaming Queens: The Riot at Compton's Cafeteria,* Brevard explains, "I had freedom to be a big sissy on stage, yes. But I did not have the freedom to live my life outside or off the stage." The club expected each performer to enter and leave the premises "as a boy," thereby underscoring strict boundaries between stage personas as women and "real life" personas as men. Brevard was a transgender woman accustomed to repressing her gender identity and presenting as a man, so certainly Finocchio's represented an improvement, a chance to be a woman on the stage, yet in no way did her career offer a resolution for her repressed gender identity.

Finocchio's held a significant place in San Francisco's LGBTQ+ history. The club initially opened in the 1920s in the Tenderloin District. Stryker reflects, "The Tenderloin looked lawless and out of control, but the police actually ran the place. They allowed the prostitution, drug dealing and gambling, and then demanded payoffs from people involved in those activities." Brevard notes that the club's location in the Tenderloin District was temporary; while other LGBTQ-frequented establishments continued to thrive in the Tenderloin, many were subject to regular police raids—in fact, these raids drove Finocchio's to relocate to the North Beach nightclub district in

1936 (Stryker, "Finocchio's"). Relocating altered the club's public profile, and for Brevard and other performers, it promised a kind of security many other queer performers did not enjoy. At the same time, Brevard notes in Stryker's documentary, the performers at Finocchio's had to be careful and follow the rules (e.g., only wearing drag while at the club), thus protecting the tenuous understanding between the owner and the police. The club was extremely popular in the 1960s when Brevard began working there; it attracted celebrities like Lana Turner and Marilyn Monroe, tourists, and "closeted homosexuals" (Brevard 4); Brevard explains, "Partly this was because our impersonators were glamorous, openly queer entertainers— and gay and lesbian audiences shared a sense of pride in our mainstream acceptance" (4). Finocchio's performers were referred to as "the elite"; many others, Brevard acknowledges, were forced to make a living in seedier joints or from prostitution, both with the constant specter of violence.

As a performer at Finocchio's, therefore, Brevard enjoyed several important freedoms—relative safety from street violence and police raids, the opportunity to dress and perform as a woman, and, moreover, a chance to live out a part of her fantasy of being a Hollywood darling. Brevard became popular for her Marilyn Monroe impersonation: "'My Heart Belongs to Daddy' was introduced at Finocchio's on a Tuesday night. My act in a red knit sweater, slowly removed to reveal a red lace merry widow, was an instant triumph" (58). Brevard enjoys the audience response, the attention of attractive young men, and the glamorous clothes, even as she struggles with the transience of performance. Nevertheless, Brevard expresses her comfort with knowing that the men who courted her at Finocchio's knew about her assigned sex—later in her memoir, after her transition, she debates when (or whether) to reveal her assigned sex.

In contrast, Mock's earlier experiences with performance involved the performance of a fantasy and necessitated some level of deception. As a teenager, Mock recalls, she created a persona, an alter-ego named Keisha. Mock cultivated this persona when she played at her cousin Mechelle's. In Mechelle's presence, Janet would dress like a girl, wear her hair like a girl (growing it long and tying it back with a purple scrunchie), and act like a girl, introducing herself to boys as Keisha (75–77). Mock explains that her persona was driven in large part by her envy of her cousin: "I longed to wear her barrettes, to shake her pom-poms, to bask in a boy's attention, to call Auntie Wee Wee Mom" (77). As Keisha, young Janet enjoys romantic attention from boys, swims in a tank top and shorts like her cousin, and

styles herself in a way that feels more comfortable and liberating. However, as with her grandmother's muumuu, Janet is punished for behaving out of accordance with her assigned sex, this time by her father, who shaves her head and demands to know if his son is gay. Later in her life, after her transition, Mock would experience the attention that Brevard relished at Finocchio's without this same fear of parental punishment.

Mock is more analytical than Brevard about the act of performance, as well as the ways that performing tends to elide different queer identities. Having transitioned decades after Brevard, Mock is careful to distinguish between drag queens and transgender women in her autobiography, even as she acknowledges that both identities fall into "the umbrella term *transgender*" (*Realness* 113). Mock clarifies the distinction when discussing performers at a gay club called Fusions in Waikiki: "Most of them were drag queens, but a select few were trans women who performed as showgirls. Society often blurs the lines between drag queens and trans women. This is highly problematic, because many people believe that, like drag queens, trans women go home, take off their wigs and chest plates, and walk around as men. Trans womanhood is not a performance or costume" (113). While trans womanhood may not be a performance, trans women do perform, as Mock recognizes—often in the same lineup as drag queens, whether at clubs or house balls. Watching these women—drag queens and trans women—deeply influenced the sense of womanhood that Mock longed to embody. Her exposure to the drag clubs and house balls (both in person and in the 1990 documentary *Paris Is Burning*) also introduced her to the concept of "realness" cited in the title of her autobiography: "'Realness' means you are extraordinary in your embodiment of what society deems normative" (116). Many of the women and queens, she notes, do more than perform their embodiment of realness on the stage: "a trans woman or femme queen embodies 'realness' and femininity beyond performance by existing in the daylight, where she's juxtaposed with society's norms, expectations, and ideals of cis womanhood" (116). Achieving realness, Mock suggests, means adopting the right attitude, drawing inspiration from the performance of female role models (like Beyoncé), as well as knowing how to style oneself—the application of makeup, the arrangement of hair and wigs, the selection of the right clothing. Mock lends a sense of agency to these seemingly superficial modifications, noting that "'Realness' is a pathway to survival" (16).

While watching these performances shapes Mock's adolescent years in *Redefining Realness,* in her second memoir *Surpassing Certainty,* Mock

focuses on a different kind of performance as influential in shaping her gender identity. In contrast to Brevard's performance as a female impersonator at an upscale club, Mock performed as a dancer in a strip club after her transition and after she had lived for several years as a woman. Mock identifies her experience working in a strip club as paradigmatic in her physical self-acceptance: "Dancing in the club gave me greater confidence in my body, particularly enabling me to appreciate the aesthetics of my vagina" (*Certainty*). Wearing skimpy clothing and high heels, accentuating her new, feminine features and curves, Mock relishes a sense of her new gender presentation and confidence. She describes her "aesthetic" as "1970s black goddess glam, a cross between blaxploitation icon Pam Grier and disco queen Donna Summer. I was brown, backlit, and bodacious." She takes pride in her appearance and deliberately develops an aesthetic that incorporates the style of black female icons and bright, bold colors that will show up better within the darkly lit venue. Mock's self-consciousness is alleviated not merely by the audience's acceptance of her and response to her as an attractive, sexy woman, but by comparing herself and her anatomy to the scores of other performers in the venue, which reassures her that "No two were identical, yet all belonged to women." She also emphasizes the bonding among the women who work there, the collective support engendered by their shared experience: "My feminism is rooted in the conversations I had backstage where these working women spoke it plain and persevered." Performing as an exotic dancer, for Mock, becomes a vehicle for accepting her body as well as for bonding with other women, connecting with and supporting her friends while experiencing acceptance as a woman.

Mock situates her experience as a stripper within the context of hip-hop culture, pushing back against any popular assumptions that exotic dancing and skin-revealing clothing are degrading. She explains that within the culture of her upbringing, "strippers or women who appropriated the stripper aesthetic" visually displayed themselves, often dancing in music videos— she cites Tupac's "How Do U Want It," in which some women dress in hot pants and tight halter tops and others in corseted, Marie Antoinette–style costumes, as well as Nelly's "Tip Drill," in which women wear string bikinis and expose their breasts and genitals to the camera as they dance. Mock reflects, "I stood in awe of these women who seemed empowered by their bodies and sexuality—even if it was all pretend or for pay." Though aware of a mainstream stigma attached to stripping, Mock rejects much of this discourse as patriarchal—*not* feminist—and contrasts such statements with

the celebration of dancers represented by women like Blac Chyna, Cardi B, Amber Rose, and Beyoncé in her song "6 inch." While these women cast exotic dancers as empowered, others offer "commentary that aimed to shame dancers." She specifically faults comedian Chris Rock for repeatedly underscoring a public maligning of exotic dancers, citing a bit from *Never Scared* (2004) in which he talks about his daughter: "sometimes I pick her up and I just stare at her and I realize my only job in life is to keep her off the pole. Keep my baby off the pole! I mean, they don't grade fathers, but if your daughter is a stripper you fucked up" (quoted in Mock, *Certainty*). Mock highlights the patriarchy in Rock's claim here, noting that he essentializes the varied experiences of all strippers and implies that "a woman's profession—respectable or not—reflects on the man who did or didn't raise her." Rock and others might characterize Mock's performance as a stripper in a negative light, arguing that she put her body on display for the appraisal of spectators (or worse, she has done so because some male authority figure neglected to nurture her), and perhaps characterizing her dancing not as performance but as gender performativity. Yet Mock characterizes such assumptions as reductive, illuminating the importance her performances played in negotiating her gender identity.

Buttressing each example of performance in these narratives is the need to explore, to experiment, to experience public validation of one's gender identity. These instances of performance may be private or public, part of fleeting childhood games—as when Brevard catalog-shops with her friend or when Mock poses as Keisha (*Realness* 68–76)—or of professional careers. These instances of performance, of donning feminine clothing and playing a role, are distinct, however, from the experience of transitioning, of accepting one's gender identity holistically. Despite her enjoyment of her performances at Finocchio's, for example, Brevard would not feel at home in her body or presentation until she underwent both hormone therapy and multiple surgeries, and arguably until she developed a sense of self that extended beyond accepting contemporary social norms for women. Performance is, for both Brevard and Mock, an important part of negotiating gender identity, but transgender identity is not in and of itself a performance.

Both authors ultimately reject the certainty that governs earlier transgender memoirs like those critiqued by Stone. Early in *Redefining Realness,* Mock observes, "When I say *I always knew I was a girl* with such certainty, I erase all the nuances, the work, the process of self-discovery. . . . The fact that I admit to being uncertain doesn't discount my womanhood. It adds value

to it" (*Realness* 16). Neither Brevard nor Mock tell a fairy-tale transformation story through their narratives—in fact, both reveal the dangers of such archetypal journeys. Brevard shows how blindly conforming to her social understanding of feminine behavior repeatedly placed her in harm's way and prevented her from developing an identity as a woman that did not hinge on male approval and love. While Mock's first memoir concludes with her finding a happy relationship, she does not reduce her narrative to any kind of male validation but presents the relationship as yet another example of her own self-acceptance. Mock's understanding of gender identity is shaped by Hawaiian and Polynesian culture. She describes the centrality of the term *mahu* to Hawaiian culture, and how it refers to a kind of liminality, rejecting the gender binaries of Western culture: "*Mahu* defined a group of people who embodied the diversity of gender beyond the dictates of our Western binary system. *Mahu* were often assigned male at birth but took on feminine gender roles in Kanaka Maoli (indigenous Hawaiian) culture, which celebrated *mahu* as spiritual healers, cultural bearers and breeders, caretakers, and expert hula dancers and instructors" (102). In a way, both authors come to accept this concept of liminality as essential to their transgender identities. While both Brevard and Mock present as classically feminine, their experience living/presenting as both men and women has ultimately empowered rather than thwarted them in their self-understanding as women. They have the insight of how men move and operate in the world, the relative privilege awarded to them, and they understand—perhaps more than cisgender women—the value of maintaining a feminist perspective and rejecting a reductive understanding of gender binaries.

Queering Gender Binaries through Clothing

Although both Mock and Brevard conclude their narratives by rejecting aspects associated with femininity, they still embrace femininity in a form that empowers them. Their journeys encompass their transitions as well as the aftermath of transitioning, in which they develop an understanding of what it means to be a woman, and determine the kind of women they want to be. Their journeys are a negotiation of self-presentation and gender identity that *also* happens to include public acceptance and the love and acceptance of family members. In contrast, for Jess Goldberg of Leslie Feinberg's *Stone Butch Blues* and Louis Ives of Jonathan Ames's *The Extra Man,* this negotiation of gender

identity is never fully resolved. In each narrative, the protagonist must settle on something in between, a gender identity that defies a clear label.

Early in *Stone Butch Blues*, when Jess has just begun to develop a sense of community within the butch/femme bar scene, she comes face-to-face with Rocco: "At that moment the bar door opened and everyone fell silent. Standing in the doorway was a mountain of a woman. She wore a black leather jacket unzipped. Her chest was flat, and it was clear she wasn't wearing a binder. Her jeans were low slung, unbelted. She carried her riding gloves and her helmet in one hand. Rocco. Her legend preceded her" (95). Although Rocco has "beard stubble on [her] chin and cheeks," Jess immediately reads her as a woman—a powerful pillar of strength she perceives as a potential role model. Rocco's motorcycle jacket instantly makes an impression on Jess; the leather moto jacket quickly becomes an important part of Jess's presentation and a symbolic garment within the novel's butch community.

The leather jacket in LGBTQ+ culture (among both lesbians and gay men) has the same roots as in a wider culture of bikers and rebels (Rubin 473). In chapter 2, I discuss the rise of "street fashion" during the 1950s, a trend that would continue well into the 1960s and become an entrenched part of the fashion industry. When this street style first emerged, it became popularized by Hollywood icons, men who famously wore working-class attire like T-shirts, jeans, and motorcycle jackets. These clothing items signified rebellion against a homogenous, repressive mainstream American culture, "the gray-flannel-suit-wearing establishment" (Gunn 243). Much of lesbian popular culture, even today, evokes this same image of the leather jacket–wearing, tough rebel, as Gayle Rubin describes in her article on butch lesbian identity: "The iconography in many contemporary lesbian periodicals leaves a strong impression that a butch always has very short hair, wears a leather jacket, rides a Harley, and works construction. This butch paragon speaks mostly in monosyllables, is tough yet sensitive, is irresistible to women, and is semiotically related to a long line of images of young, rebellious, sexy, white, working-class masculinity that stretches from Marlon Brando in *The Wild One* (1954) to the character of James Hurley on 'Twin Peaks' (1990)" (473). Rubin notes that these icons' masculinity is often enhanced by their visual juxtaposition with a femme—"a half-dressed, ultrafeminine creature who is artfully draped on her boots, her bike, or one of her muscular, tattooed forearms" (473). Within these popular images, the leather jacket consistently connotes fortitude, rebellion, and toughness, a necessary armor against violence from an oppressive mainstream culture.

From its inception as a staple of iconic American fashion, the leather jacket has carried such anti-mainstream connotations as well as class symbolism—another characteristic of Rocco's jacket that gives it symbolic weight for Jess. *Stone Butch Blues* is a novel not only about gender identity and sexual identity, but also about class and race, and how these facets of identity intersect in the individual subject as well as in clothing. In her article on "queering class," Cat Moses discusses how identity issues intersect with class in the novel, arguing that "Feinberg grounds performative theories of gender in the context of class struggle" (76). The clothing that Jess is drawn to alternately signifies class identification and aspiration—for example, motorcycle jackets enhance the affiliation she feels with the butch community and other outliers of mainstream privilege, while donning a suit gives her a fleeting sense of class security and the privilege typically denied her.

Throughout the novel, Jess is drawn to clothing that connotes strength, stoicism, and survival. Feminine clothing only highlights Jess's difference, seems to mock her much as her family and society have. The clothes that she's drawn to—mainly leather jackets, jeans, BVDs, and plain T-shirts—thus also represent a resistance to mainstream society. Jess's attraction to wearing suits stems from her aspirational class fantasies; however, suits also have another appeal for her: they eclipse any remaining curves or signs of femininity *and* the oppression she feels regularly as a result of class. These clothes also function as a form of armor—against touch and inquiring eyes, as Jess comments when she first begins a new job: "I was being watched and I knew it. The first day I wore sunglasses, defensively, all day long. I didn't take off my denim jacket and kept it buttoned up over my black T-shirt" (77). Moses characterizes Jess's clothing as "drag," arguing that Jess recognizes that while her clothes may feel protective in one respect, they also represent a public violation of social and legal taboos: "Jess chooses [her clothing] very carefully because she is more aware than most of us of its cultural meaning. She consciously violates laws that require the wearing of three pieces of gender-specific clothing that 'reflect' one's 'biological' sex, preferring BVDs and an elastic binder to traditional women's underclothing, which would, to her, represent drag attire" (Moses 80–81). Though Jess breaks these rules of dress with full awareness of the risk she is taking, she does not do so out of a sense of rebelliousness; rather, she feels more vulnerable when she wears gender normative clothing.

Jess initially identifies her preferred aesthetic through her early contact with the butch community, where she experiences a kind of initiation by Butch Al and her girlfriend, Jackie. She describes meeting Butch Al for the first time: "I immediately loved the strength in her face. The way her jaw set. The anger in her eyes. The way she carried her body. Her body both emerged from her sports coat and was hidden. Curves and creases. Broad back, wide neck. Large breasts bound tight. Folds of white shirt and tie and jacket. Hips concealed" (29). Her description of Al foreshadows the liminal gender presentation Jess will eventually settle into, for in Al's appearance she sees both muscle and "curves," she sees the interplay between the clothing and binder Al wears with Al's body, repeating words like "hidden" and "concealed." Through Al and her partner, Jackie, Jess develops her own sense of butch style: "Al and Jackie groomed me. Literally. Jacqueline gave me haircuts in their kitchen. They took me to get my first sports coat and tie at the secondhand stores. Al combed the racks, pulling out sports coats, one after another. . . . Finally, Jackie smoothed my lapels and nodded in approval. Al gave a low whistle of appreciation. I had died and gone to butch heaven!" (30). In her pedagogical treatment of the novel, Erica Rand notes the significance of these shopping/initiation scenes in terms of Jess's developing identity as a butch: "Older butches . . . school Jess in how to be a butch, dramatizing gender enculturation" (38). In other words, through these scenes, Feinberg suggests that gender identity is both innate and learned.

One of Jess's most pivotal lessons from the butch community occurs when she and Ed (another younger butch) attend Butch Ro's funeral, where Ro's family has requested that all female attendees wear dresses. Jess and Ed refuse to abide by this request—Ed more defiantly, Jess with a sense of helpless resignation: "I couldn't put on a dress. I shuddered at the thought. Besides, it was a moot point—I didn't own one" (116). Jess and Ed initially feel that wearing dresses would mean sacrificing their identity for Ro's narrow-minded relatives; however, when they arrive and see the older butches in dresses, they perceive that they have failed to make a small personal sacrifice for Ro that the other butches were willing to make. Moreover, as Moses notes, the older butches' attire actually serves a more subversive function than Jess's and Ed's masculine clothing: "The reverse drag ritual at Ro's funeral doubles this doubling [that is, the double-subversiveness of drag] and challenges the naturalness of gender binaries.

When butches dressed as butches pass as men, the restricted categories of 'men' and 'women' are challenged. When butches dressed as women cannot pass as women, the binary categories break down altogether" (84). The butch women's feminine clothing only highlights the absurdity of forcing gender-normative clothes onto genderqueer women, accentuating the performative nature of gender. In addition to recognizing their mistake and unintentional disrespect to Butch Ro, Jess and Ed are temporarily ostracized from their friends for their transgression after their choice to wear suits leads the funeral director to immediately end the service.

Each of these pivotal encounters prompts Jess to reexamine herself, as Feinberg includes a series of scenes throughout the novel in which Jess confronts her own image in the mirror. The mirror is an important motif in transgender literatures in general (it appears in *Trans-Sister Radio, The Extra Man, The Woman I Was Not Born to Be,* among many others), but it also carries significance in literature about fashion. The mirror is the site where individuals confront their public presentation and analyze the images they project to the world. In this respect, it's not only a tool for self-examination but a correcting mechanism, a place people ask, "How does this look on me?" or, as in the case of Louis Ives in *The Extra Man,* a site of shame, a place where an individual might realize that he doesn't look the way he thought he looked. Jay Prosser suggests that in *Stone Butch Blues,* the mirror serves as a tool for revealing Jess's double consciousness ("No Place like Home" 497). Early in the novel, when she is eleven years old, Jess stands before the mirror wearing her father's clothing: "As a child cross-dressing in her father's suit, Jess sees reflected not a man but an 'uncatalogued' woman, the woman she expects to become" (498). Cat Moses interprets this same scene in light of Jess's longing for the security of both gender identity and class: "The suit represents not just the gendered self-expression that Feinberg claims for it, but also Jess's unconscious yearning for a class status that might afford her more breathing room as a transgendered person" (82). As a working-class person, Moses notes, Jess is far more vulnerable to violence than if she had been from a more privileged family. Both Prosser and Moses see in this initial mirror scene a sense of Jess's yearning and *seeking;* Jess has to try on clothes and see herself in a mirror to situate herself, to check in on her sense of comfort in her body and presentation, to read the signifiers she folds into her appearance. Her life often depends on her ability to do so.

In the scene opening this section, Jess meets Rocco, a character who strikes Jess with her clothing and imposing appearance and introduces

the possibility of taking hormones, of "passing": "Jan heard that Rocco had taken hormones and had breast surgery. Now she worked as a man on a construction gang. . . . It was a fantastic tale. I'd only half believed it, but it haunted me" (95). Rocco's identity and gender presentation are unique within the butch community: she still identifies as a woman and butch, and in having "top" surgery (as opposed to sex reassignment surgery, or SRS), she avoids the medical and bureaucratic obstacles that self-identifying FTM transsexuals face. She openly settles for a liminal identity, presenting as a man at work while still accepted as a butch woman socially. Jess reflects, "I was afraid to see myself in Rocco," perhaps foreshadowing her own FTM transition, her reluctant decision to "pass" for the sake of survival, *or* her eventual realization that she cannot settle on either end of a binary gender spectrum but only somewhere in the middle.

Although the novel is characterized as a transgender work, and Feinberg as a pioneer within transgender discourse, Jess most strongly identifies not as transgender but as butch. Much of the novel, in fact, feels like an introduction to the butch culture and community. As Jess educates (and is educated by) her friends, readers also learn about the fluidity of transgender and butch identity as Feinberg has characterized it. One reason Feinberg has advocated for "transgender" as an umbrella term for various genderqueer identities, perhaps, is hir own confrontation with boundaries within the LGBTQ+ activist community—a series of tensions ze incorporates into the novel. As she navigates these tensions, however, Jess continues to develop her sense of self in relation to these inscribed gender and sexual identities.

Even among butches and femmes, with whom Jess is most comfortable, she observes how codes of dress and behavior seem standardized. Speaking to these codes, Rubin notes that within the butch community, "the most commonly recognized butch styles are those based on these models of white, working-class, youthful masculinity" (474). Rubin contrasts butches with the femmes with whom they typically partner: "'Femmes' identify predominantly as feminine or prefer behaviors and signals defined as feminine within the larger culture; 'butches' identify primarily as masculine or prefer masculine signals, personal appearance, and styles" (472). Despite these seemingly set codes of appearance and romantic partnering within the butch/femme community, both Rubin and Feinberg acknowledge the variants within the community—those who don't fit the standard and often face ostracism from outside and within the community. For

example, Jess's coworkers Ethel and Laverne present as butches (and Jess's coworker Duffy assumes they are), but they are married to men, and Jess notes that they "really seem to love the guys they married" yet still "deal with the same shit butches do" (86–87). Jess also acknowledges her own disgust when she discovers two of her butch friends (Frankie and Johnny) are a couple (202). By including these characters, Feinberg alludes to the diversity within the butch community, a variety of sexual and gender identities that illuminates cracks within the community's solidarity. Rubin affirms such fluidity within the butch community: "Some butches are comfortable being pregnant and having kids, while for others the thought of undergoing the female component of mammalian reproduction is utterly repugnant. Some enjoy their breasts while others despise them. Some butches hide their genitals and some refuse penetration. . . . Some butches are perfectly content in their female bodies, while others may border on or become transsexuals" (474). Rocco represents one end of this spectrum, and yet despite Jess's admiration for her, Rocco's choice to take hormones is controversial among other butches in their community. Jess experiences some of this same resistance—both from her community and from the increasingly activist LGBTQ+ community—when she decides to transition and pass as a man.

Jess's passing is driven not by an innate desire to present as a man, but by concern for her own safety. Prosser explains why Jess's decision to pass, as well as her eventual decision to stop taking hormones, is significant within a larger context of transgender and queer literature: "For the transsexual, passing is a step toward home, a relief and a release. . . . The transsexual takes hormones and undergoes surgery in order to make this reconciliation between inside and outside convincing. In contrast, queer theory has made passing its central mechanism for deontologizing sex and gender, for illustrating that gender is performative" ("Home" 496–97). Prosser indicates how Jess's narrative initially echoes other transsexual narratives in that she "does not feel at home in her female body in the world and attempts to remake it with hormones and surgery" (498). His use of the phrase "in the world" alludes to how Jess is constantly punished and humiliated for her ambiguous presentation and masculine-but-still-female body. Her experience of public shaming is different from the pre-transition experience of Mock, Brevard, and other transsexual individuals who longed to present as the opposite gender and experienced some degree of public approval for their gender presentation even before their surgeries.

When presenting as a man, Jess enjoys a level of safety, public accep-
tance, and camaraderie with male coworkers that she has never known
before, and in this sense, her transition seems like a welcome alternative
to the violence and public shaming she experiences before hormones and
surgery. Jess enjoys the feel of her new body, the muscles, the absence of
her breasts, the angular look of her frame and her jaw—yet she does not
feel the comfort and, to use Prosser's wording, sense of "home" in this new
presentation that other transsexual narratives describe, including those
by Mock, Brevard, Jorgensen, and FTM transsexuals like Chaz Bono and
Jamison Green. One reason for her sense of dissonance is the intimacy she
has lost, an intimacy she enjoyed with her former partner Theresa as well as
with the butch/femme community. She feels a sense of betrayal to herself
and her community, a sense that her passing is a political choice.

Most importantly, perhaps, Jess can no longer "recognize the he-she" (222)
in her reflection when she stands before the mirror. Before this mirror
scene, Jess has not realized her need to see the contrast—the same mixture
that she initially found so beautiful in Butch Al when she first entered the
butch/femme community. She observes, "My face no longer revealed
the contrasts of my gender. I could see my passing self, but even I could no
longer see the more complicated me beneath my surface" (222). Prosser
notes that in contrast to the other transition narratives, therefore, "Jess
turns back in her transition, thus refusing the refuge of fully becoming the
other sex and the closure promised by the transsexual plot. She chooses,
instead, an incoherently sexed body, ending up in an uneasy borderland be-
tween man and woman, in which she fails to pass as either" (498). Know-
ing the risks involved in presenting in "an incoherently sexed body," Jess
nevertheless prioritizes feeling that her presentation reflects the contradic-
tions she feels within, and the openness she enjoys in her friends seeing her
for who she is, over her public acceptance, job security, and physical safety.

Jess remains in this liminal body, a body that continues to elicit taunts,
shaming, and violence, once she leaves her blue-collar town and moves to
New York City. Her willingness to remain "incoherently sexed" despite daily
challenges to her physical and emotional well-being is a testament to her
commitment to activism, to living the confrontation with gender norms in
her grassroots efforts and in her own body. At the end of the novel Jess
reflects, "I'm so sorry it's had to be this hard. But if I hadn't walked this
path, who would I be?" (301). Jess may not find the security she longs for,

but she finds friends, she finds a cause as the Stonewall Riots launch the LGBTQ+ activist movement, and she finds a voice in this activist community that initially seemed so averse to transgender people. Prosser draws parallels between Jess's choices and Feinberg's own interpretation of transgender identity, referencing hir 1980 pamphlet *Journal of a Transsexual:* "That Feinberg is here a transsexual and a woman emphasizes the 'trans' as an ongoing process, not as a necessarily transitional state prior to the resolution of gender ambiguity but an identity site—a categorical home— in which the contradictions of the somatic and psychic, both within each and against the other, are sustained, and sustained painfully, not playfully" (507). Like Stone, Feinberg contradicts the notion that all transsexuals long to "pass" as the other gender (507); like Jess, ze stopped taking hormones and ultimately chose to present as "neither" or "both," as genderqueer. Such liminal identities are, as Rubin notes, far more common among transgender and transsexual individuals (478) yet tend to disappear in the cracks between the more acceptable, gender binary–affirming transition stories that permeate published transgender novels and memoirs, speaking to a public preference for the "trans" over the "queer."

In *Stone Butch Blues*, a queer writer credited with introducing the term "transgender" reveals the inherent fluidity of transgender identities and of gender and sexuality more broadly by engaging specific transgender and queer identities within her fictionalized narrative. In *The Extra Man*, cisgender author Jonathan Ames reveals this same fluidity by exploring different trans identities through a queer character's own struggle with sexual identity and gender presentation. In making Louis's gender identity unclear, Ames may have simply wished to avoid speaking for transpeople about their experience, instead allowing their voices to surface in the transgender characters Louis meets (based on people Ames interviewed). Yet in not resolving Louis's identity, Ames allows the audience to share in the confusion and frustration of Louis's queerness.

In the opening chapter of *The Extra Man*, protagonist Louis Ives comes across a bra in the teacher's lounge of the Pretty Brook Day School, where he works as a teacher. Louis immediately feels tormented by the very presence of this bra. He stares at it, noting, "I saw the barely visible etchings of flowers in the white material. I saw the sturdily lined, ample cups, whose very shape implied so much. I saw the white loops for lovely shoulders" (3). A moment later, he tries on the bra, only to be discovered by one of his colleagues. Shortly after the incident, Louis is fired.

Ames writes this opening scene with a tragicomic tone. Louis is a relatable, likeable character throughout the novel, someone the reader cannot help but root for as he struggles to adapt to life in New York City, to his quirky elderly roommate, and to his multifaceted sexual and gender identity. Of all of the transgender works discussed in this section (with the possible exception of Brevard's, whose writing Ames cites as inspiration), *The Extra Man* is the only narrative that feels both serious and comedic at the same time.

Whereas much of Feinberg's narrative references masculine, working-class clothing, Ames focuses more on middle-class gendered clothing, especially sports coats and ties for men and feminine sweaters, skirts, and undergarments—especially bras—for women. The bra as a motif surfaces several other times in the novel, illustrating its centrality to Louis's confusion about his sexuality. Louis recalls trying on his mother's bra at a young age, longing to be a "pretty girl," and feeling disappointed when he views himself in the mirror. In another scene, Louis visits a woman who advertises herself as a "Recession Spankologist"; she dresses Louis in a bra, underwear, and a slip. Later in the novel, Louis overhears his attractive colleague, Mary, as she shows off her newly purchased bra to a friend, and when she leaves the room, Louis steals the bra from her shopping bag (279). In another encounter, Louis pays for a woman to make him over as a woman, hoping (fruitlessly) to try on Mary's bra.

For Louis, the bra becomes a symbol of his ambiguous sexuality and gender identity. He vacillates between physical attraction to men (for example, his older roommate, Henry), ciswomen (his coworker, Mary), and transitioning transsexual women (the women at Sally's, a transsexual bar he frequents), as well as between his desire to be a lady and a gentleman—what he calls his "bipolar condition": "On one pole there was a desire for femininity and beauty, to appear like a pretty girl, and on the other pole I wanted to be a young gentleman who wore a tie and went to hear *Tosca* at Lincoln Center" (61). For much of the novel, Louis ruminates about his desire to be a "young gentleman," waxing poetic about his sports jackets and ties and fantasizing about being a character in a Fitzgerald novel: "I used the authors themselves as models: I attempted to dress like them after studying photographs in their biographies. I never wore sneakers, favored pants with texture—linen, wool, or corduroy—and went to Italian barbers for short haircuts" (23). Donning his sports coats and ties gives Louis a sense of confidence and security—"a fantasy that I wore like armor to get me through the

day and to enjoy the day" (23)—for he believes that such clothing will ensure his conflicting desires stay hidden from casual observers. These clothes also enrich Louis's active fantasy life, for in these dapper garments he imagines the world sees him as he wants to be seen, as a classy Fitzgeraldian gentleman living a respectable life.

Yet at the same time Louis cultivates his young gentleman persona, he is magnetically drawn to women's undergarments and frequently fantasizes about being an attractive woman. His fantasies about women often center on their clothing—how the clothing feels, how they admire their figures in the mirror, or how they look as they put the garments on, as with the women he speaks to at work: "While the ladies spoke, I would start to imagine what their day was like. I would picture them rushing in the morning to get ready for work . . . putting on their bras and panties and stockings. Then I'd see them in simple dresses, standing in their kitchens, drinking coffee" (59). Louis seems fascinated with the experience of being an attractive woman, of putting on women's clothing and feeling natural in it. When he describes his coworker Mary, he notes that she makes him feel "anguish the way pretty, clean-looking blond girls with thin arms always have. . . . I would notice acutely the way her thin figure would move underneath her loose blouses, her light wool pants. I would smell the air when she would walk past me and then try to hold the scent of her perfume in my nostrils for as long as possible" (58); he describes feeling "attacked by her beauty." A part of Louis's attraction to women, Ames implies, stems from his identification with them, his vision of their bodies as a template for delicate garments. As Louis negotiates his often conflicting sexual and gender-related desires, the reader shares his confusion; Ames makes the ambiguity palpable.

Because of this sustained ambiguity, *The Extra Man* is an anomaly among works of transgender literature. Like *Stone Butch Blues,* the novel does not follow the archetypal transition narrative (nor is it a memoir, for that matter)—it echoes these narratives in that Louis discovers a transgender community and learns more about transitioning, yet the narrative arc does not focus on his coming to terms with identity as a transgender or nonbinary person. A second departure from other transgender literature, therefore, is that the novel's protagonist does not explicitly identify as transgender: Louis remains, throughout the novel, confused about his sexuality and gender identity. His ambivalence is actually more characteristic of people who

identify as transgender than not. Many transgender scholars have noted, in fact, that while transsexual transition narratives have served as a life-line to transgender individuals struggling to negotiate their gender iden-tity, they have also eclipsed stories that queer binary constructs of gender, leaving little room for transgender or genderqueer individuals who identify as "neither" or "both."[10] In her 1995 piece on transgender autobiographies, Bernice Hausman asserts that the primary takeaway from Christine Jor-gensen's autobiography is "'I was meant to be a woman—see what a good woman I turned out to be, far more successful than my male self'" (342). She clarifies: "This is not to suggest that transsexuals' accounts of their own experiences are wrong, or flawed; rather, it is to suggest that representa-tions of transsexual experience are constructed within the parameters of a humanism that pervasively denies the existence of disruptive accounts of sex and sexuality" (357). Hausman's analysis is consistent with Stone's in that both suggest that transgender experiences build on one another; a pub-lished account of one person's transsexual journey becomes a lifeline, even a blueprint, for another transgender person struggling to negotiate their identity outside of gender-normative parameters. Keeping this pattern in mind, it is also possible—even likely—that fewer memoirs that would resemble Ames's novel are published, or even written. Most transgender and queer memoirs—even Feinberg's semiautobiographical account limned in *Stone Butch Blues*—tend to offer some sense of resolution, of reflection or self-assuredness, by the end of the story. At the end of *The Extra Man*, after many trips to Sally's and many sexual liaisons with transsexuals he has met there, Louis remains uncertain, confused about his gender identity and sexual orientation.

That's not to suggest Louis has not tried to understand his desires. He has experimented with his appearance and sexuality. He frequently reads and quotes from Krafft-Ebing's *Psychopathia sexualis* (29) in an attempt to puzzle out his gender confusion from a medical standpoint. He asks the women at Sally's questions about their transitions as well as their opin-ions about his gender and sexual identity, to which Miss Pepper, one of the Sally's women, replies that he's a "tranny-chaser": "First of all you're cute. Most girls would die for your blond eyelashes. And you dress nice, like a gentleman, And you have a good personality. You treat Queens with respect. You're a typical tranny-chaser. You're not really straight, but you're not really gay. You're straightish" (211). Miss Pepper's assessment aligns with

Louis's self-perception, but unfortunately, it still fails to provide him the sense of resolution he craves.

In addition to visiting Sally's, studying Kraft-Ebing, and having relations with transsexual women, Louis attempts to indulge his fantasies of being a "pretty girl" by responding to various advertisements offering cross-dressing experiences. His visit to the Recession Spankologist begins as just a curiosity, but when he has the opportunity to dress in women's lingerie, the experience becomes exhilarating for him: "Once [the bra] was in place I felt great. I don't know what it is about brassieres. My whole inner feeling was changed. I felt pretty and girlish, happy and light. The breast, the bra, for me it's all very potent, though I didn't dare look in the mirror. I just stared down at the black cups and I felt good" (75). Louis's response to wearing the bra echoes a similar moment from his childhood, when he puts on his mother's undergarments, comparing the sensation to "receiving a shot of pure adrenaline" (63). In this earlier scene, however, Louis sees himself in the mirror and feels horrified at the juxtaposition of his masculine face and body with the feminine garments, so in this present encounter, he avoids that same sense of disappointment. Louis enjoys the idea of being a woman and dressing in women's clothing, but he cannot stomach the juxtaposition of his masculine features with the feminine clothing, nor can he imagine himself transitioning as he learns more about the process from the women at Sally's (113), nor can he imagine wearing women's clothes for himself, in private: "I had read enough transvestite-oriented pornography to know what happens to men. It takes you over: I'd have to shop, spend money. . . . The whole thing would be a lot of work" (60). His continued efforts to befriend the women at Sally's, to hire the services of transsexual prostitutes, and to answer the classified ads offering services related to cross-dressing represent a quest for self-discovery, a quest with few triumphs or moments of illumination.

In one climactic scene, Louis invests in a full makeover, indulging his desire to see himself as a beautiful woman. He brings Mary's bra with him, yearning to be an elegant lady counterpart to his "young gentleman" public persona. Immediately, Louis expresses his dissatisfaction with the makeover experience created by Sandra, to whom he refers as "a wacky nurse for wacky men" (293). In Louis's fantasy, he dresses in a spotlessly elegant boudoir in brand-new lingerie and stylish clothing, but Sandra's apartment is dark and littered with cat hair, her makeup clearly used, and her clothing worn and out of fashion. Louis tries to embrace the experience with enthusiasm, even when Sandra insists on making him a redhead rather than a

blonde and informs him that Mary's bra is too small for him to wear. When Sandra has dressed him, he feels hopeful at first: "I squinted and I almost looked like a tall, sexy, red-headed woman. My legs were long and had a nice shape in the tights. From the side, my breasts looked large, which excited me a little. And the makeup on my face gave me a much healthier look than my own late-February pallor. And my scarlet lips and my vampish raccoon eyes were seductive" (291). For an instant, Louis's fantasy is satisfied, for he sees reflected the desirable woman he wishes to see, even if he modifies the type of woman from elegant lady to "vampish" seductress.

When Louis really examines his reflection, he sees something different: "I looked like a man who wanted to wear women's clothing despite how terrible he appeared. My shoulders were too big, my hips too narrow, my rear too small and flat, my face too waxy, my breast molds too lumpy. I looked like the amateurs who came to Sally's and sat quietly at the bar by themselves and received no attention from the men" (291). Louis's response reveals the aspirational nature of the makeover, as though in seeing himself as a beautiful, stylish woman, he would validate a desire he has had since childhood to be not either but *both,* a chameleonic subject with the ability to embody polarized personas and, in doing so, feel fulfilled. At the same time, Louis's response and attraction to the women at Sally's suggests he would also have been satisfied to see an attractive mixture in the mirror, a blend of his masculine and feminine sides, for it is this mixture that he finds so mesmerizing about the women at Sally's: "They liked to look at themselves. And many of them did have the most beautiful faces. Faces I had never seen anywhere else in the world. Some kind of crazy mixing of man and woman: the arrangement of cheekbones and eyes and lips was all different and yet beautiful" (99). In this scene, too, Louis mentions the presence of mirrors, the images of the transsexual women reflected back at themselves for their own admiration. As I suggest in my discussion of *Stone Butch Blues,* the mirror surfaces as a site for analyzing one's public presentation reflected back, for self-scrutiny and the affirmation or denial that follows. Louis weighs the image he longs to see against the disappointing image of himself as a woman. His disappointment is intense enough for him to cease his cross-dressing and set aside his aspirations of being able to present as both gentleman and lady. While Louis continues to frequent Sally's and pursue the transsexual women he encounters, he never resolves the question of his sexual identity or his gender identity. Much as Louis has left himself open to the judgment of his roommate Henry and

the women at Sally's, Ames leaves Louis's identity ambiguous, open to the reader's interpretation.

This ambiguity may seem frustrating in the context of a larger body of transgender literature that offers a triumphant resolution, a sense of "becoming" or "revealing" one's true self and synchronizing the gender identity a subject feels with that individual's public presentation. Within this same context, however, the ambiguity may serve a more urgent function: it normalizes the liminal and the uncertain. Stone has argued for transgender voices "to speak from outside the boundaries of gender, beyond the constructed oppositional nodes which have been predefined as the only positions from which discourse is possible" (230). She argues for "constituting transsexuals . . . as a *genre*—a set of embodied texts whose potential for *productive* disruption of structured sexualities and spectra of desire has yet to be explored" (231). While other scholars have indicated some of the problematic implications of casting transsexuals as a genre, her emphasis on embracing a spectrum of gender identities and sexualities is useful for situating transgender literature in relation to queer literature. Prosser calls into question "queer theory's embrace of the transsexual for dehomo(e)genizing sexual and gender identities and deconstructing the narrative of gendering" ("No Place like Home" 488), including the claim purported by Butler and others that the transgender individual is a "debunker" of sex as "the natural cause or ground of gender" and thus part of a "poststructuralist unraveling of a previous narrative of gender in which sex stands for nature and gender for culture" (484). Rather, transgender narratives (he specifically names transsexual narratives) reify stable, even binary, constructions of gender, because they are so often "centered on embodied becoming" (488). The transition narrative begins with uncertainty and confusion, as well as "somatic and psychic pain," but is ultimately "worth its risk" when the transgender subject arrives at "the destination, the telos of this narrative (being able to live in one's 'true gender identity')." Prosser concludes by clarifying why these narratives are not "queer": "Gender is not so much undone as queerness would have it as redone, that is, done up differently" (488). Though Prosser suggests that *Stone Butch Blues,* in perpetuating a narrative of finding one's "home," still resembles the transgender rather than queer narrative, I suggest that Feinberg's novel, like Ames's, represents a mode of transgender literature that, in departing from the more familiar transition narrative and asserting a spectrum of gender and sexual identities,

transforms the genre itself and aligns its interpretive potential with that of queer literature.

Analyzing transgender literatures through the lens of fashion studies queers constructs of gender in a way that the transition narrative alone cannot. The transition narratives identified by Stone and Hausman,[11] like Jorgensen's story, have a clear beginning, middle, and happy ending: an individual "trapped in the wrong body" struggles with gender identity, goes through the purgatory of transition (with its social, financial, and painful physical ramifications), and ultimately feels self-actualized in the post-transition body and presentation. These narratives also focus on the individual's relationship with family and the public response to the transition; Chaz Bono's *Transition*, for example, spotlights Chaz's evolving relationship with his mother, Cher—initially resistant to his gender identity and later vocally defiant of any public criticism of her son. In Jorgensen's autobiography, she recollects public responses including news coverage of her post-transition appearances and relishes the public approval of her glamorous female self.

Although Mock's *Redefining Realness* and Brevard's *The Woman I Was Never Meant to Be* resemble these more archetypal transition narratives, a closer look at how the women reference their relationships with clothing, style, and other ways of publicly constructing femininity reveals their differences. These authors did not follow Jorgensen's path of only wearing women's clothing after they had gender confirmation surgery; instead, they tried on their grandmother's clothes at a young age, studied women's fashions, identified style icons, experimented with clothing and style as teenagers, and—like many ciswomen—tried a range of fashions and styles once they were taking hormones and presenting as women. They did not have a "big reveal" after surgery; surgery was another part of the process, rather than the pivotal and transformative moment. These moments of experimentation punctuate the lengthy process of self-actualization, of which gender presentation is *only a part*. Their narrative structure, in which fashion functions both normatively and queerly, alters the structure of the archetypal transition narrative from scripted and familiar to messy, confusing, volatile, and filled with small triumphs and disappointments along the way.

Ames and Feinberg take the deconstruction of the transition narrative a step further. Mock and Brevard present as women (as admired, attractive

women) by the end of their stories, even if they remain aware and critical of how gender is constructed and performed in American culture. Jess and Louis, on the other hand, while still conscientious about curating their appearances, do not "pass" or present as the opposite gender. Louis maintains his young gentleman persona. Although he recognizes his persistent yearning to inhabit a feminine persona, as well as his confusion about his sexual identity, his public presentation is still one of his choosing and one that gives him a sense of pride. This ending challenges the notion that anyone can curate a public persona that holistically represents their inner self. Ames's novel also places in high relief his protagonist's persistent ambivalence rather than any post-transition sense of fulfillment, which may resonate more with gender nonconforming individuals (who may still identify as transgender).

Louis, despite his ambivalence about gender and sexual identity, retains a public presentation that appears innocuous; his young gentleman appearance fits neatly within socially sanctioned gender binaries. Jess, on the other hand, presents as something in between, as gender nonconforming. She has decided to stop taking hormones, and therefore to stop "passing," to sacrifice the relative safety and approval she enjoyed while presenting as a man in the interest of presenting in a way that feels more in tune with her identity. Like Louis, she still curates her appearance despite her gender-ambiguous presentation: she continues wearing her masculine, working-class attire (motorcycle jacket, white T-shirt, jeans, etc.) and continues to work out, yet by stopping hormones, she allows her features and angles to soften, resulting in an amalgam of feminine and masculine features that confuses onlookers, who feel threatened by what they cannot understand. Through Jess, Feinberg channels hir own process of negotiating gender identity, a process that could not be labeled as a clear arc from one gender to another nor as a completed transition. By presenting the process of transitioning as ongoing, subjective, and fluid—and perhaps not even unidirectional—Feinberg deemphasizes the "reveal" or the "final product" as the climax of a transgender story.

Including these narratives, and these considerations of style and self-presentation, within a category of transgender literature that continues to grow and is still being defined introduces new ways to debunk gender as a construct. Through the lens of fashion and style, these narratives also imbue with new meaning cross-dressing, gender confirmation surgeries, top surgeries, and other forms of physical transformation so often tied to

gender identity. In her 2003 article "Feminist Solidarity after Queer Theory: The Case of Transgender," Cressida Heyes argues, "Either feminists elide, with Feinberg, the ethical questions that are raised by self-fashioning in the context of gender relations, or, with Hausman and Raymond, we condemn any trans move as merely another iteration of oppressive norms" (206). In other words, Heyes argues that transgender scholarship on body technologies is polarized: those in the Hausman/Raymond camp see such modifications as a means of validating gender binaries; those who share Feinberg's views argue for the social acceptance of any modifications transgender individuals make without considering how various contexts (race and relative privilege, for example) may shape these desires to transform or how gender is defined within a particular social group. Heyes suggests that between these "positions is a relational, historicized model of the self that remains sensitive to context." What Heyes suggests is that the changes transgender people make to their bodies—whether taking hormones or undergoing surgery—are connected to other technologies or adaptations meant to alter one's appearance, including "dieting, and cosmetic surgeries." She explains that while these modifications are not "directly equivalent—experientially, ethically, or politically," looking at these modifications in association with one another, detaching those associated with transgender identity from the perceived gendered motivations, allows for a more holistic explanation of the impetus to transform and mold the self.

Although she rightfully resists equating SRS, dieting, and cosmetic surgeries, as well as painting their purveyors as "victims of false consciousness," Heyes perhaps misses an opportunity to explore the possibilities of drawing *some* equivalency here and extending the collective to include modifications precipitated by fashion (e.g., corsetry or even the optical illusions nonbinding clothing can create), makeup, tattooing, hair treatments, or any other number of ways people alter the body, hair, and face they present to the public, whether temporarily or permanently. On the one hand, drawing such equivalencies means overlooking a range of important factors—the spectrum of risk (from minimal with clothing to very high with surgery), the degree of urgency, the relative permanence of the change, the expense involved, among others. Yet on the other hand, viewing these modifications as a collective may allow for a franker conversation about the motivations for self-transformation, motivations that may stem from the internalization of problematic social norms (e.g., restrictive gender norms, standards of beauty or body type, and colorism) *or* from a more positive sense of

personal agency, a desire to curate one's presentation and to align that presentation (whether in terms of gender or some other facet of identity) with an individual's sense of self. Viewing transgender narratives in this way, recognizing this multiplicity of voices articulating the urges to modify, transform, and present a certain way, ultimately sheds light on a larger cultural impulse toward self-transformation.

Fashion and Fiction of the Future

In New York it was called the Manhattan Cleanup. There
were bonfires in Times Square, crowds chanting around
them, women throwing their arms up thankfully into the
air when they felt the cameras on them, clean-cut stony-
faced young men tossing things onto the flames, armfuls
of silk and nylon and fake fur, lime-green, red, violet; black
satin, gold lamé, glittering silver; bikini underpants, see-
through brassieres with pink satin hearts sewn on to cover
the nipples. And the manufacturers and importers and
salesmen down on their knees, repenting in public, conical
paper hats like dunce hats on their heads, SHAME printed
on them in red.

—Margaret Atwood, *The Handmaid's Tale*

IN THE OPENING OF this book, I discussed Margaret Atwood's 1985 novel
The Handmaid's Tale, in which women are forced into the roles of either
Wives, Marthas (homemakers), or Handmaids (breeders) for wealthy "Com-
manders"—or, in the case of the working-class men, "Econowives" who play

all three roles. These women's roles are signaled by their clothing—blue for Wives, green for Marthas, and red with white veils for Handmaids. Since the novel was adapted to a television series in 2017, the Handmaid uniform has been adopted by women protesters, especially those advocating for women's reproductive rights, most recently in response to multiple states' abortion bans. In addition to protests in the United States, where the novel and series are set, and in Canada (where the author is from), protesters have also donned the uniform in Argentina and Ireland.

In *Handmaid's Tale* and other works of speculative fiction, the characters' dress is a good indicator of the governmental regime as well as other political, social, and environmental conditions. If choices in wardrobe are restricted to assigned uniforms, it follows that individual freedoms are restricted. In George Orwell's famed dystopia *1984* (1949), for example, all of the major characters, male and female, wear uniforms, an indicator of the totalitarian regime and severe limitations on individual choice and even thought. In *Handmaid's Tale,* certainly men's choices are limited; however, only women are so stripped of agency that their lives, bodies, day-to-day activities, and reproductive destinies are displayed by mandate in their uniforms. In appropriating these uniforms for protest, women worldwide recognize the symbolic resonance of the full-coverage red, veiled uniform— redolent of a government that denies women choice, and therefore freedom, and therefore the potential for self-discovery, self-expression, and personal autonomy. Without these things, Atwood suggests, women are reduced to drones serving in a man's world.

Envisioning a dystopian future tends to mean looking at where the world is heading and taking it to a logical extreme. In his introduction to Ray Bradbury's *Fahrenheit 451,* Neil Gaiman argues that speculative fiction can be broken down into three phrases: "What if . . . ?"; "If only . . ."; and "If this goes on. . . ." The first represents a "departure from our lives"; the second, an exploration of "the glories and dangers of tomorrow"; and the third "takes an element of life today, something clear and obvious and normally something troubling, and asks what would happen if that thing . . . became all-pervasive, changed the way we thought and behaved. . . . It's a cautionary question, and it lets us explore cautionary worlds" (Gaiman). Gaiman refutes the notion that writers of speculative fiction, especially dystopias, write works of realism or even attempt to predict a realizable future. Instead, such novels focus on the present, functioning almost like satire in that they magnify elements of a current social or political condition and invite

others to see them in high relief. In the context of fashion, then, the writers identify some element of the fashion industry from today and align it with the character of that imagined future world. The fashions of speculative fiction anticipate the future of fashion while critiquing its current role in our culture.

In the previous chapters, I've canvassed some of the ways that the modern fashion industry in the United States has become entangled in identity politics, and in particular how clothing in literature signals a character's process of identity construction. Although the authors at times criticize elements of the fashion industry—for the way it reinforces gender binaries, perpetuates racial stereotypes, and appropriates from marginalized cultures, for example—they also expose the value of choice, of allowing individuals to explore and negotiate identity through presenting themselves in different ways. Implicitly, in celebrating this choice, the authors embrace an ever-expanding, consumer-focused fashion industry. However, as authors like Hettie Jones, Joseph Boyden, Wynona LaDuke, and Alice Walker suggest, individuals who curate their public presentations can do so without becoming slaves to the industry. They can hand-make, repurpose, or embellish their own garments, personalizing them and drawing from their respective cultural backgrounds to tailor-make their own personal style. These authors show that choice in fashion and the concept of fashion as freedom does not require more production, more manufacturing, and more waste, but more self-understanding and a sense of personal style.

As a close to this book, it seems appropriate to consider how authors envision the future of fashion. These authors write from a vantage point in which the industry has become increasingly pluralistic and accessible, targeting a range of populations and offering a range of price points. In this context, consumers attempting the project of self-understanding can sometimes see themselves in the clothes and curate a public persona that resonates with their individuality and social or political affiliations. What, then, does the future hold for such an industry?

In speculative fiction, clothing tends to fall into three different categories: utilitarian, uniform, and decadent. Utilitarian clothing features prominently in apocalyptic novels in which environmental conditions are so rough or dangerous that function supersedes all other concerns about appearance. These novels—for example, Olivia Cole's young adult novel *Panther in the Hive* (2014), Atwood's *Oryx and Crake* (2003), and Octavia Butler's *Dawn* (1987)—tend to focus less on social freedoms and identity

politics and more on human nature and survival; attention to attire seems frivolous and even dangerous in the context of a natural disaster, nuclear war, or zombie apocalypse. Uniforms, as noted above, tend to connote a repressive regime that seeks to control identity and limit individual freedoms, as exemplified by *1984, Handmaid's Tale,* and Ally Condie's *Matched* (2010). These novels tend to present the contemporary fashion industry in the most positive light, as any choices and freedom of expression appear desirable once those choices are taken away. And decadence tends to indicate, at once, a Marxist take on excessive disparities in wealth and privilege, and a more psychological statement about self-denial: those who follow even the most absurd trends blindly belie a lack of self-awareness, a greater concern with showing themselves to be on the cusp of the new and part of an insider group than with self-understanding. We see this decadence in Scott Westerfeld's *The Uglies* series (2005–7), the flashback scenes of *Oryx and Crake,* and the Capitol scenes of *The Hunger Games* (2008). In these novels, fashion is not freedom but consumerism masked as freedom, or a frivolous distraction from government corruption.

In these novels' visions for the future, authors reveal their understanding of the larger significance of fashion and, in the case of more recent novels, the future of a global fashion industry now dominated by fast fashion. Sometimes these critiques of fashion feel latent, less central to the novel's plot, and perhaps unintentional on the authors' part. In the utilitarian category, fashion signifies the wastefulness and excess of a doomed civilization (or a civilization already in ruins), as well as the staggering disparity between contemporary clothing (usually decorative and impractical, often restricting) and clothing that feels practical for the environment. In the postapocalyptic landscape of *Oryx and Crake,* protagonist Jimmy wears only a sheet and baseball cap, finding such attire easier for dealing with the excessive heat, ultraviolet rays, and movement required on the coast he inhabits. In contrast, in the ruins strewn around him, Jimmy sees the scattered remnants of his former civilization, as when he visits a corporate compound in search of more food: "Along the road is a trail of objects people must have dropped in flight, like a treasure hunt in reverse. A suitcase, a knapsack spilling out clothes and trinkets; an overnight bag, broken open, beside it a forlorn pink toothbrush. A bracelet, a woman's hair ornament in the shape of a butterfly; a notebook, the handwriting illegible." Jimmy reflects that as the fugitives were leaving the compound, they gradually realized the uselessness of these items (264–65). Jimmy now perceives clothes

not only as useless but also cumbersome, perhaps in part because his only companions—the genetically engineered "Crakers"—wear no clothing at all. When he comes across a closet full of neatly arranged clothing, shoes, and underwear, he realizes "he can no longer stand the thought of footwear. It would be like adding hooves. . . . Underpants in stacks on the shelves. Why did he used to wear such garments? They appear to him now as some sort of weird bondage gear" (392–93). Jimmy's response to these clothes resembles contemporary consumers' responses to out-of-date trends. He recognizes his own investment in these clothes, his own need for multiple options and prints and cuts of clothing, yet his current attire reflects who he is now as well as the situation he has come to embrace.

His reaction to the clothes also highlights the disparity between fashion and utility, a common consideration in these speculative novels. In another apocalyptic novel, *Panther in the Hive,* protagonist Tasha shows a deep love for fashion, hinting that before the zombie apocalypse that descends on Chicago, she spent much of her savings on designer clothing. As she prepares to flee her apartment, throwing essentials into "her Prada backpack" (122), Tasha struggles to leave behind her wardrobe: "Tasha carries the rejected Jimmy Choos into the closet, which is almost as large as the bedroom itself and the reason she had chosen the apartment. Inside, she stands among the pants and blouses billowing from padded hangers in a jungle of silk and tweed" (124). With reluctance, Tasha changes out of the "purple chiffon top" she wears and selects practical clothing—clothes that will better suit the survival situation outside of her building: "She looks at herself in the full-length mirror—jeans, black tank top, plain hoops, half-curly hair—and sighs. So much has changed" (125). As with Jimmy, Tasha's reflection implies that what has changed is the situation, the environment that these characters navigate—a hostile landscape that demands only utilitarian clothing. Yet their reveries also indicate that they themselves have changed. The conditions of their respective apocalypses have demanded the characters become more autonomous, assertive, and improvisational, and the changes to their wardrobe reflect these personal shifts. For Tasha, wearing her pre-zombie apocalypse clothing would no longer make her feel like herself: she would feel foolish and vulnerable. New situations demand new trends as well as ongoing self-evaluation. The novel implies that the relationship between fashion and identity is not stable but fluid.

In addition to these reflections on trends and personal growth, these novels offer another reflection on the industry, one that points more directly

to contemporary discourse about fashion. They expose the environmental cost of contemporary fashion, especially a fast fashion industry dominated by trend forecasts. Where once the fashion industry generated clothing to last a season, and women clung to their custom-fitted garments for several years before they went out of mode, now the industry generates new clothing by the week. The apocalyptic novel, above all, presents a wasteland rather than a clean slate; all around them, the protagonists see not only dead bodies but also "dead" things—large landfills of clothing and other possessions now rendered pointless, taking up space, belying the culture of waste and excess that has been destroyed. As the authors describe heaps of clothing littering an apocalyptic wasteland, they conjure up images of the waste generated by contemporary fashion, especially the environmental impact of mass-producing cheaply made clothing meant to go out of style in a matter of weeks. Americans are especially culpable in generating this environmental crisis; in the past two decades, for example, the amount of clothes discarded by U.S. citizens each year has increased from an estimated seven million tons to fourteen million tons (Wicker). The utilitarian novels, without directly commenting on fast fashion, contrast the wastefulness of excessive clothing with the utility of a few items suitable for movement and environment.

In this sense, the discarded clothing of the apocalyptic novels mirrors the novels in the decadent category of speculative fiction, which underscore the wastefulness of trends in contemporary fashion. These novels portray a mindless populace obsessed with surfaces. Characters in these speculative works do not think for themselves or use fashion as a means of negotiating identity; instead, they wear only what's on trend, essentially becoming slaves to fashion. The authors simultaneously mark the characters in such novels as lacking in self-awareness and critique fashion for its excesses. In Westerfeld's *Pretties* (2005), for example, trendy clothes literally spew from the walls at characters' commands, creating a tableau of superficiality and waste that evokes the image of discarded fast fashions sitting in a landfill.

Novels of the "uniform" category also offer their takes on contemporary fast fashion, often indirectly. Because the uniforms of dystopian novels represent the absence of choices and individuals' inability to express themselves, fashion surfaces with an element of nostalgia and longing. In Condie's *Matched*, for example, the characters are allowed to select their own clothing for special occasions like the "matched" ceremony, in which young citizens are paired by the government with their future spouses

based on statistical data. The ceremony takes away one of the most impor-
tant freedoms an individual can have—the freedom to choose one's life
partner—and yet the government obscures this reality by giving citizens
the illusion of choice, allowing them to select from a range of glamorous
clothes to wear, a welcome contrast to the "plainclothes" they wear as daily
uniforms. The clothes are destroyed after a single wear, the citizen given a
framed panel of the fabric as a treasured souvenir. For Atwood and Condie,
the array of choices in the contemporary industry may seem superficial and
even excessive at times, but the choices are essential for personal autonomy,
for allowing people to make mistakes, the occasional poor choice, in a jour-
ney toward cultivating a public persona that expresses one's identity and
values. In this sense, they reflect more positively on the endless choices of
contemporary fashion.

In her *Hunger Games* trilogy, Suzanne Collins blends all three fashion
categories for speculative fiction: the utilitarian, the uniform, and the
decadent. The heroine of these novels, Katniss, feels most comfortable in
her utilitarian clothes, like her late father's jacket and her hunting boots—
"Supple leather that has molded to my feet. I pull on trousers, a shirt, tuck
my long dark braid up into a cap, and grab my forage bag" (3). Each ele-
ment of Katniss's attire, including the way she braids her hair, is meant to
give her comfort, ease of movement, and camouflage, as her primary drive
in life involves hunting and foraging for food for her family. As the novel
progresses, Collins uses clothing to signal the ruthlessness of the Capitol
government and the socioeconomic disparity between the wealthy Capi-
tol and the poor Districts, from whom children (or "tributes") are randomly
selected to fight to the death in an annual gladiatorial battle (the Hunger
Games). The uniforms surface as the attire of the Avox, Capitol slaves whose
tongues have been cut out as punishment for attempting to betray or flee
from Panem (the former United States). Similarly, the tributes are dressed
uniformly when they are launched into the Hunger Games arena; both the
tributes and Avox represent citizens whose choices have been all but en-
tirely removed, who are reduced to the same fate.

In the decadent clothing of the Capitol citizens, Collins offers a more
direct critique of contemporary fashion and consumerism. Capitol citizens
look ridiculous, often overly colorful, flamboyant, and obsessed with the
newest trend. This decadence is first introduced in the character of Effie
Trinket, the escort for District 12's tributes. Effie is described as hav-
ing a "scary white grin, pinkish hair and spring green suit" (17). Similarly,

the members of Katniss's "prep team" (the trio of citizens who get her camera-ready for the Games' media spectacle) include a woman "with aqua hair and gold tattoos above her eyebrows," a man with "orange corkscrew locks" and "purple lipstick," and "a plump woman whose entire body has been dyed a pale shade of pea green" (61). Through Katniss's eyes, all of these trends appear not luxurious or beautiful (she's not contrasting, say, coarse homespun cloth with fine supple silks and leather), but absurd. While she envies the comforts of Capitol bedding and steaming hot show-ers, as well as the sumptuous meals she enjoys, Katniss never envies the fashions. Rather than painting the Capitol fashions as the pinnacle of luxury and elegance, therefore, Collins characterizes them as wasteful and gaudy. The country's name—Panem—is in fact a nod to the Latin saying *panem et circenses,* meaning "bread and circuses" or the appeasement of a population by frivolous activities. The citizens are bored, looking forward only to the media circus surrounding the annual Hunger Games because all of their needs are met. Katniss wonders how she might spend her time in the Capitol, without having to worry about scrounging for food: "What do they do all day, these people in the Capitol, besides decorating their bod-ies and waiting around for a new shipment of tributes to roll in and die for their entertainment?" (65). For creatures of comfort, chasing the latest fashion trends offers a fleeting spark of novelty. Fashion is not a vehicle for self-discovery, but a way of postponing boredom.

Collins magnifies the discrepancy between taste and ignorant decadence through Katniss's personal stylist, Cinna. In many ways, it is Cinna who helps Katniss understand herself better. The self-effacing Katniss initially sees herself as a creature of necessity, her noble self-sacrifice as tribute in place of her sister an obvious choice. She does not think of herself as attrac-tive or desirable, nor does she care. Her friendship with Cinna, however, forces her to start developing a sense of self-awareness. In conceptualizing her pre-arena "look," Cinna dubs her "the girl who was on fire": "I'm in a simple black unitard that covers me from ankle to neck. Shiny leather boots lace up to my knees. But it's the fluttering cape made of streams of orange, yellow, and red and the matching headpiece that define this costume. Cinna plans to light them on fire just before our chariot rolls into the streets" (66). Katniss notes that aside from the fire, her look feels like her own style, her hair in its usual braid, her makeup minimal. Later, Katniss reflects, "Cinna has given me a great advantage. No one will forget me. Not my look, not my name, Katniss. The girl who was on fire" (70). Initially, Katniss sees the

value of her stylist only in terms of what he means for her survival: the shallow citizens of the Capitol are more likely to support tributes they admire in the arena. Yet Cinna has also sparked a latent confidence in Katniss. In the clothes he makes for her, she feels bolder, more sure of her potential, and more willing to stand out from the crowd.

Cinna's role in the trilogy may seem secondary, but in many ways he creates Katniss: he helps her journey from the self-effacing huntress of District 12 to the Mockingjay, the face of the rebellion against the Capitol government and President Snow's leadership. In affixing Katniss's gold mockingjay pin, a gift from her friend, to her arena uniform, Cinna already sees the potential symbolism in the person Katniss will become—the Capitol accidentally created mockingjays when genetically engineering another type of bird; they are seen as "funny birds and something of a slap in the face to the Capitol" (42). Like the mockingjay, Katniss cannot be molded into a pawn for the Capitol. Over the course of the trilogy, Cinna uses this bird as the inspiration for Katniss's style, including her military uniform once she joins the rebellion. When in the *Hunger Games* sequel, *Catching Fire* (2009), Cinna designs a wedding dress for Katniss that before the public eye transforms into a mockingjay-inspired gown (fig. 14), the President views his act as treasonous. As Katniss is about to be launched into the arena for a second time, she is forced to watch as Cinna is beaten to death.

The *Hunger Games* trilogy might be something of an anomaly in presenting a hero in the form of a fashion designer, but Cinna's heroism in this context is unquestionable. He combines all of the passion and talent of a gifted artist, the kindness and compassion of a dear friend, and the cleverness and

FIGURE 14. Film still from *The Hunger Games: Catching Fire,* starring Jennifer Lawrence and directed by Francis Lawrence, Lionsgate 2013.

skill of a powerful insurgent. Cinna exemplifies the positive, transformative potential of fashion. Every outfit he custom-designs for Katniss is meant to empower her and serves a practical purpose—to help her stand out and gain media sponsors in the arena, to garner sympathy from Capitol citizens, to highlight her innocence and protect her once she has fueled the President's anger, and to subvert the government's power. He never forces Katniss into an absurd Capitol trend but lets her set the trends (in the film adaptations, young girls in the Capitol begin wearing their hair like Katniss, and in the novels, copies of her pin become trend items). He draws from elements of Katniss's personal style, like her hunting boots, her mockingjay pin, and her braid, and fuses them with the glamor of high fashion and the utility of what a given costume must help her accomplish. Because of Cinna, Katniss *becomes* the person her clothes pronounce her to be, her mockingjay military outfit a reclaimed tool for self-assertion. Cinna's designs exemplify contemporary "trickle-up" fashion in the best possible light.

These works of speculative fiction anticipate the future of fashion while reflecting on its past. In its display of economic disparity and decadence, the novels point to fashion's elitist roots; in the haunting uniformity of the dystopian subjects, the novels create a stark contrast to the industry's twentieth-century development into a field of consumer choice. The novels champion this movement toward choice while offering a cautionary tale about the dangers of excessive consumption and the exploitative practices that the industry's stunning veneer tends to eclipse. In this way, each speculative work invites reflections on a contemporary industry increasingly dominated by fast fashion. While the "uniform" novels celebrate, by contrast, the array of choices available to consumers, who in making such choices can explore identities and express their desires, the "decadent" novels expose the excesses of fast fashion, the ways this industry encourages the consumer to be a mindless trend-chaser rather than a self-aware, autonomous subject. The "utilitarian" novels, meanwhile, signal the impracticality of these fashions—their fragility and disposability in contrast to the practical clothing characters must select instead. These novels also hint at the environmental cost of fashion, as characters bypass heaps of clothing discarded throughout an apocalyptic wasteland. In writing works of speculative fiction, authors imagine hypothetical futures; their weaving of a fashion commentary into these narratives indicates their reflection on the industry as it stands today, and what that means for the future of fashion. Finally, these novels indicate the authors' awareness of fashion's past, of its

elitist roots, and how the contemporary industry contrasts that past in both positive and problematic ways.

Ethics and Identity in the Future of Fashion

The texts discussed in the previous chapters characterize both the potential and the danger of fashion for mass consumption. As Plath and Sexton show in chapter 1, fashion can allow women to explore new roles and identities, to imagine themselves following a range of different personal and professional paths, or it can confine them to a scripted role characterized by scripted behaviors. Similarly, the Beat writers discussed in chapter 2 show how clothing can project a willingness to reject mainstream values and conformity and to celebrate creative expression. As the Beat women reveal, however, even nonconformity can be co-opted and sold by a mainstream industry; in addition, these writers reveal the cultural appropriation and racial plagiarism that can inform both mainstream and counterculture fashions.[1]

The African American and Native American authors discussed in chapters 3 and 4 expand on this issue of cultural appropriation, showing how hairstyles, motifs, and textiles can be co-opted by the fashion industry and worn by consumers hoping to subvert social convention by incorporating "exotic" items or styles into their looks (Craik 17). Despite a history of cultural appropriation of indigenous motifs, writers like Winona LaDuke, Sherman Alexie, and Louise Erdrich show how contact with European and later mainstream American culture has generated new art forms and designs in indigenous culture—designs that preserve indigenous values (of craftsmanship, sustainability, and originality) while introducing new materials. In doing so, the authors characterize indigenous culture not as static but as ever changing and fluid. Transgender writers, meanwhile, tend to deploy fashion to illustrate the fluidity of gender, to show the ways that gender presentation must be negotiated and explored. Transgender authors Chaz Bono, Leslie Feinberg, Janet Mock, and Aleshia Brevard demonstrate how clothing can imprison and reinforce problematic gender roles but can also liberate, allowing individuals to find themselves and the way they wish to present. Taken together, the texts discussed in the preceding chapters alternately characterize the consumer-centered fashion industry as hopeful and damaging, localized and global, and increasingly complex. They place the burden of change and awareness not on the industry itself (the designers,

producers, manufacturers, etc.) but on the consumers, especially public fig-
ures with the power to influence the industry.

Fashion has a history of being aspirational, of presenting a tableau of
glamour beyond the reach of the average citizen. As the industry shifted to
a ready-to-wear focus during the twentieth century, its social role changed.
Fashion design no longer targets a select elite, even though custom-designed
couture still plays a role in creating a media frenzy and inspiring trends for
ready-to-wear. Instead, fashion has become a field that—on the surface, at
least—feels accessible and democratic, providing endless options for differ-
ent classes, tastes, body types, ages, affiliations, and cultures.

However, as the authors featured in this book have shown, providing
these endless options has not resulted in a celebration of diversity and
individuality for several reasons. First, in order for fashion to serve this
purpose, individuals must have a basic knowledge of fashion and style, as
Maria MacKinney-Valentine notes in her 2017 book *Fashioning Identity:
Status Ambivalence in Contemporary Fashion:* "The social exercise involved in
fashioning identity relies on the nature of *fashion literacy* understood as the
ability to decipher sartorial assemblages within the framework of shifting
taste preferences. What is being read is the *social currency*" (5). Even with
allowances for personal taste, body type, and choice, fashion still demands
knowledge of taste, trends, and tailoring; it still sets standards of beauty
and body type even as it promises acceptance. Second, as the previous chap-
ters demonstrate, fashion perpetuates stereotypes and encourages cultural
misappropriation, obscuring the significance behind the cultural motifs and
garments worn by cultural insiders. And third, even with a globalized mar-
ket and lower production costs, fashion still retains elements of the elitism
that framed its origins, championing expensive, high-end brands through
popular culture and social media influences, demanding that fashionable
subjects keep up with its trends.

The relatively recent industry of fast fashion is one way consumers are
educated in fashion literacy and trend forecasts, as well as given access to
high fashion at all socioeconomic levels. Fast fashion represents lower-end
brands (including relatively unknown brands as well as more established
retailers like Forever 21, H&M, and Zara) responding quickly to runway
trends by getting product made and available for sale quickly—sometimes
within weeks of a season's runways shows. In many ways, fast fashion seems
like the pinnacle of the industry's efforts at democratization and accessi-
bility, as Elizabeth L. Krause notes in her book *Tight Knit: Global Families*

and the Social Life of Fast Fashion (2018): "If readymade wear represented the democratization of fashion, fast fashion is the fantasy of democracy and equality. . . . For consumers, fast fashion enables and promotes flexible identities through its economy of constant choice" (5). Krause's phrasing "flexible identities" is ambiguous, but it implies consumers' ability to try on different personas that appeal to them as they are marketed by the industry, as though shopping for identities that feel compatible with their values *or* aspirational identities they seek to embody. Fast fashion is cheap and highly commercial; consumers can easily purchase pieces of a look to incorporate into their own wardrobes without feeling as though they need to do a head-to-toe ensemble. If the runways show high-brow equestrian looks as the mode, consumers might purchase a riding jacket, or knee-high boots, or jodhpur-inspired pants, and incorporate the garment into their wardrobe without succumbing blindly and completely to a trend. Krause notes that fast fashion also benefits the retailers, producers, and investors—often yielding high returns, allowing for "flexible work regimes," and keeping "costs down and profits up" (5). Certainly for consumers looking to find themselves in fashion and for industry insiders looking to make high and fast profits, fast fashion seems like a fantasy solution.

While fast fashion may seem ideal, it in fact exposes the sins of contemporary fashion: it leaves a damaging carbon footprint and generates exploitative practices for workers. In areas where fast fashion is produced (and often disposed of), usually countries in the Global South, locals contend with toxic wastewaters, air pollution, a high concentration of pesticides from cotton growth, excessive carbon emissions from the production of synthetic fabrics, the dumping of plastic microfibers, and the enormous amount of textile waste that ends up in landfills—to name only a few of the ecological impacts.

These environmental factors do not even address the damage to livestock and other animals through higher-end textile industries like leather and fur, nor do they address the social costs—the conditions of workers who produce these clothes. Krause explains: "The model requires that workers work when there is work. They have to be available. They have to work long shifts, up to sixteen or eighteen hours, when there are orders to fill—to keep inventory on hand so the trendy items can fill up and fly off store shelves" (5). Such work schedules create a lack of stability for the workers and force them to part from their families for long stretches of time. In addition to long hours and unstable schedules, the low cost of fast fashion demands keeping

production costs at a minimum; as a result, wages are low and factory conditions often deplorable. Over the past twenty years, more and more retailers have garnered negative media attention for their reliance on sweatshop labor, paying unlivable wages, or relying on child labor, including—among many others—the Gap, ASOS, Forever 21, Urban Outfitters, and Victoria's Secret. As a result of the maelstrom of reports describing unsafe working conditions, unlivable wages, and child labor associated with these and other global brands, more companies have made efforts to change working conditions and offer more transparency about where their manufacturing centers are located and how much workers are paid (Kashyap); however, these efforts have emerged only recently and have a long way to go in reshaping the industry.

One reason for this increased transparency and shift to more equitable labor practices is the pressure created by contemporary media outlets, from more traditional news outlets to individual Twitter accounts. Companies that perpetuate inhumane working practices or excessive environmental cost are more likely to be exposed, publicly excoriated, and boycotted by consumers. One positive prediction for the future of fashion, therefore, is the role that consumers might play in shaping the ethics of the industry. As global fashion markets continue to expand, providing more options for consumers, establishing new fashion capitals, and reaching a wider public with greater immediacy through online media channels, the industry itself will face greater scrutiny as consumers attach various ethical or unethical practices to specific brands.

Consumers are becoming more savvy about these practices, whether considering the ethics of design, the conditions of workers, the sustainable practices of a company, or any number of other factors. In chapter 4, I reference Jessica Metcalfe's *Beyond Buckskin* blog and other contemporary media that expose both designers and fashion retailers for their cultural misappropriation of American Indian motifs and sacred objects, mass-producing and marketing these garments and accessories for low prices. Such practices represent multiple breaches of ethics, the most egregious being the appropriation of sacred objects (like Jeremy Scott's appropriation of totem poles for his Adidas line or Novum Crafts' sale of trendy, colorful warbonnets), but misrepresenting a culture now draws more media scrutiny and alienates a larger body of consumers, even while continuing to attract uninformed consumers who associate indigenous culture with popular culture clichés. One frequent culprit is Urban Outfitters, a national clothing,

accessories, and home goods retailer popular on college campuses. Urban Outfitters has a history of appropriating what it deems native motifs (e.g., Navajo prints) and using them for flasks or hot pants, as well as images of Hindu deities on items like socks, and a number of other cultural themes that it has cheapened by making them into mass-produced novelties. Such actions have damaged the brand, with multiple lawsuits forcing them to pull items off the shelves and issue public apologies (C. Coleman; Shelly). As I discuss in chapters 3 and 4, designers from developing countries and from marginalized populations, two groups most frequently subjected to cultural appropriation, have gained more visibility and popularity over the past two decades; these designers, by being transparent about their production and manufacturing processes, exert additional pressure on fashion corporations to use more ethical and equitable practices in their labor, production, and disposal.

Such associations and media scandals place a greater burden of responsibility on any individual consumer wishing to curate a public persona through clothing. For decades now, many American consumers have avoided wearing fur—some out of genuine concern for the treatment of animals, and some because they have found that the public disapproval of fur outweighs its connotations of wealth and status. Fashion can no longer be divorced from ethical stances, whether these relate to brand loyalty, sustainability, cultural literacy, animal rights, political causes, or some other factor—and, as Sue Thomas has indicated in her research, there are many factors. In her book *Fashion Ethics* (2018), Thomas includes a graphic that illustrates how every phase of the design process involves an ethical decision—from conception to disposal by consumer.[2] The graphic is divided into thirteen stages, each labeled with ethical decisions, including the "Design Phase" (1–4), "Production Phase" (5–7), "Pre-Purchase Phase" (8–11), and "Post-Purchase & Consumption Phase" (12 and 13):

1) Evolution of concept;
2) Fabric selection;
3) Size selection;
4) Fabric utilization;
5) Garment construction methods;
6) Selection of manufacturing equipment;
7) Recruitment/employment/conditions/pay;
8) Transport;

9) Distribution;

10) Merchandising;

11) Marketing;

12) Wear care conditions; and

13) Disposal. (16)

Thomas accompanies her breakdown of these phases with notes about the ethical decisions that go into each stage. The majority relate to environmental impact (e.g., the selection and utilization of fabric, methods of garment construction, transport, and disposal, among others), but other ethical questions relate to workers' conditions and identity politics. For example, under "evolution of concept," the first stage, she lists "intellectual property, cultural property, sexism, ageism, racism, sizeism, speciesism." The graphic illustrates, above all else, that the burden of ethical considerations is not confined to manufacturers or retailers; rather, everyone connected to the fashion industry—designers, producers, textile manufacturers, marketers, distributors, wear care professionals, and consumers—participates in these negotiations.

An optimistic view of the future of fashion might include a consumer base of informed, ethically conscious buyers, which would also imply a consumer base of self-aware buyers. To be ethically conscious, consumers must know their causes, what issues motivate them, alarm them, inspire them to effect change. Thomas notes that consumers have the power not only to broadcast their support for or disapproval of brands via the clothing on their bodies, but also to alert a wider public of unethical practices within the industry: "As fashion speeds up production, lessening lead times, and everyone with a mobile phone is a potential citizen-journalist, the fashion industry is susceptible to scrutiny more than ever. Industry disasters, workers' protests, incidents of animal cruelty are now on everyone's Facebook and Twitter-feed long before the traditional print or video media channels" (10). With this level of visibility and the immediacy of a global discursive community, consumers wield the power of impacting brands via their ethical awareness. As they curate their personal style, consumers might fuse this ethical awareness with their identity—both current and aspirational—and project the amalgam of these abstracts in the clothing and accessories they wear.

Being an ethical consumer, unfortunately, does not necessarily mean being an informed consumer. Evangeline M. Heiliger illustrates why in her analysis of the Product (Red) campaign, a product line supporting women

and children impacted by HIV/AIDS in Africa. The campaign, Heiliger argues, tells "a tale of virtuous style-conscious consumers who bestow life on deserving ghost-like recipients of shoppers' 'good deeds.' The problem is that while deploying an ostensibly well-intentioned marketing campaign, it is one that simultaneously erases from our sightline the workers who make (Red) products" (150). Heiliger specifically examines the marketing of Gap (Red) T-shirts, whose promotional campaign targets the "ethical consumer" (153), suggesting that the purchase of a stylish T-shirt will benefit needy women and children in Africa. This practice promotes a lazy ethical consumerism as well as a naive paternalism, in which Western consumers see the beneficiaries of (Red) as a "group of people *in need of rescue* from illness (in this case, HIV) by socially aware first-world shoppers" (154). In addition to these ideological problems, campaigns like (Red) conveniently focus on "third-world recipients of profits or material goods" (156) while "disappearing" another key group—"the workers who make (Red) items" (157). In doing so, Heiliger points out, these campaigns avoid any public engagement with "issues of workers' rights, environmental destruction, and the fair distribution of resources" (157). Companies involved with Product (Red) may argue that they're investing in the African economy and therefore benefitting the nation as a whole, but such neoliberal arguments overlook the workers' low wages and unsafe working conditions (157).

This campaign offers a good example of the difference between the ethical consumer and the informed consumer (we might say the informed ethical consumer). Ethical consumerism itself is a consumer campaign. Like the characters discussed throughout this book who blindly chase trends, ethical consumers like those Heiliger describes believe marketing campaigns of large clothing corporations that promote products as somehow conferring morality—because they're good for the environment, they benefit the poor, they help fund cancer research, or they promote some other worthy cause. In the context of fashion, recent iterations of the ethical consumer include "the fashionably 'ethical' consumer, who purportedly fulfills his or her duty to uplift the Third World's poor while simultaneously stimulating economic growth and prosperity in First World nations" (159). In drawing consumers' attention to one cause, these companies might eclipse unethical practices—unregulated sweatshop labor for the production of garments; irresponsible disposal of byproducts; cultural misappropriation; poor wages for workers; and undermining of local artisan work with cheaply made imitation products. Such practices illustrate the need for informed

consumerism, for making responsible purchases from companies that offer transparency about their labor and environmental practices. The informed consumer understands not only what clothing best complements an individual's features or expresses that individual's tastes, but what the clothing represents in a broader contexts—what social identities and ethical priorities that clothing confers.

Throughout this book, I have discussed works of American literature increasingly populated with informed consumers. While some authors (Sylvia Plath, Anne Sexton, and Janet Mock, for example) see the potential to champion feminism through clothing, others (like Joseph Boyden and Wynona LaDuke) advocate ecological responsibility and respect for cultural traditions in their choice and treatment of clothing. Still others (like Joyce Johnson, Danzy Senna, and Leslie Feinberg) see the activist potential in culturally or politically affiliated garments, in antifashion, and in gender-ambiguous styles. Further scholarship on the role of fashion in literature might delve more deeply into the increasing social and political power of the informed consumer, particularly as social media channels, blogs, and other platforms broadcast their voices to a broader consumer audience.

The speculative novels discussed earlier indicate the possibilities for contemporary fashion as well as the dangers. As more brands become conscious of their environmental impact, their potential to do good for the industry as well as harm, and the ways that all phases of design impact local populations, perhaps the industry will change—if only because of the public pressure exerted by media channels and consumers. If consumers take advantage of the options available not to chase trends blindly but to find themselves in fashion, to cultivate self-awareness and stay informed of ethical and unethical practices within the industry, then contemporary fashion will lose some of its association with frivolity and waste. As Atwood implies in *The Handmaid's Tale*, choices in fashion do not have to signify excess and superficiality; they can represent freedom and a source of empowerment. Offred suggests as much as she surveys the women in the forbidden magazine: "There they were again, the images of my childhood: bold, striding, confident, their arms flung out as if to claim space, their legs apart, feet planted squarely on the earth" (157). Choice in fashion does not have to mean frivolous choice—opting for one outfit or scarf over another because it's prettier or trendier. Choice, for these authors, implies personhood, exposure, self-acceptance, openness, the future—and the ability to create that future.

Notes

Introduction

1. In *Appearance and Identity: Fashioning the Body in Postmodernity* (2008), Llewellyn Negrin notes the changing discourse of fashion: "Until the late 1980s, the predominant attitude of feminists toward fashion was a largely hostile one. Fashion was regarded primarily as an instrument of oppression in which women were turned into passive objects of the male gaze" (33). Since this period, however, feminist and cultural studies scholars have acknowledged the dialogic relationship between fashion and identity. For example, in her discussion of how fashion is expressed through "cultures of femininity," Ilya Parkins discusses how fashion reveals "everyday life as a site for identity formation through both self-perceptions and negotiations of the self in relation to others" (8).

2. In chapter 5, I discuss in detail the difference between performance in this context and Judith Butler's concept of performativity.

3. In *Fashion and Its Social Agendas,* Diana Crane explains, "In postmodern culture, consumption is conceptualized as a form of role-playing, as consumers seek to project conceptions of identity that are continually evolving" (11).

4. Negrin has offered a similar critique: "The degree of agency exercised by individuals in the cultivation of their personal appearance is also questionable in a world where advertisers and celebrities, more than ever before, are the trendsetters in matters of style. While individuals are not just passive dupes totally manipulated by the

fashion industry, at the same time, the pressures and constraints within which they make their style 'choices' are considerable and should not be underestimated" (5).

5. Portions of this section are taken from my previous book, *Fashion and Fiction: Self-Transformation in Twentieth-Century American Literature* (2016).

6. Barthes does not work to define "real fashion" but "written" or "*described*" fashion, an institution of industrial society that relies on a collection of "calculating" clothing producers who "blunt the buyer's calculating consciousness" by cloaking the fashion object with a "veil"—"in short, a simulacrum of the real object [that] must be created, substituting for the slow time of wear a sovereign time free to destroy itself by an act of annual potlatch" (xi–xii). By imposing this expiration date on the object, the producers of fashion and its commercial venues can ensure an endless cycle of production and consumption.

7. Veblen argues that dress affords the clearest example of conspicuous "waste of goods" as well as of "indication of our pecuniary standing to all observers at the first glance" (167). To indicate leisure class status, he explains, one's dress "should not only be expensive, but it should also make plain to all observers that the wearer is not engaged in any kind of productive labour" (170).

8. In *The Face of Fashion: Cultural Studies in Fashion,* Craik expands definitions and studies of fashion to non-Western societies, noting that in both Western and non-Western cultures, "clothes construct a personal *habitus*" (4). She continues: "A fashion system embodies the denotation of acceptable codes and conventions, sets limits to clothing behavior, prescribes acceptable—and proscribes unacceptable—modes of clothing the body, and constantly revises the rules of the fashion game" (5).

9. Sociologist Tim Edwards explains, "Style may simultaneously refer to the 'what' and the 'way' of fashion—its design and how it is worn. This is at once collective, for what we understand as stylish is clearly culturally learned, and individual, as some people are simply perceived as having more style than others" (3–4).

10. Diana Crane contrasts the limitations imposed by fashion trends with the freedom of expression and choice afforded by clothing options: "Clothes as artifacts 'create' behavior through their capacity to impose social identities and empower people to assert latent social identities. On the one hand, styles of clothing can be a straitjacket, constraining (literally) a person's movements and manners, as was the case for women's clothing during the Victorian era. . . . Alternatively, clothing can be viewed as a vast reservoir of meanings that can be manipulated or reconstructed so as to enhance a person's sense of agency" (2).

11. To use Elizabeth Piedmont-Marton's phrasing, "if you want to dress in such a way to signify that you care nothing about fashion, then you must nevertheless use the language of fashion in order to construct that text" (92).

1. Plath, Sexton, and the "New Look"

1. Sociologist Stephanie Coontz discusses these nostalgic platitudes and misconceptions about the 1950s in her essay, "What We Really Miss about the 1950s."

2. As an example, the popular 4-D film *Beyond All Boundaries* at the National World War II Museum in New Orleans, Louisiana, a patriotic homage to veterans, devotes a substantial portion of the film to justifying the atomic bombings before the first explosion is rendered in a theatrical, thrilling display of 4-D film technology.

3. Fashion editor Carmel Snow first gave the collection this name in *Harper's Bazaar* (Parkins 111).

4. In *A Consumers' Republic*, Lizabeth Cohen discusses this phenomenon as part of the purchaser-as-citizen campaign: "Some merchandisers viewed the married couple as an increasingly important purchasing unit. . . . Other advertisers emphasized the newfound market significance of the purchasing family" (314). In placing pressure on women to make themselves desirable and feminine in order to "attract a man," consumer media campaigns worked to widen the most productive new target markets (couples and nuclear families).

5. Betty Friedan describes a similar consensus among retailers: "Department-store buyers reported that American women, since 1939, had become three and four sizes smaller. 'Women are out to fit the clothes, instead of vice-versa,' one buyer said" (59–60).

2. The Beat Writers and the Dawn of Street Fashion

1. The phrase "who wore black" surfaces in literature and scholarship about the Beats, including the title of the collection referenced later in this section, *Girls Who Wore Black: Women Writing the Beat Generation*.

2. Hollinger explains, "what celebration there was of ethno-racial groups in the World War II era was generally cast in an Americans-all idiom, aimed not at reinforcing ethno-racial affiliation but at affirming a transethnic vision of American nationality against Anglo-Protestant ethnocentrism" (96).

3. In an interview with Nancy M. Grace, Johnson says of Cowen, "She was secretive about her writing. . . . she considered herself, what she called, a *mediocre*. You know, that was horrible" ("In the Night Café" 198).

4. In "The Black Boy Looks at the White Boy," James Baldwin responds to this passage: "Now, this is absolute nonsense, of course, objectively considered, and offensive nonsense at that." He then qualifies his statement: "And yet there is real pain in it, and real loss, however thin; and it *is* thin, like soup too long diluted; thin because it does not refer to reality, but to a dream" (278).

3. Afrocentric Fashion in the Writing of
Walker, Morrison, and Senna

1. In *Against Race* (2000), Gilroy argues, "Black culture is not just commodified but lends its special exotic allure to the marketing of an extraordinary range of commodities and services that have no connection whatever to these cultural forms or to the people who have developed them" (214).

2. Lipsitz's term is derived from Gayatri Chakravorty Spivak's term "strategic essentialism," which refers to the formation of an essentialized (often temporary) collective identity and solidarity for the purpose of resisting oppression, or pursuing some other form of resistance/sociopolitical action. Spivak introduces this term in her 1987 essay "Subaltern Studies: Deconstructing Historiography."

3. Richard J. Powell notes that during the postwar decades and up until the 1970s, nonwhite artists' creations remained outside of the academy: "The creations by these artistic 'outsiders,' while highly praised in this period, were routinely misunderstood, removed from their aesthetic and social contexts, and inserted into a catch-all 'folk art' category that accommodated the mainstream art world's unwritten policy based on exclusion by race and class" (99).

4. This use of intense color, clashing tones, stripes, and shine dates back to Africa in the ninth century, according to Robert Farris Thompson, who notes in *Flash of the Spirit* (1984) that Mande culture incorporated striped, narrow-strip textiles and bold color in their art and dress (197).

5. The golliwog is a racist black caricature usually depicted as a rag doll; it originated in Florence Kate Upton's children's literature of the late nineteenth century.

6. See, for example, Barbara T. Christian's "Alice Walker: The Black Woman Artist as Wayward"; Jennifer Martin's "The Quilt Threads Together Sisterhood, Empowerment and Nature in Alice Walker's *The Color Purple* and 'Everyday Use'"; and David Cowart's "Heritage and Deracination in Walker's 'Everyday Use.'"

7. In the interview, Walker explains, "I went to Africa. I was given the name Wangero by the Kenyans . . . I could have embraced that identity and called myself that and tried to be that even though I was in Kenya for only a month, but instead when I came back to Georgia, to my parents, I could see that I couldn't really just latch onto that and dismiss them" (Walker et al.).

8. See, for example, Daniel Grassian's chapter on *Caucasia* in *Writing the Future of Black America: Literature of the Hip Hop Generation* (2009); Michele Elam's "Passing in the Post-Race Era: Danzy Senna, Philip Roth and Colson Whitehead" (2007); and Habiba Ibrahim's "Canary in a Coal Mine: Performing Biracial Difference in *Caucasia*" (2007). I outline several of these readings in chapter 2 of my book *The "White Other" in American Intermarriage Stories, 1945–2008* (2012).

9. I discuss the interracial marriage of Deck and Sandy at length in *The "White Other" in American Intermarriage Stories, 1945–2008* (2012).

10. One famous example is Thomas Stothard's *Voyage of the Sable Venus* (1781); for more on this and similar representations of black women, see Felipe Smith, *American Body Politics* (1998).

11. Rabine cites as a source for this figure *Informal Sector Development in Africa* (1996), written by the Office of the Special Coordinator for Africa and the Least Developed Countries, published by the UN's Department for Policy Coordination and Sustainable Development.

4. American Indian Literature and a Legacy of Misappropriation

1. Throughout this chapter, the tribal designations "Chippewa," "Ojibwa/e," and "Anishinaabe" are used interchangeably to refer to a northern tribal group spanning Quebec, Ontario, and Manitoba in Canada and the states of Michigan, Wisconsin, Minnesota, Montana, and North Dakota in the United States. The designation I use depends on the author's choice for self-designation. While Chippewa and Ojibwa refer to a specific tribe, Anishinaabe refers to a category of tribes that also includes Cree, Odawa, Algonquin, and Potawatomi. The term loosely translates to "First People." The novels by Boyden, Erdrich, and LaDuke all use the term Anishinaabe, yet both Erdrich and LaDuke write about Ojibwa/Chippewa people while Boyden writes primarily about the Canadian Cree and Métis (mixed ancestry, white and Anishinaabe).

2. See the introduction or, for a full discussion of cultural appropriation, George Lipsitz, *Dangerous Crossroads: Popular Music, Postmodernism and the Poetics of Place* (1994).

3. For examples and more detailed analysis of these works, see Ronald Takaki, *Iron Cages: Race and Culture in Nineteenth-Century America*, 86–91; and Werner Sollors, *Beyond Ethnicity: Consent and Descent in American Culture*, 127.

4. Social work researchers Angela R. Gebhardt and Jane D. Woody suggest the statistic may be even higher. The frequently cited 34 percent statistic comes from the National Violence Against Women Survey conducted by Patricia Tjaden and Nancy Thoennes; however, Gebhardt and Woody suggest that other, more recent surveys place that number closer to 40 percent (238).

5. Boyden is a Canadian author. I include his novel in a volume otherwise focused on U.S. authors for two reasons: (1) much of the novel is set in New York City and focuses on the American fashion industry, and (2) the Anishinaabe tribes span from the northern United States to Canada, as noted above, and therefore the tribal

culture represented in the novel parallels elements of the culture represented in LaDuke's novel.

6. The Spokanes are a Plateau tribe who live in the Pacific Northwest; the reservation is located in Wellpinit, in eastern Washington.

7. The Flathead Indians are another Plateau tribe, from western Montana.

8. It's worth noting that Boyden's claims to indigenous heritage (Nipmuc and Ojibwe) have generated controversy among other American Indian writers and public figures, a controversy that emerged after a 2016 feature by APTN National News. The article was responding to a Twitter post and video by Noonsack blogger Robert Jago, who, after indicating the ambiguity surrounding Boyden's ancestry, asked his audience to consider the repercussions: "Think of all the Native writing awards he won. . . . Some are cash awards, for Natives only. . . . And how many Native writers, thinkers, Residential School survivors have gone unheard because he's colonized their public space?" Boyden has since responded, providing evidence of his ancestry and asserting his claims to tribal identity; however, his heritage remains contested.

9. Quoted from Morgan O'Neal's review in *First Nations Drum*, Ron Charles's review in *The Washington Post*, and a piece from *Kirkus Review* ("Through Black Spruce"), respectively.

10. Literary scholar Timothy Sweet suggests that although this trope appears in both white popular culture and native works, it is likely invented: "The trope of photographic soul-stealing is a means of narrating the dynamic of agency, of figuring the power-relations of the photographic encounter. The origin of the trope probably lies in white attitudes of cultural superiority, according to which a 'primitive' submission to the subject-object dynamic created by photographic technology is read as signifying an analogous submission to an all-encompassing subject-object dynamic at the level of culture in general" (498).

11. In her work on the "Dying Indian Speeches" (2001), Kristina Bross explains, "However much nineteenth-century authors may have lamented the disappearance of Indians, they agreed with seventeenth-century writers that Indian deaths were necessary and inevitable—whether because of divine will, 'natural' inferiority to whites, or manifest destiny" (326).

12. In his novel *Flight* (2007), Alexie alludes to this same phenomenon through the narrator, Zits. Because he grew up outside the reservation and was a foster child to (mostly) white guardians, Zits's knowledge of tribal culture comes from the Discovery Channel (12).

5. Gendered Fashion and Transgender Literature

1. Feminist, activist, and cultural anthropologist Gayle Rubin offers the following definition of butch: "Butch is most usefully understood as a category of lesbian gender that is constituted through the deployment and manipulation of masculine gender codes and symbols" (472).

2. Julia Serano, for example, describes the cliché of the trans "deceiver" in films like *The Crying Game* and *Ace Ventura: Pet Detective,* which has skewed public perception of trans women, many of whom "are outspoken feminists and activists fighting against all gender stereotypes" (229, 226).

3. Riley C. Snorton references Mock's comment in his book *Black on Both Sides: A Racial History of Trans Identity* (2017). He echoes her sentiments and identifies this feeling of having "made it" as his motivation "to find a vocabulary for black and trans life" (xiv).

4. The "passing" trope originates in African American literature, with its popularity beginning in the early twentieth century as a means of playing on white anxieties about miscegenation. Here, gender studies scholars appropriate the term to apply not to race but to gender (e.g., an individual whose assigned sex is male passing as a female). The term is used frequently and yet is problematic, since transsexual and transgender individuals who identify as male or female (having been born a different gender) view themselves as being, not passing as, that sex, and in most cases are legally recognized as that sex.

5. In this piece, Stone responds to Janice G. Raymond's 1979 radical feminist screed *The Transsexual Empire: The Making of the She-Male.*

6. Dan Irving notes another issue with medical interventions in his 2008 essay "Normalized Transgressions": not only do these interventions reinforce a normative transgender journey or transition, but they also reinforce both capitalist and heteronormative social structures through their standards of practice—structures that focus less on patient care and more on procuring good citizens (18).

7. Irving explains, "The real-life test functioned as an oppressive appraisal of endurance that disciplined transsexuals through the reiteration of their sex/gender variance as problematic and abnormal. . . . Medical experts believed that the individual who succeeded in withstanding the daily harassment and discrimination that accompanied the real-life test demonstrated a genuine dedication to pursuing transition and therefore deserved to be diagnosed as transsexual" (20).

8. Theorists Charles Shepherdson and Catherine Millot have written psychoanalytic analyses of the distinctions between "transvestite" and "transsexual"; online resources in addition to GLAAD, such as TransMediaWatch, differentiate "transvestite" or "cross-dresser" from "transgender" and "transsexual." As an example of stereotypes, on the popular television series *Friends* (Crane and Kaufman),

Chandler's father is portrayed as gay (Chandler references his father's relations with other men during his childhood), a drag queen (her first on-screen appearance is in a Vegas drag show), and a transgender person (based on her appearance and the casting choice of Kathleen Turner, the audience is led to believe she has transitioned).

9. Jay Prosser paraphrases Butler: "*Gender Trouble* presents the transgendered subject as the concrete example that 'brings into relief' this performativity of gender" (Butler 31; Prosser, "Judith Butler" 261).

10. Bernice Hausman argues, "Transsexual autobiographical narratives cannot merely be a part of the repressive structure of 'official' transsexual experience, since they clearly enable others to identify themselves as transsexuals, thereby allowing a variety of individuals to actively construct themselves as transsexuals. This is evident in the autobiographies themselves, where the authors mention that finding texts by other transsexuals helped to authorize their own identifications" (339).

11. Hausman lists, among others, Nancy Hunt, *Mirror Image;* Jan Morris, *Conundrum;* and Renée Richards, *Second Serve: The Renée Richards Story.* Of these transition narratives, Hausman explains, "What is most consistent in transsexuals' self-representations is the oft-repeated insistence that there must be something physical, measurable, materially detectable that motivates and justifies the desire to change sex. Because of this, the transsexual autobiographers feel sure that the body he or she achieves through sex reassignment is his or her 'real body,' the one he or she was meant to have, the one denied by some cruel trick of Nature or God" (352).

Conclusion

1. Minh-ha T. Pham uses the term "plagiarism" in lieu of "cultural appropriation" because of the latter's ambiguity, whereas "racial plagiarism" offers "a more precise formulation for these kinds of practices of unauthorized and uncredited fashion copying" ("Racial Plagiarism" 68).

2. The graphic was initially published in Thomas's RMIT dissertation, "Situated Empathy: Constructed Theoretical Discourse Addressing the Empathetic Motivations Shared by Fashion Design for Sustainability, and the Potential of Socially Engaged Buddhist Ethics to Inform Design Practice" (2011).

Works Cited

"About Us." *Indian Headdress—Novum Crafts,* indianheaddress.com/pages/about-us.

Adichie, Chimamanda Ngozi. *Americanah.* Anchor, 2014.

———. "My Fashion Nationalism." *The Financial Times,* 20 Oct. 2017.

Aizura, Aren, and Susan Stryker, editors. *The Transgender Studies Reader.* Vol. 2, Routledge, 2013.

Alexander, Jeffrey C. *Trauma: A Social Theory.* Polity Press, 2012.

Alexie, Sherman. *Flight.* Black Cat, 2007.

———. "Interview." *The Colbert Report,* 28 Oct. 2008.

———. *Reservation Blues.* Grove Press, 1995.

———. *You Don't Have to Say You Love Me: A Memoir.* Little, Brown, 2017.

"An Ally's Guide to Terminology: Talking about LGBT People & Equality." *GLAAD,* 8 Feb. 2015, www.glaad.org/publications/talkingabout/terminology.

Ames, Jonathan. *The Extra Man.* Scribner, 1998.

Archer-Straw, Petrine. *Negrophilia: Avant-Garde Paris and Black Culture in the 1920s.* Thames & Hudson, 2000.

Atwood, Margaret. *The Handmaid's Tale.* Houghton Mifflin, 1986.

———. *Oryx and Crake.* Anchor Books, 2004. Kindle.

Avatar. Directed by James Cameron, Twentieth Century Fox, 2009.

Avery, Faith M. "'Let Loose the Dogs': Messiness and Ethical Wrangling in Toni Morrison's Tar Baby." *Iowa Journal of Cultural Studies,* vol. 16, no. 1, Fall 2014, pp. 5–21.

Baker, Houston A., Jr., and Charlotte Pierce-Baker. "Patches: Quilts and Community in Alice Walker's 'Everyday Use.'" Walker and Christian, pp. 149–65.

Baldwin, James. "The Black Boy Looks at the White Boy." *Esquire,* May 1961, pp. 102–6.

Baraka, Amiri. *Autobiography of Leroi Jones.* Lawrence Hill Books, 1997.

Barrera, Jorge. "Author Joseph Boyden's Shape-Shifting Indigenous Identity." *APTN News,* APTN, 23 Dec. 2016, aptnnews.ca/2016/12/23/author-joseph-boydens-shape -shifting-indigenous-identity/.

Barthes, Roland. *The Fashion System.* Translated by Matthew Ward and Richard Howard, Cape, 1985.

"Beauty Bulletin: The Natural: The Beat-Beat-Beat of Marsha Hunt, the Zip of Her Looks, the Froth of Her Hair." *Vogue,* vol. 153, no. 1, 1 Jan. 1969, pp. 134–37, 178.

"Beauty Bulletin: Two Young Naturals: Ro Anne Nesbitt and Carol La Brié." *Vogue,* vol. 153, no. 4, 15 Feb. 1969, pp. 106–7.

Black Panther. Directed by Ryan Coogler, Marvel Studios, Walt Disney Pictures, 2018.

Blecha, Peter. *Sonic Boom: The History of Northwest Rock, from "Louie Louie" to "Smells Like Teen Spirit."* Backbeat Books, 2009.

Blount Danois, Ericka. "From Queens Come Kings: Run DMC Stomps Hard out of a 'Soft' Borough." *Hip Hop in America: A Regional Guide,* edited by Mickey Hess, ABC-CLIO, 2010, pp. 47–73.

Bohjalian, Chris. *Trans-Sister Radio.* Vintage Contemporaries, 2000.

Bono, Chaz, with Billie Fitzpatrick. *Transition: Becoming Who I Was Always Meant to Be.* Plume, 2011.

Bourdieu, Pierre. *Distinction: A Social Critique of the Judgment of Taste.* Translated by Richard Nice, introduction by Tony Bennett, Routledge, 2010.

Boyden, Joseph. *Through Black Spruce.* Penguin Books, 2010.

Brevard, Aleshia. *The Woman I Was Not Born to Be: A Transsexual Journey.* Temple UP, 2001.

Bross, Kristina. "Dying Saints, Vanishing Savages: 'Dying Indian Speeches' in Colonial New England Literature." *Early American Literature,* vol. 36, no. 3, 2001, pp. 325–52.

Buff, Rachel. *Immigration and the Political Economy of Home: West Indian Brooklyn and American Indian Minneapolis, 1945–1992.* U of California P, 2001.

Butler, Judith. *Gender Trouble: Feminism and the Subversion of Identity.* Routledge, 1990.

Calder, Alison. Review of *Through Black Spruce,* by Joseph Boyden. *Canadian Ethnic Studies Journal,* vol. 40, no. 3, 2008, p. 208.

Carden, Mary Paniccia. *Women Writers of the Beat Era: Autobiography and Intertextuality.* U of Virginia P, 2018.

Cardon, Lauren. *Fashion and Fiction: Self-Transformation in Twentieth-Century American Literature.* U of Virginia P, 2016.

Charles, Ron. "Book Review: 'Through Black Spruce' by Joseph Boyden." *The Washington Post,* 18 Mar. 2009.

Cohen, Lizabeth. *A Consumer's Republic: The Politics of Mass Consumption in Postwar America*. Vintage Books, 2004.

Cole, Olivia. *Panther in the Hive*. Fletchero, 2016. Kindle.

Coleman, Christina. "Why You Gotta Be So Rude? A Recent History of Urban Outfitters' Offensive Products (LIST)." *Global Grind*, 15 Sept. 2014, globalgrind.cassiuslife.com /4014261/urban-outfitters-offensive-products-clothing-history-list/.

Coleman, James. "The Quest for Wholeness in Toni Morrison's *Tar Baby*." *Black American Literature Forum*, vol. 20, no. 1/2, 1986, pp. 63–73. doi:10.2307/2904551.

Collins, Patricia Hill. *Black Feminist Thought: Knowledge, Consciousness, and the Politics of Empowerment*. 2nd ed., Routledge, 2008.

———. "What's in a Name? Womanism, Black Feminism, and Beyond." *The Black Scholar*, vol. 26, no. 1, Winter/Spring 1996, pp. 9–17.

Collins, Suzanne. *Catching Fire*. Scholastic, 2010. Kindle.

———. *The Hunger Games*. Scholastic, 2009. Kindle.

"The Controversy of Cher's Heritage." *AAA Native Arts*, https://www.aaanativearts.com /the-controversy-of-cher-s-heritage.

Coontz, Stephanie. "What We Really Miss about the 1950s." *Rereading America: Cultural Contexts for Critical Thinking and Writing*, edited by Gary Colombo et al., Bedford/ St. Martins, 2013, pp. 27–43.

Coupland, Douglas. *Polaroids from the Dead*. Harper Perennial, 1996.

Cowart, David. "Heritage and Deracination in Walker's 'Everyday Use.'" *Studies in Short Fiction*, vol. 33, no. 2, 1996, pp. 171–84.

Cowen, Elise. *Poems and Fragments*. Edited by Tony Trigilio, Ahsahta Press, 2014.

Craik, Jennifer. *The Face of Fashion: Cultural Studies in Fashion*. Routledge, 1994.

Crane, David, and Marta Kaufman, creators. *Friends*. Bright/Kauffman/Crane Productions and Warner Bros. Television, 1994–2004.

Crane, Diana. *Fashion and Its Social Agendas: Class, Gender, and Identity in Clothing*. U of Chicago P, 2000.

Davis, Fred. *Fashion, Culture, and Identity*. U of Chicago P, 1992.

Deerwester, Jayme. "'I've Grown into Caitlyn': '20/20' Catches up with Jenner 2 Years Later." *USA Today*, Gannett Satellite Information Network, 23 Apr. 2017.

Deloria, Philip J. *Playing Indian*. Yale UP, 1998.

Dinerstein, Joel. *The Origins of Cool in Postwar America*. U of Chicago P, 2017.

Dior, Christian. *Dior and I*. Dutton, 1957.

Dippie, Brian W. *The Vanishing American: White Attitudes and U.S. Indian Policy*. Wesleyan UP, 1982.

Donofrio, Nicholas. "White-Collar Work and Literary Careerism in Sylvia Plath's *The Bell Jar*." *Contemporary Literature*, vol. 56, no. 2, Summer 2015, pp. 216–54.

Dubin, Lois Sherr. *North American Indian Jewelry and Adornment: From Prehistory to Present*. Harry N. Abrams, 1999.

Edwards, Tim. *Fashion in Focus: Concepts, Practices and Politics.* Routledge, 2011.

Edwoodzie, Joseph C., Jr. *Break Beats in the Bronx: Rediscovering Hip-Hop's Early Years.* U of North Carolina P, 2017.

Elam, Michele. "Passing in the Post-Race Era: Danzy Senna, Philip Roth, and Colson Whitehead." *African American Review,* vol. 41, no. 4, pp. 749–68.

Ewen, Stuart, and Elizabeth Ewen. *Channels of Desire: Mass Images and the Shaping of American Consciousness.* U of Minnesota P, 1992.

"Eyes Only: For Summer: Red Frames, Sports News, Sun Tips." *Vogue,* vol. 169, no. 5, 1 May 1979, p. 122.

Farrell, Susan. "Fight vs. Flight: A Re-evaluation of Dee in Alice Walker's 'Everyday Use.'" *Studies in Short Fiction,* vol. 35, no. 2, Spring 1998, pp. 179–86.

"Fashion: Fashions for a Man's Eye . . . We Hope." *Vogue,* vol. 112, no. 8, 1 Nov. 1948, pp. 110–17.

"Fashion: Pucci's Africa: The Pure Wonder." *Vogue,* vol. 145, no. 1, 1 Jan. 1965, pp. 106–11.

"Features: The Navajo Blanket." *Vogue,* vol. 21, no. 14, 2 Apr. 1903.

"Features/Articles/People: Special Features: Colour from Africa." *Vogue,* vol. 118, no. 1, 1 July 1951, pp. 68–71.

Feinberg, Leslie. *Stone Butch Blues.* Alyson Books, 2003.

———. "Transgender Liberation: A Movement Whose Time Has Come." Stryker and Whittle, pp. 205–20.

Fleming, Eugene D. "Psychiatry and Beauty." *Cosmopolitan,* vol. 146, no. 6, June 1959, pp. 31–37.

Ford, Tanisha C. *Liberated Threads: Black Women, Style, and the Global Politics of Soul.* U of North Carolina P, 2015.

———. "Why Fashion Is Key to Understanding the World of *Black Panther.*" *The Atlantic,* 15 Feb. 2018.

Friedan, Betty. *The Feminine Mystique.* 1963. W.W. Norton, 2001.

Fuller, Hoyt W. "Towards a Black Aesthetic." *The Black Aesthetic,* edited by Addison Gayle Jr., Doubleday, 1971, pp. 3–12.

Funny Face. Directed by Stanley Donen, performances by Audrey Hepburn and Fred Astaire, Paramount, 1957.

Furlan, Laura M. *Indigenous Cities: Urban Indian Fiction and the Histories of Relocation.* U of Nebraska P, 2017.

Gaiman, Neil. Introduction. *Fahrenheit 451: A Novel,* by Ray Bradbury, 1953, Simon & Schuster, 2013. Kindle.

Gallico, Paul. *Mrs. 'Arris Goes to Paris.* Doubleday, 1958.

Gebhardt, Angela R., and Jane D. Woody. "American Indian Women and Sexual Assault: Challenges and New Opportunities." *Affilia Journal of Women and Social Work,* vol. 27, no. 3, 2012, pp. 237–48.

Gilbert, Sandra M. *Rereading Women: Thirty Years of Exploring Our Literary Traditions.* W. W. Norton, 2011.

Gilroy, Paul. *Against Race: Imagining Political Culture beyond the Color Line.* Belknap P of Harvard UP, 2000.

Global Fashion Capitals. 2 June–14 Nov. 2015, Fashion Institute of Technology Museum, New York.

Grassian, Daniel. *Writing the Future of Black America: Literature of the Hip Hop Generation.* U of South Carolina P, 2009.

Grobe, Christopher. *The Art of Confession: The Performance of Self from Robert Lowell to Reality TV.* New York UP, 2017. Kindle.

Gunn, Tim. *Tim Gunn's Fashion Bible: The Fascinating History of Everything in Your Closet.* Gallery Books, 2012.

Hadi Radhi, Shaimaa. "Aesthetic Image of the Animal Epithet in Alice Walker's Short Story 'Everyday Use.'" *Advances in Language and Literary Studies,* vol. 8, no. 5, 2017, pp. 120–27.

Hausman, Bernice. "Body, Technology, and Gender in Transsexual Autobiographies." Stryker and Whittle, pp. 335–61.

Hebdige, Dick. *Subculture and the Meaning of Style.* Routledge, 1979.

Heiliger, Evangeline M. "Ado(red), Abho(red), Disappea(red): Fashioning Race, Poverty, and Morality under Product (Red)™." *Fashion Talks: Undressing the Power of Style,* edited by Shira Tarrant and Marjorie Jolles, State U of New York P, 2012, pp. 149–64.

Heyes, Cressida. "Feminist Solidarity after Queer Theory: The Case of Transgender." Aizura and Stryker, pp. 201–12.

Hill, Daniel Delis. *As Seen in Vogue: A Century of American Fashion in Advertising.* Texas Tech UP, 2004.

Hirschberger, Gilad. "Collective Trauma and the Social Construction of Meaning." *Frontiers in Psychology,* 2018.

Hollinger, David. *Postethnic America: Beyond Multiculturalism.* Basic Books, 2000.

Holmes, John Clellon. "The Name of the Game." *Nothing More to Declare.* E. P. Dutton, 1967.

———. "This Is the Beat Generation." *New York Times Magazine,* 16 Nov. 1952, pp. 10, 19, 20, 22.

Ibrahim, Habiba. "Canary in a Coal Mine: Performing Biracial Difference in Caucasia." *Literature Interpretation Theory,* vol. 18, no. 2, April–June 2007, pp. 155–72.

In Vogue—The Editor's Eye. Directed by R. J. Cutler, HBO Documentary Films, 2012.

Irving, Dan. "Normalizing Transgressions: Legitimizing the Transsexual Body as Productive." Aizura and Stryker, pp. 15–29.

Jenner, Caitlyn. "I'm a Woman: Interview with Diane Sawyer." *ABC News 20/20,* 25 Apr. 2015.

Johnson, Diane. "Nostalgia: Being Green." *Vogue*, vol. 193, no. 9, 1 Sept. 2003, pp. 200, 208, 216.

Johnson, Joyce. *Come and Join the Dance: A Novel*. Open Road Media, 2014. Kindle.

———. "In the Night Café." Interview with Nancy M. Grace. Johnson and Grace 2004, pp. 181–206.

———. *Minor Characters*. 1983. Anchor Books, 1994. Kindle.

Johnson, Ronna C., and Nancy M. Grace, editors. *Breaking the Rule of Cool: Interviewing and Reading Women Beat Writers*. UP of Mississippi, 2004.

———. *Girls Who Wore Black: Women Writing the Beat Generation*. Rutgers UP, 2002.

Jones, Hettie. *Drive*. Hanging Loose Press, 1997.

———. *How I Became Hettie Jones*. Grove Press, 1996.

———. *Love, H: The Letters of Helene Dorn and Hettie Jones*. Duke UP, 2016.

Jones, Lisa. *Bulletproof Diva: Tales of Race, Sex, and Hair*. Doubleday, 1994.

Jorgensen, Christine. *Christine Jorgensen: A Personal Autobiography*. 1967. Cleis Press, 2000.

Kai, Nubia. "Africobra Universal Aesthetics." *AFRICOBRA: The First Twenty Years*. Nexus Contemporary Art Center, 1990. 5–14.

Kaiser, Susan B. *Fashion and Cultural Studies*. Berg, 2012.

Kaiser, Susan B., and Ryan Looysen. "Antifashion." *Berg Encyclopedia of World Dress and Fashion*, vol. 3, *Fashion in the United States and Canada*, edited by Phyllis G. Tortora, Berg, 2010.

Kashyap, Aruna. "'Soon There Won't Be Much to Hide': Transparency in the Apparel Industry." *Human Rights Watch*, World Report 2018, 6 Apr. 2018, www.hrw.org/world-report/2018/essay/transparency-in-apparel-industry.

Keene, Adrienne. "New York Fashion Week Designer Steals from Northern Cheyenne/Crow Artist Bethany Yellowtail." *Native Appropriations*, http://nativeappropriations.com/2015/02/new-york-fashion-week-designer-steals-from-crow-artist-bethany-yellowtail.html.

Keith, Joseph. "Neither Citizen nor Alien: Rewriting the Immigrant Bildungsroman across the Borders of Empire in Carlos Bulosan's *America Is in the Heart*." *Unbecoming Americans: Writing Race and Nation from the Shadows of Citizenship, 1945–1960*. Rutgers UP, 2013, pp. 27–65.

Kerouac, Jack. *On the Road*. 1957. Penguin Classics, 2016.

Körpez, Esra. "The Windigo Myth in *The Antelope Wife* and *Last Standing Woman*: The Evil Within and Without." *Comparative Critical Studies*, vol. 2, no. 3, Oct. 2005, pp. 349–63.

Krause, Elizabeth L. *Tight Knit: Global Families and the Social Life of Fast Fashion*. U of Chicago P, 2018.

Krumholz, Linda. "Blackness and Art in Toni Morrison's *Tar Baby*." *Contemporary Literature*, vol. 49, no. 2, 2008, pp. 263–92.

LaDuke, Wynona. *Last Standing Woman*. Voyageur Press, 1999.

Leonard, Garry M. "'The Woman Is Perfected. Her Dead Body Wears the Smile of Accomplishment': Sylvia Plath and 'Mademoiselle' Magazine." *College Literature*, vol. 19, no. 2, 1992, pp. 60–82.

Lewis, Samella S., and Ruth G. Waddy. *Black Artists on Art*. Vol. 2, Contemporary Crafts, 1972.

Lieber, Chavie. "The Reclaiming of Native American Fashion." *Racked*, Vox Media, 21 Jan. 2016, www.racked.com/2016/1/21/10763702/native-american-fashion.

Lipsitz, George. *Dangerous Crossroads: Popular Music, Postmodernism, and the Poetics of Place*. Verso, 1994.

Lorde, Audre. "Learning from the 60s." *Sister Outsider: Essays and Speeches*, Crossing, 1984, pp. 134–44.

"Lost Highway." *Vogue*, vol. 202, no. 10, Oct. 2012, pp. 314–25.

MacKinney-Valentine, Maria. *Fashioning Identity: Status Ambivalence in Contemporary Fashion*. Bloomsbury Academic, 2017.

Mailer, Norman. "The White Negro: Superficial Reflections on the Hipster." *Dissent*, vol. 4, Spring 1957, pp. 276–93.

Maquet, Jacques. "Features/Articles/People: The Quest for Beauty in Dahomey: A Photographic Essay by Irving Penn." *Vogue*, vol. 150, no. 10, Dec. 1, 1967, pp. 218–29, 265–66, 274–75.

Marsan, Loran. "Cher-ing/Sharing across Boundaries." *Visual Culture & Gender*, vol. 6, 2010, pp. 47–64.

May, Elaine Tyler. *Homeward Bound: American Families in the Cold War Era*. Basic Books, 1988. ACLS Humanities e-book.

"Mayday." *The Handmaid's Tale*, written by Bruce Miller, directed by Mike Barker, MGM, 2019.

McKay, Nellie. "An Interview with Toni Morrison." Taylor-Guthrie, pp. 138–55.

Mellis, James. "Interview with Sherman Alexie." *Conversations with Sherman Alexie*, edited by Nancy J. Peterson, UP of Mississippi, 2009, pp. 180–86.

Mercer, Kobena. *Welcome to the Jungle: New Positions in Black Cultural Studies*. Routledge, 1994.

Metcalfe, Jessica. "I Don't Like Etsy, and This Is Why. . . ." *Beyond Buckskin: About Native American Fashion*, blog, 30 May 2016, http://www.beyondbuckskin.com/2016/05/i-dont-like-etsy-and-this-is-why.html.

———. "Misappropriation and the Case of the Yellow Crotch." *Beyond Buckskin: About Native American Fashion*, blog, 22 Jan. 2013, http://www.beyondbuckskin.com/2013/01/misappropriation-and-case-of-yellow.html.

———. "Some History: Ribbon Work and Ribbon Shirts." *Beyond Buckskin: About Native American Fashion*, blog, 23 Mar. 2010, http://www.beyondbuckskin.com/2010/03/ribbon-work-and-ribbon-shirts.html.

Miles, Barry. *Jack Kerouac, King of the Beats: A Portrait*. Virgin, 1998.

Mock, Janet. *Redefining Realness: My Path to Womanhood, Identity, Love & So Much More.* Atria, 2014.

———. *Surpassing Certainty: What My Twenties Taught Me.* Atria Books, 2017. Kindle.

Montgomery, Maureen. *Displaying Women: Spectacles of Leisure in Edith Wharton's New York.* Routledge, 1998.

Moore, Jennifer Grayer. *Street Style in America: An Exploration.* Greenwood, 2017.

Morrison, Toni. *Tar Baby.* Penguin Books, 1981.

Moses, Cat. "Queering Class: Leslie Feinberg's *Stone Butch Blues.*" *Studies in the Novel,* vol. 31, no. 1, Spring 1999, pp. 74–97.

Mulvey, Laura. "Visual Pleasure and Narrative Cinema." *Film Theory and Criticism: Introductory Readings,* edited by Leo Braudy and Marshall Cohen, Oxford UP, 1999, pp. 833–44.

Murray, David. "Representation and Cultural Sovereignty: Some Case Studies." *Native American Representations: First Encounters, Distorted Images, and Literary Appropriations,* edited by Gretchen M. Bataille, U of Nebraska P, 2001, pp. 80–97.

Neal, Larry. *Visions of a Liberated Future: Black Arts Movement Writings.* Basic Books, 1989.

Negrin, Llewellyn. *Appearance and Identity: Fashioning the Body in Postmodernity.* Palgrave Macmillan, 2008.

Obama, Michelle. *Becoming.* Crown, 2018.

Office of the Special Coordinator for Africa and the Least Developed Countries. *Informal Sector Development in Africa.* UN Department for Policy Coordination and Sustainable Development, 1996.

O'Neal, Morgan. "Book Review: *Through Black Spruce* by Joseph Boyden." *First Nations Drum,* 28 Feb. 2010, www.firstnationsdrum.com/2010/02/book-review-through-black -spruce-by-joseph-boyden/.

Parkins, Ilya. *Poiret, Dior and Schiaparelli: Fashion, Femininity and Modernity.* Berg, 2012.

Pham, Minh-Ha T. "Racial Plagiarism and Fashion." *QED,* vol. 4, no. 3, 2018, pp. 67–80.

———. "The Right to Fashion in the Age of Terrorism." *Signs: Journal of Women in Culture & Society,* vol. 36, no. 2, Winter 2011, pp. 385–410.

Piedmont-Marton, Elizabeth. "Reading and Writing about Fashion." *The World Is a Text: Writing, Reading and Thinking about Visual and Popular Culture,* edited by Jonathan Silverman and Dean Rader, 3rd ed., Longman, 2009, pp. 91–93.

Plath, Sylvia. *The Bell Jar.* 1963. HarperPerennial, 1996.

———. *The Collected Poems.* Edited by Ted Hughes, Harper and Row, 1981.

———. *The Unabridged Journals of Sylvia Plath.* Anchor, 2007.

Pollard, Claire. "Her Kind: Anne Sexton, the Cold War and the Idea of the Housewife." *Critical Quarterly,* vol. 48, no. 3, 2006, pp. 1–26.

Poneman, Jonathan. "Features: Grunge & Glory." *Vogue,* vol. 182, no. 12, 1 Dec. 1992, pp. 254–63, 313.

Powell, Richard J. *Black Art: A Cultural History.* 2nd ed., Thames & Hudson, 2003.

Primus, Pearl. "People and Ideas: In Africa." *Vogue,* vol. 116, no. 7, 15 Oct. 1950, pp. 98–99, 145, 148.

Prosser, Jay. "Judith Butler: Queer Feminism, Transgender, and the Transubstantiation of Sex." Stryker and Whittle, pp. 257–80.

———. "No Place like Home: The Transgendered Narrative of Leslie Feinberg's 'Stone Butch Blues.'" *Modern Fiction Studies,* vol. 41, no. 3/4, 1995, pp. 483–514.

Rabine, Leslie W. *The Global Circulation of African Fashion.* Berg, 2002.

Rand, Erica. "So Unbelievably Real: Stone Butch Blues and the Fictional Special Guest." *The Radical Teacher,* no. 92, Winter 2011, pp. 35–42.

Raymond, Janice G. "Sappho by Surgery: The Transsexually Constructed Lesbian-Feminist." Stryker and Whittle, pp. 131–43.

Ruas, Charles. "Toni Morrison." *Conversations with Toni Morrison,* Taylor-Guthrie, pp. 93–118.

Rubin, Gayle. "Of Catamites and Kings: Reflections on Butch, Gender, and Boundaries." Stryker and Whittle, pp. 471–81.

Schleifer, Marc D. "The Beat Debated—Is It or Is It Not?" *Village Voice,* vol. 4, no. 4, 19 Nov. 1958, pp. 1, 3.

Screaming Queens: The Riot at Compton's Cafeteria. Directed by Susan Stryker and Victor Silverman, Frameline, 2005.

Senna, Danzy. *Caucasia.* Riverhead Books, 1998.

Serano, Julia. "Skirt Chasers: Why the Media Depicts the Trans Revolution in Lipstick and Heels." Aizura and Stryker, pp. 226–33.

Sexton, Anne. *The Complete Poems: Anne Sexton.* Mariner Books, 1999.

Shelly, Jared. "Urban Outfitters Pulls Religiously Insensitive Socks." *Bizjournals.com,* 17 Dec. 2013.

Simmel, Georg. "Fashion." *American Journal of Sociology,* vol. 62, no. 6, 1957, pp. 541–58.

Smith, Felipe. *American Body Politics: Race, Gender, and Black Literary Renaissance.* U of Georgia P, 1998.

Snorton, Riley C. *Black on Both Sides: A Racial History of Trans Identity.* U of Minnesota P, 2017.

Sollors, Werner. *Beyond Ethnicity: Consent and Descent in American Culture.* Oxford UP, 1986.

Spivak, Gayaytri Chakravorty, et al. "Subaltern Studies: Deconstructing Historiography." *Alif: Journal of Comparative Poetics,* no. 18, 1998, pp. 122–56.

Steele, Valerie. *Fifty Years of Fashion: New Look to Now.* Yale UP, 2000.

Stone, Sandy. "The *Empire* Strikes Back: A Posttranssexual Manifesto." Stryker and Whittle, pp. 221–35.

Stryker, Susan. "(De)subjugated Knowledges: An Introduction to Transgender Studies." Stryker and Whittle, pp. 1–17.

———. "Finocchio's, A Short Retrospective." *FoundSF,* Shaping San Francisco, a Project of Independent Arts & Media, www.foundsf.org/index.php?title=Finocchio%27s%2C _a_Short_Retrospective.

Stryker, Susan, and Stephen Whittle, editors. *The Transgender Studies Reader.* Vol. 1, Routledge, 2006.

Sweet, Timothy. "Ghost Dance? Photography, Agency, and Authenticity in 'Lame Deer, Seeker of Visions.'" *Modern Fiction Studies,* vol. 40, no. 3, Fall 1994, pp. 495–506.

Takaki, Ronald. *Iron Cages: Race and Culture in 19th-Century America.* Rev. ed., Oxford UP, 2000.

Taylor-Guthrie, Danille, editor. *Conversations with Toni Morrison.* UP of Mississippi, 1994.

Theado, Matt. *Understanding Jack Kerouac.* U of South Carolina P, 2000.

Thomas, Sue. *Fashion Ethics.* Routledge, 2018.

Thompson, Robert Farris. *Flash of the Spirit: African and Afro-American Art and Philosophy.* Random House, 1983.

Thomson, Gillian. "Gender Performance in the Literature of the Female Beats." *Comparative Literature and Culture,* vol. 13, no. 1, March 2011, pp. 1–8.

"Through Black Spruce by Joseph Boyden." *Kirkus Reviews: Digital Edition,* Kirkus Media, 23 Mar. 2009, www.kirkusreviews.com/book-reviews/joseph-boyden/through-black -spruce/.

Tioleu, Linda. "I Will Not Be Quiet." *Last Real Indians,* The New Indigenous Millennium, accessed April 2017.

Tjaden, Patricia Godeke, and Nancy Thoennes. *Extent, Nature, and Consequences of Rape Victimization: Findings from the National Violence Against Women Survey.* NIJ Special Report, U.S. Department of Justice, Office of Justice Programs, National Institute of Justice, 2006.

Trilling, Diana. "Other Night at Columbia: A Report from the Academy." *Partisan Review,* vol. 26, Apr. 1959, pp. 214–30.

Veblen, Thorstein. *The Theory of the Leisure Class.* 1899. Dover, 1994.

Vinken, Barbara. *Fashion Zeitgeist: Trends and Cycles in the Fashion System.* Berg, 2005.

"Vogue's Own Boutique." *Vogue,* vol. 148, no. 6, 1 Oct. 1966, pp. 260–62.

"Vogue's Own Boutique: A Head of Hair." *Vogue,* vol. 153, no. 4, 15 Feb. 1969, pp. 142–46.

Vowel, Chelsea. "Hey You in the Headdress, Know What It Means?" *HuffPost Canada,* Huffington Post, 11 Apr. 2012.

Walker, Alice. "Everyday Use." *In Love and Trouble: Stories of Black Women,* Harcourt Brace Jovanovich, 1973, pp. 47–59.

———. "In Search of Our Mothers' Gardens." Walker and Christian, pp. 39–49.

Walker, Alice, and Barbara T. Christian. *Everyday Use,* edited by Barbara T. Christian, Women Writers Series, Rutgers UP, 1994.

Walker, Alice, et al. *Alice Walker: A Stitch in Time.* Films on Demand, 2003.

Wardlaw, Alvia J. "Metamorphosis: The Life and Art of John Biggers." *The Art of John Biggers: View from the Upper Room,* edited by Wardlaw, Harry N. Abrams, 1995, pp. 16–75.

Washington, Mary Helen. "An Essay on Alice Walker." Walker and Christian, pp. 85–103.

Watten, Barrett. "What I See in *How I Became Hettie Jones.*" Johnson and Grace, pp. 96–118.

"The Well-Dressed Man: Some Observations on the Ways of Smart Men/Consideration of Broad Fashions and Narrow Fashions." *Vogue,* vol. 16, no. 20, 15 Nov. 1920, pp. 334–35.

Welters, Linda. "The Beat Generation: Subcultural Style." *Twentieth-Century American Fashion,* edited by Linda Welters and Patricia A. Cunningham, Berg, 2005, pp. 145–68.

Wharton, Edith. *The Age of Innocence.* 1920. Macmillan, 1993.

Wicker, Alden. "Fast Fashion Is Creating an Environmental Crisis." *Newsweek,* 16 Mar. 2017.

Wilson, Elizabeth. *Adorned in Dreams: Fashion and Modernity.* Rutgers UP, 2003.

Wilson, Judith. "A Conversation with Toni Morrison." Taylor-Guthrie, pp. 129–37.

———. "Shades of Grey in the Black Aesthetic." *Next Generation: Southern Black Aesthetic.* Southern Center for Contemporary Art, 1990, pp. 24–30.

Womack, Steven. "Popular Media Representations of Beat Culture; or, Jack Kerouac Meets Maynard G. Krebs." *Popular Culture Association in the South,* vol. 24, no. 3, 2002, pp. 17–24.

Ziarkowska, Joanna. "Marketing Indigenous Bodies in the Fiction of Leslie Marmon Silko, Louise Erdrich, and Sherman Alexie." *Indigenous Bodies: Reviewing, Relocating, Reclaiming,* edited by Jaqueline Fear-Segal and Rebecca Tillet, State U of New York P, 2013, pp. 101–12.

Index